Karel Appel Sculpture

A Catalogue Raisonné

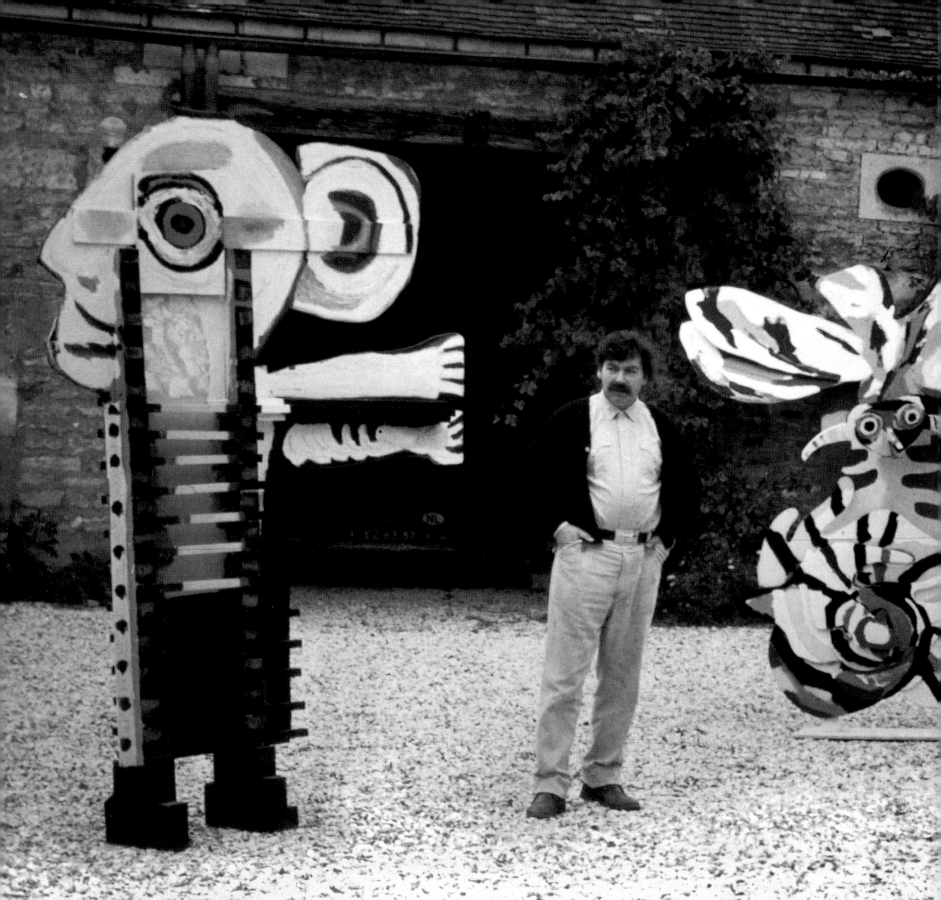

By Donald Kuspit

Harry N. Abrams, Inc., Publishers

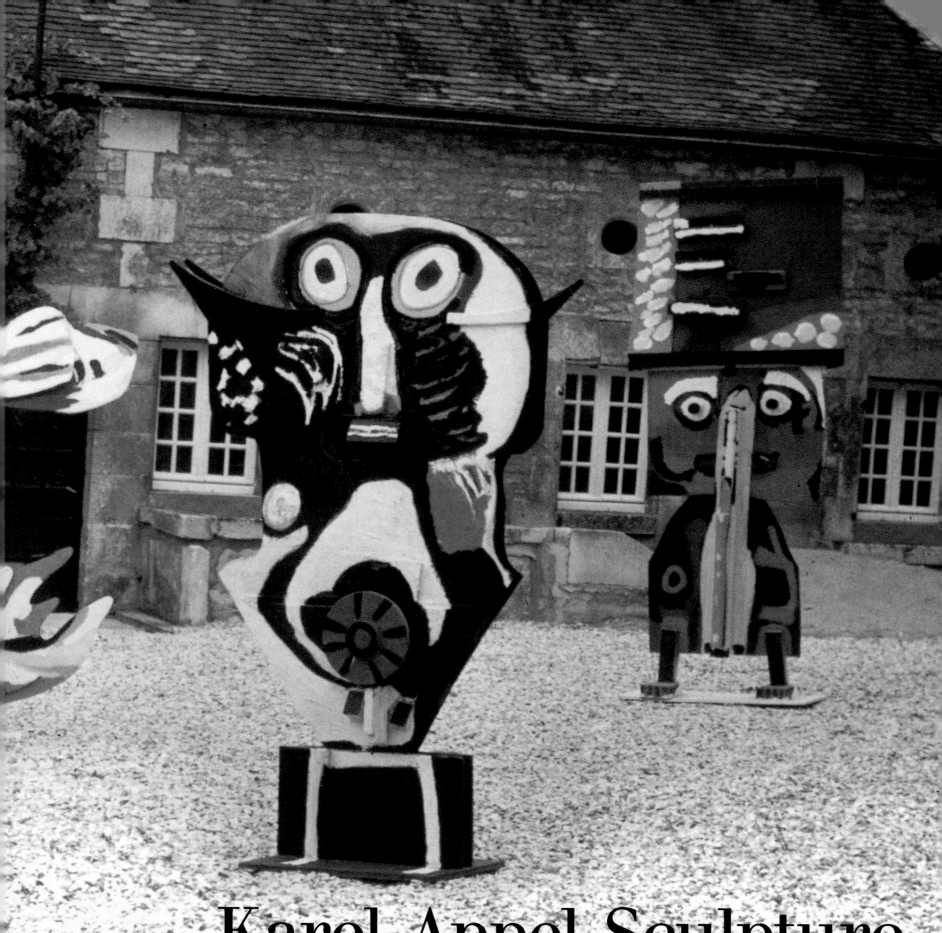

Karel Appel Sculpture

A Catalogue Raisonné

Project Manager: Margaret Rennolds Chace
Editor: Robbie Capp
Designer: Judith Michael

Project Coordinator for Karel Appel: Laura Davey Solomon

A note on the illustrations:
The works of art reproduced in this volume are in the collection
of the artist, unless otherwise indicated.

Pages 2–3: Karel Appel in the courtyard of his studio in Molesmes, France, 1966
Page 6: Karel Appel in Italy, summer 1991

Library of Congress Cataloging-in-Publication Data

Kuspit, Donald B. (Donald Burton), 1935–
Karel Appel sculpture: a catalogue raisonné/by Donald Kuspit.
p. cm.
Includes bibliographical references and index.
ISBN 0–8109–1945–1
1. Appel, Karel, 1921– Catalogues raisonnés. I. Title.
NB653.A6A4 1994
709′.2—dc20 94–8416

Published in 1994 by Harry N. Abrams, Incorporated, New York
A Times Mirror Company

Printed and bound in Japan

Contents

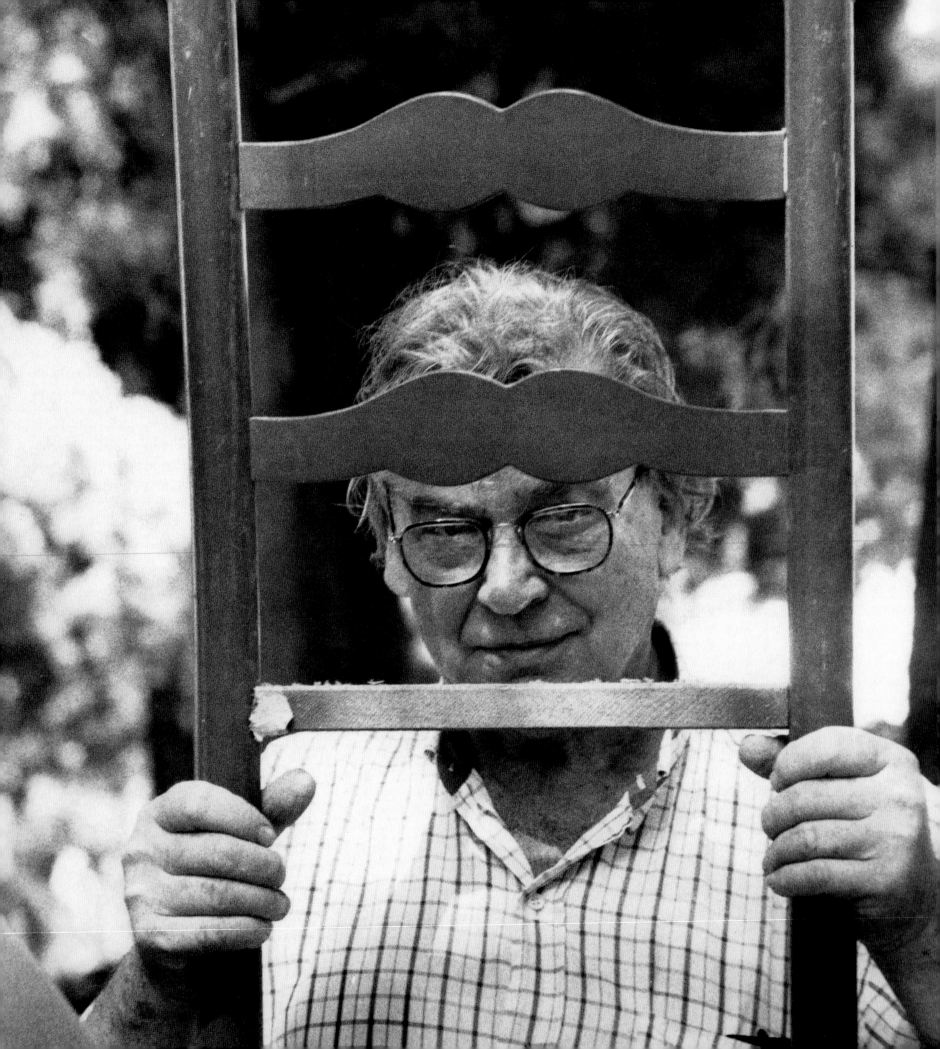

Mad Talk

Mad is mad

madmen are mad

to be mad is everything

to be everything is mad

not to be mad is everything

to be everything is not mad

to be nothing is to be mad

to be mad is nothing

everything is mad

mad is everything

because everything is mad

yet everything is mad

and not to be mad is to be mad

nothing is mad after all

non-madmen are mad

madmen are not mad

mad is mad

mad mad mad

—KAREL APPEL, 1947

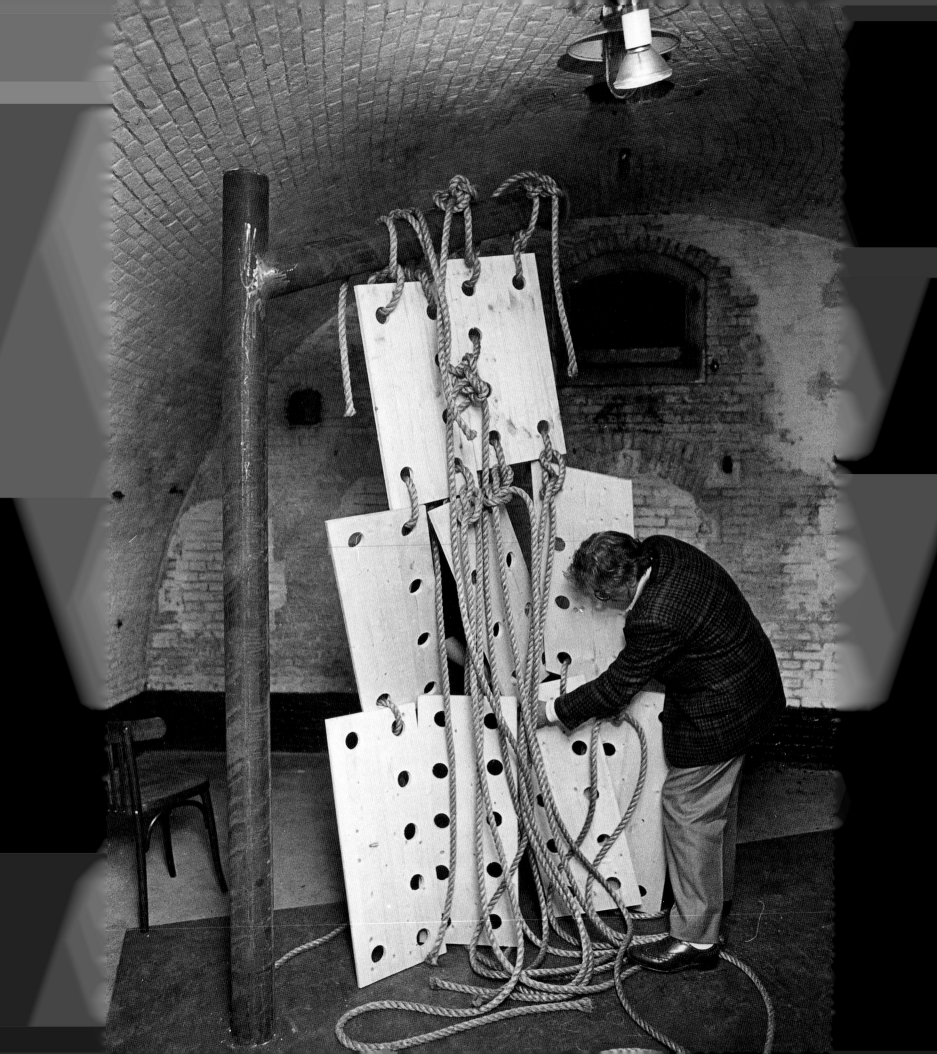

Primordial Presences: The Sculptures of Karel Appel

by Donald Kuspit

I have moreover retained a lasting affection and a reasoned admiration for that strange statuary art which, with its lustrous neatness, its blinding flashes of colour, its violence in gesture and decision of contour, represents so well childhood's ideas about beauty.
CHARLES BAUDELAIRE, "A Philosophy of Toys"[1]

Apparently the possibility of releasing into art powerful passions which cannot find expression in normal everyday life is the biological basis of art.
LEV SEMENOVICH VYGOTSKY, The Psychology of Art[2]

As we watch the progress of aggressive activity in our child, we can gradually discern a developmental move from free play, which permits direct id expression and satisfaction ... to a more structured game setting in which not mere discharge of aggression but a higher integration—the ascendency of good over evil—is the goal.
BRUNO BETTELHEIM, "The Importance of Play"[3]

I

"My art is childlike," Karel Appel said in 1970,[4] as though to say that his paintings and sculptures are toys. Especially the sculptures, because, like real toys, many of them seem to be made to be played with—recent ones have movable parts, which can be mentally manipulated by the spectator—making them more conspicuously mischievous than the paintings. And like toys, all of Appel's works make a "barbaric," "primitive" impression, to use the words Charles Baudelaire used to express his appreciation of toys.[5] Since the time Paul Gauguin wrote that "infantile things, far from being injurious to serious work, endow it with grace, gaity and naivete,"[6] and declared that the works he made went "back very far" for their inspiration, "as far back as the toys of my infancy,"[7] it has been a fact of modern art that its development depends in part upon regression to the perspective of childhood, which some have thought to be the perspective of eternity.

The attitude of the child must constantly be renewed, because it fades away as one grows older and has to deal with reality in a cold and calculated way—and one is always growing older and having to deal with more and more reality with more and more detachment and deliberation. Many modern masters, after an initial very creative, peculiarly personal, childlike—avant-garde—phase, settle down into making an older-looking, more public and traditional—ostensibly more mature, more socially shared (less mysterious?)—art. They in effect stablize their avant-garde ideas into a

Left:
Karel Appel at work on *Between Banner and Flag*, 1987

Overleaf, left:
Questioning Children. 1949. Tempera mural (painted to dimensions of wall). Former City Hall, Amsterdam

Overleaf, right:
Green Personage. 1947. Oil on wood, 30¾ × 13¾ × 4¾" (78 × 35 × 12 cm)

The Big Totem Pole. 1947. Oil on wood, 52⅜ × 4⅜ × 4⅜" (133 × 11 × 11 cm)

Totem Pole. 1948. Gouache on wood, 33⅛ × 9½ × 3⅞" (84 × 24 × 10 cm)

appel
14-3-49

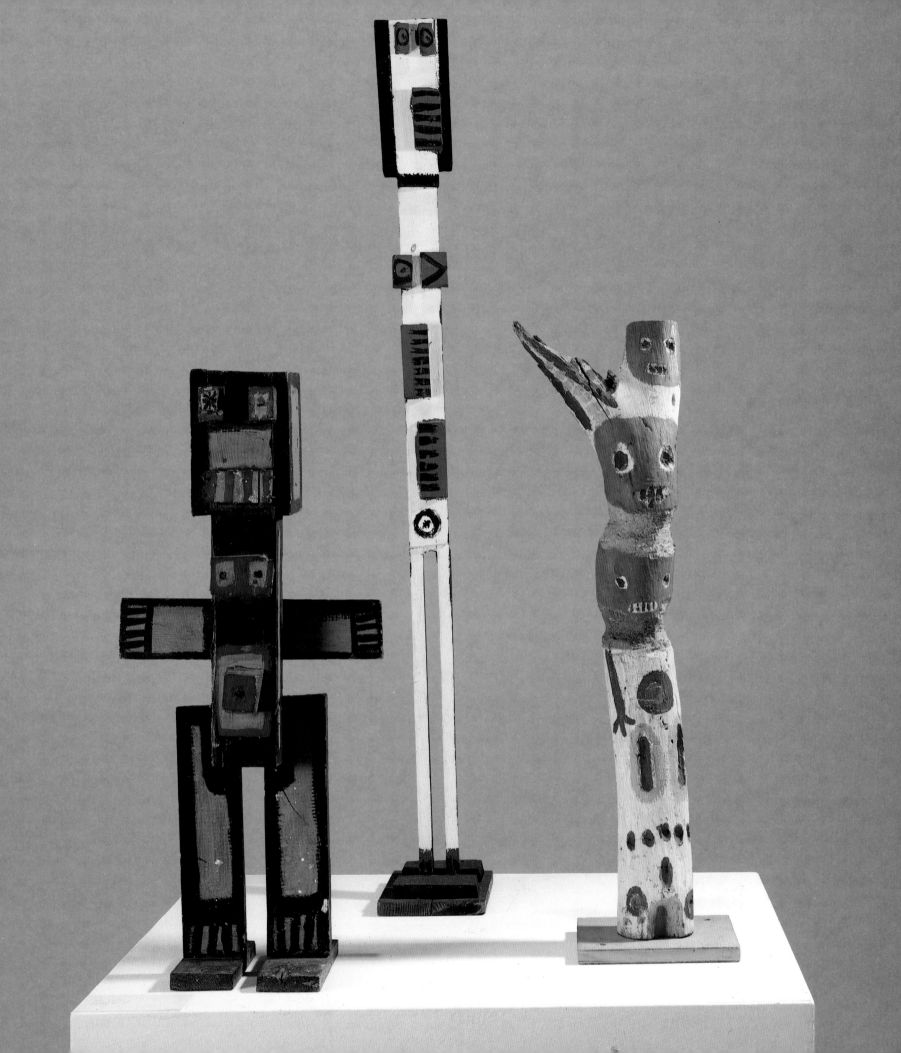

fixed style, losing their creativity. But Appel's art has continued to remain childlike, intensely personal, vigorous, and innovative into what is officially described as old age.

More than ever, it seems to be a demonstration that "creative instinct," as Appel calls it,[8] is inseparable from being an eternal child—from staying in touch with the child hidden within one's psyche. The child is close to the roots of being, which makes his response to things more spontaneous than that of the adult. He is barely separated from nature, and so, still full of its elemental force. Appel's art seems close to the childhood source of art because of its relentless, profound spontaneity and energy, which bespeaks the organic source of our being. Such organic spontaneity as Appel's art shows is increasingly rare—and perhaps always was—in modern art, which has much manufactured and manipulated spontaneity. Passionately expressed spontaneity is the most fundamentally avant-garde aspect of modern art, indeed, the root of its rebelliousness and authenticity, whether such childlike spontaneity— unnerving from an adult point of view—be found in Vincent van Gogh's proto-Expressionistic realism, Henri Matisse's Fauvism, or Jackson Pollock's Abstract Expressionism, to all of whom Appel acknowledges a debt.[9] Appel sustains and extends Expressionism in a way that does credit to their spirits.

Even his work of the late 1980s, which is informed by a growing awareness of death, shows no decline in childlike spontaneity. This work—I am thinking particularly of the four Standing Nudes of 1987 and the eight sculptures, jumbling body parts, of the 1988 Titan Series—is tense with perhaps the most powerful contradiction of all. It forcefully represents the erotic pleasure of being young and the erotic attractiveness of the young—conveyed through figures that are photographically instantaneous and actual (rather than faded, mystified memories). But they are surrounded by the shadow of death—a macabre contour, whose presence is as aggressive and immediate as theirs for all its abstractness. It latently chastises them with its harsh sobriety. Perhaps it reflects Appel's guilt at his desire for them and their youth. The works suggest the inescapability of intense desire and guilt—of ambivalence. But in a sense, this is nothing new, or rather Appel has made something that has always been basic to his art new: the fusion of Eros and Thanatos. Eros—the life instinct—has always won. Indeed, its victory is evident not only in the dominance of bright color in these late figurative works, but in the spontaneous way in which the death instinct is articulated, as though to embrace it passionately. Death is not depressing for Appel—anticipation of it does not stop spontaneity—but rather is itself peculiarly spontaneous. Appel makes the blackness of death vivid to the point of vitality, as though death itself is a kind of growth. Indeed, death is a biological fact of

life, as organically integral to it as growth—a fact that Appel's perhaps most pointedly organic sculptures, made of the gigantic roots of dead olive trees in the early 1960s, makes explicit.

"One of my first sculptures," Appel states, "was made of bicycle parts," found "in the street, like when I was a boy."[10] Played with, these parts came together in an unexpected way, took a strange, suggestive shape that had nothing to do with their intrinsic appearance. The anarchic, aggressive look of Appel's *Bicycle Collage*, 1947, seems like a wild, mutant growth—the bicycle parts jut centrifugally and unsystematically in every direction, making them less mechanical in effect—and is very different from the ironically streamlined, indifferently mechanical, shrewdly tidy look of Marcel Duchamp's mounted *Bicycle Wheel*, 1913 (the first readymade), which the artist liked to set in motion, mentally riding it, as well as from the epigrammatic brevity of Pablo Picasso's *Bull's Head*, 1943, made by juxtaposing two incongruous, indeed, antithetical parts of the bicycle, namely, its handlebars and seat. The former evokes one's active relation to it, the latter one's passive position on it. Appel's sculpture is the most abstract, dramatic, and least mechanical of the three sculptures, all derived from an everyday machine. Also, it more conspicuously triumphs over dead materials by giving them exceptionally vital, expressive artistic life. But all are equally glorified toys, and the unexpected products of deliberate play—fun pieces, as it were.[11]

"The ropes, wires and paint" Appel scavenged from "the garbage cans" of the red-light district of Amsterdam to make his first sculptures in the late forties[12] remain the basic materials of his sculpture. They reappear prominently in the puppet show figures of the Titan Series and the equally titanic portraits of the same year. These works literally have strings, which Appel, *King of the Titans*, clearly pulls, no doubt with manipulative cunning, but also, like one of the *Questioning Children* in his own 1948 and 1949 works, with intense and anguished curiosity—with the wide-eyed stare of innocence at larger-than-life adults, raising the question of how they "work." The child lords it over the adults, whom he reduces to toys, thus making them less dangerous and lofty. He, in the end, feels more imperial than they are. All these titans are Appel's playthings. The tragic human reality they represent—they communicate the tragedy of growing up, the melancholy of becoming serious, of no longer being able to play—is made comic by the peculiarly caricatural, grotesque way Appel renders them. They are all puppets in the same Grand Guignol children's theater that Appel's art has been from its very beginning. Taken together, the Titan Series and the sculptural portraits, which render adults personally meaningful to Appel—who represents himself as a childlike totem of death—are a major

metaphorical statement of his attitude of childlike wonder at and curiosity about the adult world. Much as a child might pull an insect's body apart to see how it works, so Appel pulls the bodies of adults apart to see how they work, then puts them back together to make them work artistically. By pulling their bodies apart, he imagines he can find the soul in them, just as, according to Baudelaire, a child has an "overriding desire . . . to get at and *see the soul* of [his] toys."[13] Indeed, the titanic works are simultaneously monumental and fragmented, as though after dissecting the figures Appel put the parts back together to give them the grandeur of a new soul. They are

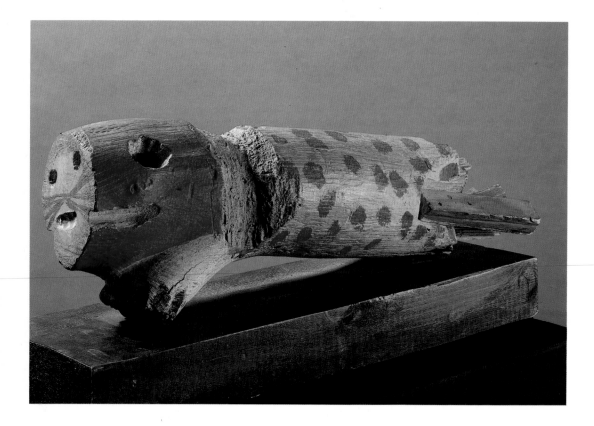

his Frankenstein monster toys, that is, mock human inventions. The titanic sculptures are also symptomatic of the growing symbolic complexity—the increasingly overt allegorical character—of Appel's art. We will return to them.

Why is the ideology of the child crucial to modernism, that is, an important source of the feeling of being new, unprecedented, on one's own, radically autonomous? Baudelaire suggested one reason: "The child is possessed in the highest degree of the faculty of keenly interesting himself in things, be they apparently of the most trivial."[14] More than that, "the child sees everything in a state of newness; he is always *drunk*."[15] This is the modern attitude toward things: No matter how insignificant they may be, they can be intoxicating, and thus seem new, or rather

Left:
Wooden Cat. 1947. Gouache on wood,
4¾ × 20⅞ × 4¾" (12 × 53 × 12 cm)

Opposite:
Passion in the Attic. 1947. Found objects and gouache on wood, 61¾ × 24" (157 × 61 cm).
Karel Van Stuyvenberg, Caracas

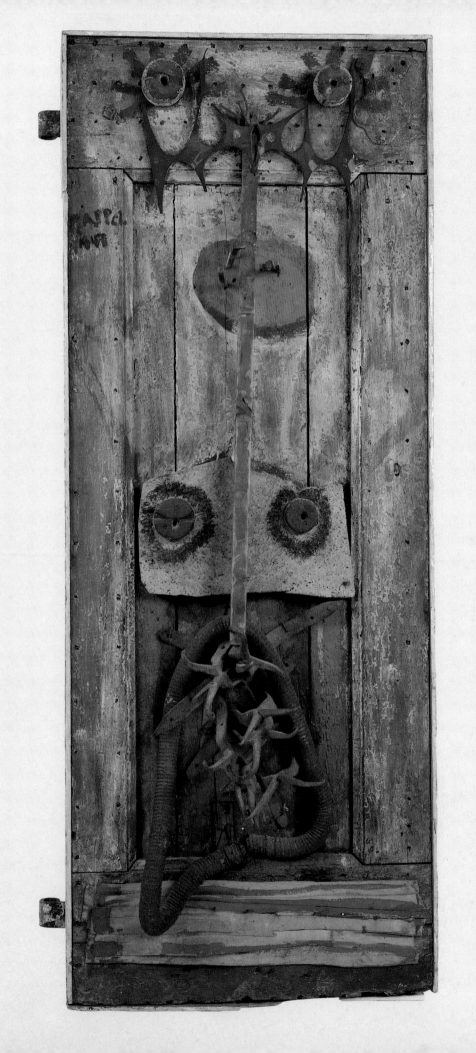

made into something artistically new. For the modern, the perception and conception of objects are not bound by old habits of observation and thought, which makes them exciting. The child finds things new in part because he is experiencing them for the first time and they are unfamiliar, but mostly because he responds to them unreflectively, indeed, reflexively.[16] He is not yet inhibited by self-control, suggesting that he instantly identifies with them emotionally, that is, spontaneously projects his feelings onto them. For the child, things are both what they are objectively and what the child subjectively experiences things to be. This simultaneity is what makes them toys, and in what the child's creativity consists.[17] Without this projection, which in effect re-creates the thing in the child's own image, it would seem ordinary. With the projection, the thing becomes extraordinary—radically transformed by the child's state of mind. It becomes an exciting fantasy as well as a mundane reality—an internal as well as external object. Thus, "the deep and joyful curiosity . . . [in] the animally ecstatic gaze of a child confronted with something new"[18] is his or her creativity in action. The thing may be objectively new, but the child's ecstatic curiosity makes it subjectively new.

"Art" is the process of transformation of an objectively, externally given object into a subjectively, internally given one—a kind of transmuting internalization.[19] More precisely, it leaves the object in a transitional limbo, where the adult can see it as representative of either the objective, external world or of the subjective, internal world. Adults force an intelligibility on the artistically mediated object that it does not have, because they cannot tolerate the fact that there is no such thing as an unequivocally objective or unequivocally subjective world. Unlike the child, the adult cannot embrace the truth that a thing belongs to both worlds. In a sense, the moment it seems to belong exclusively in only the external or the internal world, neither seems credible. Indeed, they almost cease to be real. The artistic transitional object is the pivot of their conjunction and disjunction—their dialectical unity, without which each would be a sterile reification. The artistic transitional object is the umbilical cord which allows us to theorize about the autonomy of each but implies their inseparability in emotional practice.

Children lose their artistic attitude toward things—an attitude which, to reiterate, sees things in their subjective truthfulness as well as objective givenness and as perpetually transitional and undecided, between both poles—when they learn the functional significance of things, thus becoming adults. To learn this is to fall from artistic grace—the grace of childhood perception and conception of things, which gave them so much expressive resonance and being. The problem of the adult artist, then, is to recover that childhood sense of things. As Baudelaire wrote, "genius

The Wild Fireman. 1947. Rubber and iron, 24½ × 21¼ × 18″ (62.2 × 54 × 45.7 cm)

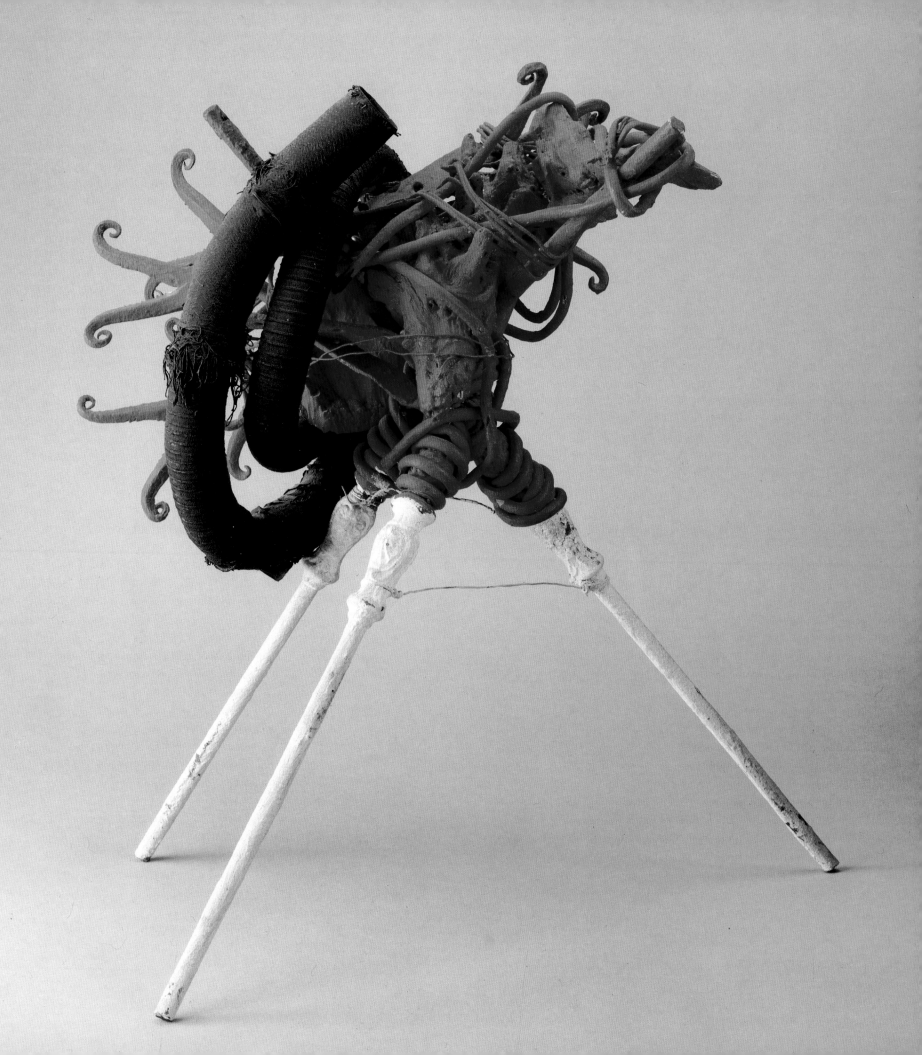

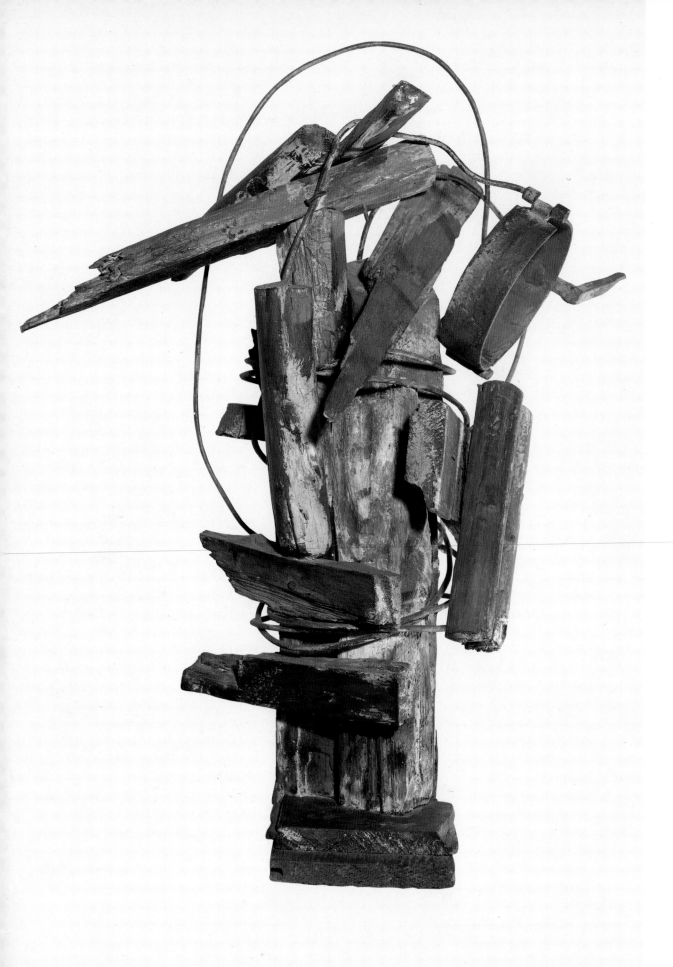

Left:
Windmill. 1947. Gouache on wood and metal, 21⅝ × 16½ × 11⅜″ (55 × 42 × 29 cm). Dr. Felix Ganteführer, Düsseldorf

Opposite:
Scream into Space. 1947. Wood, metal, gouache, and cork collage, 32⅞ × 28⅞″ (83.6 × 73.2 cm). Centraal Museum, Utrecht

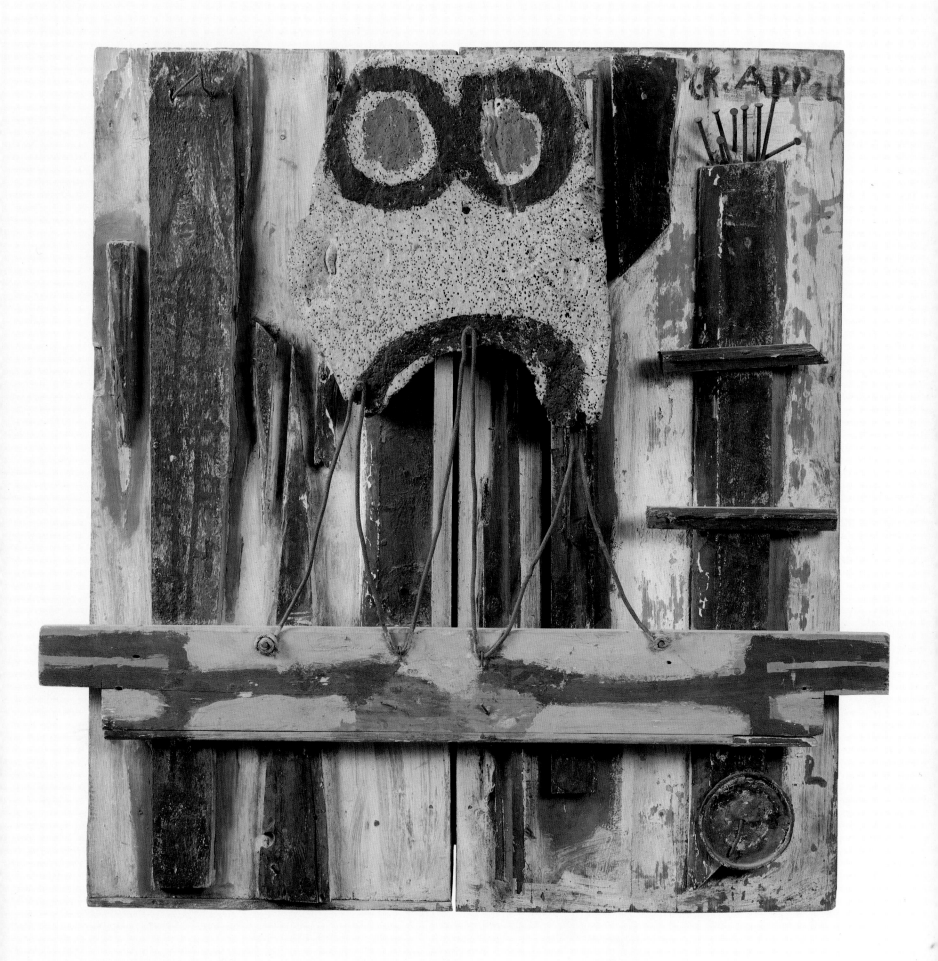

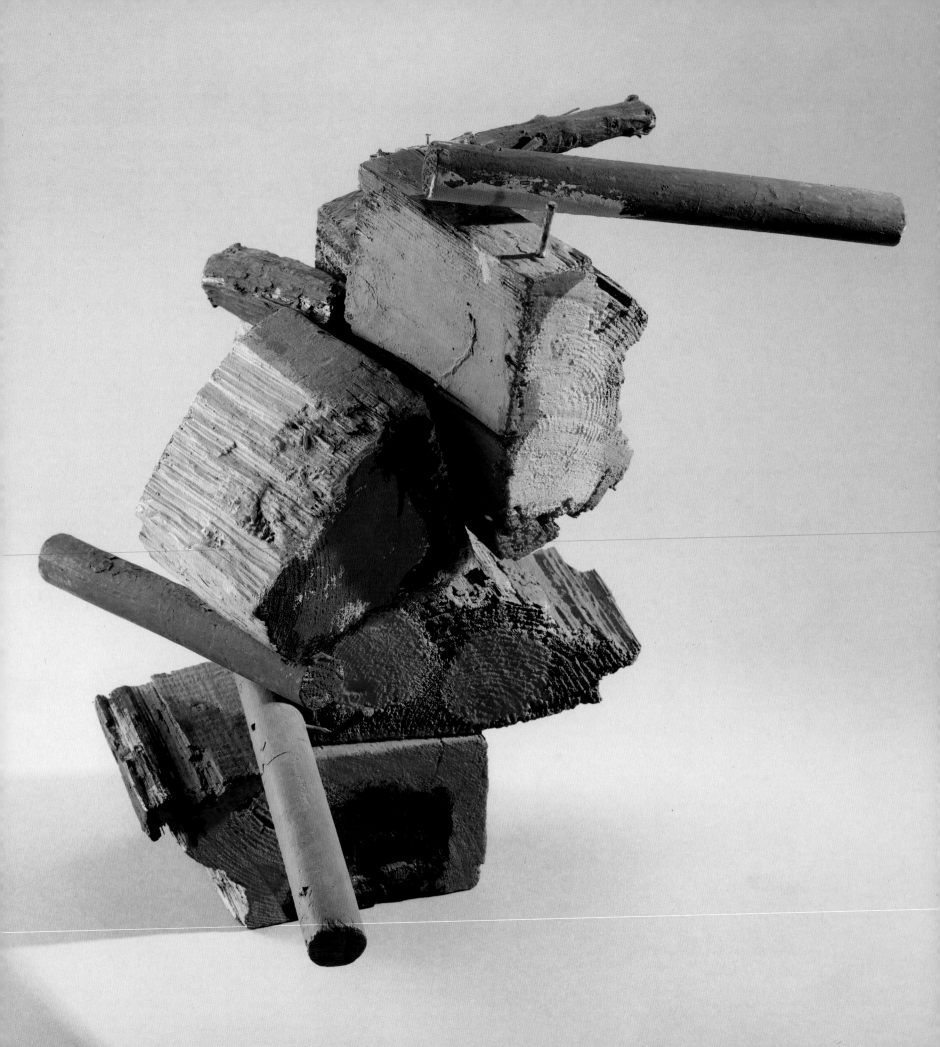

is nothing more nor less than *childhood recovered* at will," if "now equipped for self-expression with manhood's capacities and a power of analysis which enables it to order the mass of raw material which it has involuntarily accumulated."[20] Appel, indeed, seems literally able to recover childhood at will, as the testimony of his art's extraordinary spontaneity, vitality, and projective power implies. But he also seems to understand the child within him, as the symbolic dimension of Appel's art, giving it an intellectual coherence, suggests.

The artistic genius's recovery of childhood at will not only reoriginates external things in all their emotional immediacy and novelty, but reoriginates the self. It is not only the sense of external things as subjectively given that is recovered, but of internal things—each representative of some aspect of the self—as objectively given. The artistic genius restores our sense of the consequentiality as well as primordiality of the self. "The idea of origin may tempt us to use it as if it were a structure devoid of content," as Andrew Samuels writes,[21] but actually, it exists to call attention to the fact that some contents are more fundamental and, therefore, more influential than others. Thus, Appel's "litany of household monsters," as they have been called,[22] is a chorus of internal objects representing Appel's "original self."[23] They are primordial personages, and the fact that they are self-contradictory—full of "the thunder of desire," as their surreal convulsiveness suggests,[24] but also "humiliated by so much unexpected misery"[25]—does not so much deny their primordiality as show in what its originality consists. The self originates in artistically effecting a transition between the opposite instincts of life, full of the joy of Eros, and of Thanatos, full of the misery of guilt at having lived and desired. The self is also a transition, not unlike what the child effects between the subjectively and objectively given thing. The toy embodies both transitions.

II

Thus, Appel's primordial presences seem magically made from the "mass of raw material . . . involuntarily accumulated" in the course of life, to use Baudelaire's words again—the material which the self cannot discard but does not quite know what to do with, but eventually uses to express excess passion. This mass of raw material embodies aspects of the original childhood self, and as such exists at the origin of art. They are in effect cultic, primitive expressions originating it. The seemingly artless turbulence of these figures sometimes looks peculiarly sophisticated, even elegant—this is evidence for the "analysis" that has gone into their making—but they never fail to convey the artful childhood attitude that has

Windmill. 1948. Gouache on wood, 18⅛ × 17¼" (46 × 43.8 cm)

been repressed by adulthood. (Appel can make the "anarchically aclassical"[26] look uncannily classical, without turning it into another expressive cliché, another signature art comfortable with its narcissism.) Their point is to suggest the spontaneous, massively energetic, formless id-expressivity of childhood (such direct expression always seems naive) in which art originates, rather than the tyrannical superegoistic perfection of adulthood in which it formally dead-ends. Appel, as he repeatedly says, is opposed to the, for him, overcontrolled, certainly unspontaneous, art of Piet Mondrian.[27]

It is interesting that the Netherlands has produced Mondrian as well as Van Gogh—both major modernist innovators—and that when faced with the choice between them, Appel chose the path laid down by the latter. There are social and historical reasons for this. In my opinion, Mondrian became the unconscious symbol of the repressive occupation of the Netherlands for Appel, who came to manhood during it. That is, Mondrian was the symbol of living death. (Indeed, I suspect Appel's decision to be an artist was an unconscious rebellion against the occupation and the sense that it induced of being stifled and almost completely destroyed inwardly.) This is of course ironic, for Mondrian wanted to offer reason—enlightenment—in dynamic artistic form that would be emotionally convincing and lively. But such ideal reason in realistic practice became German "reason and order," which were carried to an inhuman extreme by Nazi authoritarianism and totalitarianism. Appel necessarily repudiated reason and order in whatever forms they took, for they seemed the instruments of oppression. He wanted, above all, to be liberated; after such oppression he wanted to be a completely free spirit. Van Gogh's Expressionism was a breath of fresh air, a sign of inner freedom and joy after the depressing, dangerous occupation and war. It symbolized release from as well as acknowledgment of suffering. It symbolized rebirth: Van Gogh's violent, energetic, painterly gestures, like those of Appel, were in effect the birth pangs of the new self, the labor pains of creating it. As Michel Tapié said of Appel's Expressionism, Van Gogh's painting was "dizzily euphoric" with "Dionysian intoxication," as well as full of "human tragedy."[28] Compared to Van Gogh's art, Mondrian's canvases seemed tyrannically intellectual and sterile—all too reasoned and ordered. Indiscreet, free expression was at last possible, after so much wartime caution, repression, and lack of freedom.

Also, in a not unheard-of developmental pattern, Appel rejected a twentieth-century father figure to return to a nineteenth-century grandfather figure, who seemed more primordial—closer to the childhood source of art—partly because he was temporally remote. Mondrian was closer to Appel in time and so an immediate threat, and thus, impossible to idealize. His art, anyway, was already perfect, clean,

The Bridge. 1948. Wood, wire, burlap, and gouache, 28¾ × 30¾ × 21⅝" (73 × 78 × 55 cm)

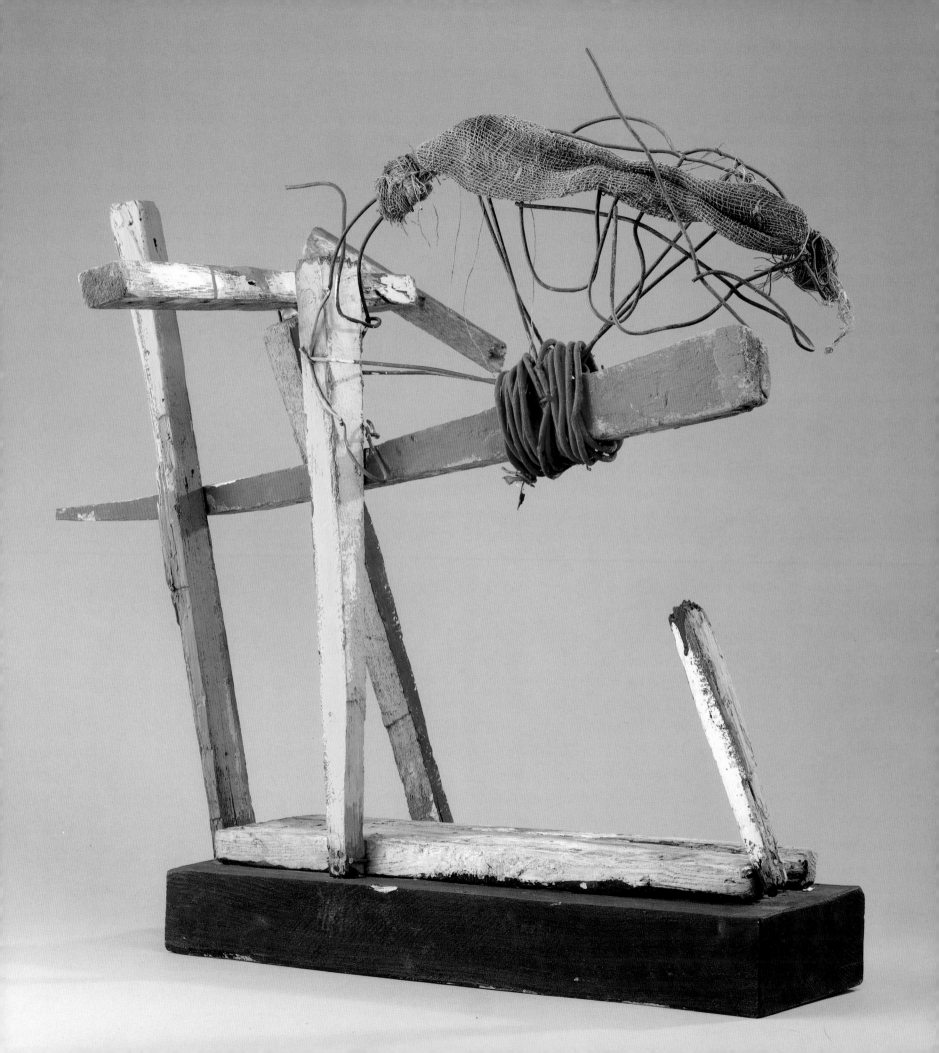

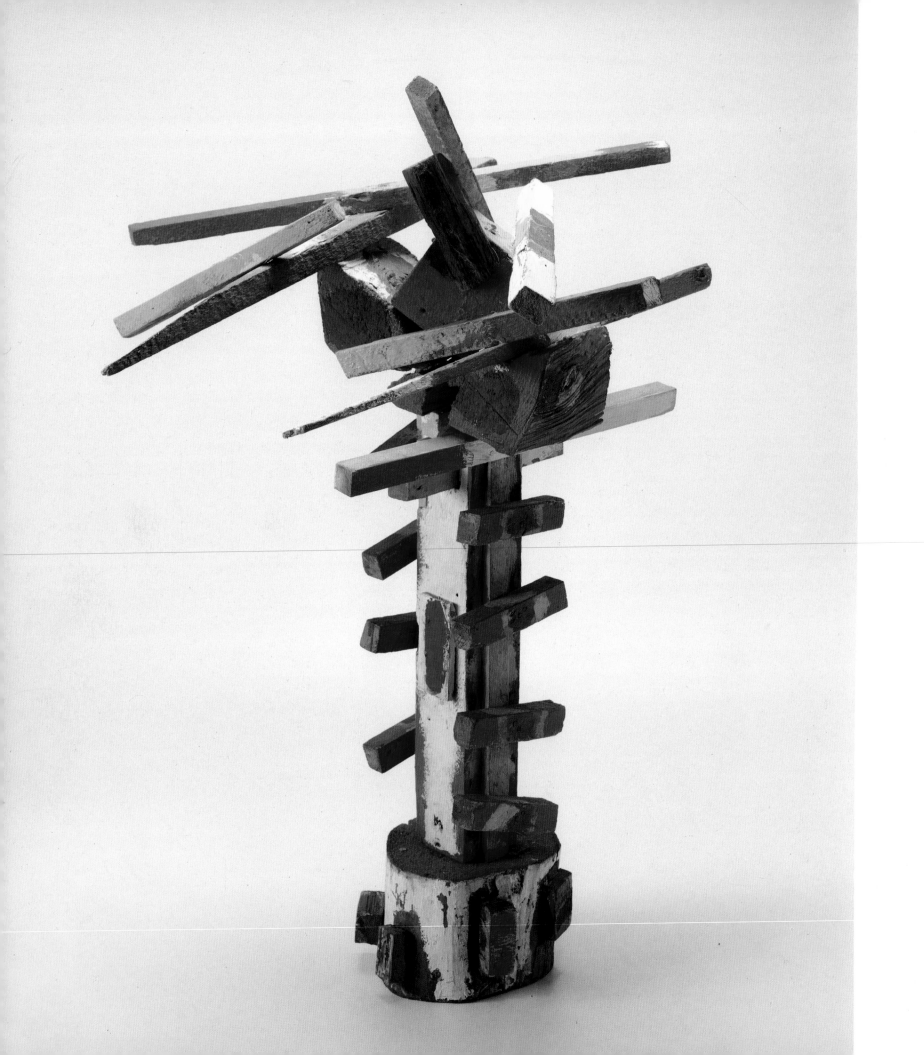

transcendent, suggesting that it had not been made by the hands of life, had never been touched by its dirt and suffering—while Van Gogh's messy life, reflected in his messy art, made him a natural model for Appel. Van Gogh's proto-Expressionist Impressionism conveyed empathy for the human condition, while Mondrian's Geometric Abstraction seemed to dismiss it contemptuously. Mondrian also represented a lost idealism—an artistic garden of paradise lost, impossible to even imagine regaining after the devastation of World War II, which showed humanity at its most infernal. For Appel, the only possible task for art after the tragedy of World War II was to help humanity renew and redeem itself. People had to recover a sense of being vitally human after their demoralization. The terror of total war had to be counteracted by the joy of total freedom and spontaneity, which sublated the aggression of war into libidinous pleasure. Neither the Dadaistic option of disgust and mockery nor the de Stijl option of transcendence—they were antithetical but related responses to the tragedy of World War I, like Appel's Expressionism was to World War II—were humane responses to human suffering and loss. One could mock civilization as a farce and failure or try to rise above it to a heavenly art that claimed to be better than it could ever be, but both attitudes perversely reflected, even reified, its tragedy, rather than tried to remedy it.

Also, World War II showed the dehumanizing power of scientific objectivity, which seemed predicted by Mondrian's "scientifically" executed, technically correct paintings. It was clearly time to return to raw subjectivity, if one was to salvage anything of one's sense of being instinctively human; indeed, of the naturalness of one's existence and of one's natural right to it, which seemed denied by a war that threatened to take one's life at any moment, thus making it seem peculiarly unnatural to be alive. Through a spontaneity that seems to express life at its most passionate, Appel reaffirmed his will to live and be natural in a society that had become unlivable and unnatural. In contrast, Mondrian's unspontaneous art, presenting itself as the ingenious symbol of a scientific utopia, seemed to forfeit the will to live. Appel's irrational messiness, a regression to infantile chaos, as it were— he in fact describes his art as chaos made positive[29]—flies in the face of Mondrian's assumption that life and art have to be put on a scientific basis to be good. Such a basis is for Appel implicitly fascistic, for it implies definitive and thus devitalizing control. The vehement spontaneity of his magmatic painterliness suggests that life and art—for him inseparable at the root—rebel against control the moment it becomes total. For Appel, art is a way of throwing off the shackles of such control by free expression. The Nazis regarded the people they conquered as inferior slaves. Appel's self-expression announces that he will never again allow himself to be

Tree. 1949. Gouache on wood,
38⅝ × 29½ × 24⅛″ (98 × 75 × 62 cm)

humiliated by being treated as one. Art kept his spirit alive and free, and it would keep that spirit alive and free forever.

III

At the least, expression is about the end of repression, and to end repression always raises the fear of insanity. At the most, expression is deliberate catharsis, in the deepest sense: purgation not only of all that has inhibited the sense of the instinctive fundament of one's existence, but of the refusal to ever again feel guilty about expressing oneself instinctively, that is, about being biologically fundamental. There is rebellious expression that spontaneously throws off repression—the accompanying feeling of spontaneity masks the heroic effort necessary for genuine expressive release—and there is primordial expression that seems to present what cannot be represented, only declared: the force that is basic to being alive—the force that goes under the name of the amorphous id. The most genuine Expressionism seems to refuse any ego defense against the id, and at its most extreme and risky, seems to show the id glorying in its drivenness and intensity. (Of course, such a defenseless, unconflicted position is in artistic practice impossible.)

In other words, there is the Expressionism of disruption and violent revolt, and the Expressionism of eruption and joie de vivre. Spontaneity is disruptive, but it is also lyric. Appel's figures seamlessly fuse these contradictory effects of spontaneous expression—they seem to be simultaneously negative and positive forces, which is why they look eternally vital and archetypal. Amazingly, Appel is able to live at an id depth of being without being crushed by its great pressure. Indeed, not only is he not destroyed, driven insane by the frenzy of primordial instinct, but he seems to thrive on it, as his productivity suggests.[30] He is a lucky Prometheus, apparently paying no price for his creative theft of primordial fire, his vitalizing gift to us.

As I have said, art originates in transitional experience, but even more fundamentally, it originates in primal expression, that is, expression of primordial instinct. (Art as transitional experience carries that expression into social space.) To narcissistic human beings, the body seems either primordial in itself or primordial by extension, in that it contains the fire of primordial instinct, sacred in that it ensures vitality. With unusual directness, even for an Expressionist, Appel returns us to the first art—body art, more particularly, painting the body to express its aliveness and assertiveness, that is, to make manifest, in whatever fantastic form, the power of instinct latent in it.[31] The self paints the body in order to make sense of its own embodiment, its feeling of mutuality with the body and its instincts, without which

Questioning Children. 1949. Gouache on wood, 34¾ × 23½ × 6¼"
(88.3 × 59.7 × 15.9 cm). Tate Gallery, London

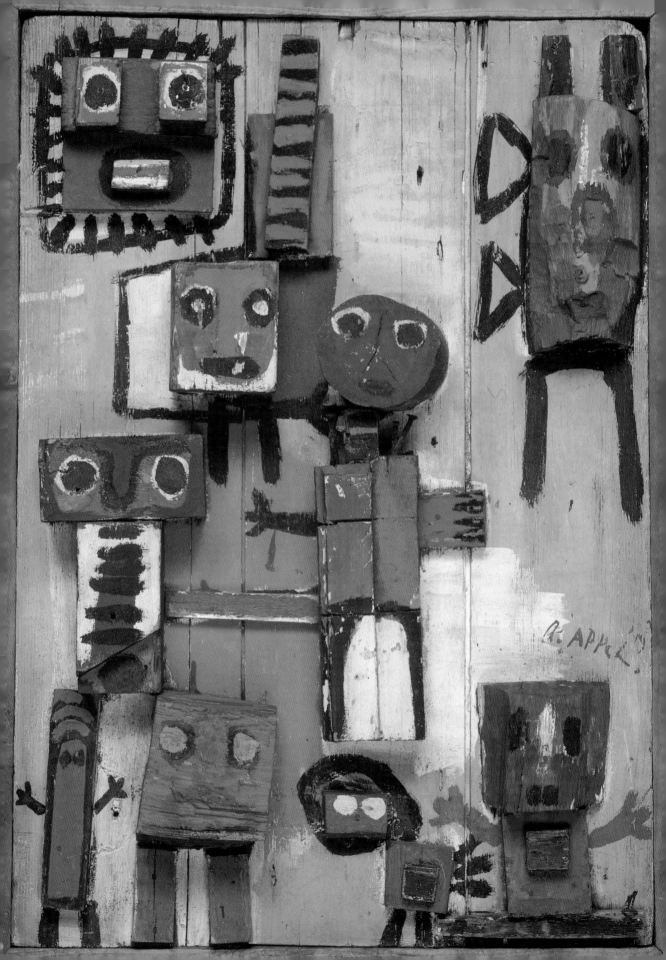

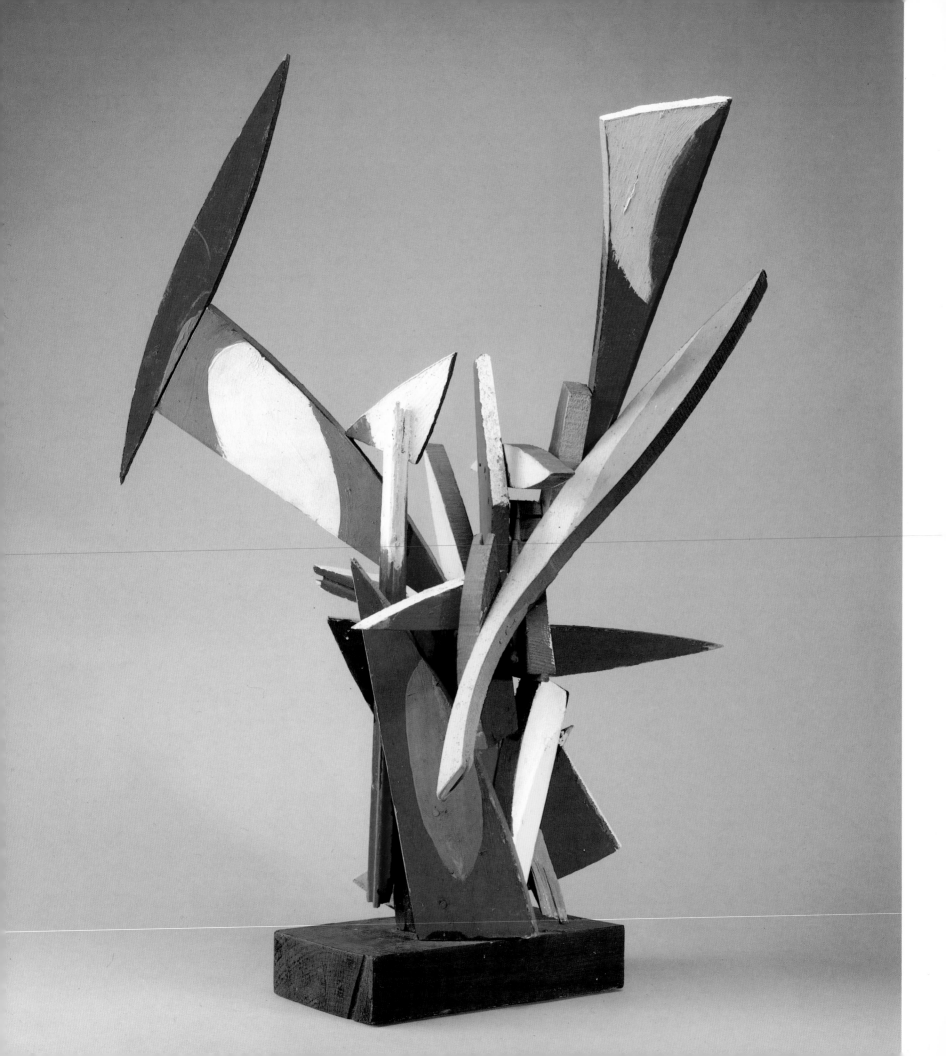

the self would not feel vital. The painted body makes these, and the experience of embodiment, intuitively intelligible. To paint the body is to reenact the magical moment in which the self seems to spontaneously generate out of the mother-child body, and the body is reciprocally viewed as the self. Indeed, Appel's painterliness, like all good Expressionistic painterliness, conveys the sense of being spontaneously generated—self-generating. It is as though his gesturalism let the jinni of instinct out of the bottle-body in which it was imprisoned. Once freed, the jinni grows gigantic—to mythological proportions—and seems autonomous. It is no longer the body's perverse little secret, the source of its power, harnessed to do its work, but seems to be a force in its own right. Nonetheless, while Appel's instinctively forceful gestures seem to have a life of their own independent of the material body they articulate, they also seem peculiarly dependent on it, for they do in fact represent it, however bizarrely. Appel's hallucinatory figure has a double function (which is no doubt why it seems especially "monstrous"): to represent the jinni of instinct, and at the same time, the body it is trying to escape from but to which it remains attached. For the body, however much it is experienced as a restraint and prison, is the only place it can exist.

Appel's art has been said to convey an "attitude of lived rather than doctrinal Surrealism."[32] This suggests that his attitude to "corporeal spontaneity"[33] is fundamentally different from that of standard Surrealism. Where it betrays spontaneity by objectifying it as a stylistic mechanism, in effect denying its corporeal, organic reference, Appel treats it as a subjective end in itself. For him, spontaneous expression is the subject's way of denying that it is an object in a world that treats it as one. It is the subject's way of saying that its body is not the world's instrument. For Appel, spontaneity is the inarticulate expression of the primordial spirit, a force that has a certain rhythm and weight that is not an objective form—a gratuitous release of instinct that not only is of no use in everyday life but is too intense to ever be. For him, authentic spontaneity can never be reified into an everyday sign of an everyday body. On the contrary, it defeats the everyday treatment of the body as a commonplace object, implying a profound indifference to its humanness and to the human in general. It restores our sense of the body-mind as a subjective reality in a world which has banalized it into another objective reality.

Appel defiantly creates organically spontaneous bodies in a world in which the body has come to be regarded as a kind of robot. His primordial personages are anti-robots, to allude to the title of a 1976 work. The typical Surrealist, in unconscious capitulation to the everyday as well as to scientific materialism, does not so much create bodies as construct them, suggesting that for him the body is implicitly a

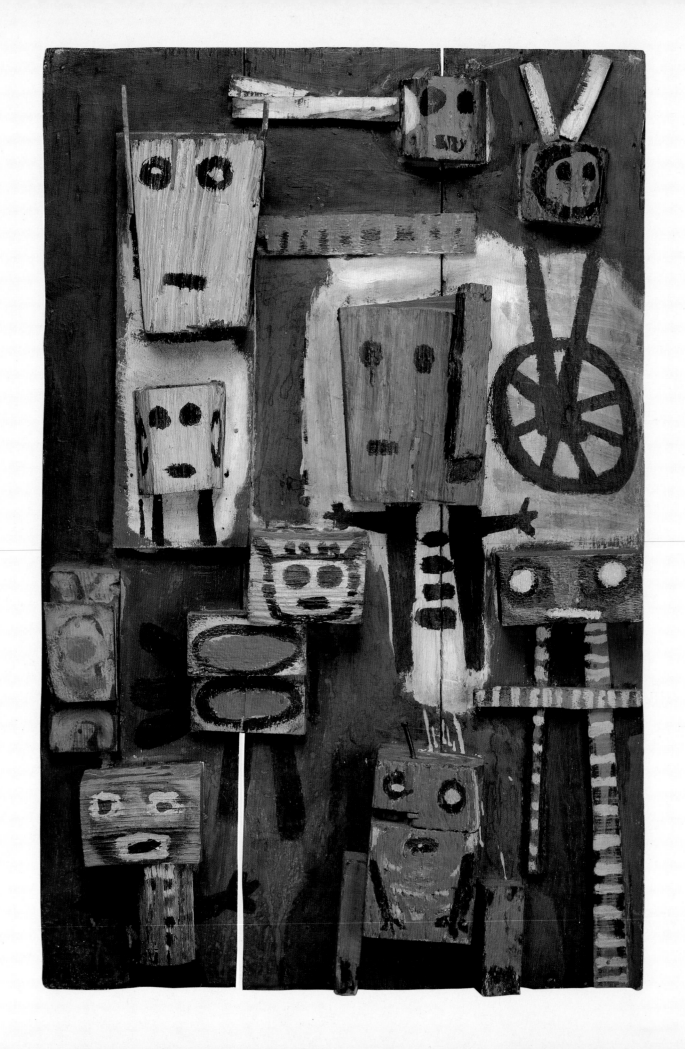

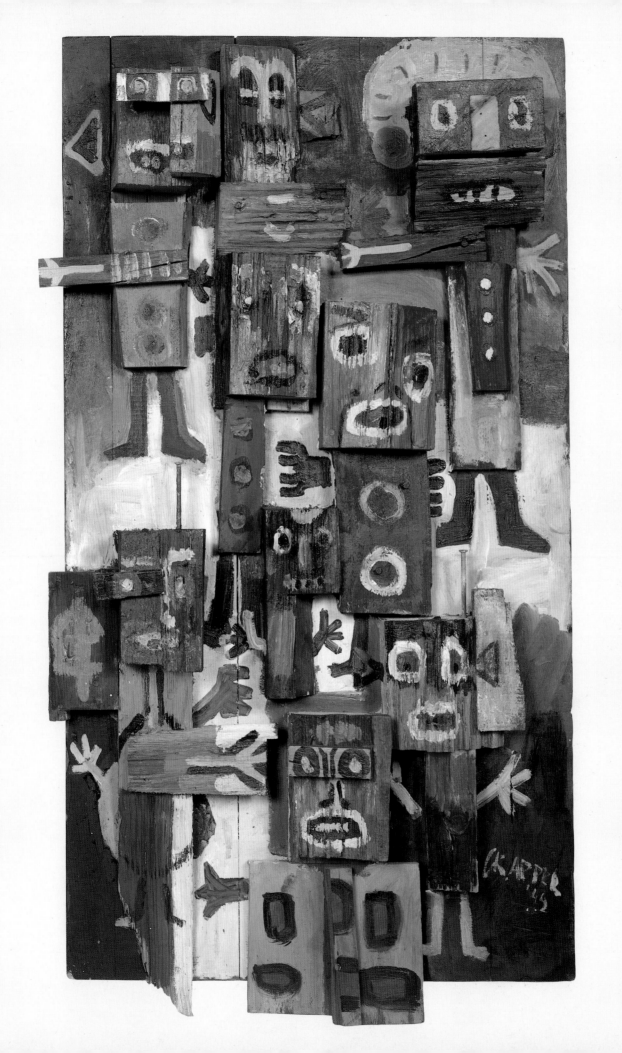

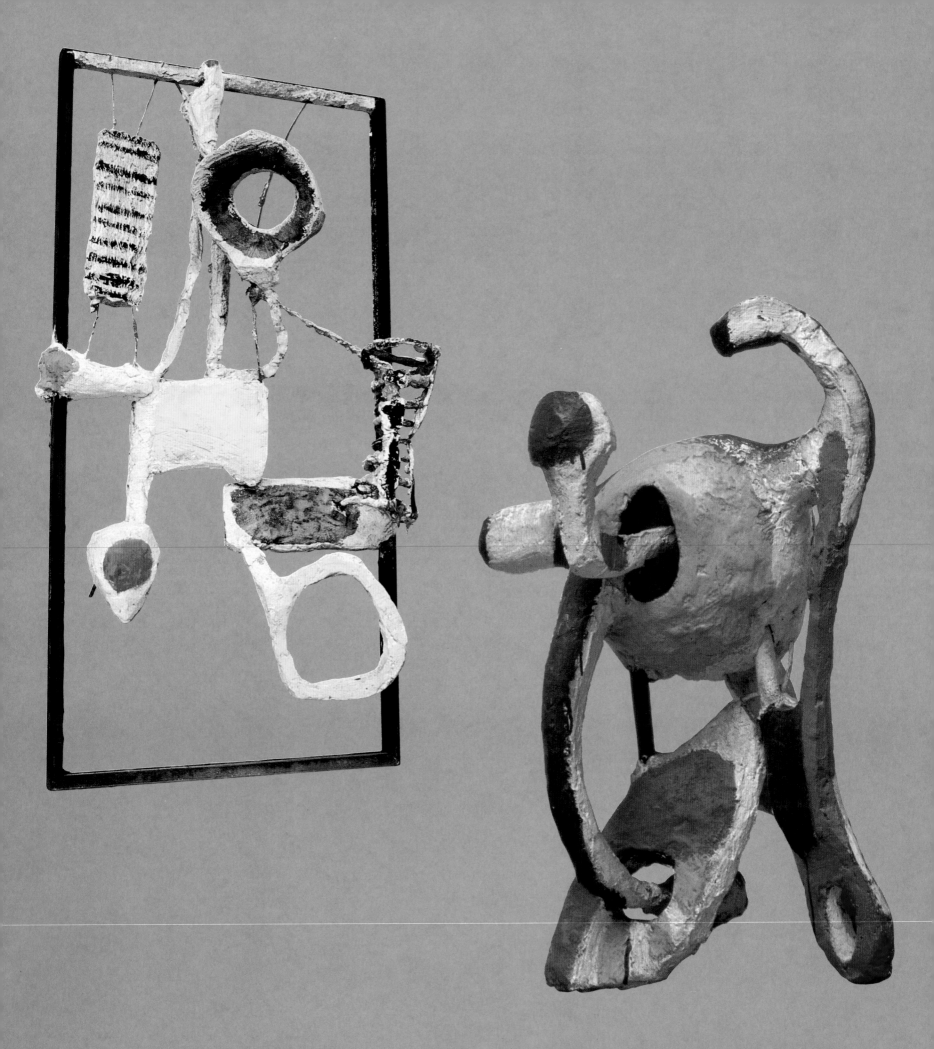

dummy, indeed, explicitly so, as the many Surrealist mannequins show. They are inorganic or at best pseudo-organic machines. (I think this is true even of Max Ernst's seemingly organic figures, although many of them look like dead plants—however much their weirdness gives them the aura of life—or rather like petrified waxworks of generalized organic growths.) In contrast, Appel's figures are defiantly organic. In this his work is much more of a revolution against the prevailing attitude of the times than Surrealism, which by reason of its strong undertone of depressive mechanization is more accommodating to them, no doubt unconsciously.

IV

Appel's subject matter is the basic material of life, as has been the Expressionist case since Van Gogh and Munch. Certain themes continually recur: animals, faces, figures—some of the figures are elongated faces—nudes, children, and plants. There is also an important group of abstract constructions, untitled works where the point is explicitly and playfully formal. They testify to Appel's intense curiosity about the possibilities of art making. Indeed, even in the obviously representational works Appel is a great inventor, exploring the different expressive effects of different materials and techniques.

Some of Appel's sculptures seem like folk art, others like quick graffiti sketches made three-dimensional. Many use found materials and found objects; others are made of plaster, steel, and wood. Some works are elaborate constructions, others seem deftly carved or modeled. Virtually all are painted. However primitive they may seem—and primitivism was a liberating influence for the CoBrA group to which Appel belonged and the *Art autre* movement with which he had affinities[34]—there is always a sophisticated awareness of color relationships, however gaudy and loud his colors often are, and a remarkable—in my opinion, completely unique—sense of the interplay of form and formlessness. This indicates a finely tuned formal sensibility and power of formal innovation, taking his sculptures far beyond their "street" origins. Responding to his association with Dubuffet's *Art Brut,* Appel remarked: "Dubuffet is not *Art Brut.* You only see *Art Brut* in New York, where the poor paint their stories in the street, on the fronts of buildings, on hoardings, on the New York subway cars. Wall graffiti are *Art Brut.*"[35] *Art Brut,* then, for Appel as well as Dubuffet, is a starting point, not an end—an inspiration, not a realization. *Art Brut* offers a raw vitality and sense of immediacy which Appel puts to his own aesthetic use. This is especially clear in his sculptures, which are made with a deliberateness that street art lacks, and thus have a profounder evocative power than it has.

Opposite, left and right:
Untitled. 1950. Gouache on plaster and wire, height 39⅜" (100 cm)

The Elephant. 1950. Gouache on plaster, 26 × 10¼" (66 × 26 cm)

Overleaf, left and right:
Cavalry Child. 1950. Gouache and burlap on plaster, 52 × 33⅛ × 4¾" (132 × 84 × 12 cm)

The Spider. 1950. Gouache on wood, 41½ × 29¾" (105.4 × 75.6 cm)

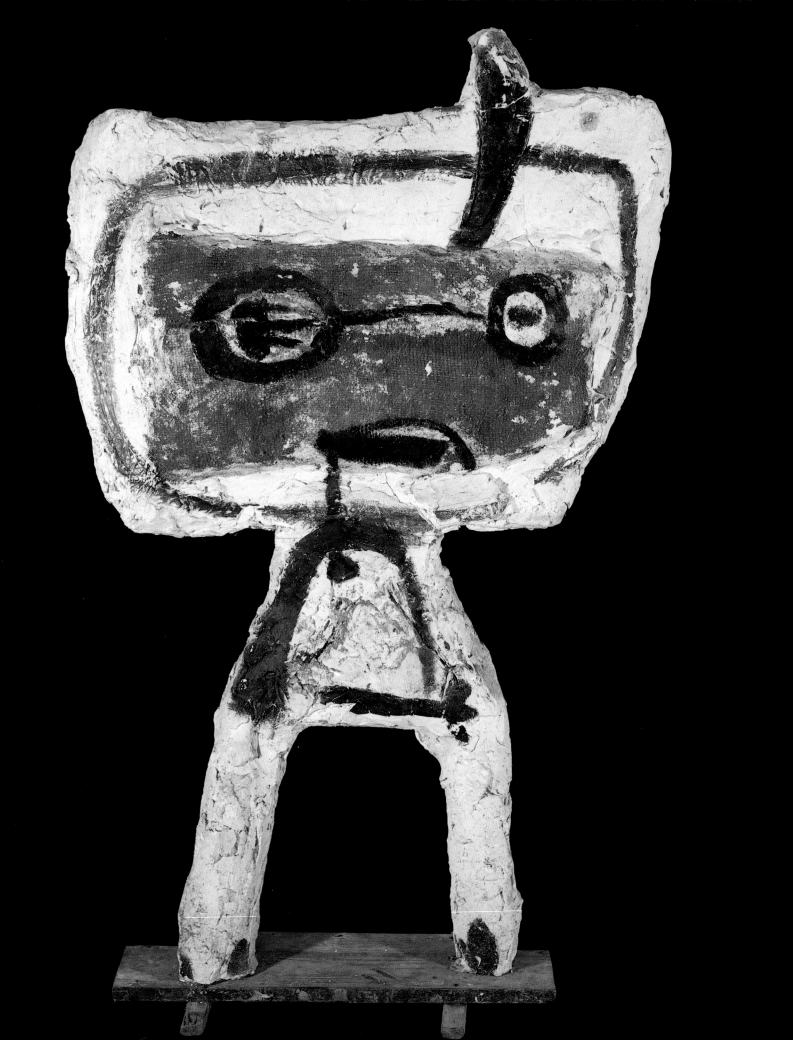

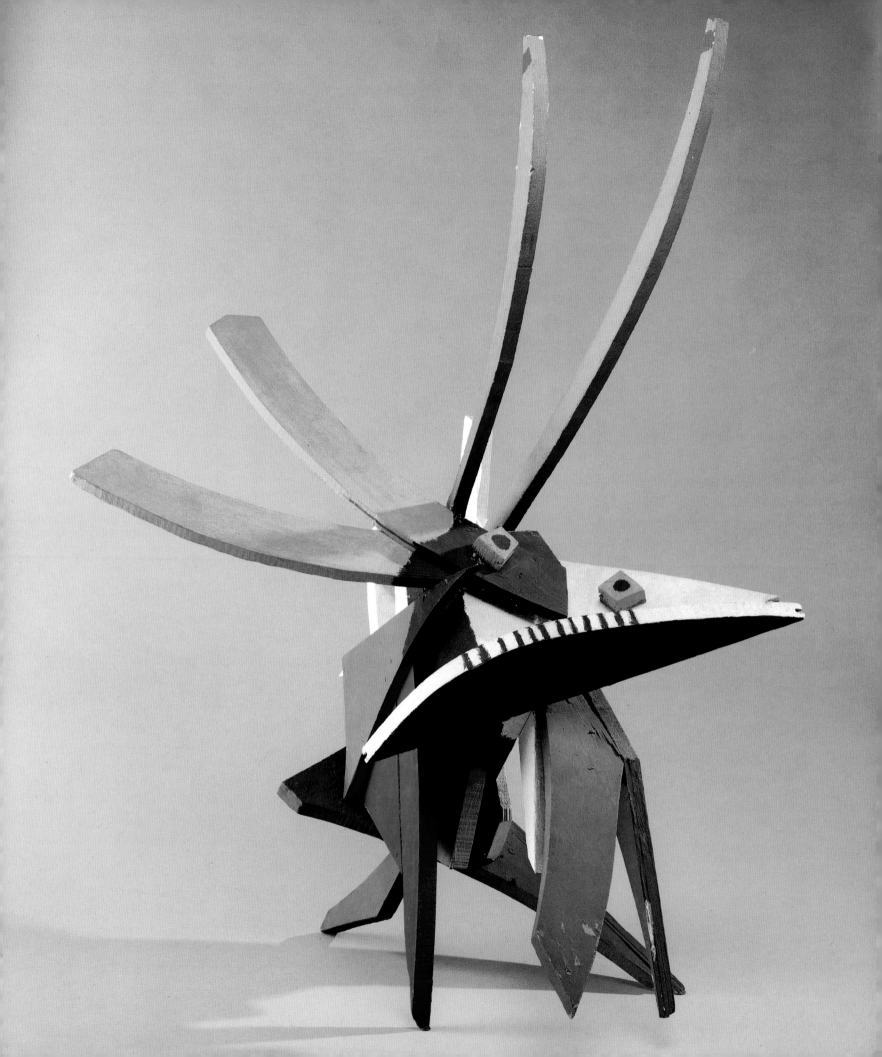

Perhaps Appel's most famous—indeed, notorious—series of sculptures are the *Questioning Children* pieces of 1948 and 1949. These works, relief assemblages of painted wood, are touchstones for Appel's attitude and style. They unfortunately became known for reasons that had nothing to do with their avant-garde merit. One of them, transposed into a mural painting, caused a public scandal, acknowledging its subversiveness, but for the wrong reasons, that is, not in recognition of its "experimental" uniqueness[36] but in shock at its difference. No doubt this was better than being damned by faint praise, but it was nevertheless damning. The painting, installed directly on a wall of the cafeteria of the Amsterdam town hall, was completed by Appel on March 14, 1949. Thereafter, all hell broke loose, as the saying goes. In my opinion, the painted mural's power of projection was one of the reasons it caused trouble. It pushed its way into the room, as it were, making it hard to ignore, and its theme dealt with something everyone wanted to ignore, especially so short a time after the war. Thus, Appel did something that he has always done, and did it with characteristic bluntness—he expressed what everyone wanted to repress. He forced to consciousness what everyone preferred to forget: the innocent victims of war, epitomized by the children. A dangerous-looking gang of street urchins, each nonetheless has an orphan's aura of isolation, and desperately begs for a handout to get by. These hungry children did not exactly help one's appetite as one was eating in the community cafeteria. One could hardly enjoy one's food with Appel's hungry children staring at you as you ate, especially if it was your job to feed them. Their hunger and gauntness was a judgment on one's full belly. The mural (and the series) was mortifying and offensive, all the more so because it was inspired, as Appel said, by the sight of German children begging alongside a train.[37] Thus, the work caused emotional confusion as well as social embarrassment, inasmuch as the Dutch, having suffered so much under the occupation, had little sympathy for the Germans. Yet, how could one not have sympathy for suffering children, whatever their nationality?

Questioning Children is abstract, but its message is unmistakable. Indeed, while the work makes a social point—the postwar plight of abandoned children, hordes of them—the abstractness makes its larger emotional point clear. The social message is the point of departure for the expression of a state of mind. Appel has always been interested in extreme, even pathological states of mind—urgent states in which the mind is stripped to its basics, and as such, seemingly insane, undefended[38]—and *Questioning Children* is his first important articulation of such a psychotic state of mind. Indeed, the children suffer from soul murder, not simply hunger.[39] They are aggressive in response to traumatic loss, and because they no longer know how to love—no longer trust enough to love. *Questioning Children* is offensive not only

because it brings the life of the street inside, but because it subliminally conveys a dangerous state of mind.

Questioning Children could not help but make a tremendous impression. Abstract art has the advantage over representational art of having instant unconscious appeal, indeed, of seeming to directly express primary process. Its form has spontaneous emotional effect before its content can be read. It is as if abstract form outsmarts the ego—slips around the repression barrier unnoticed, or rather invisibly passes through it by osmosis—which is busy looking for a dangerous content. It does not expect form to be dangerous, but form is ultimately all that is dangerous in art. Indeed, the irrational if generally vertical organization of multicolored rectilinear pieces of wood, painted in a seemingly slapdash way, is the primary content of *Questioning Children.* The narrative of the begging children is a secondary, rationally comprehended, obvious content. This narrative is a socially given gestalt, communicating what is socially considered to be real and important. In contrast, the loosely knit, generally gestural character of Appel's form—the pieces of wood in the reliefs are used as gesturally as the paint—conveys a sense of what is unconsciously relevant and viscerally real. Its gestalt-free character is what makes it dangerous.[40] Visitors to the cafeteria would eventually become indifferent to the not unfamiliar storyline of *Questioning Children,* but they could never become immune to the work's form, which would continue to subliminally affect them. Appel's form took too much liberty to be intellectually rationalized into just another style. His paradoxical combination of simple geometric shapes and simplified facial features and bodies on the one hand, and crudely painted, amorphic color on the other—a heady, irreverent combination that Appel was to continue to create with ever greater nerve, manic energy, and subtlety—was too uncanny to bring under control. His work increasingly became a wild witch's brew of gestures, unconsciously intoxicating.

If for no other reason, *Questioning Children* was emotionally inescapable by reason of the intensity of its colors, which projected even farther into space than the pieces of wood. Where the roughness of the wood suggested the ragged character of the children and their poor physical health, the drama of the colors—largely primaries, with particularly startling tones of red, abrupt if muted yellows, and blues that tended to harden into black[41]—brought out their emotional hurt and unhappiness, indeed, anguish. Moreover, Appel's figures had a primitive starkness that could not help but unconsciously remind people of toys. Looking at the work was like playing with toys—actually, the first toys that were truly one's own, because one made them oneself from odds and ends found on the street. Thus, they were more imprinted with one's personality than the manufactured toys one's parents bought for

Overleaf, left and right:
Personage. 1950. Gouache on plaster and wire, 25⅝ × 18½ × 17¾" (65 × 47 × 45 cm). Galerie Nova Spectra, The Hague

Personage. 1950. Gouache on plaster, height 27⅜" (69.5 cm). Karel Van Stuyvenberg, Caracas

37

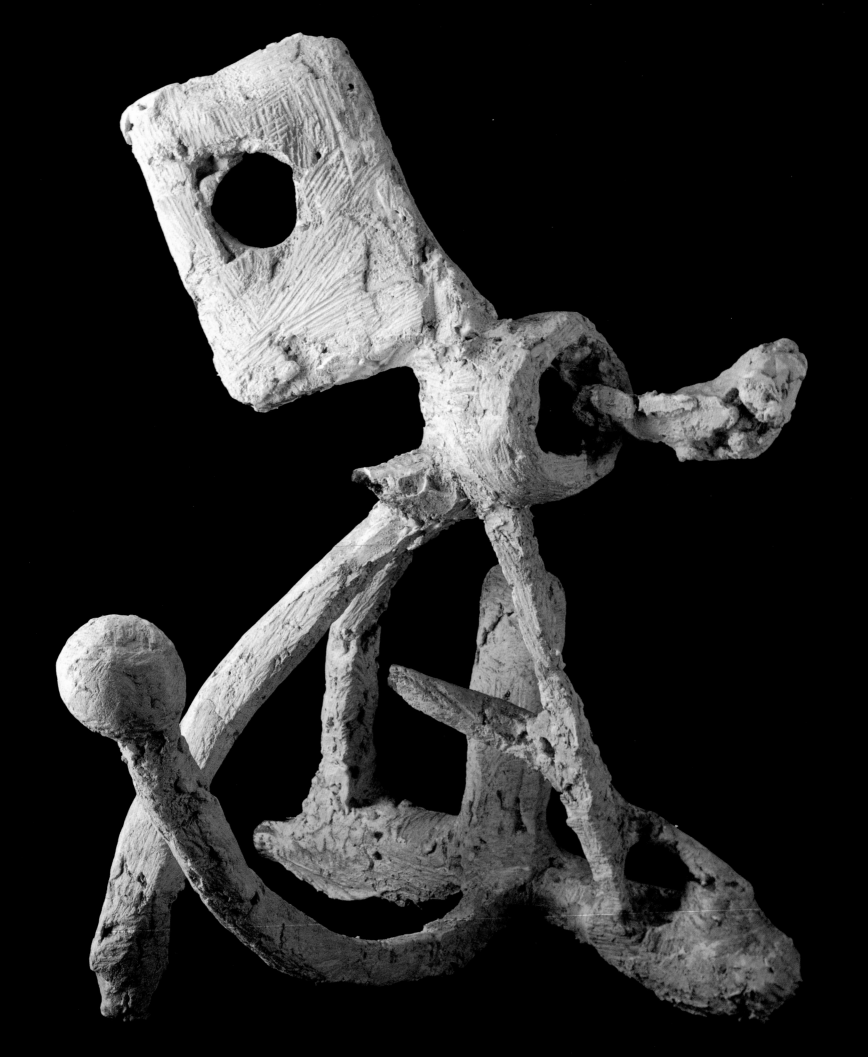

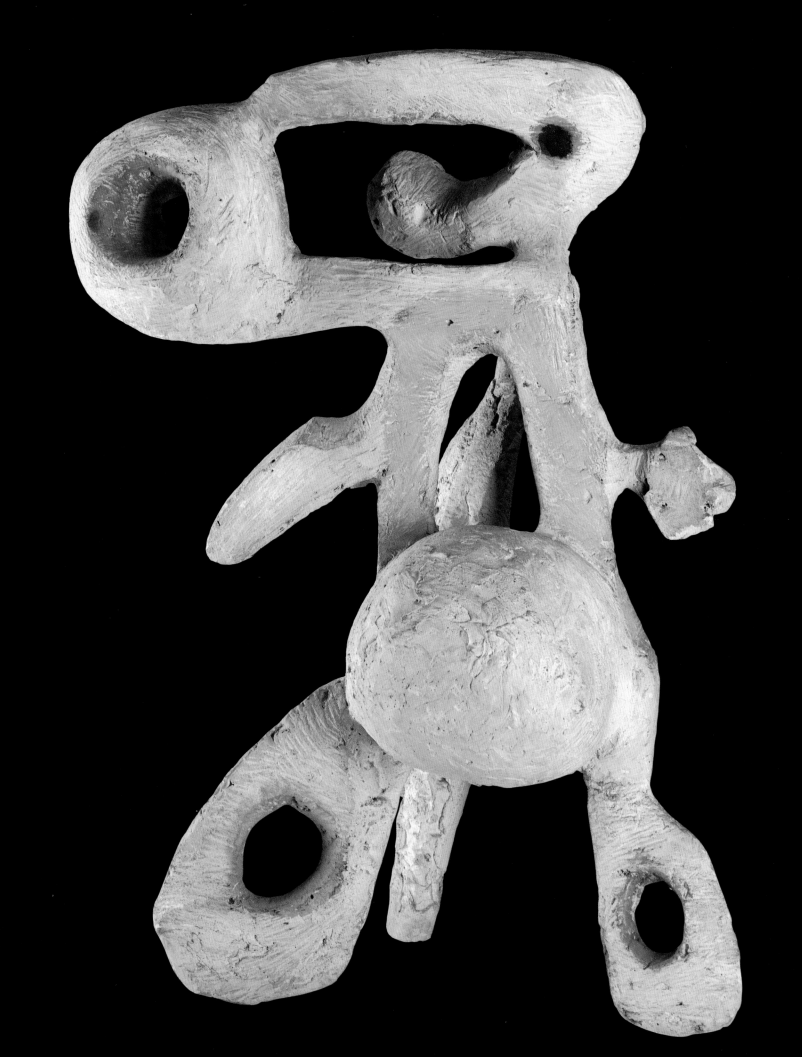

one. *Questioning Children* could not help but remind spectators of their own childhood, and of the frightened children they were inwardly reduced to by the war. It could not help but evoke the child buried deep within everyone and the questions that child had about life and continued to have. Indeed, Appel's deeply troubled children, by appealing for help, questioned every adult's conscience. They aroused ambivalence, on the one hand causing guilt because they implied neglect, even abuse, and on the other, the parental wish to care. Appel's relief sculpture established a dense, complex matrix of anxiety-arousing associations, a virtual psychic terra incognita, inevitably unnerving to the diners in the cafeteria. What was meant to be a relaxing, carefree social space, an oasis in the daily routine, became a highly personal, emotionally charged, dangerous territory. A threat to emotional stability, Appel's outrageous work had finally to be covered, arousing anger and resentment in its defenders.[42]

Questioning Children is Appel's *J'accuse*. Its artistic originality makes an avant-garde point, but also serves moral awareness. It is not so much that Appel wants to use art to make a moral statement, and so makes a bold art to make his statement forceful—makes a novel image that will make a familiar moral truth freshly importunate—but that for him, artistic revolution is inseparable from moral revolution. They are equally difficult to make, and equally subversive of the status quo, and thus equally disturbing. *Questioning Children* is a plea for action that not only questions its audience's conscience, and more deeply its will to care, but its taste, which is also a kind of moral capacity, a way of caring.[43] Appel's work suggests that conventional taste, which might accept *Questioning Children* if it were an ordinary representational painting made of "fine art" materials—and particularly if the children were pretty for all their desperateness—rather than an abstract image of street materials "touched up" with paint that was not handled in a particularly refined way, is as covertly immoral as indifference to the hunger and suffering of the children is overtly immoral. For the banality of such taste implies lack of feeling for them, much as Appel's unconventional handling opens the way to empathic understanding of them. If a work's affective depth and existential force is measured by the extent to which it contradicts the conventional horizon of expectation and the conventional wisdom about art making without seeming absurd, however strange it seems, then Appel's *Questioning Children*, through its gestural innocence and street outspokenness, plumbs depths of feeling and articulates a sense of existence unimaginable to conventional taste.

Questioning Children is a deeply empathic work. In its empathy for children, and through its confrontation with the adult world, *Questioning Children* suggests that

empathy, conscience, and art are inseparable. For Appel, no artist can be truly original without empathy and conscience. Indeed, artistic originality arises from the effort to comprehend and emulate the "originality" of a particular existence— whether it be that of a child or animal or friend—which cannot be done without empathy for it, a clean conscience toward it, and ultimately identification with it. Only then can the artist grasp, with authenticity and credibility, its life from the inside, because it has become part of his inner life. The surprise is that Appel's empathy extends to the audience; his confrontation with it expresses empathy for it, in however roundabout a way. Appel's childlike work seems inappropriate and provocative in an adult space, though the children depicted cannot help but invite the adult's empathy, however much the adult consciously wants to avoid them. And in unconsciously feeling empathy for them, the adult becomes one of them. That is, in a brief flash of feeling, he becomes a questioning, hungry, helpless child again. The child in the adult finds unexpected solace in solidarity with the children. This unconscious process of empathic merger with the children, however fleeting, is inwardly healing. The child reinvoked by the war feels less hurt, so that the adult can be happier than he was. The work becomes a corrective emotional experience, as it were. Its overt effect may be short-lived, but it catalyzes a process of emotional change that can lead to a fundamental change in the adult spectator's unconscious attitude toward the world.

Until he was confronted by *Questioning Children*, the adult spectator was unaware of the traumatized child he unconsciously carried around within him. Because he encountered it in artistic form, as a bizarre expression, he could permit himself to have empathy for it, and thus come to emotional terms with it. Without the handle of the artistic mediation, it would have been too hot to hold. Sometimes only art can permit one to face what otherwise one could not face in oneself, because in imaginative form it does not seem to matter as much and does not seem as traumatic, however intense its impact and generally exciting it may be in that form. When it becomes too threatening and moving, it can always be dismissed as "just art." It can always be regarded as too unbelievably bizarre to be true. Appel's work mocks the cliché that children should be seen but not heard, for its colors are the screams of the children.[44] They are thus loudly heard.[45] But Appel's abstractly autonomous colors, while confrontational and anxiety-arousing, also have an oblique empathic appeal, in part because they are a surrogate release of one's own inner cry of despair and anguish, expressing a frustrated passion for life. Appel's *Scream into Space*, 1947, is an objectification of his idea of art as a primordial scream from the depths, not unlike that of Barnett Newman's idea of it as "a poetic outcry," "a cry of power and

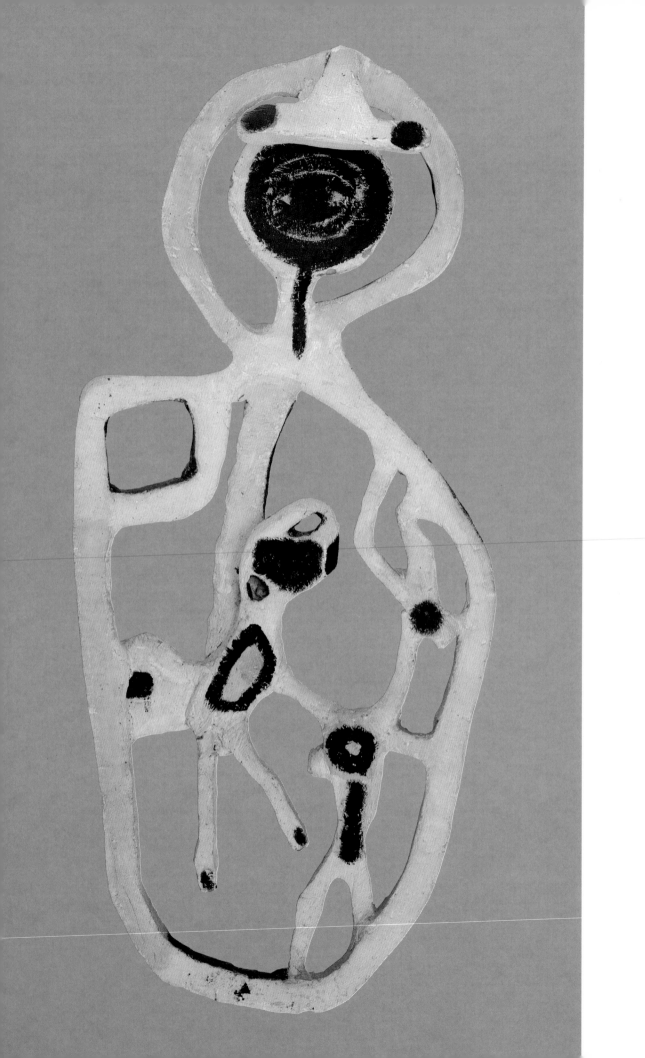

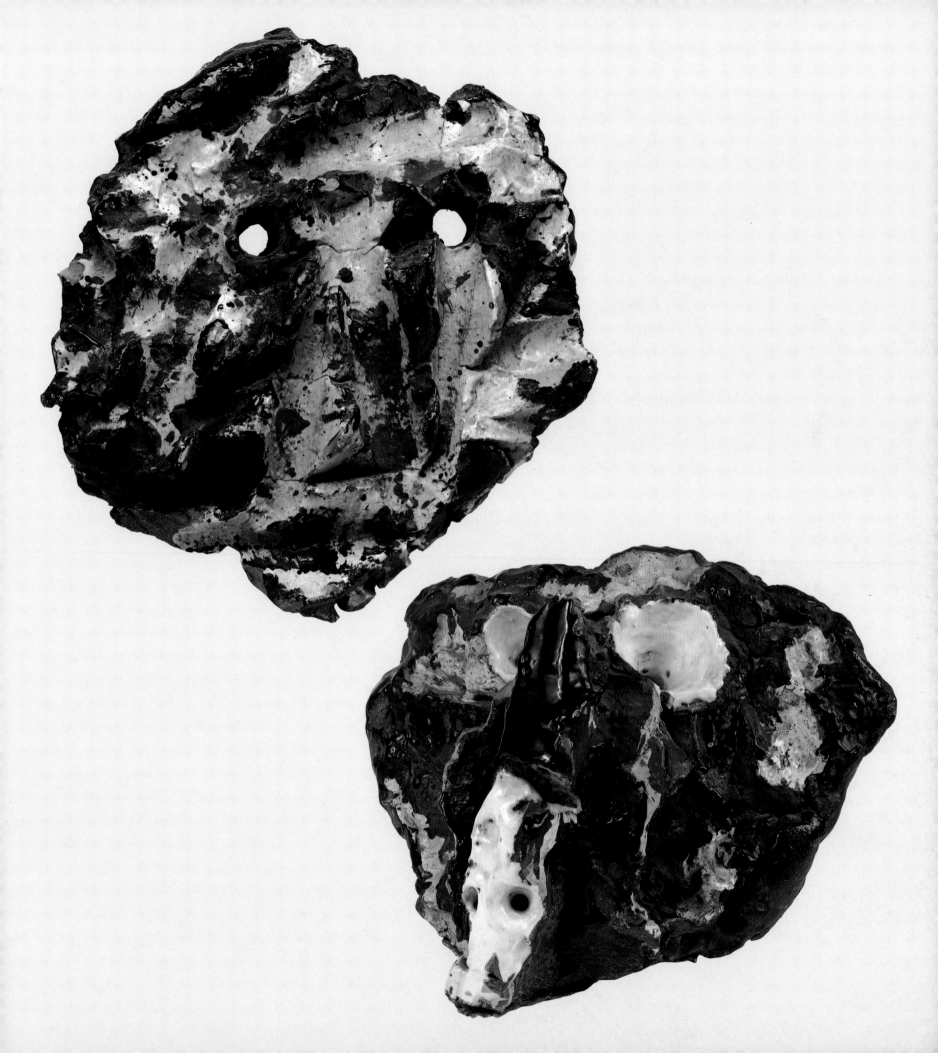

solemn weakness," man's "yell of awe and anger at his tragic state, at his own self-awareness, and at his own helplessness before the void."[46]

To put this another way, Appel wants to reach the hurt child in the Dutch spectator still inwardly traumatized by the war; confrontation is a way of doing so. The confrontational character of *Questioning Children* evokes all the overwhelming confrontations of life. It puts the adult in the child's vulnerable position again. Children are more susceptible to confrontation than adults, who when they break down—when their defenses collapse—when confronted become children. Growing up, we forget our vulnerability (however much it still unconsciously haunts us), and the traumatizing confrontations that make us suffer, building ego defenses against the world so that it can no longer hurt us deeply. But war, which confronts us with our own death, reawakens the vulnerable, suffering child in us. Appel's confrontation is meant to be a catharsis, a purge of this child: *Questioning Children* confronts the Dutch spectator with the war-traumatized child he inwardly is—the child who has unanswerable, and so all the more painful, questions about the war. In the traumatic, transferential act of seeing this child in front of him, the Dutch adult exorcises it: *Questioning Children* is a transmuting externalization of and thus liberation from the hurt child. Like all good Expressionists, Appel assumes that facing and expressing the truth makes you free. Facing the hurt child within oneself through the medium of the work frees one of it. This is what therapy in general does: confrontation with the hurt and unhappy child within, in hopes of liberation from it. Thus, for Appel, the child's trauma is therapeutically counteracted by its artistic expression.

But *Questioning Children* failed in its therapeutic mission, which was not its fault but that of its Dutch audience. Its medicine was too strong for average Dutch spectators to take. They were not yet ready to face the war-wounded, vulnerable children that were their true selves. Memories of the occupation were still unconsciously—indeed, consciously—fresh. The war was still too close. Appel asked more of his Dutch audience than it was emotionally capable of. His work asked it to face what it was trying to forget—and what the anxious, censorious, angry response it had to *Questioning Children* indicated it could not forget. The audience may have buried the traumatized child it secretly was deep in its psyche, but Appel's work was like a nightmare in which the child, and with it the war that traumatized it, returned, showing that their ghosts had not yet been truly laid to rest. Appel's work had the power to bring the suffering child and fading war back, but nobody wanted them back.

Still, while the Dutch audience did not like being reminded of the damaged child it inwardly was, and the war that did the damage—the wood with which the work

was made came in effect from buildings destroyed by the war—the audience could have enjoyed the work's bright colors and spontaneous gestures, which flew in the face of the grimness of the war and the discipline it demanded. The audience could have emotionally used the work to celebrate its own survival. Indeed, *Questioning Children* celebrates the survival of life in the face of the perpetual threat of death, however desperate the circumstances of survival. That Appel's Dutch audience could not respond to the joy in the work, only its misery, shows how deeply depressed the audience was. It had to hide and defeat *Questioning Children* to hide its own profound defeat by World War II, which, like every war, was a Pyrrhic victory.

Questioning Children reminded adults with authority and power that the Nazis had destroyed their authority and made a joke of their power. It reminded Dutch civic leaders that they had been reduced to helpless children obeying foreign orders in their homeland. One needs great emotional help to recover from such a series of blows to one's self-esteem. But few adults can admit to such need, which is another reason for rejecting Appel's work. Appel's empathic work puts the spectator in an emotional position he does not want to be in—an all too human position. Thus, Appel's sculpture has deep unconscious appeal not only because it articulates a certain "human universal,"[47] but because it reminds us of the universal need for help. It reminds us that inwardly we are all children in need of help—begging for help. Appel's children want more than food. "Take our hands and help and care for us, because we are completely helpless," they are saying. Appel's work evokes the many ways children and adults feel hurt by life and feel the need for help, twisting them together into an expressive knot. But the evocation does not exist for its own pathos; rather, as an empathic reminder of the general human feeling of helplessness and neediness and, in particular, the deep human need for healing help. It was this unacknowledged, or at best superficially acknowledged need of the period immediately after the war, that Appel's art directly addressed, as no other European art of the time did.

Thus, Appel's work is remarkable because of its innovative empathy, for both its subject matter and its audience. This goes against the usual avant-garde grain, obsessed with formal innovation, justified as an end in itself, and its alienation from its audience. Appel's work is also concerned with formal innovation, and is in fact a major innovation, and also reflects alienation from its audience. But subliminally, it has an empathic and self-expressive purpose—the two cannot be separated in genuine Expressionist art—which makes it more than just another novel conceptual, or for that matter novel physical achievement. The idea that artistic expression can be a mode of healing empathy has its sketchy modern beginnings in Baudelaire, who

Overleaf, left and right:
The Owlman I. 1960. Acrylic on olive tree stump, 61¾ × 35⅜ × 20½″ (157 × 90 × 52 cm)

The Recluse I. 1960. Acrylic on olive tree stump, height 39″ (99.1 cm)

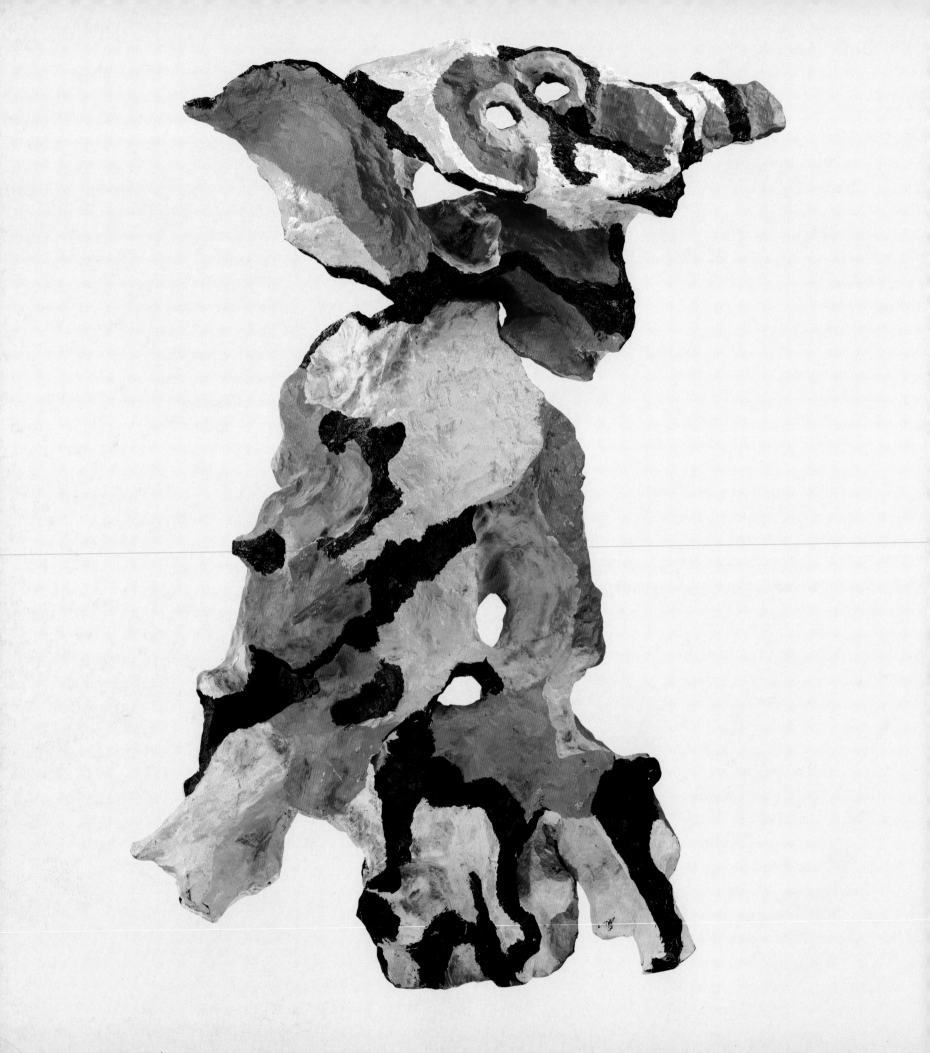

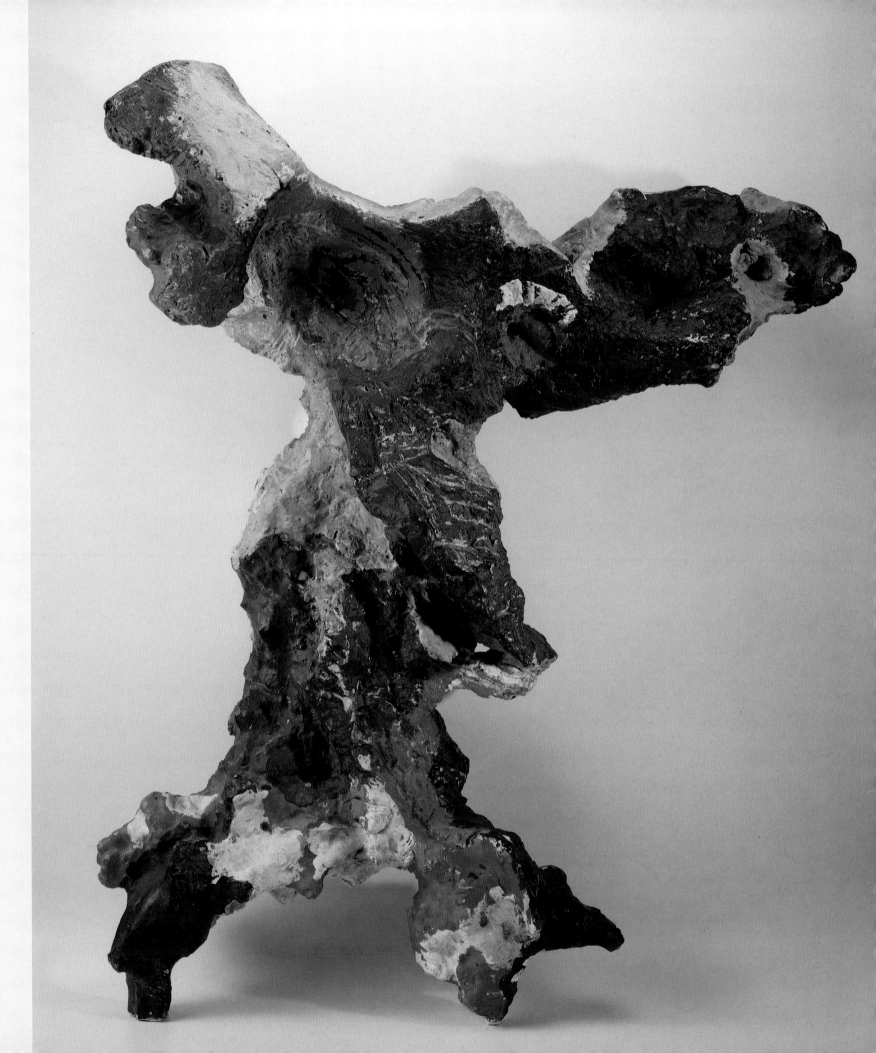

saw art as a way of restoring the mental health of the bourgeois spectator.[48] This idea has been eloquently amplified recently, in a way that suggests the healing potential of art for society as a whole, oddly parallel to if not an extension of the ancient idea of the cathartic magic art can effect.[49] In its explicit and implicit empathy, *Questioning Children* shows a profounder humanism than so-called protest art, although Appel's work is also an example of protest art, made long before it became fashionable. Indeed, Appel's work is not unrelated to Pieter Brueghel's protest against the slaughter of the innocents, as well as to Brueghel's images of children at play. In any case, Appel's art not only addresses the nuclear psychological problem of the postwar period, indeed, of modernity in general—the tragically hurt self—but suggests the empathic solution for it.

V

I have explored the meaning of *Questioning Children* at some length because of its exemplary place in Appel's oeuvre. It is a signal of everything to come and his basic attitude. The work is especially important because it makes clear that Appel always takes the child's point of view in any "argument." His work is indeed convincingly childlike. This is especially the case in its defiantly vital, indeed, animistic, totemlike figures, which show a child's conception of the body. Many of Appel's sculptures are explicitly totemic—sign-bodies, as it were—and they have been characterized as "popular totems," involving the use of masks, which are fantasies and fetishes in themselves, as well as of found materials.[50] The totem figure was an idea with great avant-garde appeal at the time, in part because of its intimidating magicality. It embodied a new sense of the human enigma and the organic, "rooted" character of being human—for the totem figure was a force of nature—at a time when society seemed more than ever determined to convince human beings that they were robots in disguise, and as such, predictably programmed.[51] *The Big Totem Pole*, 1947, a painted construction of pieces of wood, and *Totem Pole*, 1948, a carved and painted tree trunk, are explicit examples. There are many vertical sculptures that are implicit totems, from *The Wild Fireman*, 1947, and *Tree*, 1949, to the series of untitled figures made in 1992 by painting, with expressive abandon, on existing sculptures from Indonesia and India, which personalized them. (This practice, which makes routinely primitive figures for the tourist trade seem diabolically archetypal, as though they had just arisen from the underworld, is continued in a number of important late symbolic works to be examined later. They are an intimate, cabalistic last testament.)

Bird's Head. 1960. Acrylic on olive tree stump, height 35½″ (90.2 cm)

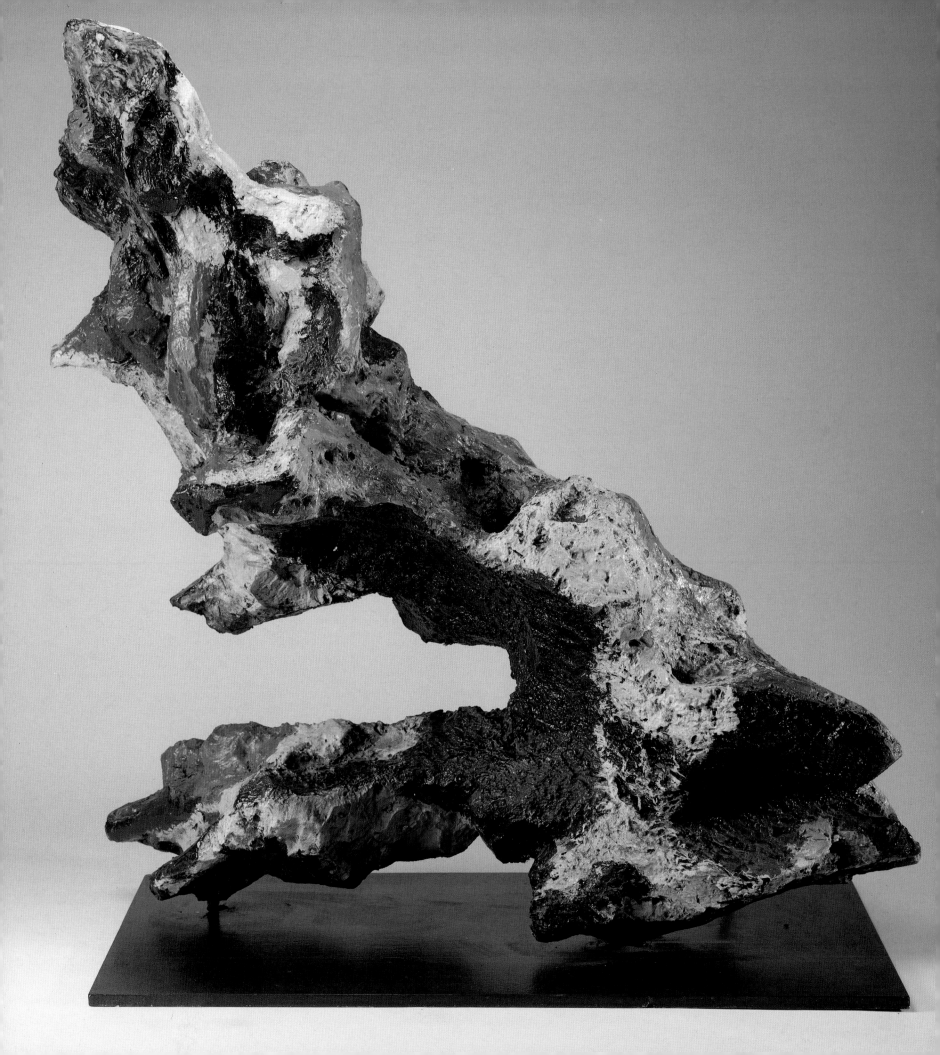

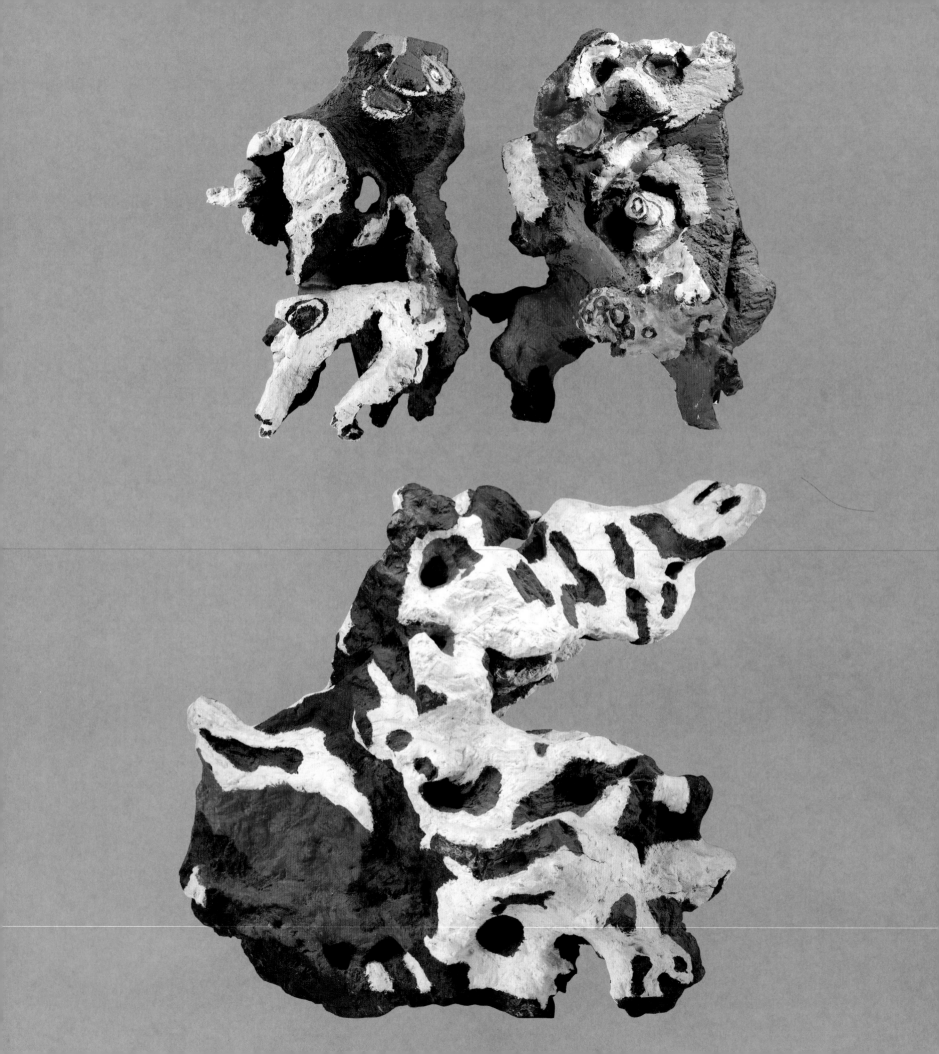

Sculpture in general lends itself more than painting to Appel's childlike representation of the body, for the child sees the body in all its viscerality, if also as an autonomous fragment. Nowhere is this more evident than in the magnificent sculptures made in the spring and summer of 1960 on the estate of l'Abbaye de Roselande in the south of France. These "eighteen man-high sculptures" were made "of the trunks of olive trees from the burned-out olive orchard . . . pulled up with their deep roots" and "rinsed and cleaned with hot water and brought back to life."[52] They are in effect naturally given gestures—forms already modeled by nature's art— which were then responsively painted by Appel, with a vivacity only he is capable of. They are "living shapes" which he has made into living art.[53] They are not only major feats of Expressionist sculpture—indeed, in my opinion, among the most outstanding Expressionist sculptures of the twentieth century—but fundamental statements of the child's conception of the body as, on the one hand, a sum of parts that do not add to a whole (and as such, an amorphous mess), and, on the other, a massive, undifferentiated whole, best understood through R. M. Simon's concept of the "Archaic Massive."

According to her, works "in the Archaic Massive style have an emotional effect through the violence of their colours and the massive appearance of large forms." For its practitioners, "emotions [are] the true guide to the reality of any situation." They "elaborate this attitude with emotional judgements of right and wrong" conveyed through color, which bespeaks the primacy of emotional reality.[54] Indeed, "this style develops the effectiveness of colour more fully than any other style. No colour is neutral for each, in a way, affects the others. Each colour . . . acts like a magnet to attract or repel the boundaries of its neighbours. Colours seem to expand or contract," and "optically 'leak'" into one another.[55] Practitioners of Archaic Massive style "unthinkingly"—that is, emotionally—"pursue the shifting colour values of the work until a harmonious balance is obtained. . . . the vitality of the colours [creates] an effect of massive form pressing beyond the outlines." Such an effect of uncontainability—ultimately of an uncontrollable process of growth and change, in which boundaries are in such flux as to seem unclear, and there is no sense that the process has any prescribed teleological outcome, and as such seems free—is crucial to Appel's Roseland sculptures, where it is not only a byproduct of painterliness, but immanent in the organic form of the olive tree roots. For Simon, Expressionism "is a recent version of Archaic Massive style. It is rooted in subjective experience, reaching beyond the limits of representation to the emotional reality felt by the painter for his subject."[56]

The issue of painted sculpture has been much debated, and advocates of purity

Opposite, above and below:
Innocent Onlookers. 1960. Acrylic on olive tree stump, height 35″ (88.9 cm)

The Cry I. 1960. Acrylic on olive tree stump, height 39″ (99 cm)

argue that it violates both the medium of sculpture and of painting. They also argue that the modernist destiny of sculpture is to become less corporeal and spontaneous and more ethereal and constructed.[57] Presumably this makes it more adult. Presumably adults are pure rather than "polymorphous perverse." But to the extent sculpture is body—and even when it is construction its model is implicitly the skeleton of the body—it will never be simply an abstract spatial structure. It may be a feat of technology, but it is also a fantasy of the body. Thus, paint is not necessarily anathema to it. Paint is not simply a crowd-pleasing ornament. A skin of paint will not distract from a sculpture's structure, but make its latent bodiliness manifest. Even David Smith, who in the last stages of his development was determined to be pure, never completely abandoned paint and texture—nor reference to the body—as integral parts of his sculptures. He put enough paint and texture on his structures to imply that they were subliminally flesh. His work capsulates the conflict between the sense of the body as a robotic structure and as a primitive mystery that pervades twentieth-century thinking about it. Presumably the former is the proper adult way to think about the body; the latter, the immature child's way. If so, then the adult is more alienated from his body than the child. The difference between them is the difference between reducing the body to the terms of its functioning, in effect understanding it from the outside, and experiencing it from the inside—indeed, as the inside one inhabits and can never escape, at least until death—and thus, as the medium, indeed matrix of feeling.

It was a stroke of genius for Appel to use olive tree roots to convey the child's sense of corporeal spontaneity—the child's sense of being rooted in the body, of being one with it, and of its being almost uncontrollably spontaneous. Also, with his unconventional use of the found growth—not simply a found object or a found material—he took the avant-garde lead, transcending existing conventions of experimental sculpture. The olive root is not a conventional readymade, which is usually a manufactured object. Appel's olive root sculptures are not conventional Expressionist carvings, in that they are already carved by nature. Perhaps most important for his own psyche, they overcome his early dependence on Picasso, evident in such works as *Bird's Head*, 1947.[58] They are typically animistic, as titles such as the 1960 *The Owlman* and *Bird's Head* indicate, and they include Appel's familiar repertoire of animals of that year: *The Rooster*, *The Cow*, and *The Cat*. Also, they have existential import, as *The Recluse*, *Man the Witness*, and *The Cry I* suggest. Indeed, many of the 1960 olive root sculptures are overtly about death-in-life, as evident in *Dying Branch*, *Wounded Animal*, and *Slaughtered Animal*. The roots in fact look as though they are still alive and growing, or as though they were writhing in

Opposite:
The Red Gnome. 1960. Acrylic on olive tree stump, 45¼ × 35⅜ × 27½″ (115 × 90 × 70 cm)

Overleaf:
The Cow [2 views]. 1960. Acrylic on olive tree stump, 61¼ × 35⅜ × 38⅛″ (155.5 × 90 × 96.7 cm). Henie-Onstad Art Center, Oslo

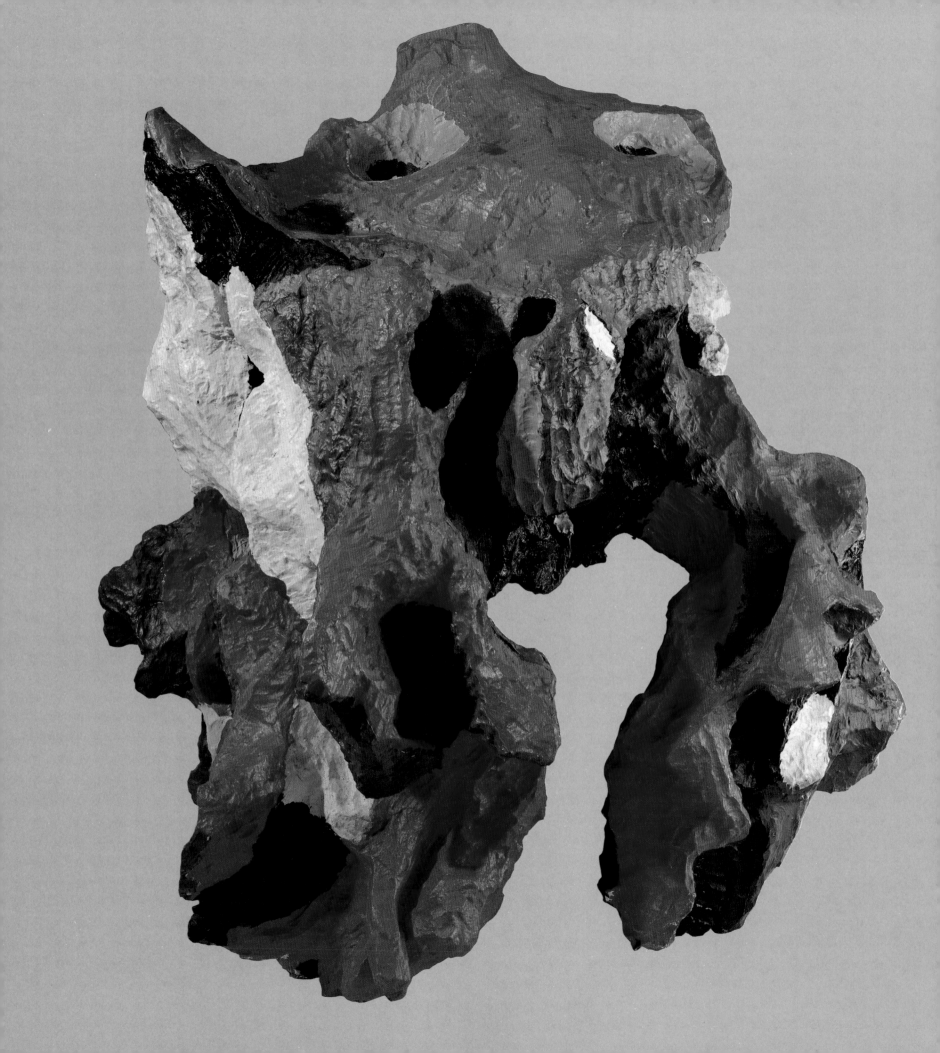

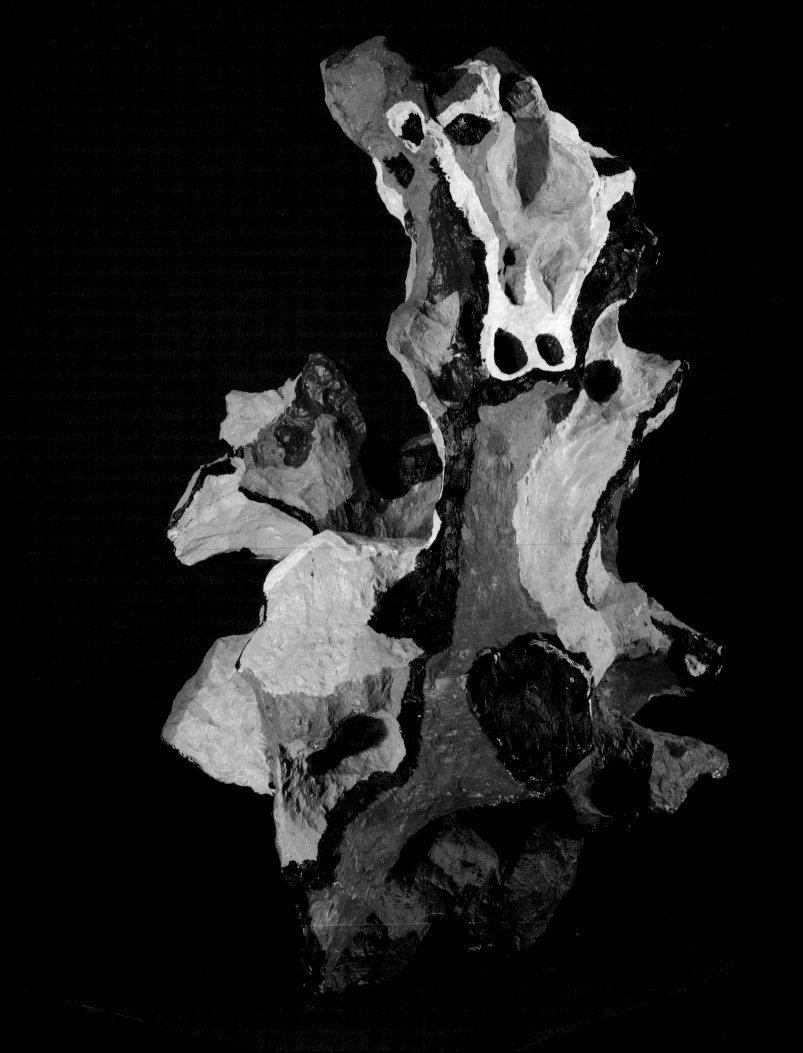

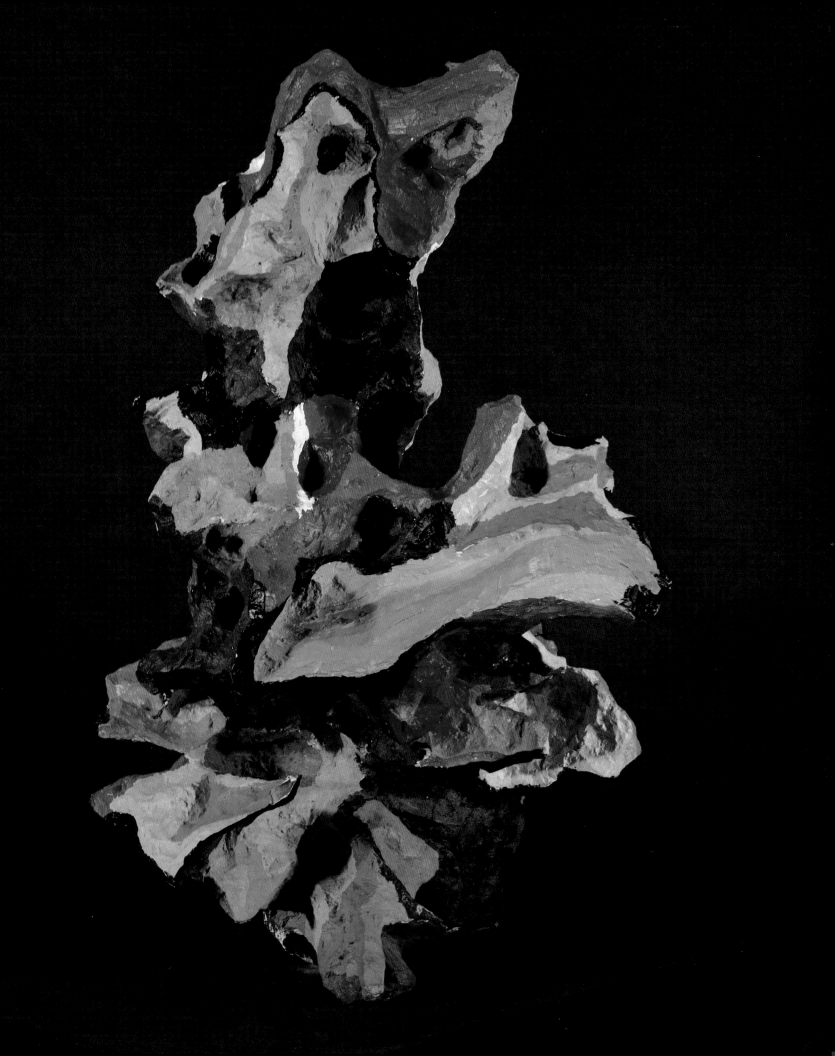

the grip of death, like some latter-day, abstract Laocoön. But what seems to me most important is the sense of them as a fusion of self and object, to the extent that one cannot determine where the one leaves off and the other begins. The sense that two figures have become one is perhaps most explicit in *Love Struggle*. *Phantom Forest* fuses a number of figural elements indistinguishably together. Even ostensibly single figures and faces, such as *Head with Horns*, seem to be a demonic intermingling of various shapes, barely distinguishable in their contradictoriness. Just as the olive root sculptures have no clear external boundaries, they have no clear internal boundaries. They seem to overflow explosively, like molten lava, and simultaneously to implode, collapsing all internal structure. In a sense, the sculptures' incredibly fluid colors simply accent the inherent fluidity of the roots. Living color makes clear that the root is still living, indeed, seems to monumentalize the life in it.

This heroic fluidity, dissolving all external and internal differences in its magnificent dynamic, can be understood as a rebellion against and undoing of the adult sense of the body, as a robot passively obeying the world. It is not only that certain works, explicitly labeled so, are screams of agony and rebellion, but that the body of virtually each and every sculpture by Appel gives shape to an outcry. Nowhere is this more the case than in the olive root sculptures. But their destructive rage is not only a cry against compliance, and as such, an assertion of the truth of spontaneous instinct; that is, not only the rebellion of the true vital self against the false robot self, but in its undoing, a playful psychosis.

Appel's olive root sculptures are his wildest works (except perhaps for his recent sculptural allegories), and indicate the need for a certain kind of wildness—seeming insanity—in a world of false sanity. Their wildness is true to the spirit of life, while that of the world is true to the spirit of death. In a sense, it is the difference between health-giving madness and the madness of a sickening world: between a deliberate return to the root of life, an open-eyed regression to primordial life, literally embodied in the olive root, and rigid, mindless conformity to society—epitomized by the robot—as though it were the all-wise parent who knows more about life than one does. To put this another way, it is the difference between regression to the primitive id in order to strengthen the ego and liberate it from an oppressive society, and regression to the sadism of the superego that enslaves the ego in the name of society and its so-called reality principle. For Appel, society betrays life—which is why art must be true to life and thus antisocial, in the deepest sense. For in practice, current society favors the reality of death over that of life—World War II was Appel's case in point—however much it professes its love of life. Society is too insane to know that this is insanity, even to know what it is to be sane. Appel's olive root sculptures are

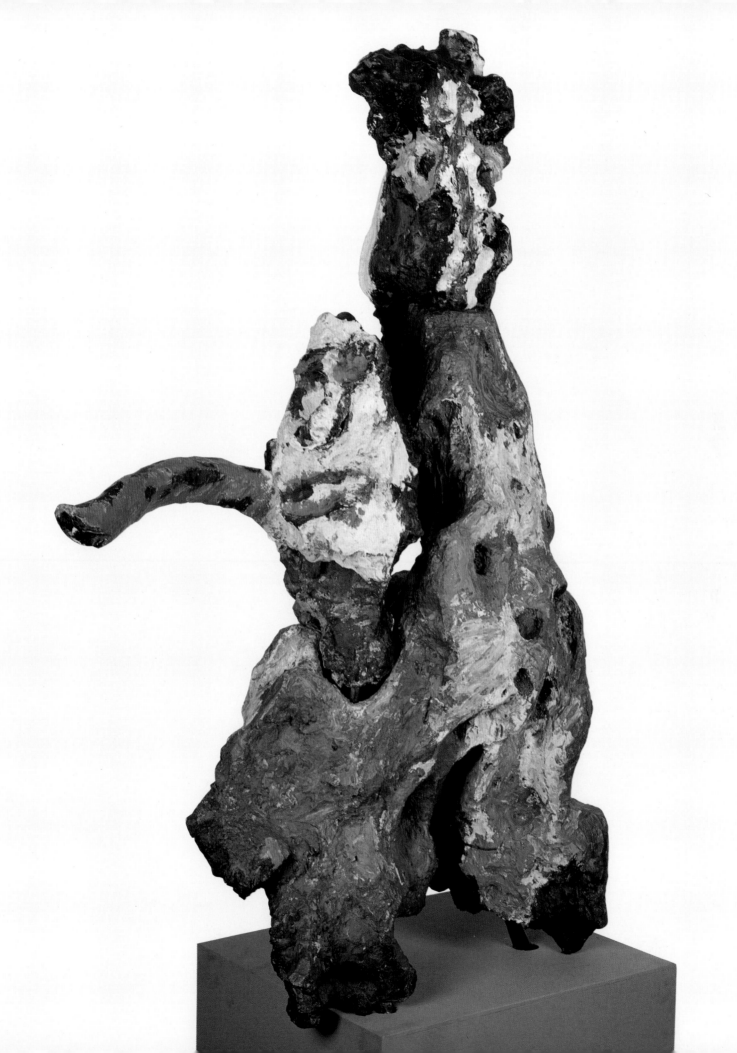

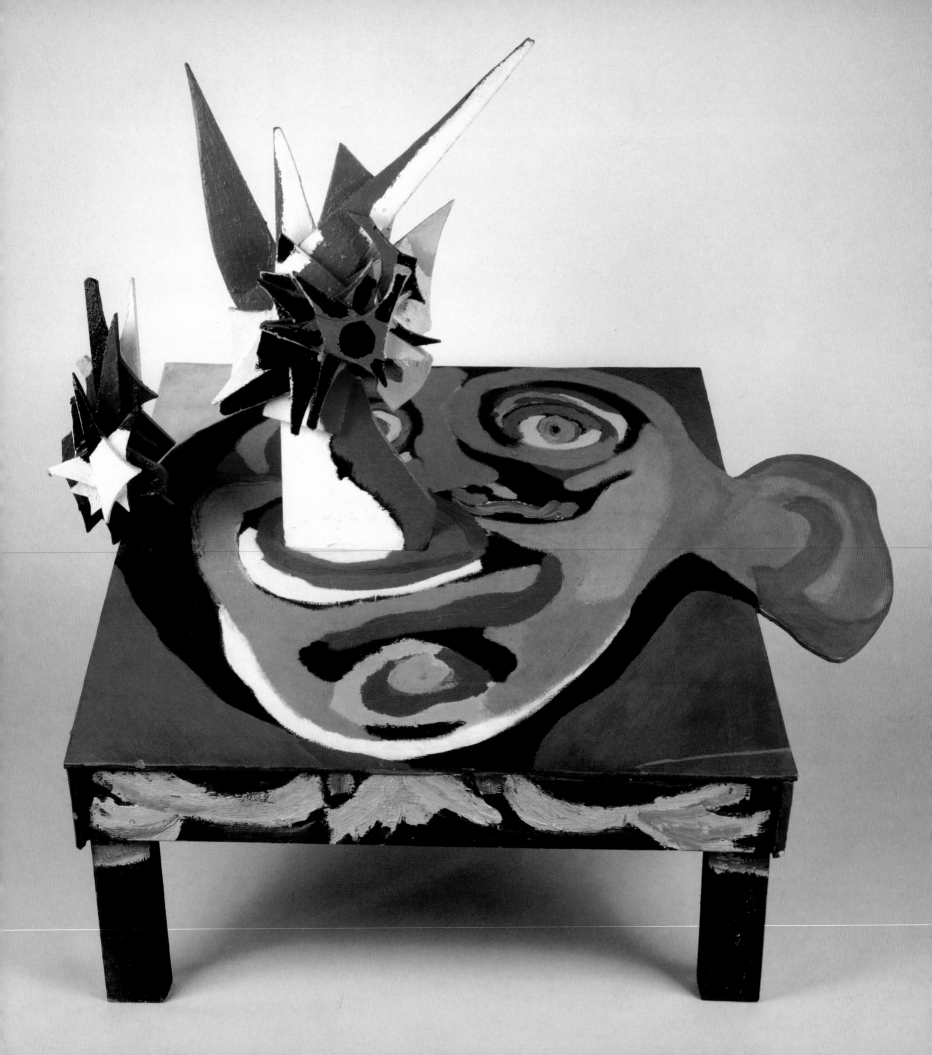

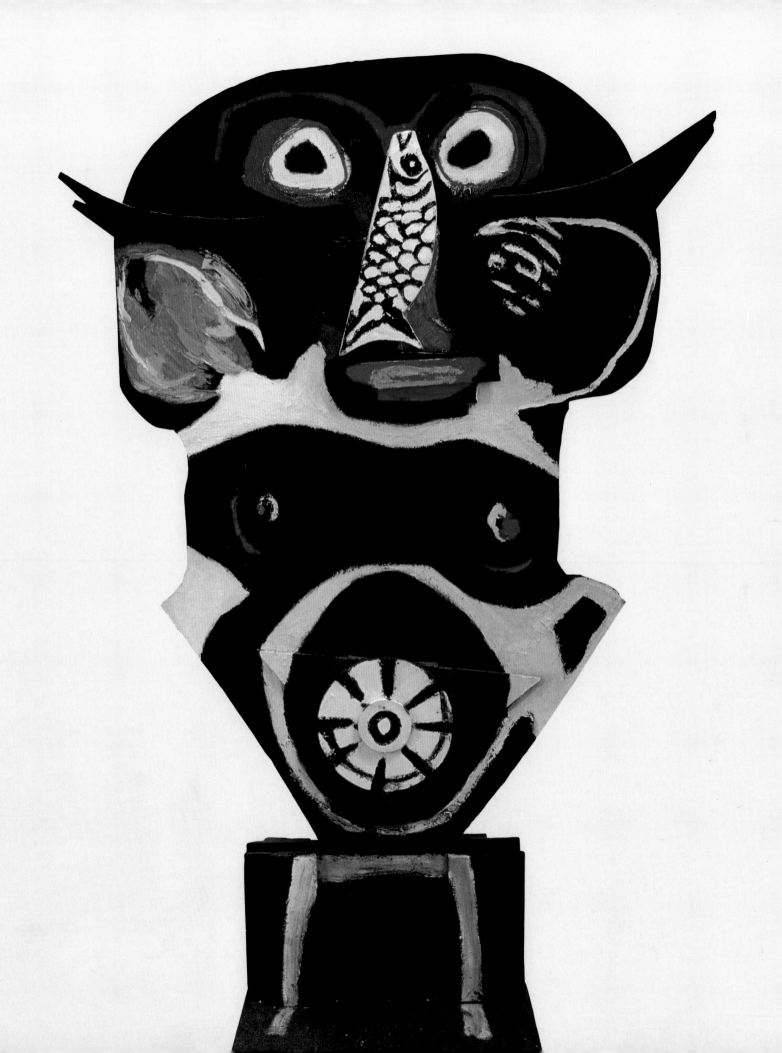

biophiliac demonstrations against the sadomasochism of society, although they cannot help but be tainted by it. No platitudinous, fraudulent olive branch of peace for Appel, but a vigorous root full of life, aggressively bursting with life.

Appel's sculptures suggest the creative force that is necessary to undo the deadly effect of society on the individual's life. They are personifications of a defiant vitality. The expressive terror that makes them powerfully nonconformist counteracts the terror, virtually petrifying the spirit, the individual unconsciously feels in a society determined to compel him to unconditionally accept its authority and thus conform to it. Indeed, Appel's work implies that society is a reign of emotional terror which only the terror action of insane art can resist. The individual's insanity against society's insanity—that is the subliminal point of Appel's wild olive root sculptures. They are a major renewal of the avant-garde attitude of resistance and opposition to society, a major restatement of the avant-garde credo that only art can terrify and mortify society the way it terrifies and mortifies the individual. As such, they are a cri de coeur of avant-garde art, as well as of Appel himself, embodying the radical subjectivity and the survival power of both. Their anarchy is meant to awaken the individual from the paralysis society forces on his inner life. They are meant to be the catalysts of a process of individuation that has been stopped in its tracks by a society that is only interested in the utility of the individual; that is, in the way he can be made to function like an efficient robot. In a sense, the olive root sculptures embody the miracle of Lazarus rising from the dead, and if still tainted by death, determined to live more spontaneously—in greater faith with the spirit of eternal life—than he did. If nothing else, they are like the Hermes figures of antiquity, sacred to the power of unconscious instinct, which not even the most deadening daily routines can defy and domesticate. Thus, they evoke the carnival of life the self must lose itself in to feel truly alive.[59]

In his poem "Mad Talk," a virtual credo, Appel acknowledges the necessity of insanity: "to be mad is everything/to be everything is mad."[60] The poem begins with the line "Mad is mad" and ends with the line "mad mad mad," suggesting that it is the alpha and omega of being. D. W. Winnicott has said that "through modern art we experience the undoing of the processes that constitute sanity and psycho-neurotic defence organizations, and the safety-first principle." That is, through modern art we are "able, so to speak, to flirt with the psychosis."[61] Winnicott saw the humor in such flirtation, as does Appel, whose art is often conspicuously funny, as is especially the case in the 1978 Circus Series, which includes many images of clowns: *Kid Clown, Clown Acrobat, Amsterdam Clown, Flower Clown, White Clown Standing,* and *Bird Clown.* Appel once said he would have been a clown if he hadn't become an artist,

Opposite:
Flower and Butterfly. 1966. Acrylic on wooden panel, height 84″ (213.4 cm). Musée d'Art Contemporain, Dunkerque, France

Overleaf, left and right:
Motherhood. 1968. Acrylic on polyester, 65 × 41 × 76″ (165.1 × 104.1 × 193 cm). Phoenix Art Museum

Mouse on a Table. 1971. Polychromed enameled aluminum, 106 × 84 × 42″ (269.2 × 213.4 × 106.7 cm). National Trust for Historic Preservation, New York; bequest Nelson A. Rockefeller

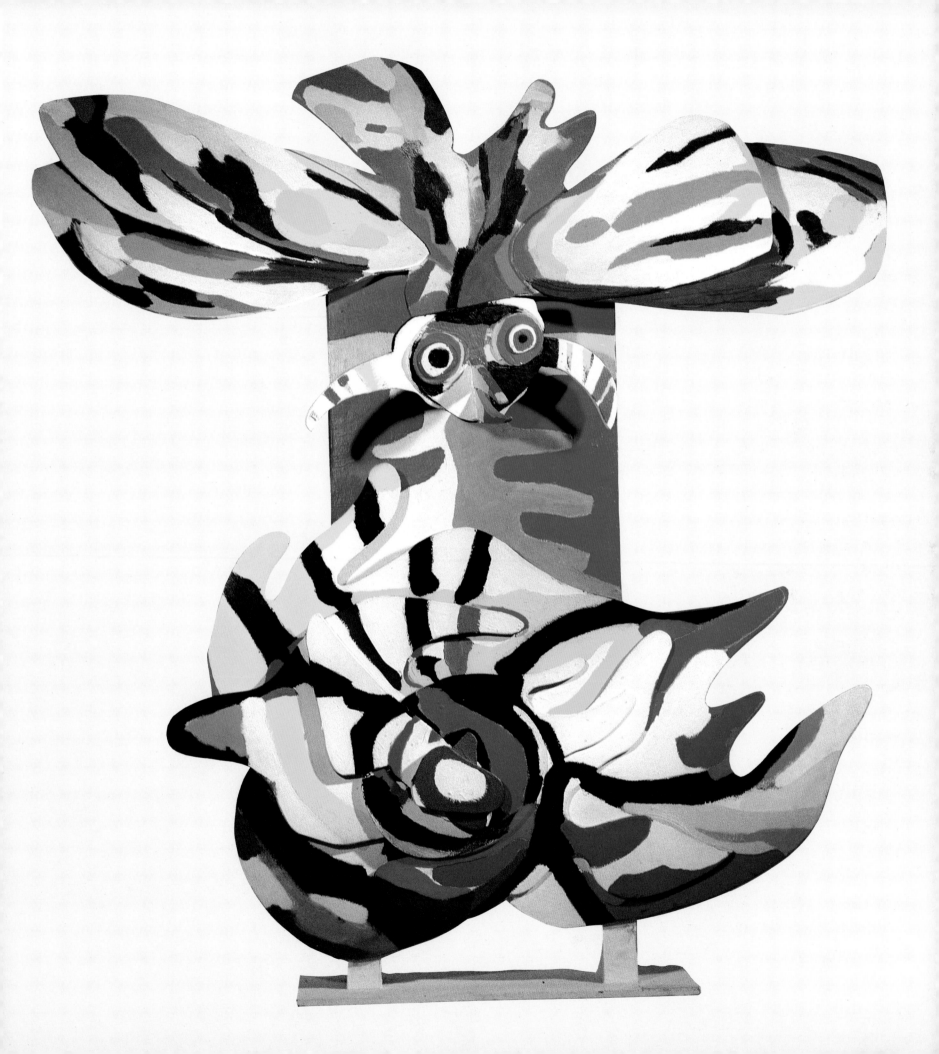

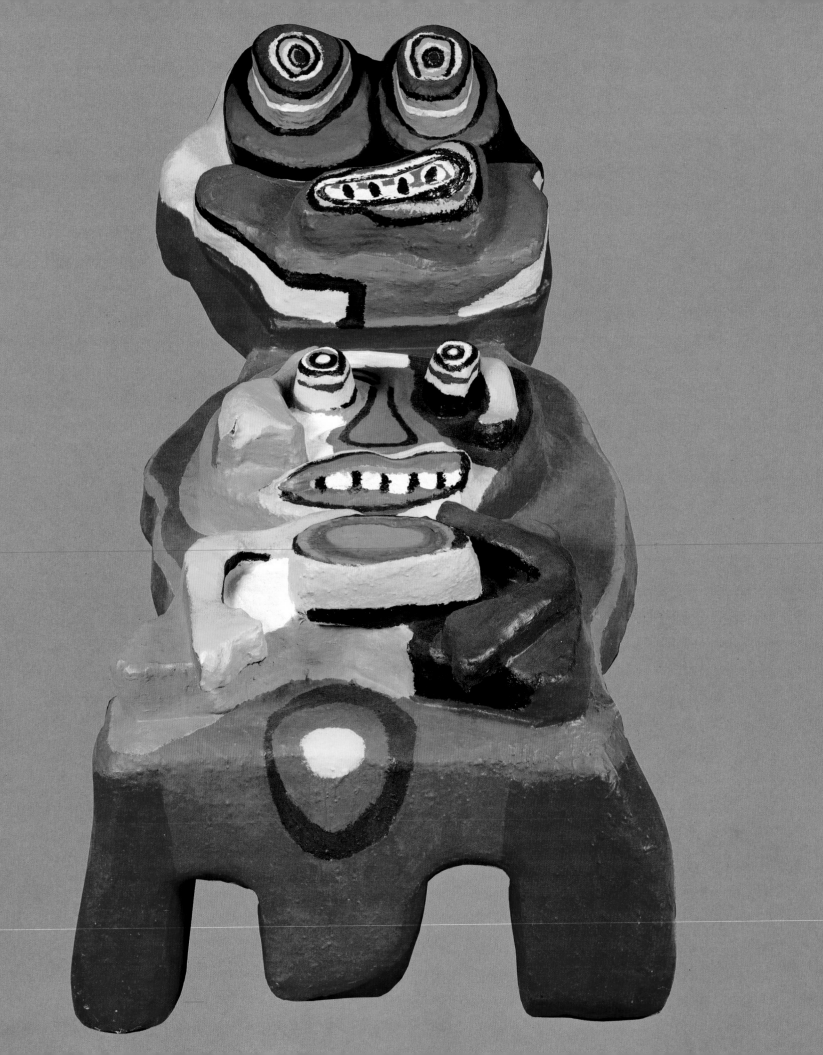

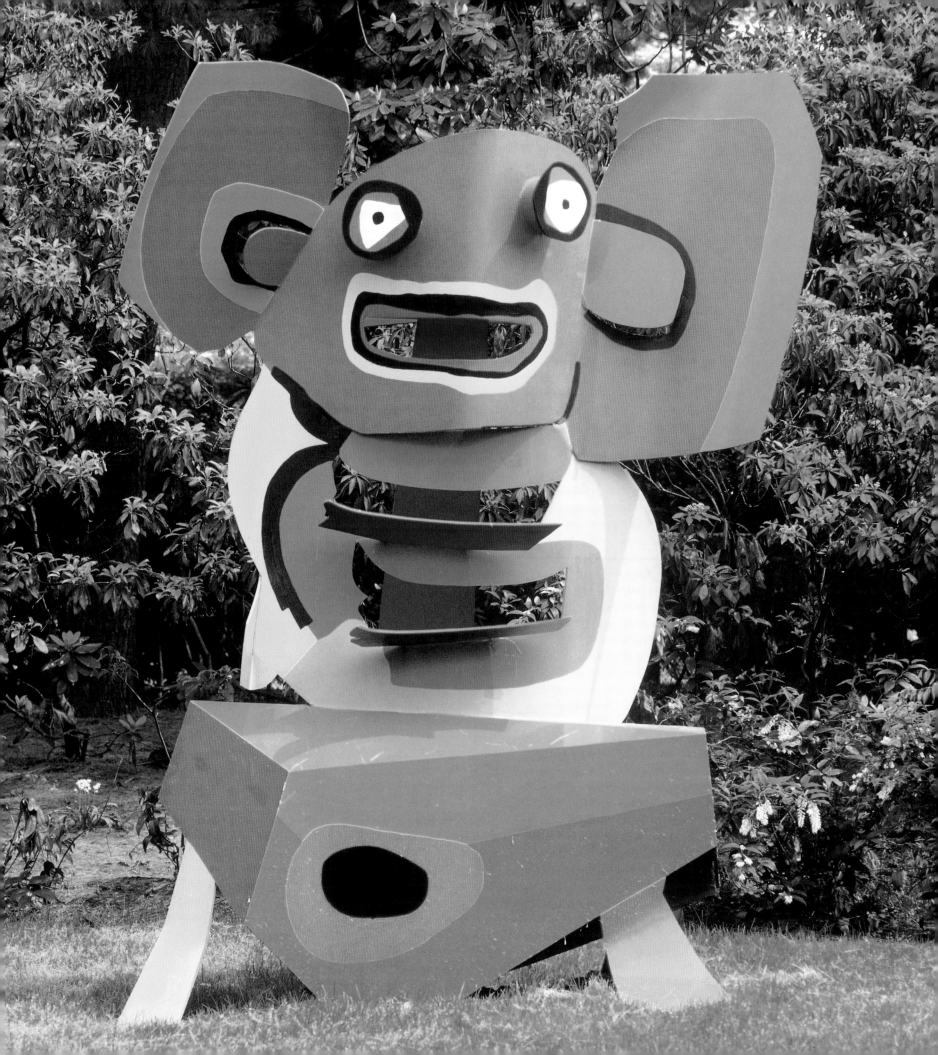

but of course, to be an artist is to be a kind of clown. "Jewish humor," associated in his mind with the pre-war Amsterdam of his childhood, remained a constant of his art,[62] along with the influence of Multatuli, by way of his mother's admiration for that free-thinking, free-spirited, insurrectionist author, whose work is also not without humor.[63] Certainly, the *King of the Titans* is a clown as well as the king of the underworld. Humor, one of the maturest defenses, was an essential lifeline for Appel in his descent into the maelstrom of the psychotic core. It is a sign of a strong ego, allowing one to keep on top of the depths even as one sank into them, to remain sane even as one explores insanity. It suggests there is method in the artistic madness.

Opposite, above and below:
Untitled. 1980. Acrylic on bubble paper and wooden crate, 15¾ × 8⅝ × 6¼″ (40 × 22 × 16 cm)

Untitled. 1980. Acrylic on packing paper and wooden crate, 15¾ × 8⅝ × 6¼″ (40 × 22 × 16 cm)

Right:
Untitled. 1980. Oil on plastic cup, and acrylic on cardboard box and wooden crate, 21⅝ × 13¾ × 3⅞″ (55 × 35 × 10 cm)

Overleaf, left and right:
Floating Windmill. 1985. Acrylic, wood, rope, and plaster, 92½ × 75½ × 58″ (235 × 191.8 × 147.3 cm)

Windmill. 1985. Acrylic, wood, rope, and plaster, 93 × 29½ × 18¼″ (236.2 × 74.9 × 46.4 cm)

In general, Appel's sculptures afford an experience of the "regressive" body, that is, the body as a relatively undifferentiated whole of incommensurate parts. Most of his sculptures are made of such parts in seemingly free, mad association. The whole is virtually an assemblage of associations. Each part is in itself an objectified association, and as such, the symbol of a certain childhood feeling. Even in the panoramic, grand finale sculptures of the late eighties and early nineties, every representational and abstract element—sometimes they are one and the same, more often they are at odds—functions as an associational part. These parts, which seem

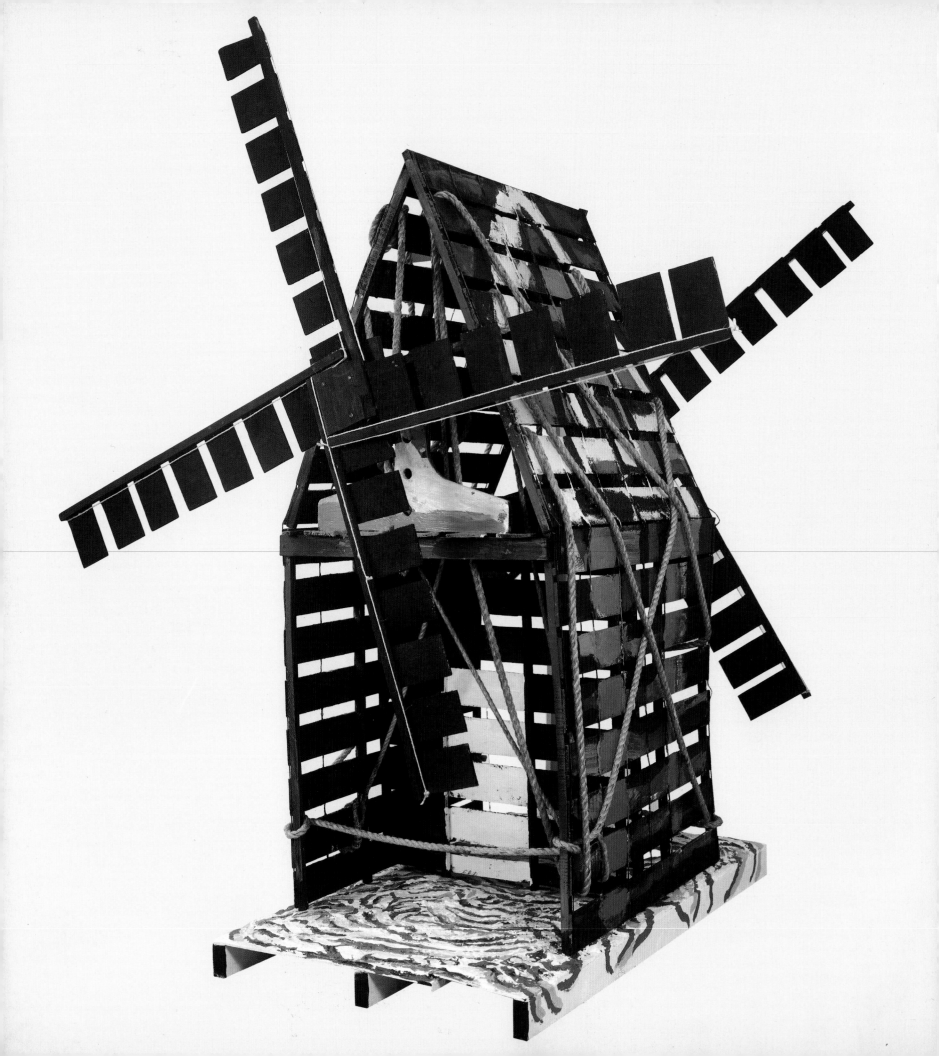

Windmill I. 1985. White earthenware, rope, and bamboo, 37×37×25″
(94×94×63.5 cm)

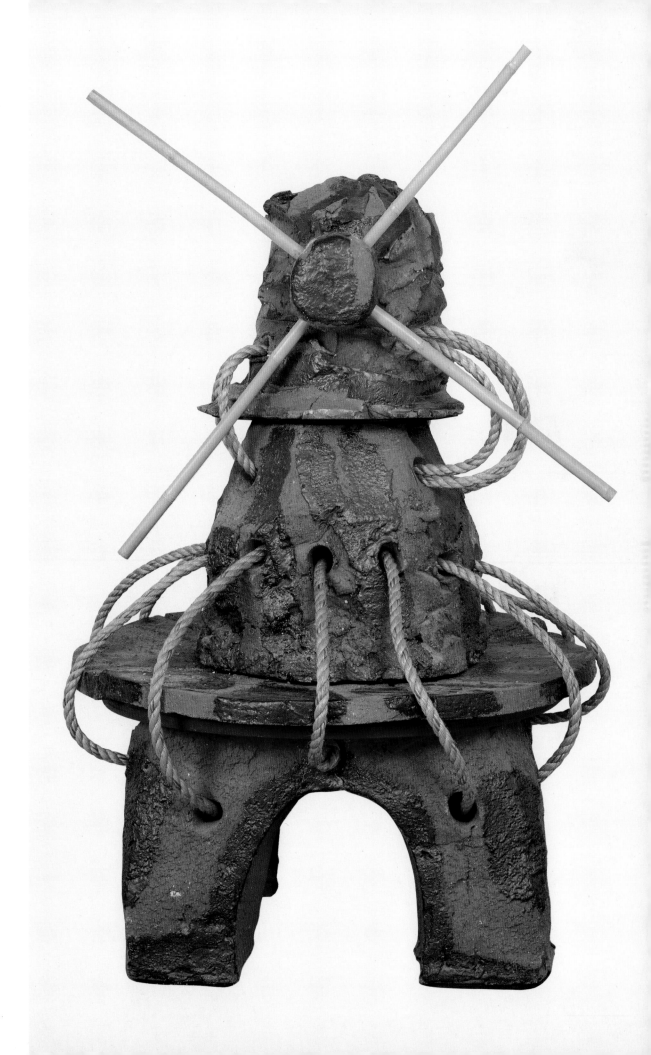

Windmill III. 1985. Terra cotta, rope, and
bamboo, 58½×32×32″
(148.6×81.3×81.3 cm)

unfitting in themselves and too ill-fitting to ever come together harmoniously, give the regressive body its uncanny vitality. More fundamentally, the seemingly chance correspondence—but there often is none—between the imagistic and stylistic or expressive and constructed levels of the work, recapitulates the primitive conflict between the good and bad, integrative and disintegrative, gratifying and frustrating, healing and destructive internal objects that constitute the regressive body, as well as their awkward fusion in ambivalence. This lack of resolution or unity, on both the material and symbolic levels, of Appel's sculptures is a powerful source of regressive, primordial effect.

Appel's heads and faces treat a conspicuous body part as an archaic whole because of its primitive emotional significance. The face, the seat of the expressive gaze, is the emotional whole of the mother's being for the child, once the breast has no longer become the primary part object, as it was when he was an infant. To relate face-to-face is to imply an exclusivity of relationship that is the source of being. Every face, and by extension every human being, seems expressively unique, because it is the product of a unique expressive relationship. When Appel's faces become masks, a rigidity of relationship is implied. When they are more expressively fluid, a joyous relationship is suggested. The ease with which he moves from one to the other indicates the absolute value he places on primordial intimacy. *Face,* 1953, and the series of glazed ceramic heads of 1954, as well as a head and face of 1975, are among the many startling examples. These sculptures have a kind of synergistic intensity by reason of their seeming synecdochic character. That is, they often have an unusual density of expression—not unlike the olive root sculptures—because of their radical economy of means. They suggest that a single body part can concentrate in itself the whole body's expressivity, an all-in-one effect that results from synecdochic economy at its subtlest.

But Appel's works seem especially mad because of their incredible lability, both as images and as constructions. The child has great emotional and expressive lability, which is why it always seems to be drunk and to see everything in a state of newness, as Baudelaire remarked. Everything is of great interest to the child because everything is fraught with great emotion for him. "All human emotions and feelings appear in my work," Appel writes, "tenderness, color, aggression, straightforwardness, spontaneity, tragedy, violence, fantasy, sadism, and imagination."[64] "An artist cannot be calculating, he has to paint to relieve himself of emotions, borne by the universal forces of life," Appel declares,[65] in a remark reminiscent of the Vygotsky epigraph at the beginning of this book. Thus, "one does not think of making up art, of styles or directions," only of using matter to express emotion.

Standing Nude 1 [2 views, front and rear]. 1987. Polaroid, acrylic, wood, and rope, 82⅝ × 38⅝ × 3″ (210 × 98 × 7.5 cm)

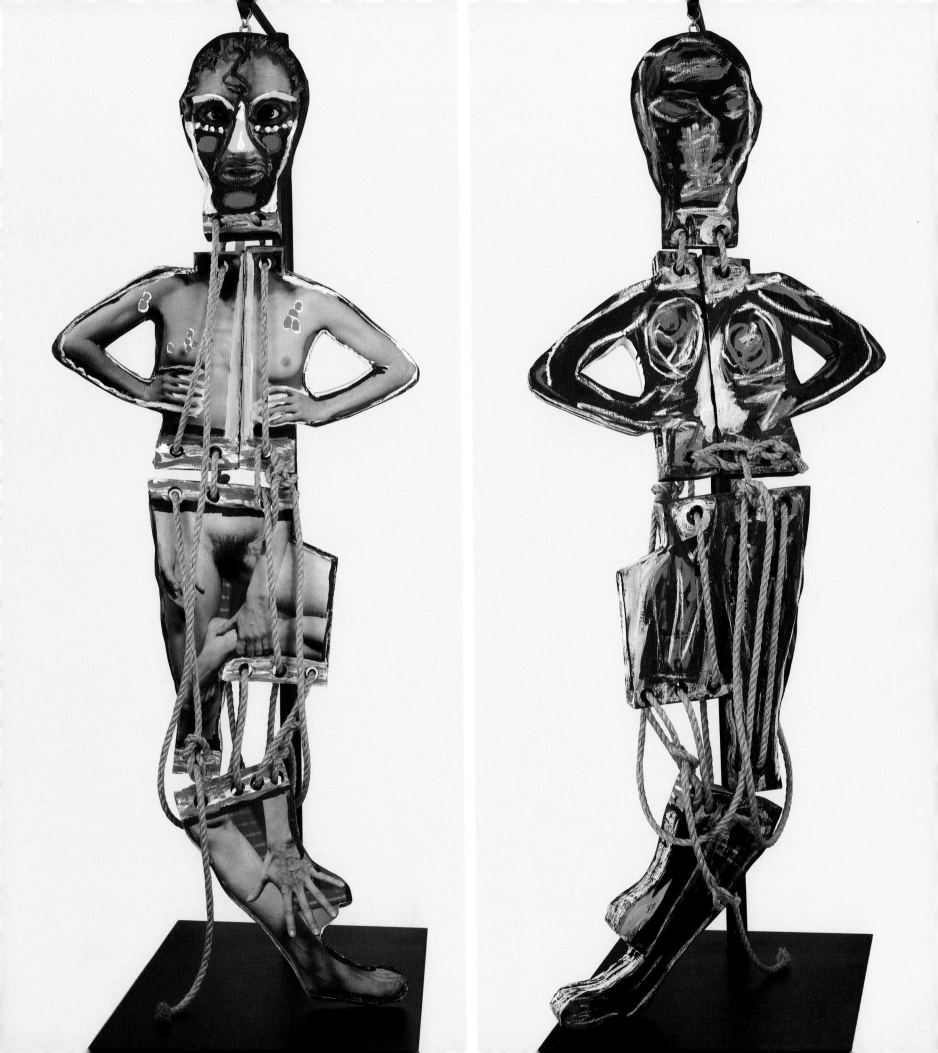

This sense of being overloaded with intense emotions in urgent need of discharge is of the essence of Appel's art. Every part of every sculpture, and the sculpture as a bodily whole, is a symbolic discharge of uncontrollable emotion, indeed, of numerous emotions, each impinging on the other, each competing and struggling with the other to find its own voice. Appel has the child's extreme lability of emotion; that is, for him, one emotion spontaneously changes into an unpredictable other, as though all were eager to express themselves simultaneously, none being able to dominate and completely occupy psychic space. To the adult, this seems like instability, but it is what gives the child his aura of spontaneous creativity. Such lability, in which every emotion seems to cross-fertilize the other, is of the essence of the psychotic core.

Appel's art is also highly labile. Every avant-garde style and direction, each suggesting a different kind of generic emotion, cross-fertilizes every other. It is as if only through such cross-fertilization could art become adequate—do any kind of expressive justice—to the lability of emotion. In general, Appel's oeuvre demonstrates that "cross-fertilization is [the] path of creativity in our time."[66] The lability and open-endedness implicit in cross-fertilization are all the more necessary to "forcefully translate the whole interior cosmography . . . directly and deeply" as Appel does.[67] For this, "the entire gamut" of stylistic means, "devoid of any purism, of any restrictive system," must be used, as Michel Tapié says. Also, the artistic freedom to cross-fertilize is necessary to save art from itself. It is the only way of dealing with a situation in which virtually every avant-garde style has been facilely mastered and become a repeatable cliché, and avant-garde defiance has become an "alibi for total impotence" and lost its social impact. Cross-fertilization is the only answer to the decadence of the avant-garde, the only way of moving beyond it. For Tapié, Appel is that rare artist, a potent, wide-ranging "individual bearing [a] new and lucid message" about pressing emotional problems, which is the only area in which art can still make a difference, and by which it makes a social difference.

Thus, cross-fertilization is not indiscriminate eclectism, but a way of achieving flexible expression of emotions that have become more dialectically twisted than ever, largely because they have become more manipulated and falsified than ever in our mechanistic society. The authentic expression of authentic emotion has become more difficult than ever because of social cynicism about it. The ideas of authenticity and expression have become suspect, leading to the devaluing of emotion. We live in a world in which it has become harder and harder to know what one feels. Affectlessness—"cool"—is the preferred state in a society in which everyone is supposed to behave like an obedient robot. In a sense, late avant-garde art, the

Standing Nude 2 [2 views, front and rear]. 1987. Polaroid, acrylic, wood, and rope, 118⅛ × 38¼ × 3" (300 × 97 × 7.5 cm)

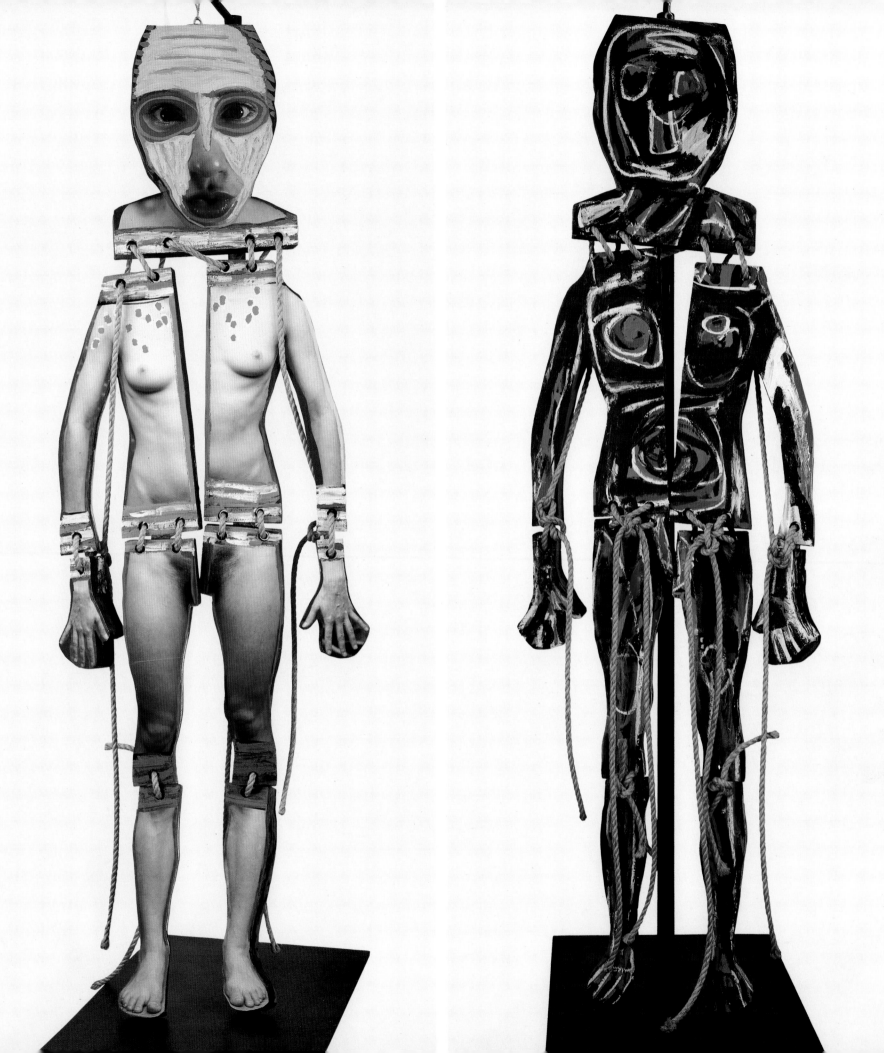

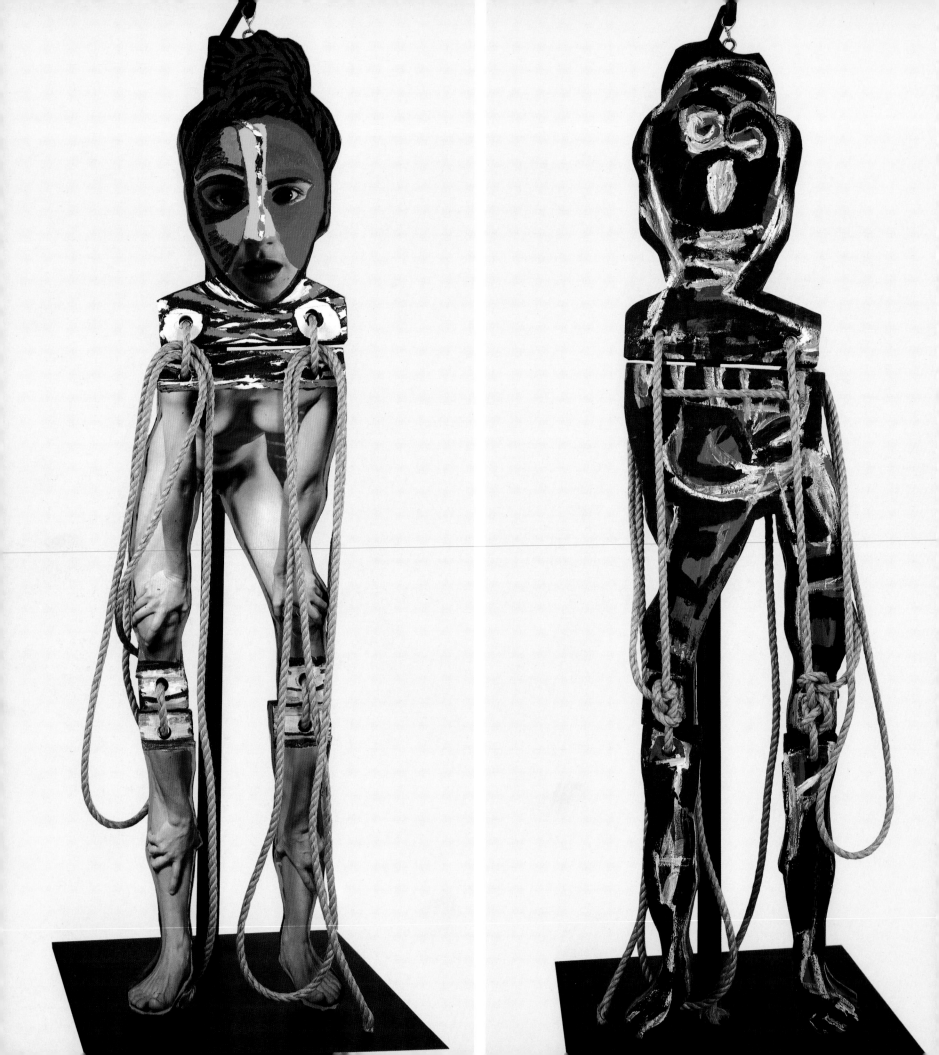

product of cross-fertilization, implies that early avant-garde art, which had stylistic purity as a goal (whether or not it achieved it is another matter), conveys a simpler sense of both emotional and social reality than it does. In general, cross-fertilization shows that seemingly dead-ended styles and directions can still breed and develop in an interesting, important way, acquiring new specificity and purpose. Indeed, cross-fertilization is essential to the process of individuation, bringing it to final fruition. Appel gives Cubist planarity, Expressionist gesturalism, Surrealist incongruity, and insouciant Dadaist nihilism a new lease on life. Actualized in the context of cross-fertilization, they reveal more potential than they were previously thought to have.

Michael Eigen writes that "in psychosis . . . fluidity of libido becomes a terrifying, uncontrollable fluctuation in the sense of self and other." Not only are "boundaries between the self and the other fluid" and almost completely open, that is, nonexistent, but "the sense of the immaterial and material shifts, seemingly at random."[68] The sense of what is emotionally expressed and objectively real spontaneously and unpredictably changes. Eigen derives this fluidity from Freud's account of perversion, the adult expression of the infant's polymorphous perversity, which involves "a fluidity of erogenous potential for which bodily boundaries offer little restraint. . . . the body is originally an undifferentiated erotic playground [that] involves a boundless interchangeability of openings and surfaces."[69] This fluidity is still evident in the child, if more channeled, but in Appel's labile art, the sense of where the emotional reality of the self begins and the social reality of the object ends is impossible to determine. However, the sense of the object's constancy remains; that is, the object can be more or less clearly identified and differentiated from other objects. What makes the olive root sculptures so emotionally remarkable is that they seem to be a spontaneous regression to complete amorphousness or psychotic undifferentiation. The barest sense of the object is retained, implying a loss of the self that observes and separates it from other objects. Hence the astonishing dynamics of these sculptures, comparable to the allover works of Pollock, which imply a greater disintegration of self-object differentiation, and with that of the self and the object.

In a sense, Appel treads a finer emotional line than Pollock, who seems never to have known what self-object differentiation was, or have known it only fitfully. He was seriously psychotic—not simply flirting with psychosis, but a victim of it. He was not playing at being the child the psychotic is, but was that disturbed child.[70] Appel knows the difference between self and object, and between playing at being mad in order to be free to speak the emotional and social truth without being punished for it—the privilege of the clown, as King Lear's clown indicates—and really being mad. He has more ego strength than Pollock, and as such, is saner. When Appel abandons

Opposite:
Standing Nude 4 [2 views, front and rear]. 1987. Polaroid, acrylic, wood, and rope, 103⅛ × 17⅜ × 3″ (262 × 44 × 7.5 cm)

Overleaf, left and right:
Study for a Portrait of Van Gogh. 1988. Acrylic, oilstick, Polaroid, rope, and wood, 94½ × 78¾″ (240 × 200 cm). Fondation Vincent van Gogh, Arles, France

Study for a Portrait of Marisa del Re. 1988. Acrylic, oilstick, Polaroid, mirror, rope, and wood, 96¾ × 78 × 24″ (245.7 × 198.1 × 61 cm)

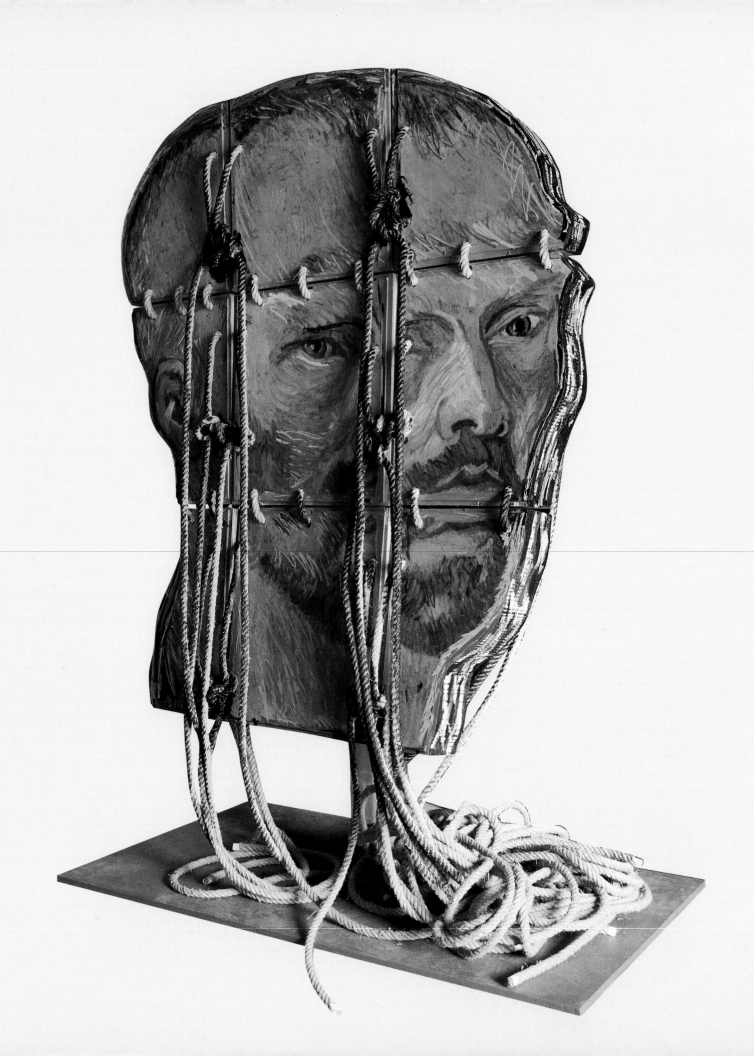

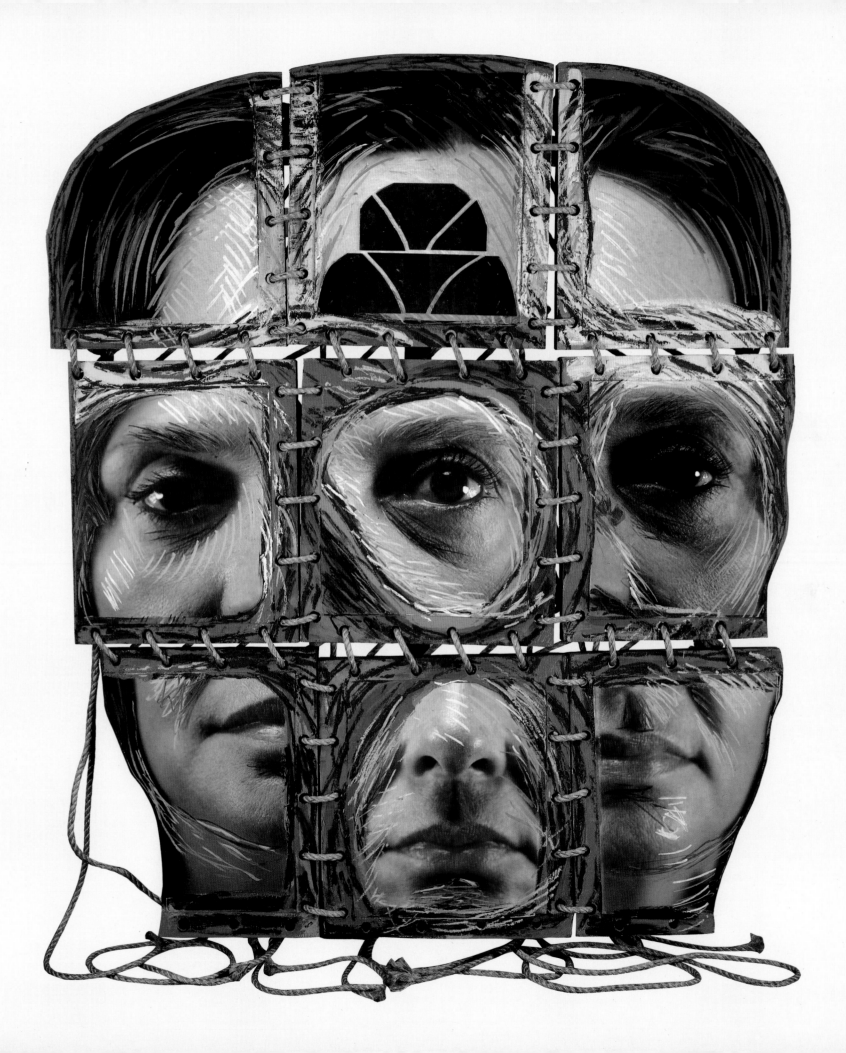

what Winnicott calls the safety-first principle and what Joseph Sandler calls "perception work"[71]—when he takes artistic risks that imply that he is insane—he does it with impish good humor. He gives us a comic psychosis. Thus, for all their psychotic power—the gnomic way they convey the transformations and deformations of the self and object in a psychotic state of mind, with its wild mood swings and failures of perception, and its general tendency to dedifferentiation—the olive root sculptures are implicitly droll. Like a latter-day Brueghel, whose art was explicitly characterized as droll, Appel presents the insane truth about human beings—a more dangerous one than any Brueghel discovered, and more difficult to articulate—under the guise of humor. He makes the regression to the primordial body seem like good fun, which makes it less threatening, and even, in the end, a hearty, healthy experience; that is, a regression in the service of the ego, making it feel organically alive rather than a mechanical robot. Thus, Appel's olive tree sculptures are traumatizing hallucinations, wildly ambivalent in character—they seem to change emotional tone before one's eyes, so that one hardly knows whether to feel pleasure or pain in front of them—but also peculiarly hilarious. It is as though Appel is joking about going mad even as he suggests what it feels like.

Thus, the olive tree sculptures are not as disintegrative as they seem, however much Appel acknowledges his disintegrative intention. Nor are they completely spontaneous, chaotic expressions of the unconscious, however much Appel intends his art "to liberate the subconscious and make it known by art."[72] That is, they are mad, but not as mad as they seem, for even in them there is humorous representation. The figures have a caricatural wit—the saving grace of sanity. This suggests that Appel is responding to an object, not simply externalizing a delusion or mired in a psychotic swamp. Thus, the olive root sculptures can be understood as more excited than chaotic—a perhaps finicky distinction that nonetheless emphasizes the point that they are not completely given over to self-absorbed insanity, but involve a sensuous response to a particular object, more particularly, the body of an object, recognized as different from the body of the self. They do indeed make chaos positive, as Appel said he wanted to do—make it into art—but this is to make it into an object, and to experience it in and through a relation to an object.

Appel's sculptures are then not entirely psychotic projections of a disintegrative self, but imply a creative effort to grasp the existential uniqueness of an external object. This no doubt involves fantasy, but it does not involve reducing the object to a symbol of one's own disintegration or inner life and emotion in general. In this sense, Appel suggests the sanity of the child's "fantastic" attitude to the object, which in contrast to the adult's sober attitude is concerned to grasp and articulate it in all its

Study for a Portrait of Harriet de Visser.
1988. Acrylic, oilstick, Polaroid, mirror, rope, and wood, 120¼ × 73½ × 24″ (305.4 × 186.7 × 61 cm)

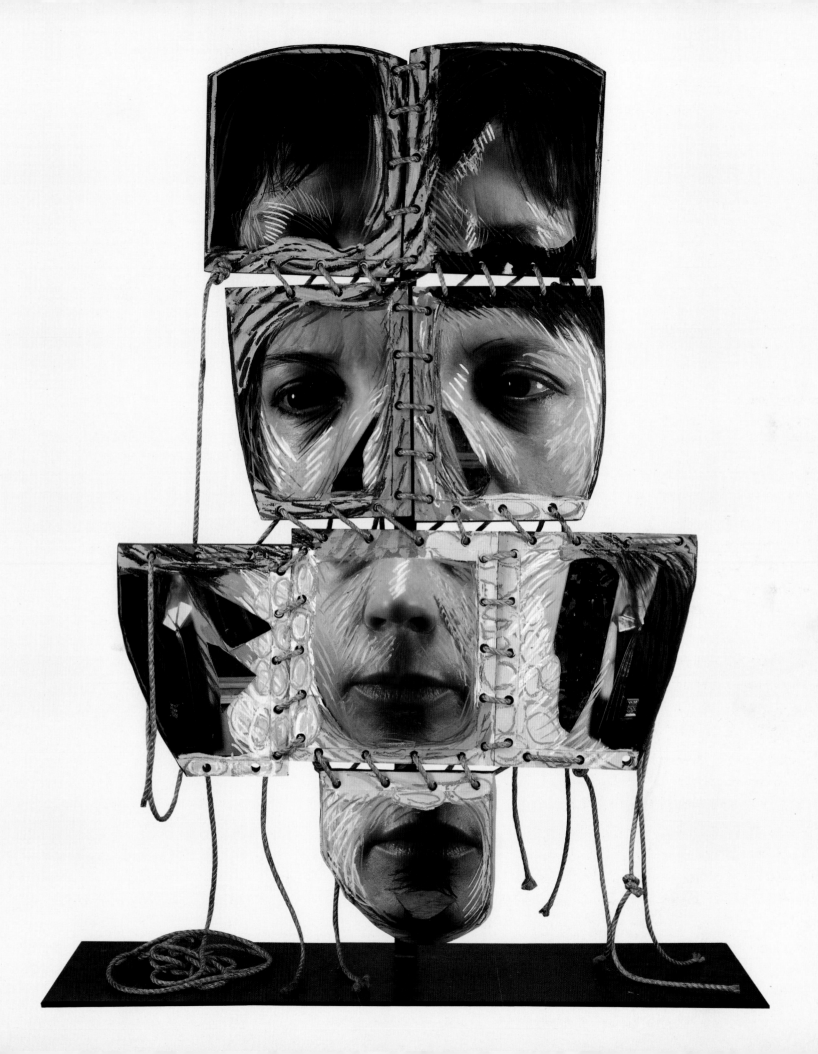

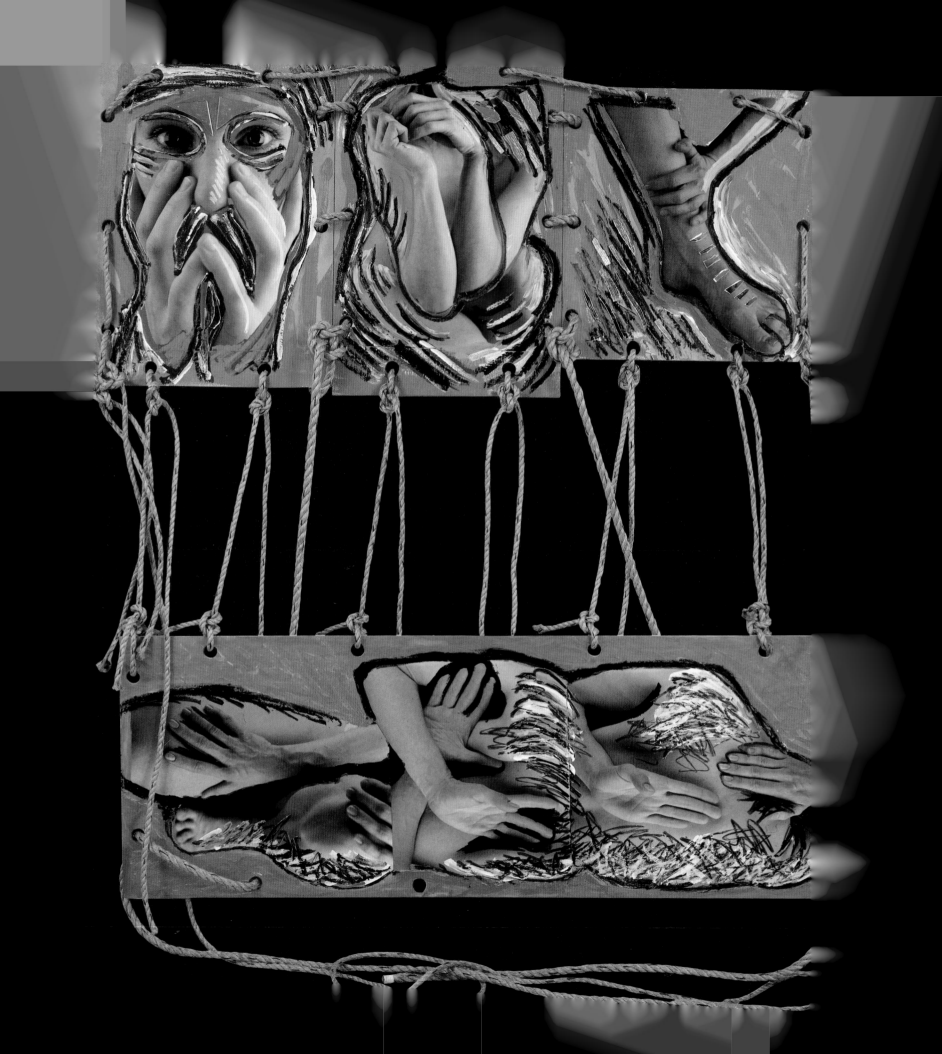

specialness, rather than to generalize it into a stereotype and/or reduce it to its functionality and categorize it according to its social role and use. The child is interested in the existential not social reality of an object—its seemingly fundamental character, not social consequence—just as the artist is ultimately interested in its colorful form and inner meaning, not its conventional significance. I think this is why Appel sets the negative insanity of society irreconcilably against the positive insanity of art. Unlike society, the artist, along with the child, respects and acknowledges the individual in all his particularity. Thus, Appel's olive tree sculptures humorously flirt with psychosis and the integrity of the child's attitude simultaneously. For him, both are infinitely preferable to the negative chaos—the truly insane disintegrative attitude—of adult society.

The olive tree sculptures are like hyperactive children, whose emotional lability coincides with their sensorimotor lability. (This coincidence, projected onto the world, is in part responsible for the child's sense of it as hyperkinetically alive and sensationally new—an extraordinarily vital and vivid spectacle existing for its own emotional sake. That is, the world serves the child as both a catalyst of and objective correlative for emotions experienced as enchanting in themselves, rather than as indications of the inner workings of one's self or signals about its attitude to the world. Indeed, the child has "selfless" emotions, as Appel does.) As such, they touch the roots of human being as few other works do in modern art. They are amazing sculptures, epitomizing Appel's sense of the madness that is the root of life.

VI

Apart from the olive root sculptures and the *Questioning Children* mural, there are two types of sculpture that show Appel at his most inventive and imaginative. There are a number of untitled boxlike works that are ironically impure constructions, and a number of constructions that function as figures and portraits. Appel makes the first kind of construction, relatively small in scale, intermittently until the eighties. He begins to make the second, rather monumental type, in the mid-eighties. Both kinds converge in Appel's windmills, which he has characterized as figures[73]—to my mind, mad ones, by reason of their association with the windmills that the mad Don Quixote hallucinated as threatening giants. Or are they his "abstract" versions of the proverbial Mad Meg that Brueghel painted, fearlessly marching through a hellishly mad world? The Windmill Series is also transitional between the two types of work. Both attempt to reconcile expression and construction, the antitheses of modern artistic method.[74] The latter type do so in an especially innovative way.

Opposite:
Titan Series No. 2. 1988. Acrylic, oilstick, Polaroid, mirror, rope, and wood, 76½ × 86¼″ (194.3 × 219.1 cm)

Overleaf:
King of the Titans. 1988. Acrylic, plaster, rope, and wood, height 28⅛″ (71.5 cm)

81

In modernism, to construct means to use a universal method to reach a universal goal. It means the totally planned work of art. As Theodor Adorno writes, construction involves the "imposition of unity" to achieve rational "over-arching validity."[75] A construction should be reducible to a simple principle and procedure, however complex it appears to be—and it should not look too complex, for that would distract from its doctrinaire point. There should be nothing surprising, untoward, enigmatic, or unconscious about a construction, for it is meant to announce the vanishing of the subject through the utopian logic of history.[76] A construction should be indifferent to the poetry of materials, viewing them prosaically as building blocks. It destroys faith in the spontaneous leap of metaphor, which can create relationship where there seems no ground for any, suggesting there is something uncanny in every relationship that seems worth the emotional trouble. Construction prepares us for that ideal world in which all relationships are self-conscious rational exchanges rather than mysteriously intimate elective affinities.

But Appel makes eccentric constructions, suggesting that the subject exists in the technologically perfect, completely objective world the construction exemplifies. Subjectivity may seem accidental and anachronistic in that totalized world, supposedly the rational utopia we have all been waiting for—or is the subject the subversive canker in its rosiness?—but it makes its failings clear. Construction may have once been a critique of the supposedly "illusory notion of organicism," but Appel's organic—not simply organicized—constructions point to "the loss of tension in constructive art today,"[77] a weakness that ironically follows from its achievement of purity; that is, its elimination—dare one say deliberate extermination?—of the subject, whose messy traces are wiped away as pollutions of the sacred technological temple which the construction has become. Construction is supposed to be the final solution to the problem of the subject, but Appel's message is that the subject survives even in construction. His chaotic constructions contradict historical necessity, suggesting that it is far from infallible. They are an attack on those who act in its inhuman name, causing much suffering. Indeed, in Appel's hands, what should be an impeccable construction becomes a Pandora's box of improbable, messy materials. Hope is no doubt at the bottom of it, but it looks far from hopeful on the surface. Appel regresses from the confidence of perfection to less confident hope, but that is truer to the reality of life. Appel's constructions thus undo the utopian premise of construction by adding random life to it, implying that it was all along an ironic manifestation of the death wish. At the least, he suggests that Constructivist idealism has been unraveled—betrayed—by history, and survives only as an aesthetic and collective illusion. Thus, Appel uses materials that have become historical by

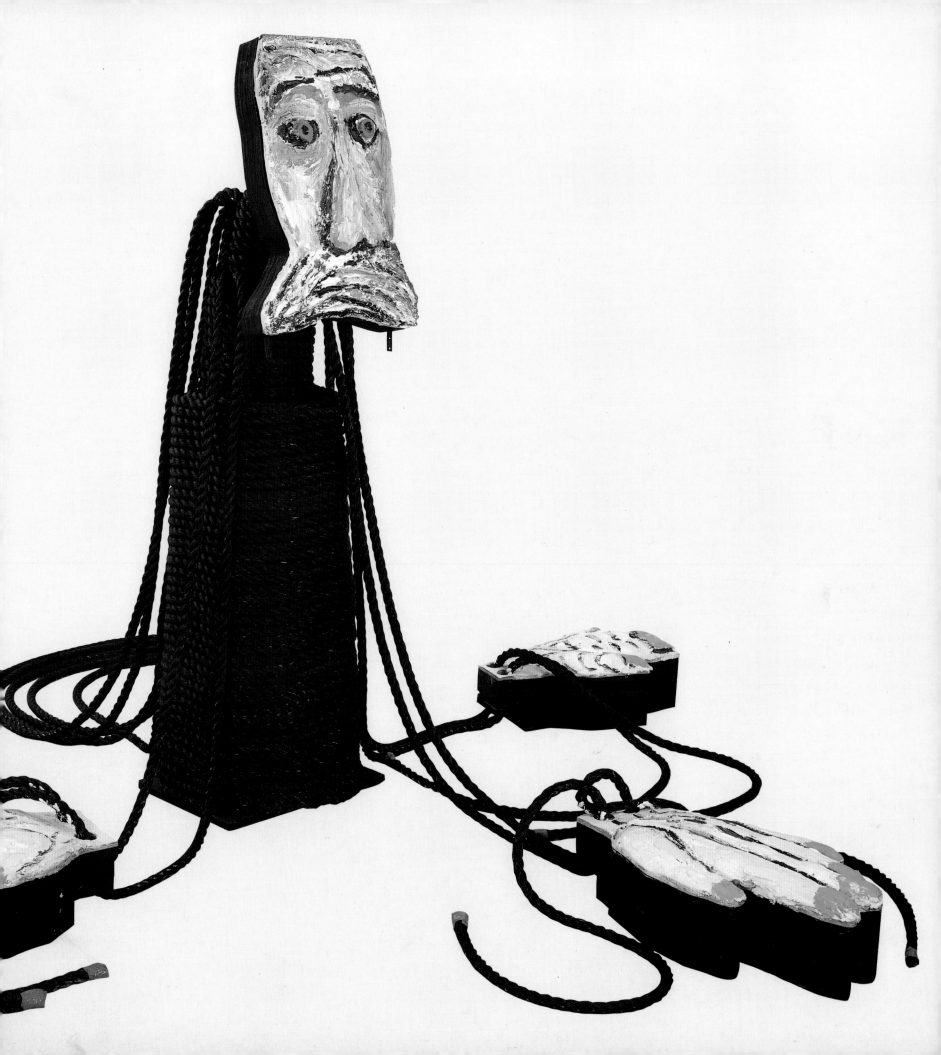

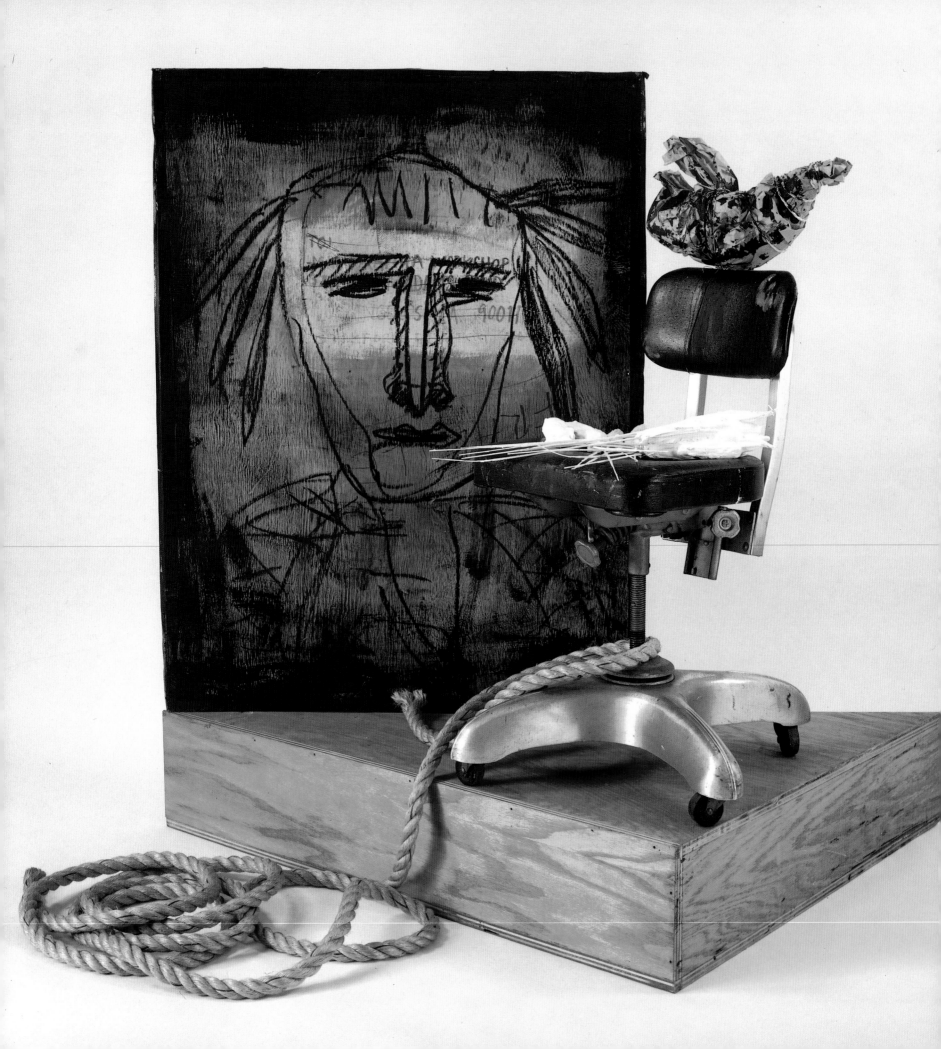

becoming waste to disrupt and violate the pure construction. His materials also suggest the plenitude of life that transcends it. With compulsive determination, Appel repeatedly denies the pregiven generality, which the seamless construction is, adding material details that undo its geometric perfection and thus, its conceptual integrity.[78]

Construction, 1949, is at once an accidental association of materials and a mutant creature, and points the way to many similar mutated constructions. But there is a group of constructions that seem like deliberate demonstrations of the undoing of perfection by chaos, with no ulterior figural motive. These works seem like object lessons of Appel's basic intention. They are magic hats out of which Appel pulls organically alive materials impossible to contain. Rope is perhaps the most conspicuous of these materials. Appel associates it with the rope used to tie ships to the dock in the Amsterdam harbor,[79] suggesting that it symbolizes empathic connection with and longing for foreign places. But Appel has also used other "random" materials to make his point, as in two untitled 1964 constructions of cardboard boxes out of which straw spills. These anticonstructionist sculptures, as it were, are straightforward statements of the irreconcilability of gestural chaos and geometric order. Earlier, in 1947, a curled piece of electric wire is contrasted with a randomly meandering piece. Both are set against a wooden grid. The chaotic wire grows out of the order of the grid, like a worm coming out of a perfectly round apple. Something similar occurs in the small version of *Passion in the Attic,* 1947, whose fetishistic nails—no doubt derived from African sculptures, as *Standing Figure,* 1949, suggests—contribute to the contrast of "overarching" chaos with "underlying" order. *The Broken Ladder,* 1947, with its use of electric wire to hold the pieces of the broken ladder together, not only prefigures the technique of the figural and portrait constructions of the late eighties, but thoroughly demolishes an instrument of construction which in itself is a rationally ordered, seamlessly unified construction. (The brilliantly chaotic *The Wild Fireman* also anticipates the later constructions in its use of wire to hold the discrepant parts of a figure together.)

The sculptures that most seem like anti-Constructivist manifestos are the eight untitled works Appel made in 1980. (The ninth, the wildest of the group, was made in 1981.) While not officially a series, they can easily be regarded as one, despite all of their differences. They all have the same format: a rectilinear cardboard box is nearly annihilated by chaotic paint and by being stuffed with a variety of materials, from polystyrene to paper. That is, Appel uses packing materials to "pack" the box to bursting. Its contours remain intact, but nothing else does. Every inside and outside of the box is "manhandled" by Appel, which is thus made to be seen in the round. But it also clearly has a picture front. In one case, a rapidly sketched grid of three

Monument for the Indian Chief Seattle. 1990. Rope, plaster, newspaper, found object, acrylic, and oilstick on wood, $53 \times 55\frac{1}{4} \times 27''$ ($134.6 \times 140.3 \times 68.6$ cm)

frames, each full of abstract "designs" and echoing the shape of the box, is painted in bright colors on its long surfaces. A second box also comes at us from all sides, one of which is a quick sketch of a comic figure. Clearly Appel is clowning—playing hard and fast with gestural and imagistic possibilities. In a third case, what seems like a grotesque face bursts out of the box. The face is a heap of squashed paper thick with very loose, broad strokes, which on the side of the box form a grid. In another work, packing polystyrene, with its endless grid of circles, is painted white, somewhat thinly and unevenly, and stuffed into a box painted white, where it functions as a giant, menacing gesture. The opening of another horizontally placed box is filled with a grid, three "modules" by four, made of crumpled paper whose chaotic texture is strongly evident behind its coat of white paint. The box itself, in its beat-up, broken character, reminds one of Picasso's 1912 Cubist guitar, supposedly turning a manufactured object into a construction, but in fact, showing it to be an expression. Like Picasso, Appel plays on the border between construction and expression, but in Appel's case, expression clearly wins out.

In three other works, the box is stripped down to bare essentials, making it skeletal, and passionately painted. In two cases, circular structures, with densely painted canvas and cloth in them, are placed in the boxes, where they seem like omens of impending disaster. Indeed, these three boxes, more than any of the others, have a shrinelike character, as though altars to an unknown god. They are clearly fetishistic in character: Appel has invested inanimate matter with mysterious life, as though making art was an ancient ritual of animistic worship. Like a Druid finding life in a stone, Appel can find life in everyday material. In the third case, rags have limply fallen to the bottom of the upright box, as though it had the stuffing knocked out of it. These are among the strangest, most materially limited but conceptually complicated, and most explicitly antipurist of Appel's anticonstructions. They are that contradiction in terms, an Abstract Expressionist construction. In the 1981 piece, Appel rebels against the ominous skeletalness and relative emptiness of the box he achieved at the end of 1980. It was probably too gravelike, so he stuffed it to overflowing with the brightly color material of life, to the extent that the material juts out of it. Appel has always been an artist of abundance rather than scarcity, to use Friedrich Nietzsche's distinction. For him, to make art is not to fill emptiness with tokens of being, as it is for Giacometti, to mention one example, but to let being spontaneously overflow until it exhausts itself in expression, at least for the moment. Appel is a Maximalist not Minimalist. His art is about uncontainable expression rather than self-contained construction. Thus, Appel's anticonstructions are as flippant and short-lived as meteors streaking across the sky, but they are also violent

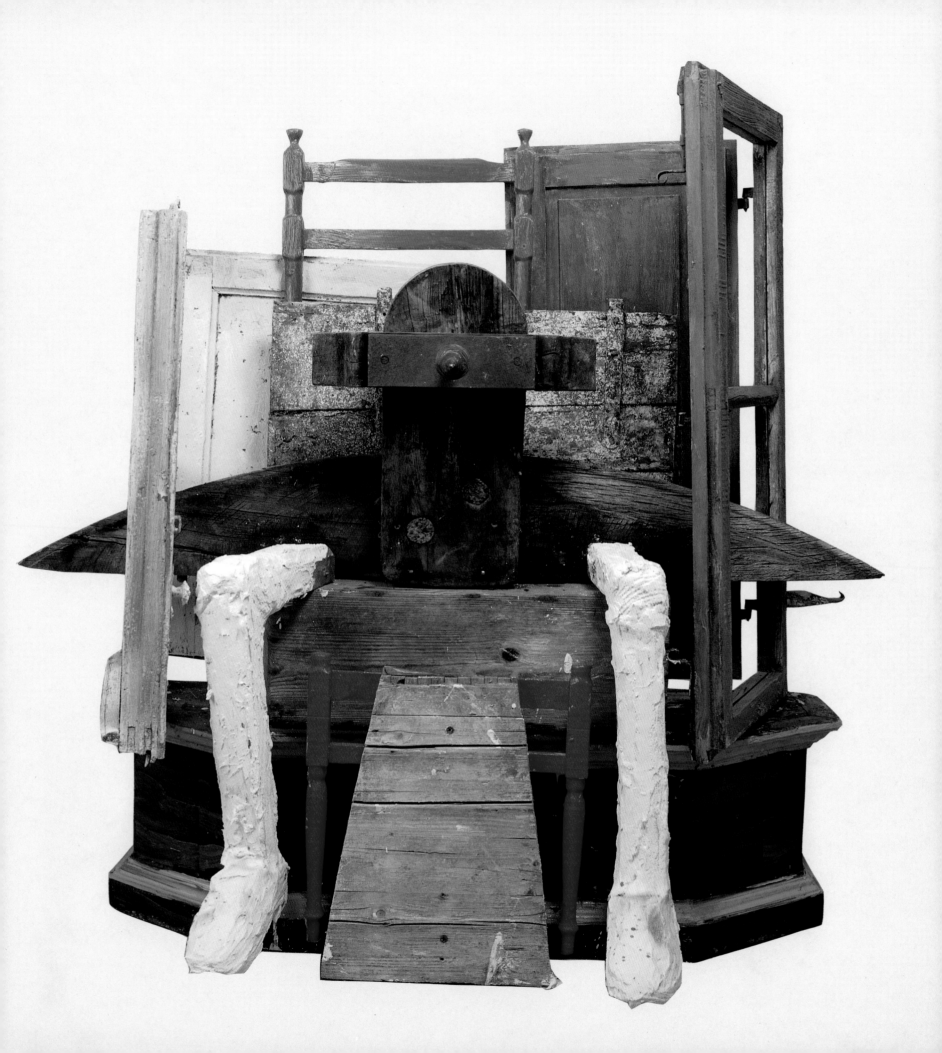

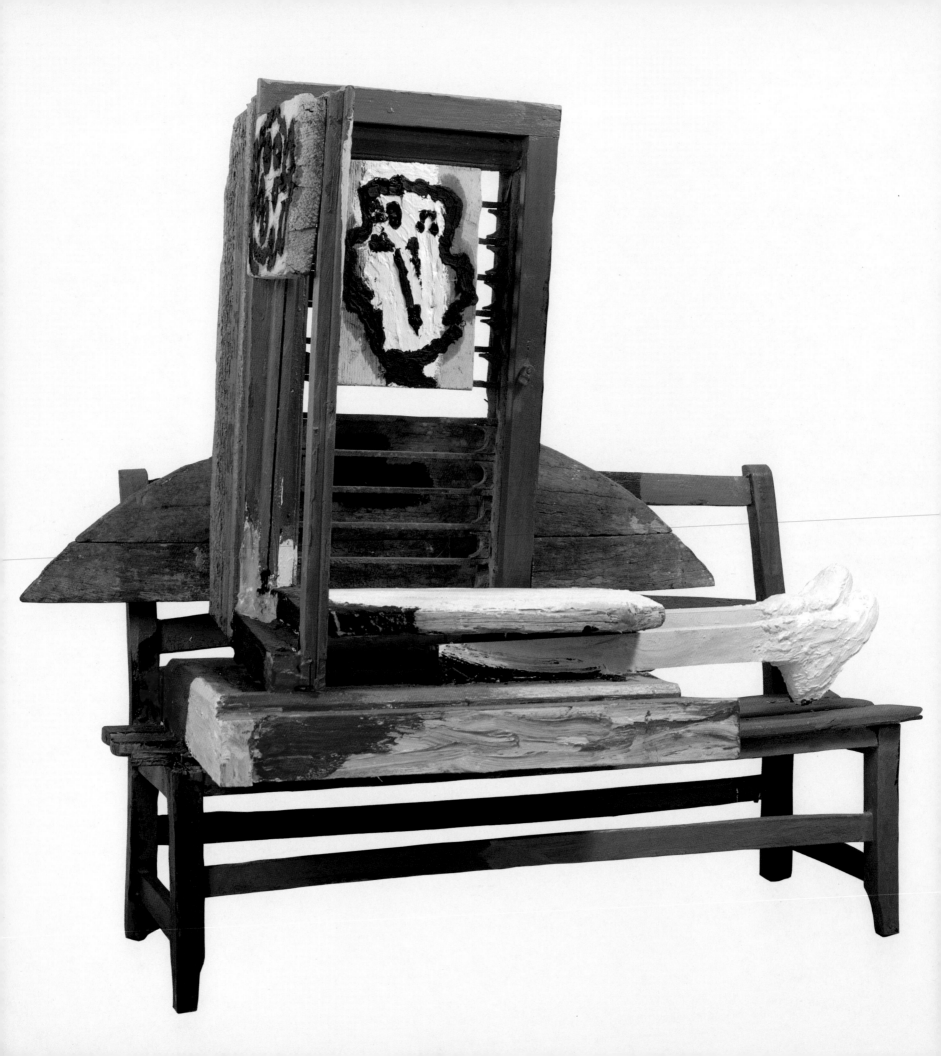

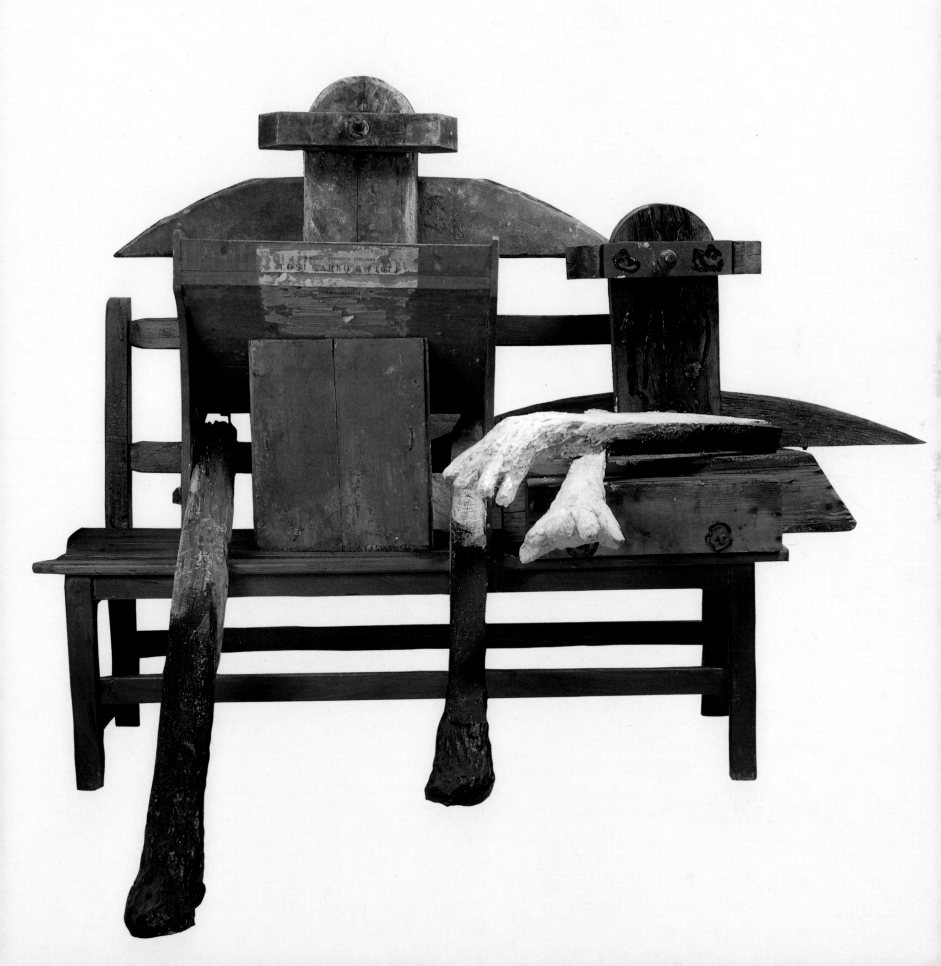

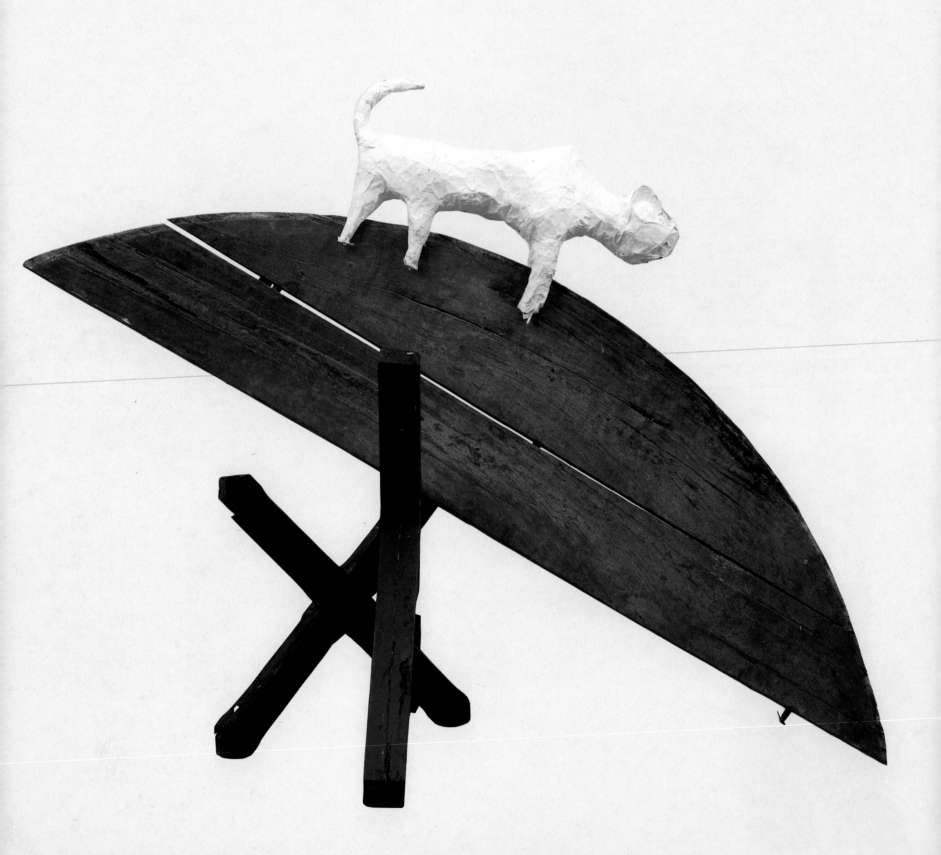

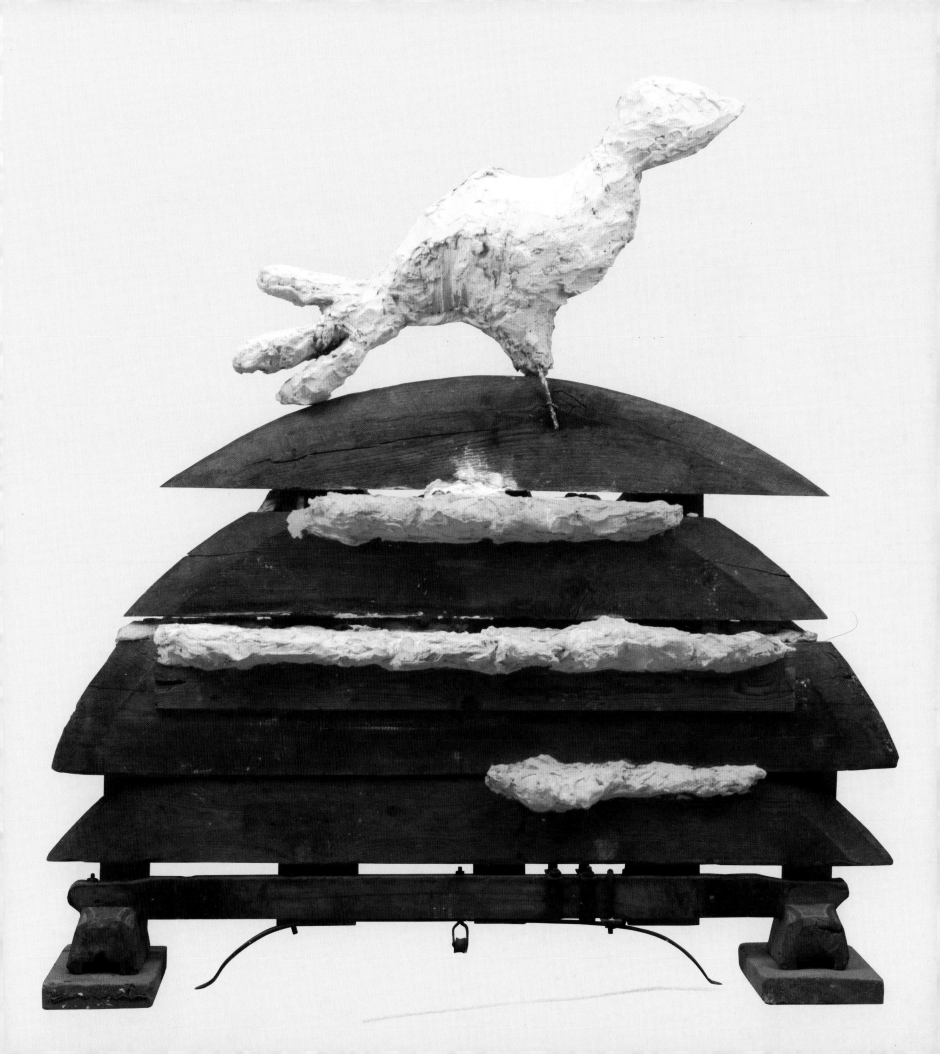

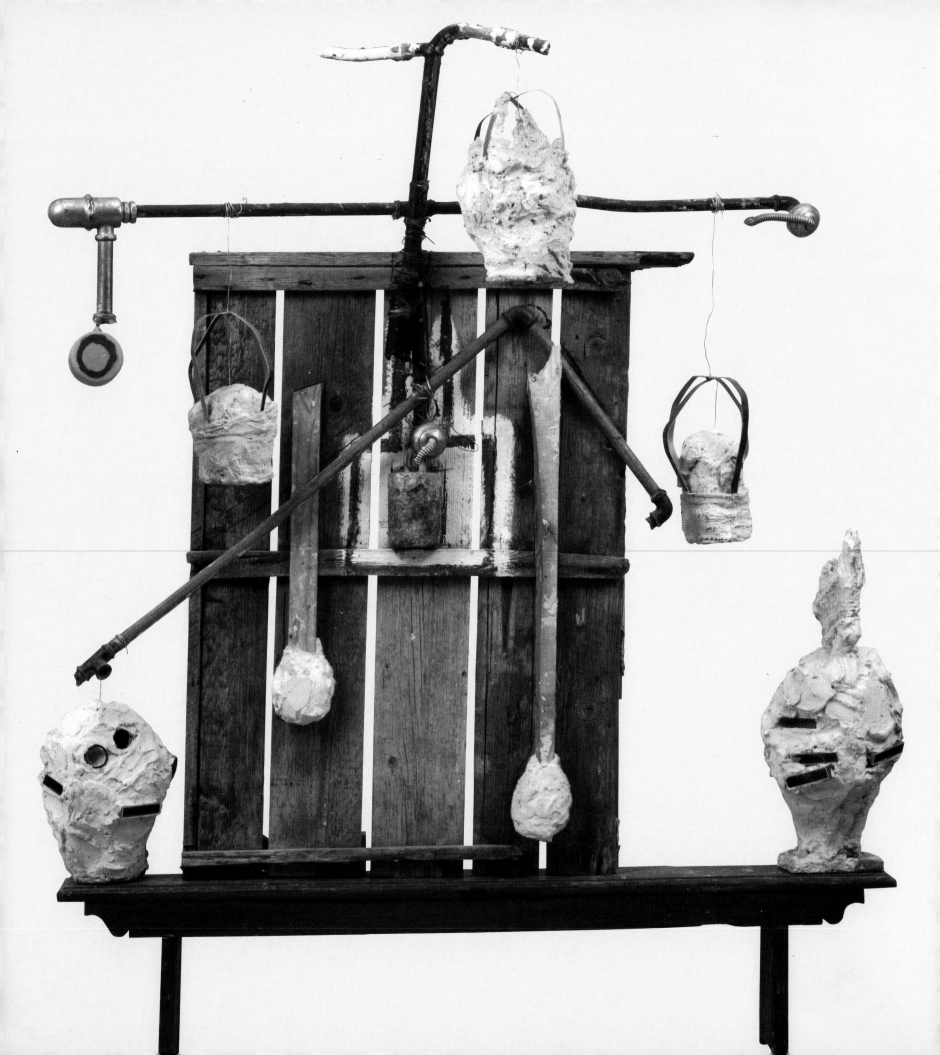

eruptions, blowing the lid off the box in Dadaist mockery of its Minimalist purity.

The 1985 windmills are basically these same boxes, now greatly enlarged and completely skeletal, and held together by rope. The windmill has become a giant toy—a plaything of the past, for it is the ghost of the Netherlandish windmills of Appel's childhood. I believe that in showing their basic engineering, Appel is unconsciously comparing them to the skyscrapers of New York. Stripped of their walls, they too are simple, hollow skeletons. But *Windmills I–IV* are earthenware bodies with wings. The windmill constructions of wood—*Floating Windmill* and two other works, both simply entitled *Windmill*—are fragile Icarian figures compared to the solid Daedalian character of the earthenware series. It is as though the former are feminine, the latter masculine. The former are more clearly constructions, the latter more clearly expressions, as though to suggest that woman is more a fabrication than man, who is closer to the earth. But then it is the earthy expression that is able to fly successfully, while the pure construction crashes to the earth. The masculine Daedalus is the authentic artist, the feminine Icarus the inauthentic artist. Defying interpretive expectations, the works reverse meaning as Appel's emotional priorities change. Perhaps my associations are all too free, but I mean to suggest not only the mythical character of the windmills, but the fact that they are emotional opposites in dialectical interplay.

Both Daedalus and Icarus rode the wind, the way the windmill does. But Daedalus, the mythical first sculptor and an important artificer in general, was successful in his flight, while his son Icarus was a failure who died. Flying too close to the light, the wax that held his wings to his body melted and they fell off. Indeed, the wooden Icarian windmills seem more likely to fall apart than the earthenware Daedalian ones. Much as the biblical myth of the fall of man is about what happens if one is tempted to reach beyond oneself—about the greatness of human ambition, but also the self-destructiveness it can lead to, especially when limits are not recognized. So the classical myth of Daedalus and Icarus is about the fall of art; that is, the great things it can achieve, but also its limits, which destroy it unless they are respected. Daedalus and Icarus are opposite sides of the same coin: both took the same risk, but only one succeeded. (He succeeded because he was the father, while the other fell because he was the son.)

Thus, Appel's windmill sculptures show him taking a big risk, and not certain if it will succeed. He is the clever artificer Daedalus, but also the incautious Icarus. Are the Icarian constructions better than the Daedalian expressions, or is it the other way around? The former are more conceptual structures, the latter more physical bodies. Which is the right way to go? Can one go in both directions at the same time? Appel,

of course, thinks one can, just as one can be Constructivist and Expressionist at the same time, without compromising either. The windmills playfully raise all these questions. Appel tests himself in both directions, saying to himself that the windmills half succeed, half fail, like anything new and risky. This is no doubt the way all avant-garde adventures seem to the artist who undertakes them. Appel is certain that he must take the step into the unknown, but he is uncertain of the results. Nothing ventured, nothing gained, but he is not certain what the gain will be.

In my opinion, Appel's windmill sculptures begin a new chapter in his development as a sculptor, however much they recapitulate ideas he has already used. They are the beginning of self-clarification and summing up, unconsciously intended to mark the artist's sense of approaching the end of his work and life. Paradoxically, however, it is impossible to take stock without innovative advance. That is, the effort to find out where one has been forces one to strip down to fundamentals, putting one in a new, unexpected situation. The struggle for self-knowledge leads to fresh artifice that suggests one never before knew what one was really capable of. Appel's windmills and the sculptures that follow from it exemplify this ironical paradigm of late style.

The myth of Daedalus suggests an even more pointed, basic interpretation of the windmills. Daedalus represents the artist's confident creativity, flying high, while Icarus represents the low feeling of self-doubt—his sense of falling below his expectations—that follows it. I submit that the skeletal Icarian windmills symbolize the feeling of emptiness that follows the orgasm of creativity, while the more substantial Daedalian windmills symbolize the feeling of fullness of being preliminary to it. I am suggesting that the windmills can be read as a relatively explicit statement of what has always been subliminally the case in Appel's art: It is about the creative process itself. Daedalian expressions suggest the erotic buildup of sensorimotor feeling to the point of saturation—which is what Appel's lush painterliness suggests—necessary for creative discharge, while Icarian constructions suggest the melancholy aftermath of the discharge, which feels like death. It is as though in exposing the windmill's duplicity, as it were—it seems like a sturdy giant, with all the strength it needs to move, but it can move only when it is "inspired" by the wind, thus showing that it is more dependent than it seems—Appel unwittingly embodies the basic emotional tension of his art. Not only is the windmill the perfect metaphor for his conception of man as the dupe of being, but it symbolizes Appel himself, the dupe of art.

That is, the windmill is a wonderfully innovative, ironic emblem of the artist. He is obviously titanic and larger than life, with wings that can soar in flight, which

Flowers. 1991. Iron, brick, and wood, 61⅜ × 80⅜ × 58⅝" (156 × 204 × 149 cm)

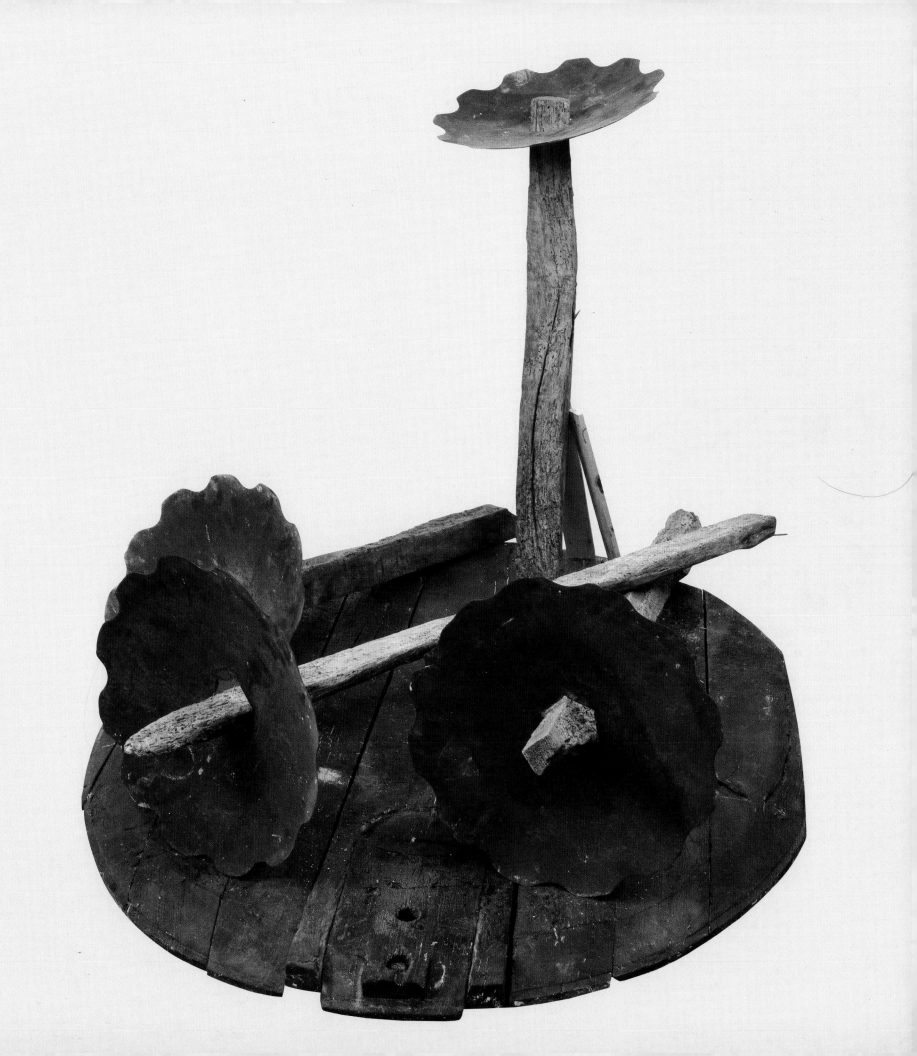

makes him unique among men. But the artist can only fly when the forces of life inspire him, and they, unfortunately, are as unpredictable as the wind. The windmill, which belongs to the sky when its sails are driven by the wind but otherwise seems passively attached to the earth, is Appel's first titanic figure. It is full of potential power, but the actualization of this potential depends upon forces beyond its control. Appel's windmill is as symbolic of the equivocal character of art as Albrecht Dürer's somewhat more sober personification of it in *Melencolia I,* which represents art as stuck between earth and heaven, inspired by both but at home in neither. Dürer and Appel seem to be saying that art is unsatisfying as both theory and practice, but that it alone can mediate between earth and heaven, if not reconcile them. However obliquely, then, Dürer's figure and Appel's windmill make the same point. Indeed, Appel's recent sculptures are not unlike Dürer's picture in their abundance of symbols and allegorical character. Both are enigmatic, melancholy, uncanny, and visionary. They are interpretively demanding, like a steep philosophical height hard to climb intellectually. And Dürer's work, for all its intellectual cunning, has something childlike about it. His figure, immobilized by melancholy and unable to escape from its quandary, seems to treat its theoretical and practical tools like so many toys it is tired of playing with. They sit unused because they do not work as well as they should. I may be overstating the comparison, but Appel's obsession with the windmill, like Dürer's reflection on art, is also a kind of praise of it. Indeed, Appel of Amsterdam seems to praise folly like Erasmus of Rotterdam, except that in Appel's case, it is the folly of art.

The titanic windmills are heralded by such gigantic figures as *Anti-Robot,* but the windmills are more elemental in appearance. Titans are grand, powerful personages but not as self-assured as Olympians; but then titans are more elemental and closer to the source of being than Olympians, who are a later refinement of the forces of life, and as such, decadent compared to the titans. Indeed, of all the gods, the titan is the most primordial, just as the artist is closer to the primordial source of being than other human beings. The older Appel becomes, the more titanic he becomes.

Donkey. 1991. Plaster, found objects, and wood, approximately 60⅝ × 102⅜ × 34¼″ (154 × 260 × 87 cm)

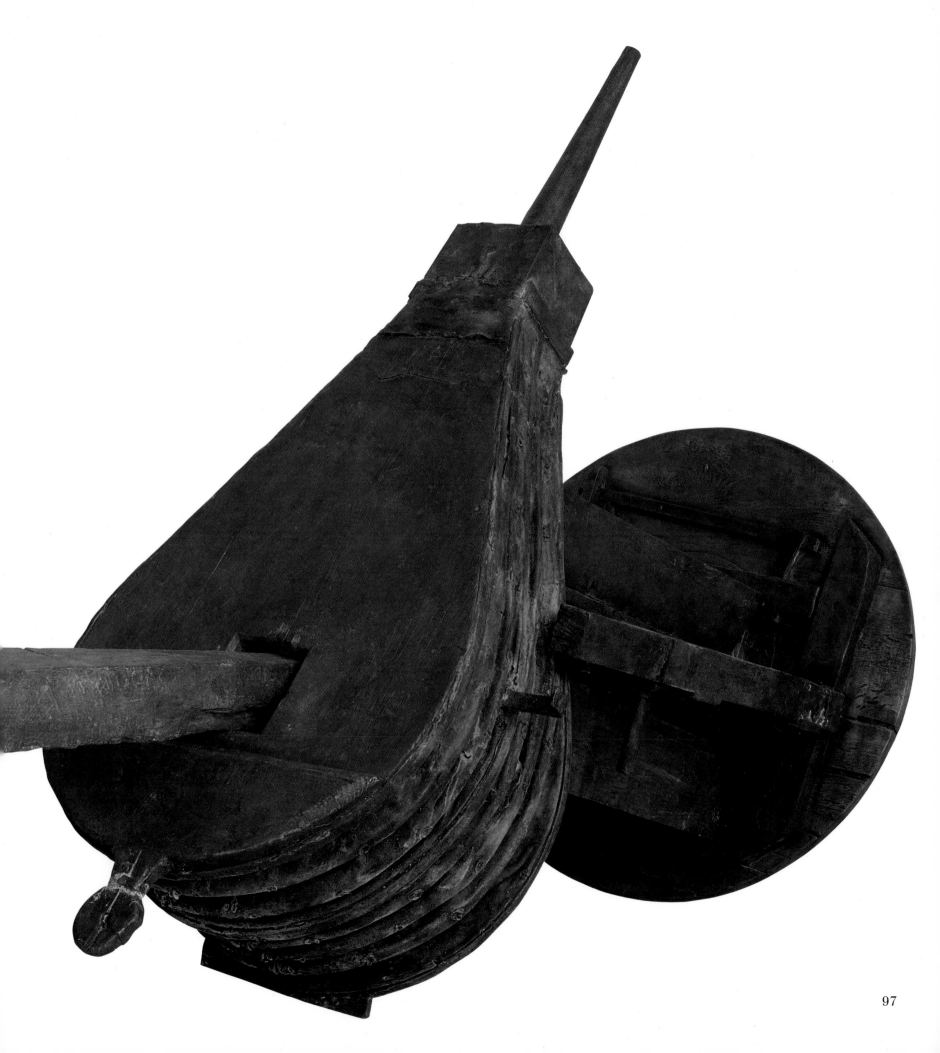

VII

The four Standing Nudes of 1987 follow directly from the windmills of 1985. Just as there are two types of windmills, so the standing nudes are two-sided or two-faced. They are also assemblages held together by rope, in their case assemblages of part body objects. Appel's sculptures have always oscillated between two- and three-dimensionality. Sometimes they are constructions of flat planes painted so that they seem to project, as in the case of *Mouse on a Table,* 1971. At other times, material is painted in a broad, flat way that seems to neutralize its three-dimensionality. *Two Columns,* also 1971, is a clear example of this. In that same year Appel made *Man with Moving Ears,* which can be seen from either side, like the Standing Nudes. But their "duplicity"—the discrepancy between the sides—is more extreme: One side is photographically realistic, the other wildly painted in black and white, with neither being the preferred view. There is another reversal or opposition: The face on the photograph side is a painted mask. Finally, where the windmills are integral wholes, for all their eccentricity, the Standing Nudes seem to be falling apart, for all their totemic majesty.

Appel breaks the female body into parts that seem more emotionally significant than the body as a whole, especially because they are not seamlessly aligned and so appear to forcefully project. Appel gives us the regressive body, fractured into erotically exciting parts, giving it a quirky vitality, but also a body that announces its own death. This literally disjointed body is further vitalized by being erratically painted with primary colors, but it is tightly contained in a conspicuous black contour. This negative halo, as it were, clearly implies the body's death. In fact, life and death—white and black—conflict on the other side, as in Robert Motherwell's *Elegies.* Every life has its dark, elemental, antisocial side.

Appel depicts a tempting young female, but her body is too nightmarish to be truly desirable. Is Appel saying something about the morbid, self-defeating character of desire? It is as though he must destroy the body he desires, protecting himself from his desire. (No doubt he is also articulating his own fear of annihilation.) The body's disjunctiveness keeps it at an emotional distance even as it acknowledges that the body can be physically handled, its parts whimsically manipulated to suit one's passion. Indeed, the Standing Nudes are monsters that embody the ambivalence and anxiety—the unsettling attraction and repulsion—they themselves inspire. *Standing Nude 4* is the most grotesque of them, for it has lost its torso. Head and legs are collapsed together. The grotesqueness of this magical, Bosch-like creature, which seems to be able to hop like a toad, threatens us with our own magical grotesqueness. (*The Beggar,* also of 1987, is an even more monstrously collapsed,

98

King's Altar. 1991. Papier-mâché, found objects, and oil on wood, 65×29½×91″ (165×75×231 cm). Mr. and Mrs. Giulio Baruffaldi, Florence

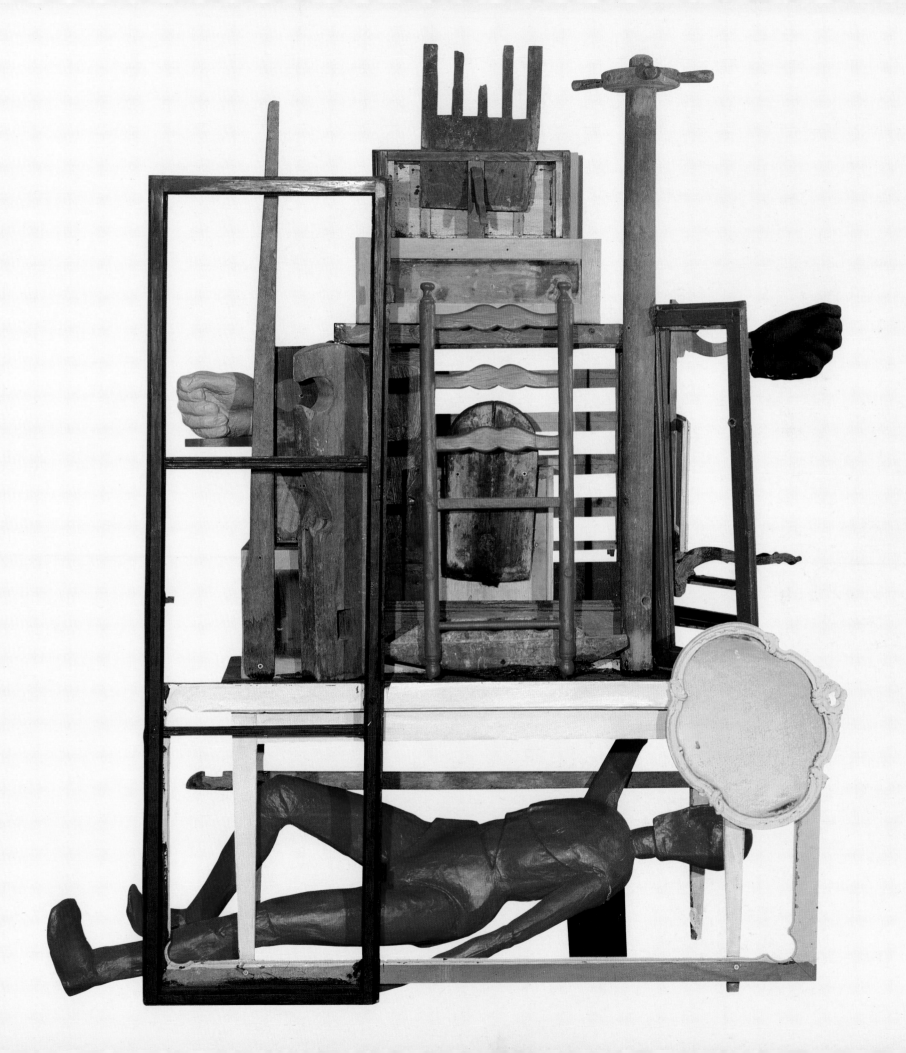

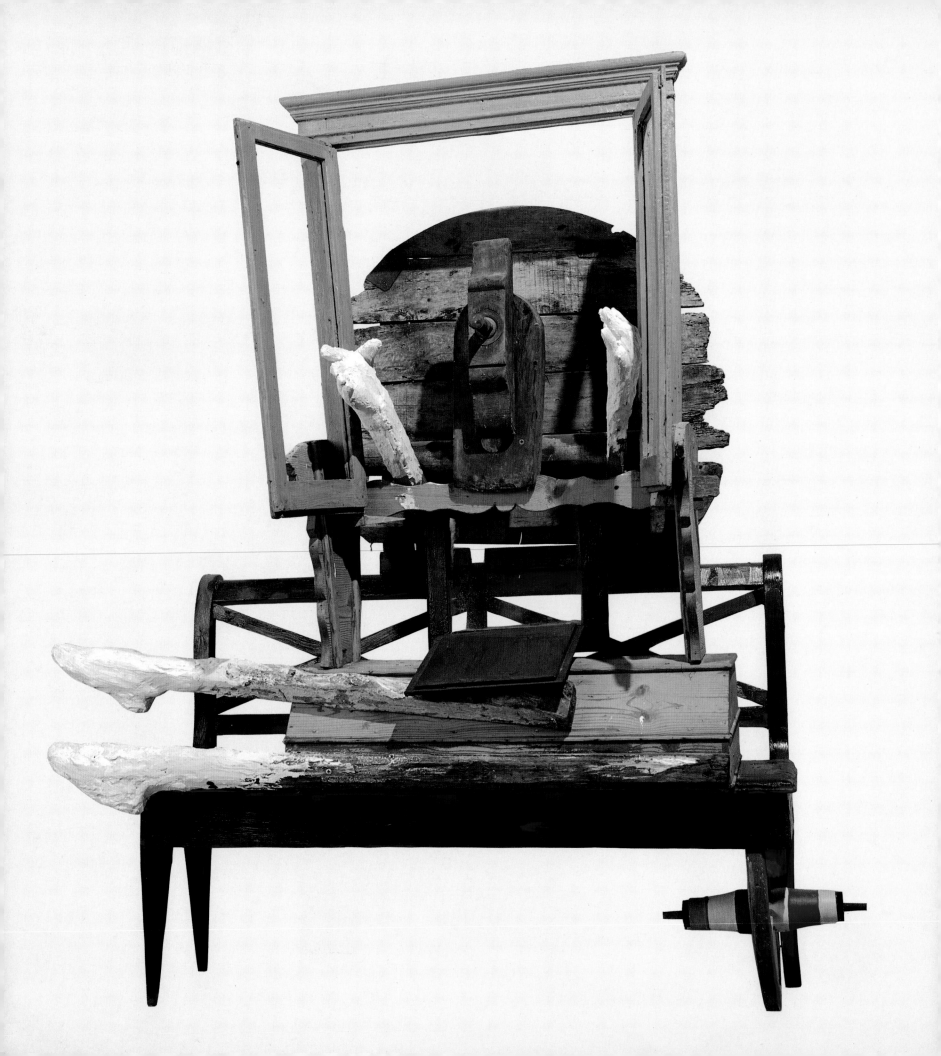

shrill creature. Its one open hand reminds us of the open hands of the *Questioning Children*.) The Standing Nudes are clearly devilish creatures from the underworld. The representation of the underworld, in fact, eventually becomes the explicit theme of Appel's sculptures for the next half decade.

The year 1988 was a very good one for Appel's sculpture. His monumental portrait studies of friends and acquaintances, all in some way connected to his art and art in general, and his Titan Series are major accomplishments. They bring together all his ideas in a startling new way. The faces of Marisa del Re, Stephane Janssen, Sam Hunter, Donald Kuspit, Harriet de Visser, and Eelko Wolf are broken into photographic fragments, which are overpainted in bright primary colors, and strongly accented with black and white strokes. The parts, somewhat more bulky and blocklike than the parts of the Standing Nudes, are held together by ropes. Some of the portraits are full-faced, others in profile. In each case, the face is spread as though it were a map, instantly converting physiology into physiognomy.

They are preceded by the *Study for a Portrait of Van Gogh*, 1987–88, with whom Appel clearly identifies. He has written:

From the mask of what unknown clown
do I derive the faces I paint?
Buried memories of real faces in life:
faces deformed by suffering, laughter, or labor
sometimes mad.
And then they become imaginary.[80]

But while Appel's Van Gogh looks quite mad and memorable, he hardly seems like a clown. Indeed, all of Appel's faces have serious expressions. Appel undoes this seriousness by playfully doubling, even tripling some of the features of the face. The third eye may be the mind's eye, but it also creates an effect of absurdity. The repetition, then, along with the fragmentation, has an unmasking effect. It seems to restore what Eigen calls the "original face"—the mad real self behind the sober social mask. Decomposing the face, Appel destroys its social composure, and suggests the intense inner life behind it. If the windmills are anticonstructions and deconstructions, then the Standing Nudes and portrait studies are anticompositions and decompositions. If the photograph with which Appel begins shows the person at his or her most socially composed and self-assured, then his decomposition of it shows how really wild and uncertain the person is on the inside. There is no doubt some black humor in the decomposition, as the fact that the figures are literally "in stitches" suggests. In general, Appel's faces seem tragically serious and comically

Opposite:
Looking Through the Open Window No. 1.
1991. Plaster, found objects, and oil on wood, 85 × 66⅞ × 32¼″ (216 × 170 × 82 cm)

Overleaf:
Looking Through the Open Window No. 2
[2 views]. 1992. Plaster, found objects, and oil on wood, 85 × 95 × 65″
(215.9 × 241.3 × 165.1 cm)

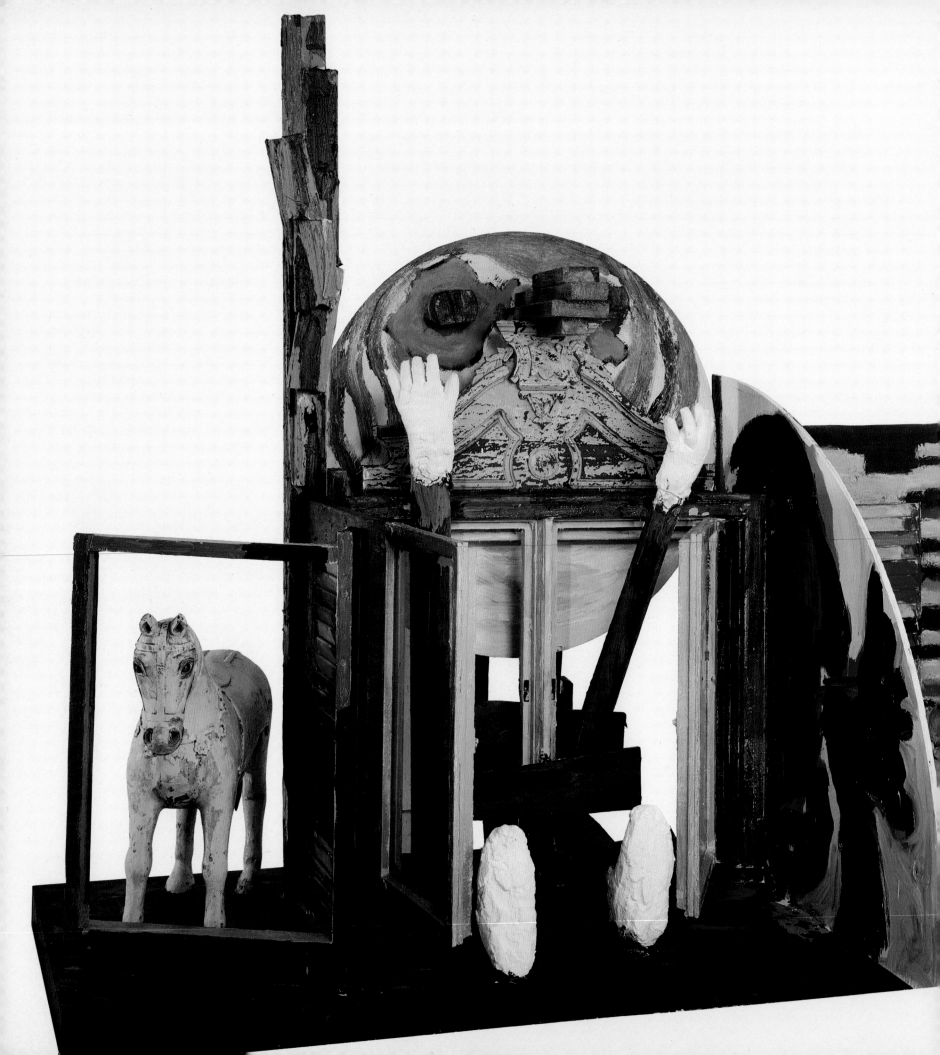

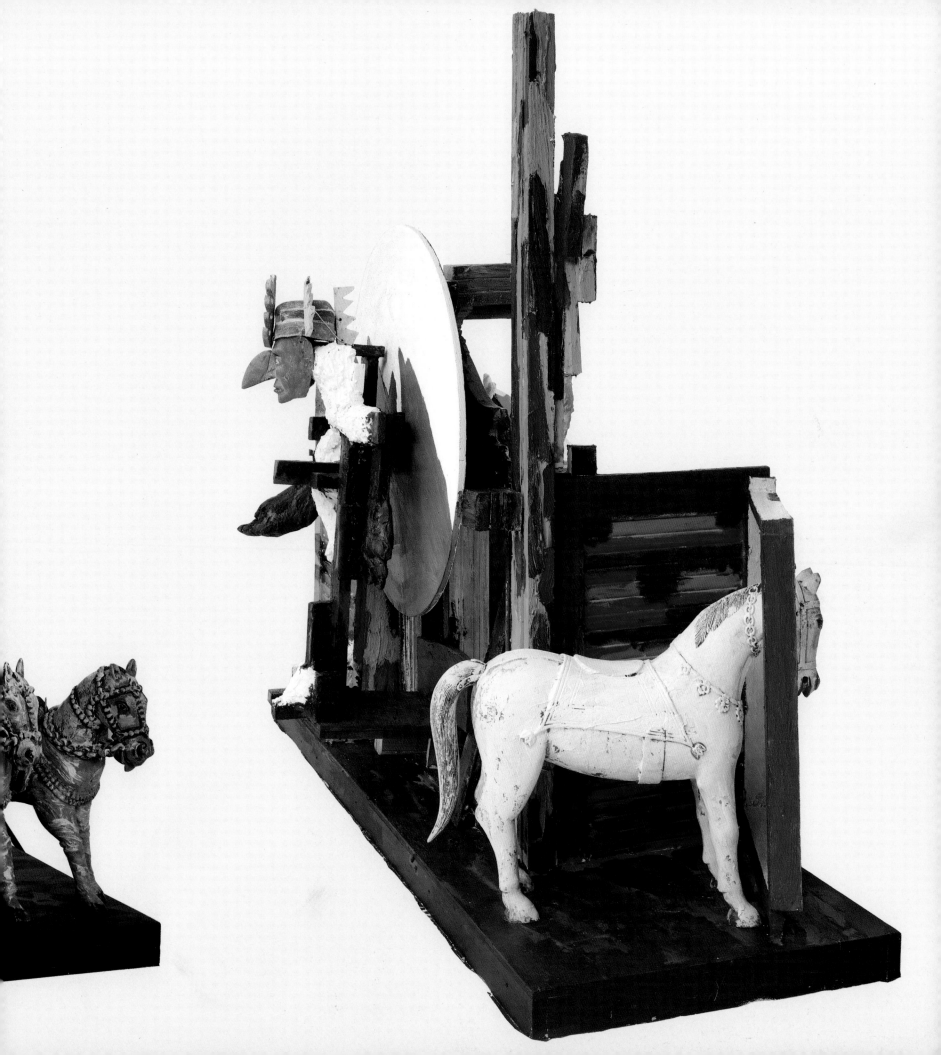

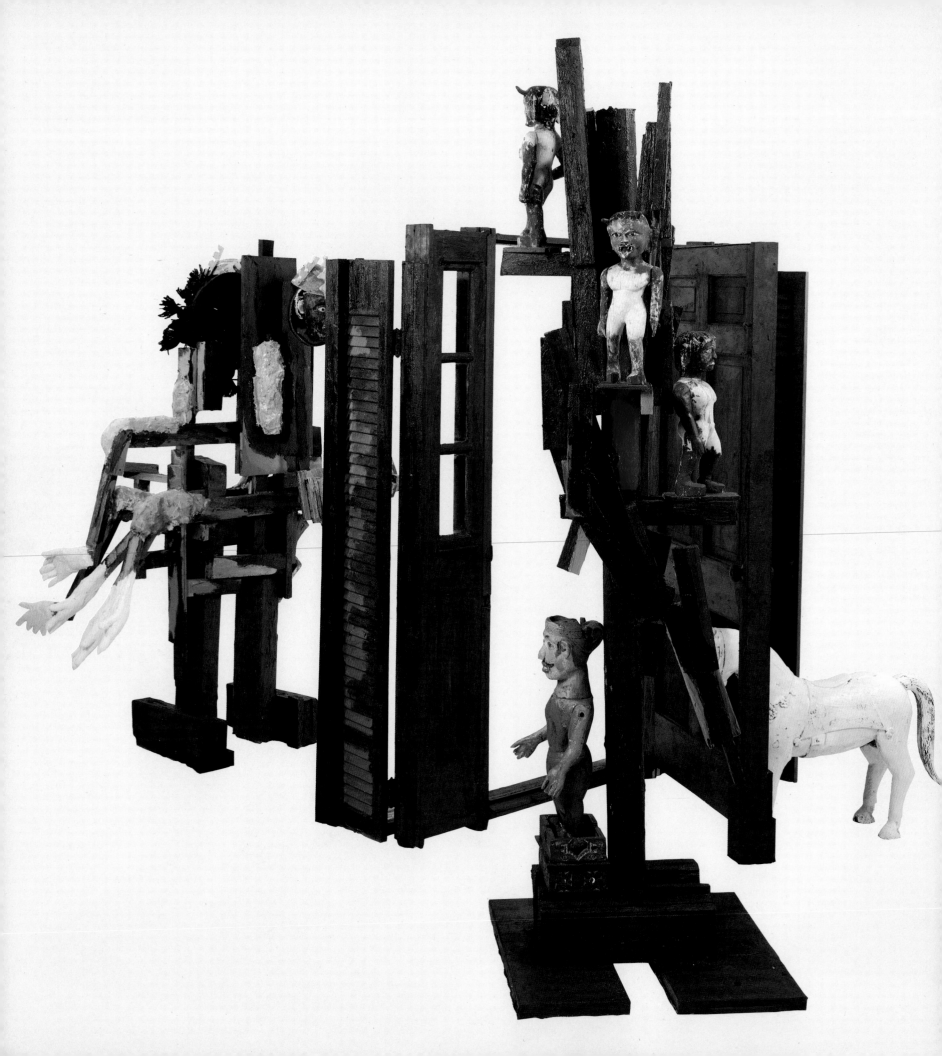

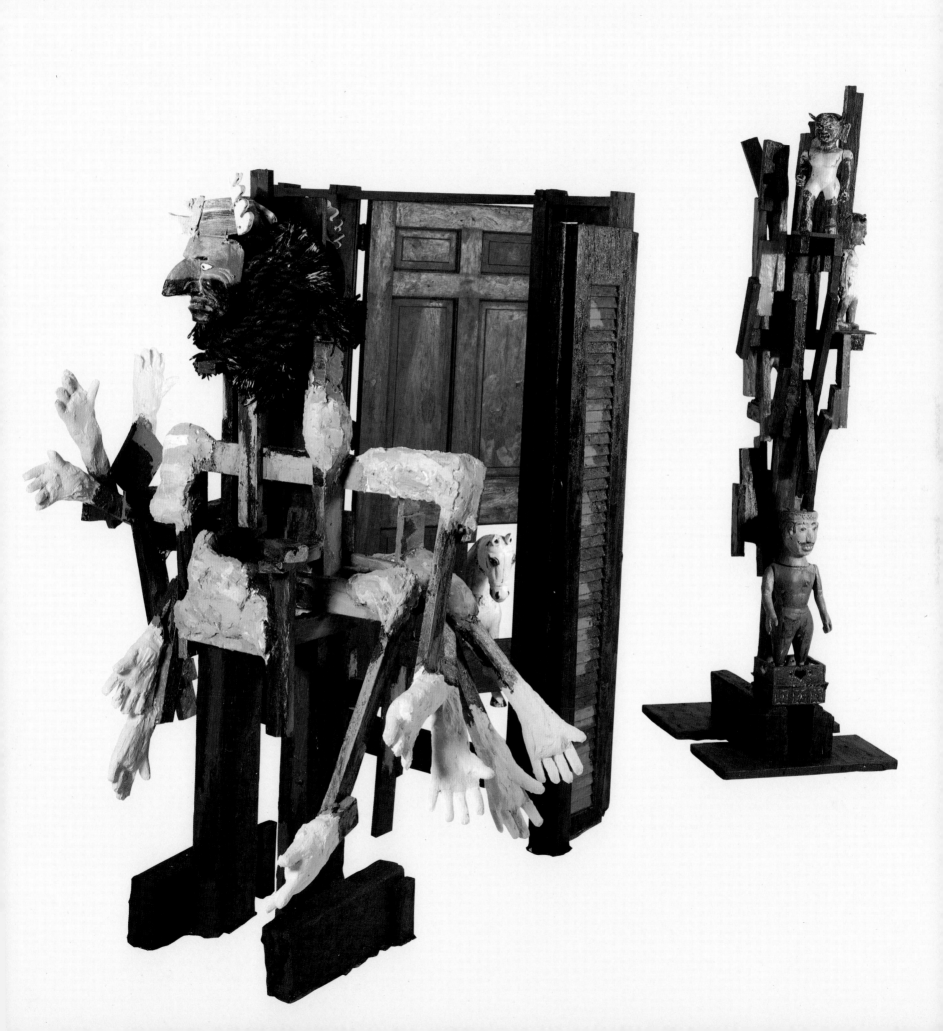

crazy at once. There is something both morbid and zany about them.

The disjunctive forces grow even stronger in the Titan Series, which uses such found objects as rope and mirror, and synthesizes easel painting, mural painting, sculpture, photography, and, like the portrait studies, have an architectural impact. These hybrid sculptures, in which all of Appel's resources are merged, are to my mind the first inkling of his ambition to create a *Gesamtkunstwerk* (total work of art) that would be a final, comprehensive statement of purpose. He successfully realizes this ambition in the grand, climactic sculptural fantasies of 1992, and to some extent of 1991. They are, as suggested in the title of a 1992 work, a philosophical, majestic *Theater of the World*. The works of both years have a remarkable material and conceptual range to them. They are truly kingly pronouncements, to allude to the *King's Altar*, 1991, as well as the earlier *King of the Titans*. The equally monumental, composite sculptures of 1989, spreading in space in a way that anticipates the later works, objectify the expansion into space that began earlier with the chance, "subjective" gestures of the dangling ropes in the portrait studies and Titan Series. Appel's big sculptures have always needed space, and now he literally incorporates it into them. They spread out with the inevitability of giants that cannot help take up a great deal of room.

It is as if a work needs space to live and thrive, even if it deals with death. Thus, *Monument for Walt Whitman; A Monument Called One White Flower for Pasolini; Monument for García Lorca; Farewell My Backyard with the White Smell of Daisies; Walking Through the Shadow;* and *Three Nudes,* all 1989, incorporate a variety of elements in a grand statement of gloom and doom, nostalgic for life. Even the erotic nude has become a ghost of itself. Black and white dominate more than ever, indeed, in some works completely—as in the case of the shadow side of the Standing Nudes— which has never been the case in the usually colorful Appel. But it is still a child's view of death: Death is a poetic force, casting a pall on life, but monumentalizing rather than diminishing it. Thus, the dead poets of life Appel celebrates. Finding poetry even in death, he brings it to life. Indeed, he treats death as a playmate.

It is in the Titan Series that the struggle between black and white on the one hand and the colors of life on the other becomes explicit. The two are brought together on the same surface, while in the Standing Nudes, they were on the opposite sides of the fence of the figure, so to speak. It is as though, in the Titan Series, Appel is taking pleasure in every part of the body, enjoying its exciting appearance—made all the more sensational by the chaotic way the parts are jumbled together, which creates an overall effect of incoherence perhaps greater than any Appel has previously achieved—while at the same time treating each part as though it were the

Preceding spread:
The Open Door [2 views]. 1992. Plaster, found objects, and oil on wood, 103 × 154 × 95″ (261.6 × 391.2 × 241.3 cm)

Opposite:
Forest in Black. 1992. Plaster, found objects, and oil on wood, 102 × 70 × 45″ (261.6 × 391.2 × 241.3 cm)

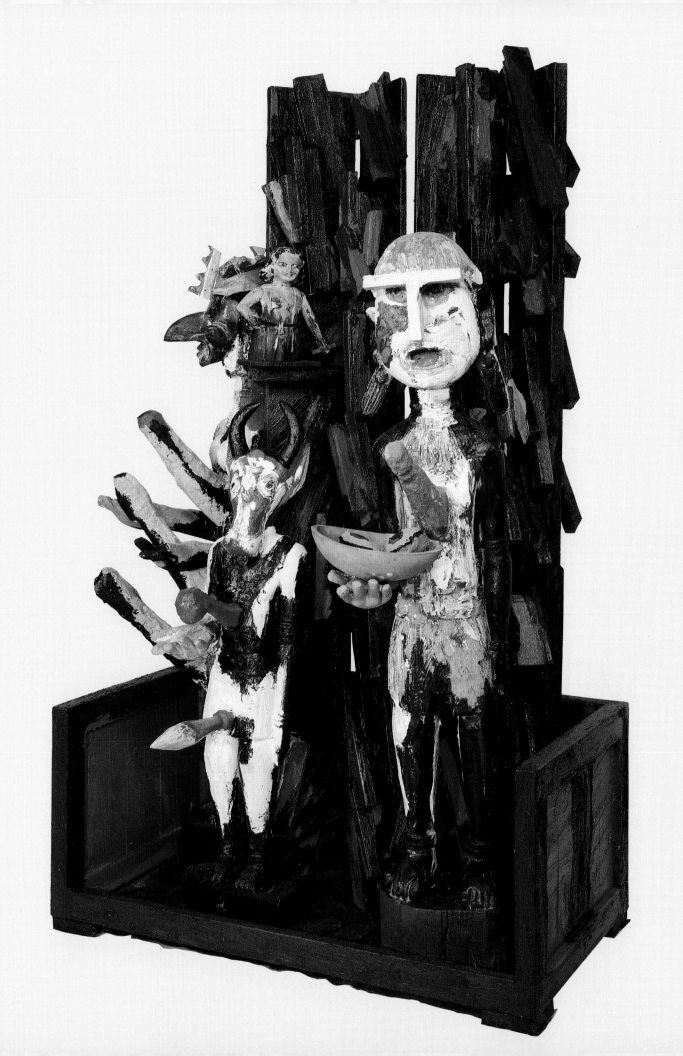

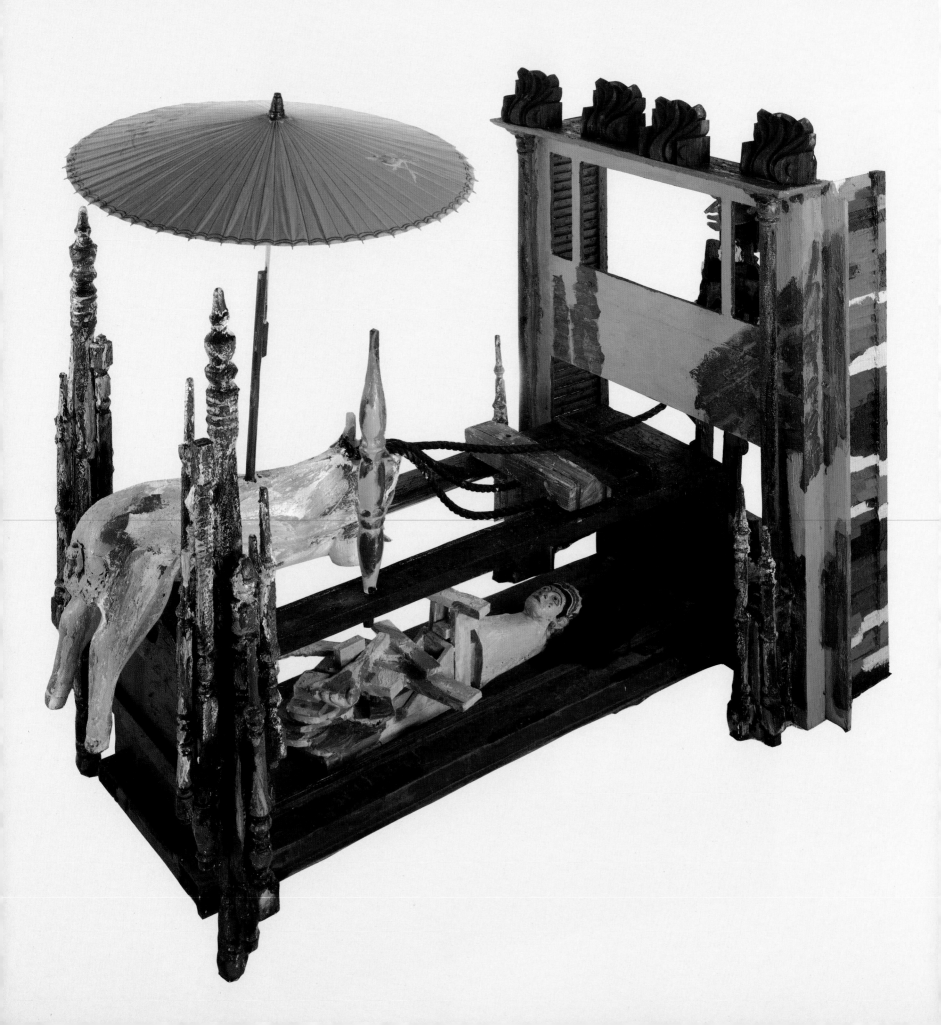

flawed remnant of a bodily glory that no longer exists, and thus is to be discarded. The body has become a Humpty Dumpty that can no longer be put together to create any semblance of a harmonious whole. It is a ruin beyond repair, with still intriguing parts, but with no larger point. As such, it seems to be more regressive—psychotically fluid—than ever. The titan images are exceptionally brash, risky, angry works, often with unusually stark contrasts, such as the black and red in Number 6 of the series. The use of the photograph is an ingenious way of giving actuality to the turbulence of the body and paint. I regard the titan works as Abstract Expressionist renderings of Death and the Maiden, more particularly, Death and Youth, a familiar theme in Germanic art. Their Sturm-und-Drang character has an ironic edge, for it bespeaks the death as well as life instinct. The young bodies are caught in a tide of death from which they cannot escape. It is at once an undertow that sucks them down and a wave that swamps them. Indeed, the sense of vertigo in the Titan Series, and their hurricane fury, is extraordinary. The figures seem to be drowning in a whirlpool, or whipped by a storm. Appel is at once angry at and admiring of a youth he no longer has. These are truly mad, enraged yet joyous sculptures.

Appel's imagination seems completely liberated by the thought of death. Thus, he literally expands his familiar vocabulary in a fanciful way. For example, the small hands of the *Questioning Children* become the giant hands of the *King of the Titans*. An even larger hand—the child's hand, magnified in size because of its importance as the hand with which the poet writes and the painter paints—appears in the *Monument to Walt Whitman* and the *Monument to García Lorca*. Colorful flowers become white ghosts, acquiring new symbolic poignancy, or charred corpses, equally Hadean. Everything that Appel used in fifty years of art making becomes a symbol of a life that once was, which gives it a new kind of life. Appel's sculptures become more intimate than ever, but also more subtly grand. For all the new monumentality, they become more playful than ever. Appel now begins to work with found toys from faraway, exotic places, such as India and Indonesia, as in *Looking Through the Open Window No. 2* and *The Open Door*, both 1992. He also starts to make new toy figures, more abstract than ever, as in *Sitting Figure in Window*, 1991, and an untitled group of skeletal stick figures of the same year. His sculpture becomes thoroughly theatrical, indeed, a new theater of the absurd.[81]

It also becomes explicitly dreamlike. Each work is like a remembered dream, whose details Appel records as carefully as possible, as though nothing of such an omen and riddle must be forgotten. The same elements, arranged differently, appear again and again, with hallucinatory regularity. Appel seems to be haunted by a recurrent vision that changes form, but whose enigmatic substance remains constant.

Opposite:
Slaughtered Pig with Umbrella. 1992.
Plaster, found objects, rope, and oil on wood, 90 × 134 × 64″
(228.6 × 340.4 × 162.6 cm)

Overleaf:
Theater of the World. 1992. Plaster, found objects, mirror, and oil on wood,
108 × 152 × 95″ (274.3 × 386.1 × 241.3 cm)

This is a trick of the theater of night—the magical theater of the underworld. Indeed, Appel still offers us a puppet show, but now it is also a magic show. The child's vision of life has become an impossible illusion that speaks the truth of death. For where Appel's figures, however monstrous, were once brightly colored day creatures, they are now sinister night creatures, not without flashes of color, but generally camouflaged with dark, to blend in to the dreamworld of death. Indeed, Appel's sculpture is now fueled by darkness, and a dreamworld from which there is no escape into life. Daytime has become the site of the recapitulative, backward look, as his 1990 Circus Series suggests, not of the aggressive avant-garde advance, which now occurs during the night. Indeed, his new visionary sculptures are like an attack that takes place under the cover of darkness, making it a complete surprise and victory.

Appel, then, anticipates death by dreaming of it. He narrates his vision of death as a voyage to the underworld, full of strange sights. Death is a primordial presence for him, but it remains peculiarly festive, a kind of sideshow—that is, a funny situation. Appel treats death like an old friend he has not seen for a long time, and so is familiar and strange at once, which makes his work of more imaginative interest than usual. Faced with death, Appel becomes more creative than ever. His uncanny sculptural poems, celebrating death as a sacred mystery, show that it can catalyze the imagination like nothing else. For, to allude to Baudelaire, for whom imagination arranged the "raw materials" of life given to us by fate "in accordance with rules whose origins [are] in the furthest depths of the soul,"[82] death is the most raw material and involuntary aspect of life, and thus cannot help but be stimulating to the imagination. The most stubborn facts of life—such as death—are the stuff of art's wildest dreams.

The imagination becomes a mirror in which the soul sees its own death as if it were an illusion, which is the only way it can tolerate death. The imagination cannot help but be obsessed by death, for its task is to help the soul come to terms with what it is impossible to come to terms with because it is inevitable. The imagination gives the soul the illusion that it has a sporting chance at survival, even when there is none. The imagination tries to understand and formulate the rules by which death plays, even though it plays by none. Appel's eschatological sculptures not only show that we cannot repress our awareness of death however much we try to do so, but also the irony of that awareness, that is, the self-deceptive way we resign ourselves to death. For to imagine something is to desire it, so that the fantasy of resignation to death shows how deeply in love with it we unconsciously are. Appel also shows us how, in a world that does not take religion seriously and does not inwardly believe in

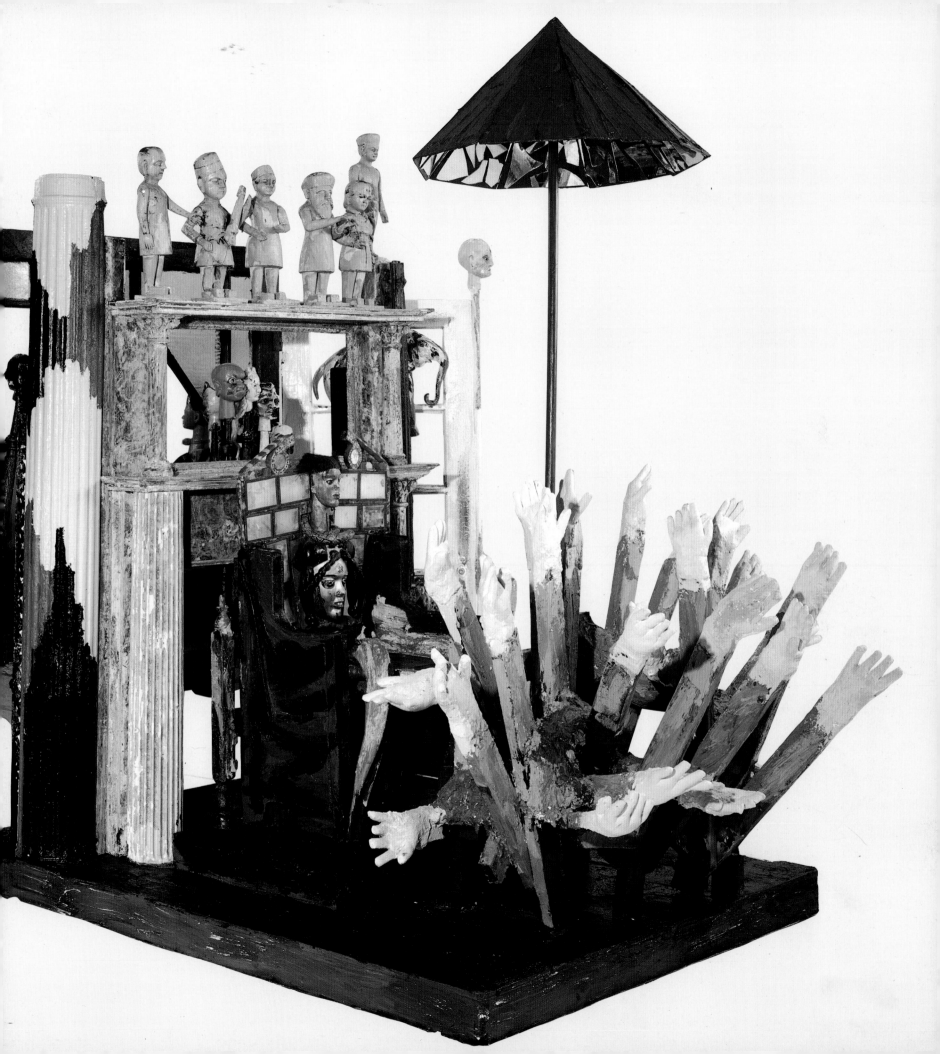

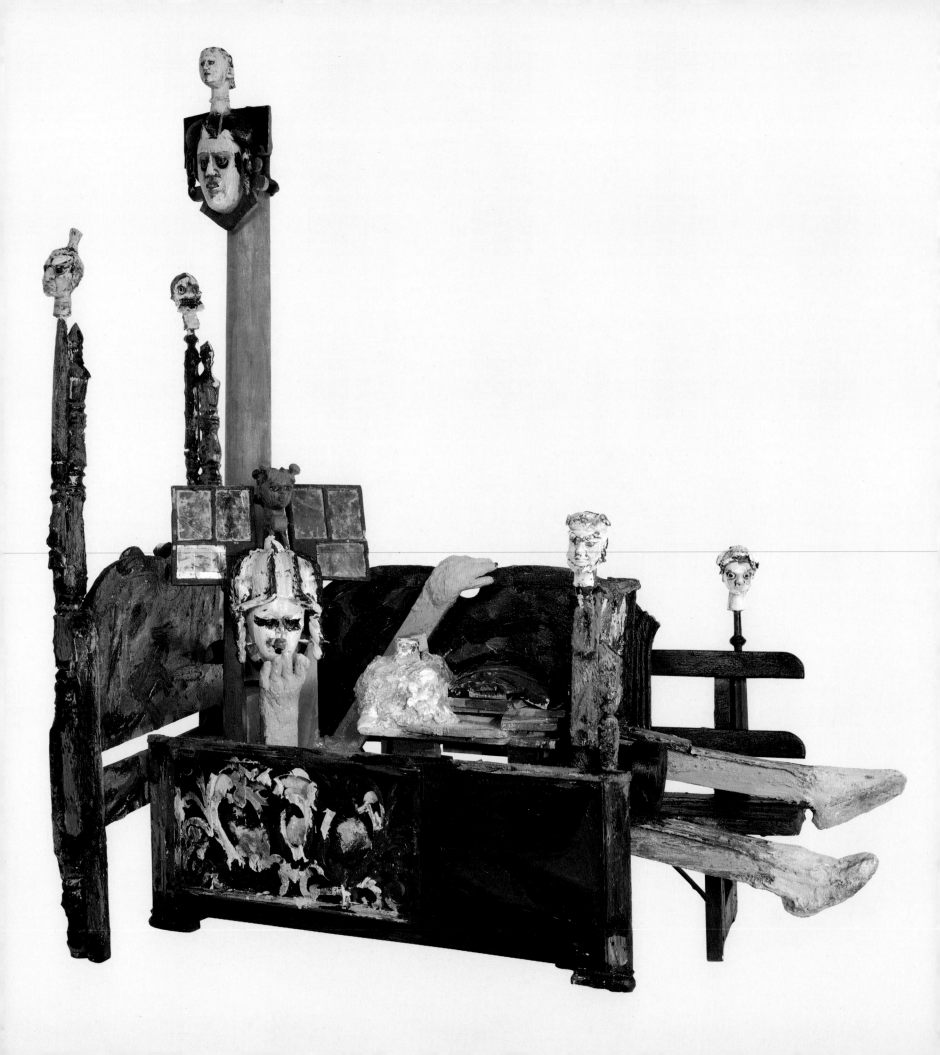

immortality, resurrection, and transcendence, death can be bravely faced: with extraordinary good humor.

It has been said that no one can imagine his own death. But our discontent and memories help us imagine our death—that is, realize that, like everyone else, we will sooner or later belong to the past, be part of social memory (the easiest, emotionally safest way to face death)—for the imagination thrives on actual experiences of frustration and loss, as well as on the feelings of unhappiness and helplessness that derive from them. (More than any of his other sculptures, the material with which Appel makes his visionary sculptures has the patina of the past. It is the material of collective memory, personalized by being made part of art.) Unconsciously, death symbolizes these experiences and feelings, thus allowing us to contemplate them with some detachment, as though they were somebody else's life. Thus, to imagine our death is to mourn for ourselves in disbelief that we will die. But it is also to face death and acknowledge its uncompromising negativity. Appel carries the imagination of death one unusual step further, in that for him recognition of its inevitability creates new respect for and defiant joy in life—a new surge of vitality—rather then depression. Life seems funnier than ever, as the sculptures of his "divine comedy" suggest.

Thus, they are apocalyptic—destruction and resurrection are inseparable in them. I think this has always been implicit in Appel's art. It is the expression of Appel's alienation from modern society, a residue of his youthful experience of the inhumanity and deadliness of World War II. His decisive turn to primitive art, whether it be children's art or the art of so-called primitive societies, is in part an expression and consequence of this alienation. Like many modern artists, Appel is in the paradoxical, unmodern position of making a kind of primitive or prehistoric art in a modern, historically self-conscious society with a name for everything. He keeps alive a certain nameless, eternal spirit of life that it lacks.

More than most of these artists, Appel seems to identify with the primitive, "childlike" artisans who made "original," traditional primitive art. They may be passing from the stage of the world, and their art and spirituality may survive in the corrupt, vestigal form of tourist toys. But even these objects symbolize a quite different, more elemental relation to life and fundamental humanity than the insidiously barbaric, far from innocent, kitschy toys, with their degraded spirituality, manufactured for consumption by the children of modern society. Those banal fabrications exist to teach children, as fast as possible, adult ways of functioning, rather than to emotionally intoxicate them and intensify their sense of the newness and uniqueness—"originality"—of things, to use Baudelaire's words once again.

Woman in Bath. 1992. Plaster, found objects, and oil on wood, 102 × 95 × 46″ (259.1 × 241.3 × 116.8 cm)

Appel's identification with the primitive spirit and mournful recognition of its passing allows him to face his own eventual departure from the world's stage, and to hope that his humanity and spirit will survive through his childlike, primitive art, as theirs has survived through their art. In general, Appel takes the flotsam of found objects adrift in modern society and primitivizes and spiritualizes them, as it were, by Expressionistically painting them and incorporating them in a consummate vision of life. This makes them more deeply human and personal than they ever were. Thus, the ordinary desk chair in the memorial *Monument for the Indian Chief Seattle*, 1990, loses its functionality in becoming part of the work. And, through the addition of a bird's head, a tail of rope, and flowers on the seat, it becomes the empty throne and archaic sign of the once great primitive king. The triangular base on which the chair stands suggests the sacred character of the artistic space as a whole. The sculpture is clearly a kind of ritual in which the chair plays the central role: It evokes the absent ruler. The evocation is successful. The ruler makes his elusive presence felt on the black wall of death behind the chair. He has returned, however temporarily, from the underworld.

Thus, a modern object is used to evoke a primitive outlook—a typical Appel ploy. Appel does the same thing to primitive kitsch—the mass-produced folk art made for tourists, such as the dolls of Indonesia and India—with the same result. He does not so much appropriate outcast, spiritless found objects, from whatever source, as add artistic life to them, thereby completely transforming their meaning. They are resurrected to a new life in a new world, as it were. Appel does not juggle them for conceptual effect, but gives them new bodies. In general, the sadistic inhumanity and brutal destructiveness of modern society—testimony to its spiritlessness—has always been the morbid ground on which Appel's "neoprimitive" art has stood. It undoubtedly has some of the same traumatizing violence as modern society, but this destructiveness is creatively sublated, suggesting that evil can magically be made good, which is the premise and myth of reparation implicit in art as such.

Appel's awareness of the disintegrative effect of death explains the transient, thrown-together look of his new theatrical assemblages, a look that is not new in Appel's art, but seems more obvious than ever. It is as though the transience of existence, bringing with it a strong sense of the fragility of construction of the house of life and body, is clearer than ever to him, which of course is normal as awareness of death and its closeness intensifies. But the effect of transient construction is also part of the theatrical vitality of the new works. It suggests that they are flexible stage sets. Everything in them has its role in the sculptural drama, and is freely moved about the set by Appel, the kingly, swashbuckling director. The sense that he

114

Opposite:
Masque. 1992. Acrylic and oil on wood, 25⅞ × 13⅜ × 15″ (65.7 × 34 × 38 cm). Neil R. Krone, Woodland Hills, California

Overleaf, left and right:
Still Life. 1992. Papier-mâché, found objects, acrylic, and oil on wood, 71⅝ × 72½ × 43¼″ (182 × 184 × 110 cm)

The Wheelbarrow. 1992. Papier-mâché, found objects, acrylic, and oil on wood, 73¼ × 62¼ × 81⅞″ (186 × 158 × 208 cm)

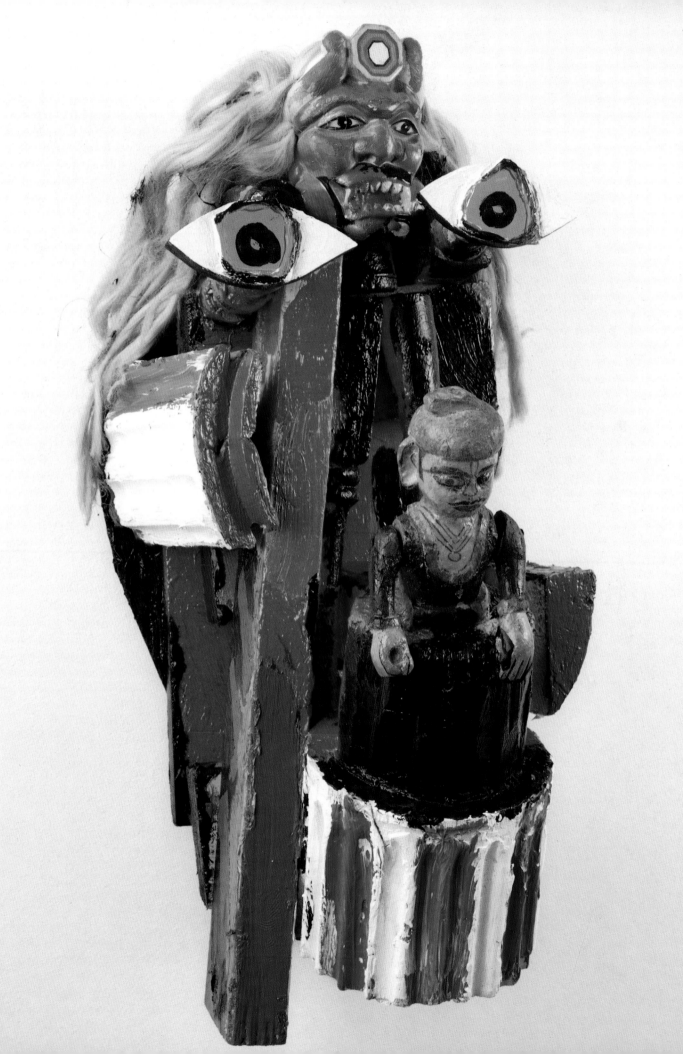

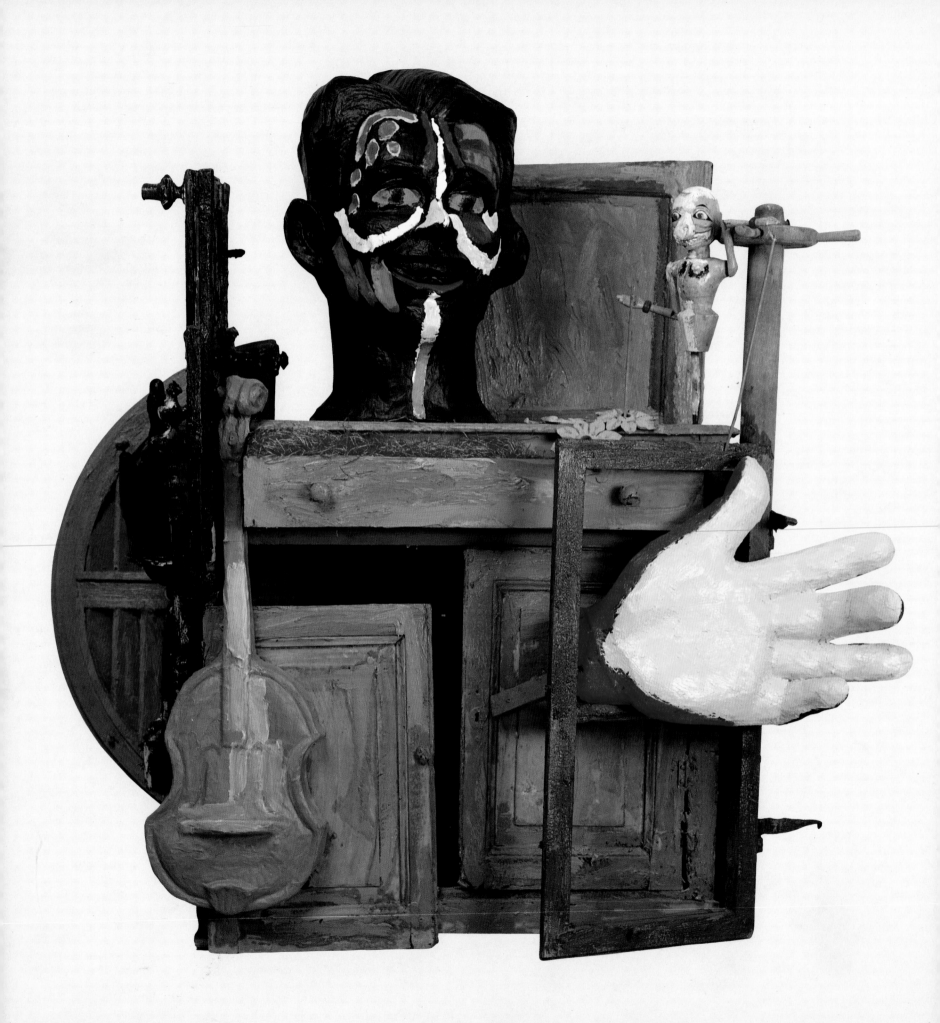

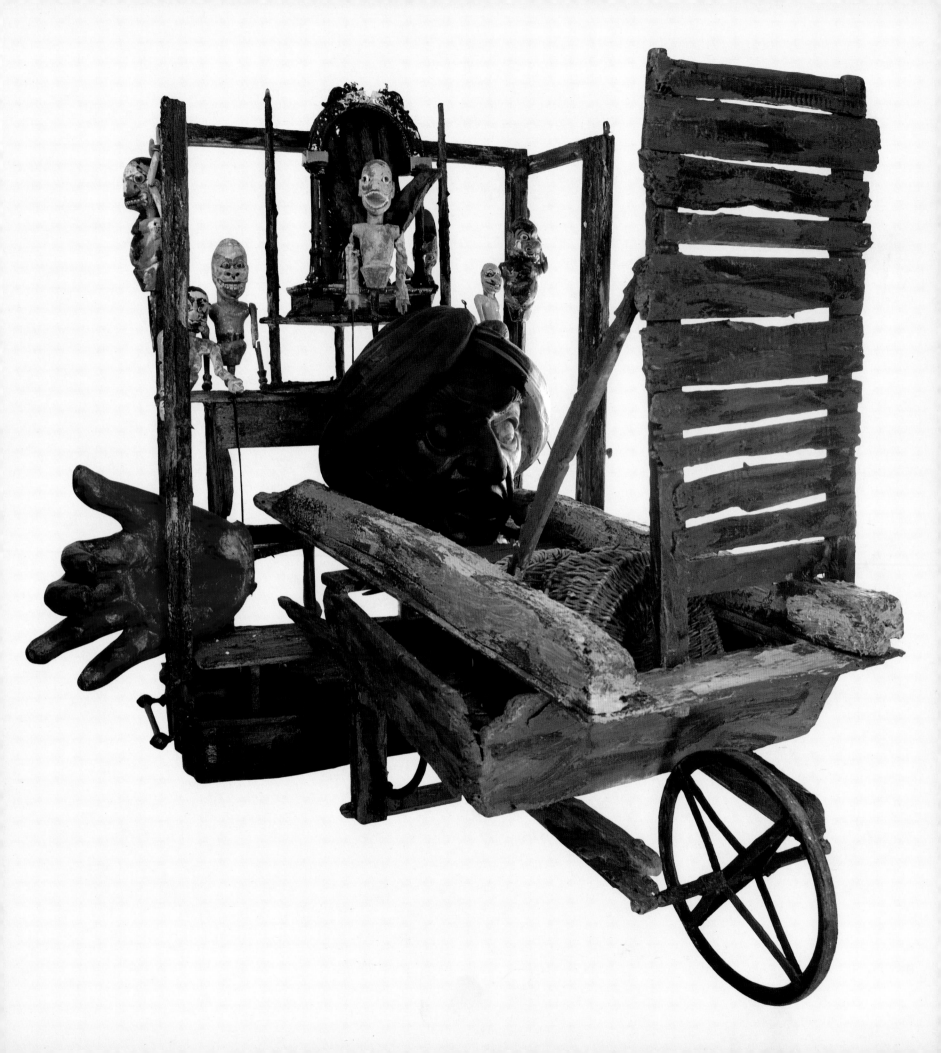

speculatively arranges and rearranges the stage, never giving it final form—an effect the sculptures share with many of the titan pieces—conveys his remarkable sense of vitality and freedom when faced by death. As always, Appel shows how spontaneous and full of life it is possible to be in the face of any threat to life. He is determined not to surrender to death before he has to, however much consciousness of it presses in on him. He simply incorporates that consciousness into the life of his art. Appel seems to be saying: The play of life will continue on its own when I am not there to be part of it, and that continuation, like the continuity of spirit between my neoprimitive and original primitive art, is worth celebrating.

VIII

Appel's theatrical sculptural fantasies of the early nineties are based on folk legends and primitive myths that have to do with the fundamentals of life. As with 1988, 1991 and 1992 were vintage years for Appel's sculpture. Almost every work produced then was a "masterpiece," in that it is an uncanny *Gesamtkunstwerk,* bringing together painting, sculpture, and architecture in an unclassifiable way. For example, *Slaughtered Pig with Umbrella,* 1992, involves two Indonesian folk stories. (Appel lived in Indonesia, a former Dutch colony, for some time, clearly identifying with the people there.) One asserts that a man becomes a pig at night if he was bad during the day. If the pig is killed, it will change back into a human being. The other states that if you call the woman who lives in the Java Sea out of it, she will come in the form of a skyscraper and drag you into the sea with her. I take them both to be bedtime stories, intended to frighten the hearer (spectator) with their moral. The former warns man not to become piggish or he will be punished by literally becoming a pig and being sacrificed to the gods. The latter—not unrelated, for it deals with one way of being a pig—warns man not to love woman too much, that is, with a love as infinite as the sea. For otherwise she—or rather his desire—will loom up larger than him and drag him to his doom. The message is that one should not be so dominated by love as to sacrifice life to it. Appel is no doubt telling himself these truths in making the sculpture—taking them to heart as basic lessons of life. Indeed, Appel's sculpture comes from the heart as well as the mind. Its heartfeltness in fact is part of what makes it unique in contemporary sculpture.

What is especially striking about Appel's sculpture, apart from its magical construction, which condenses and fuses the narratives as though in a dream, is the way he uses it as a springboard for his own "message." The man—a self-symbol to my mind—is no longer the involuntary victim of the goddess of the sea who has

118

Opposite:
Pandora's Box. 1992. Plaster, papier-mâché, found objects, acrylic, and oil on wood, 86¼ × 68½ × 59" (219 × 174 × 150 cm)

Overleaf:
The Tricycle. 1992. Iron, papier-mâché, found objects, acrylic, and wood, 76¾ × 144½ × 44⅞" (195 × 367 × 114 cm)

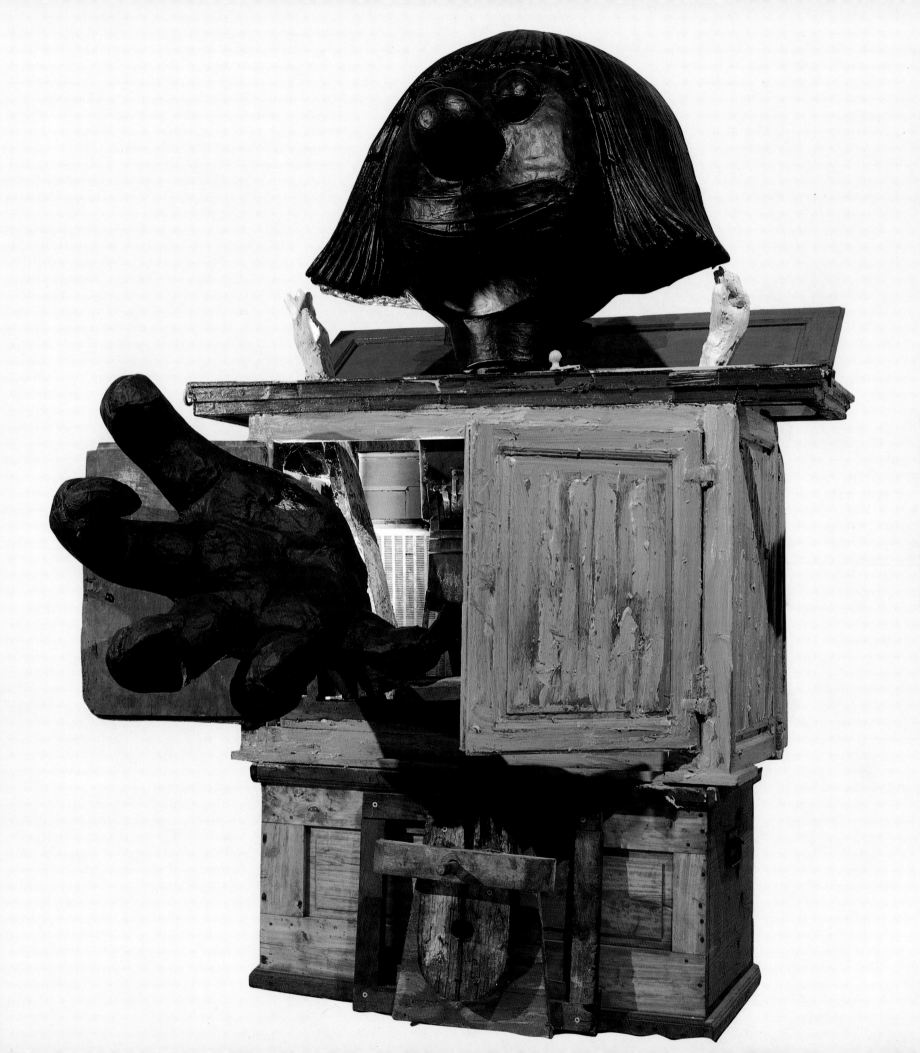

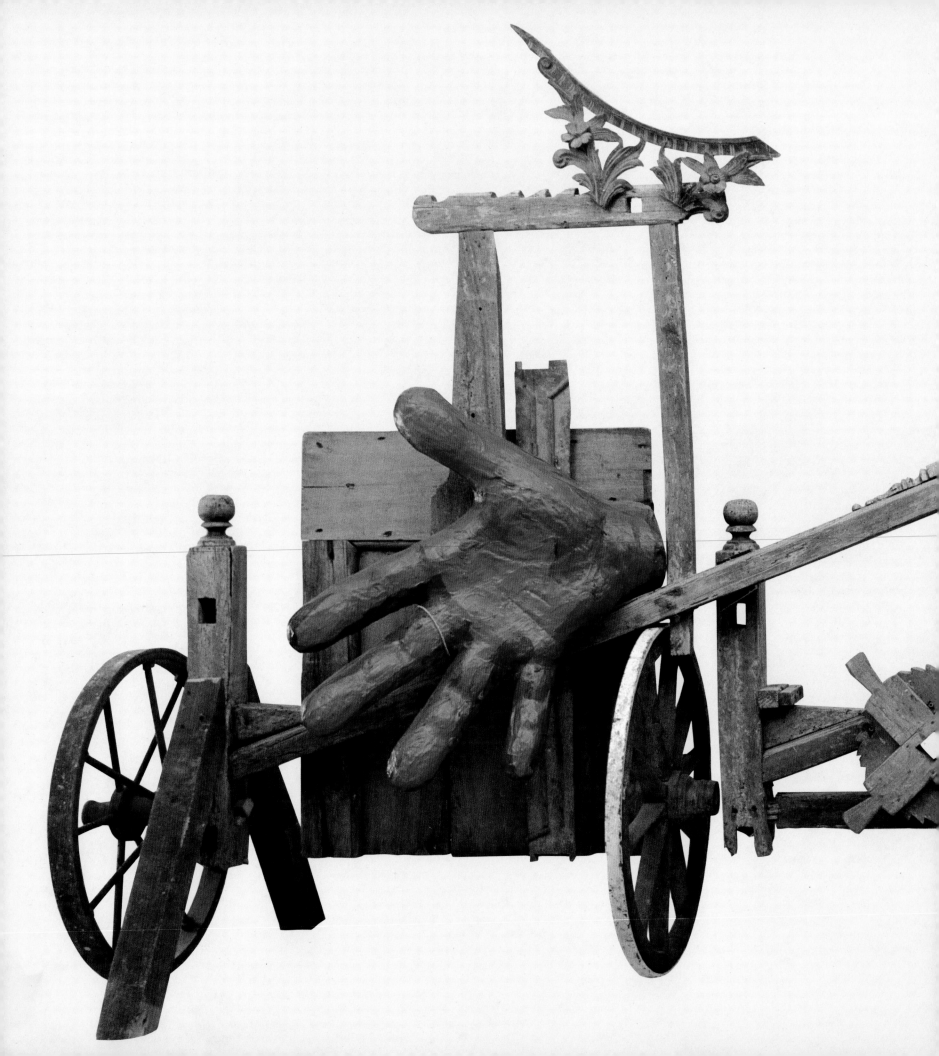

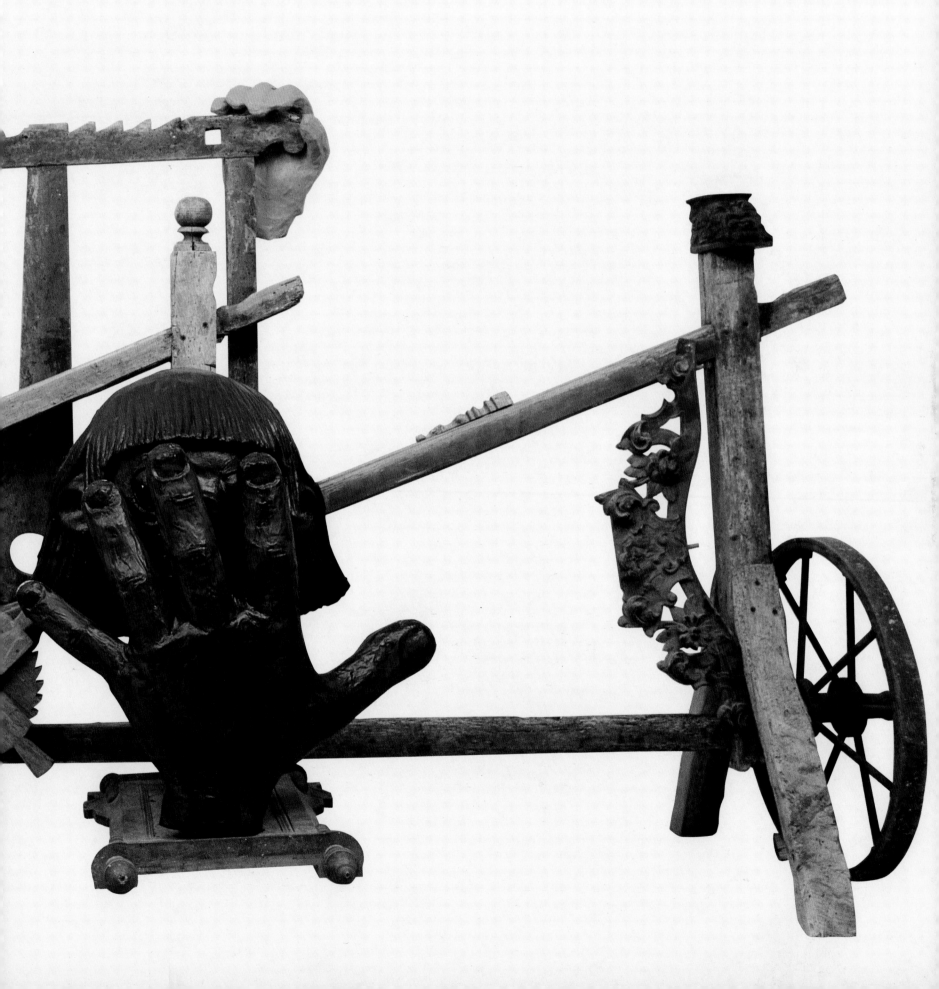

come to drag him to his death, nor is he the bad pig who has been slaughtered, as its headlessness indicates. Rather, he is completely in command of the situation—and the sculpture is a highly emotional situation—and voluntarily strides through the door toward, as Appel said in conversation, an unknown place in an unknown world. Clearly, Appel is thinking about the future fate of his art, and asserting that his ego is strong enough to survive any life situation. In the fantasy of the expressive deconstruction—the expressively elaborated decomposition, which looks like the garish, weird altar of a primitive animistic sect—Appel has turned the tables on fate, and on his sense of guilt at surviving when so many others have died and will die. He miraculously walks away from the whole mess of life toward a new destiny as an immortal—a god. He has escaped from death, symbolized by both the woman and the pig. The former represents the seductiveness of death, that is, the reversal that turns its painful inevitability into willed pleasure; and the latter, the fact that one's art—in effect one's spiritual substance—is cannibalized by society after one's death. Nonetheless, to make art is to outsmart death—ironically, to be remembered by a society one doesn't like, which is presumably better than being totally forgotten.

Slaughtered Pig with Umbrella has an incredible complexity. Not only is it a double narrative, but every part of it has a double, often contradictory function. The horizontal structure in which the woman lies is at once a coffin and bed, suggesting Appel's ambivalence toward her. The bedposts are phallic, but charred and gray, with the conspicuous exception of one bright, yellow-and-red post, indicating that there is still life in the old bone. Indeed, every part of the structure is a dead bone or relic of life reassembled into a ghost house of life, ironically—because inadequately— protected by the delicate, futilely poetic umbrella of vital green nature. All the sculptures of the nineties look like skeletons or shells of houses—bombed-out ruins, no doubt echoes of those Appel saw during World War II. Their wrecked, composite character makes them peculiarly postmodern, for all their Expressionist power and modern vitality, evident in their unstability and disunity. Thus, they bespeak fear of decadence and the wish for rejuvenation simultaneously. In general, they are unique examples of that rare thing in contemporary art: works of art that bespeak human universals.

The sculptural poems of the nineties are extraordinarily multileveled in meaning and style. There is no space here to examine every detail of their import and form, but their generally masklike character should be noted, to allude to *Masque*, 1992. Appel's sculptures are masks in every sense of the term: They are masquerades, that is, carnivals in which everyone wears a mask to hide his social identity but also to articulate a deeper, more essential self than the one who appears in everyday social

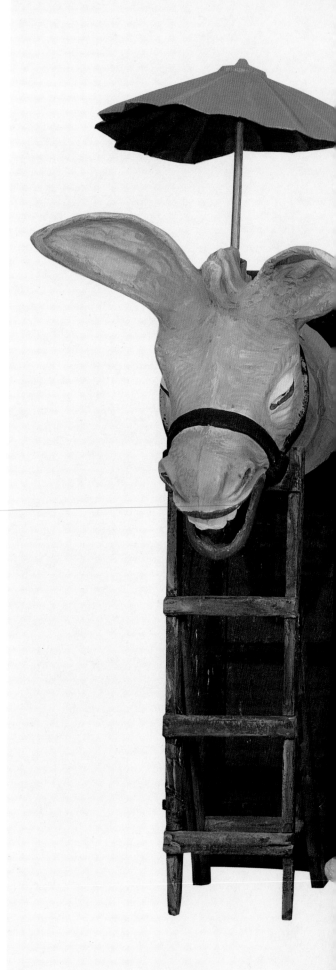

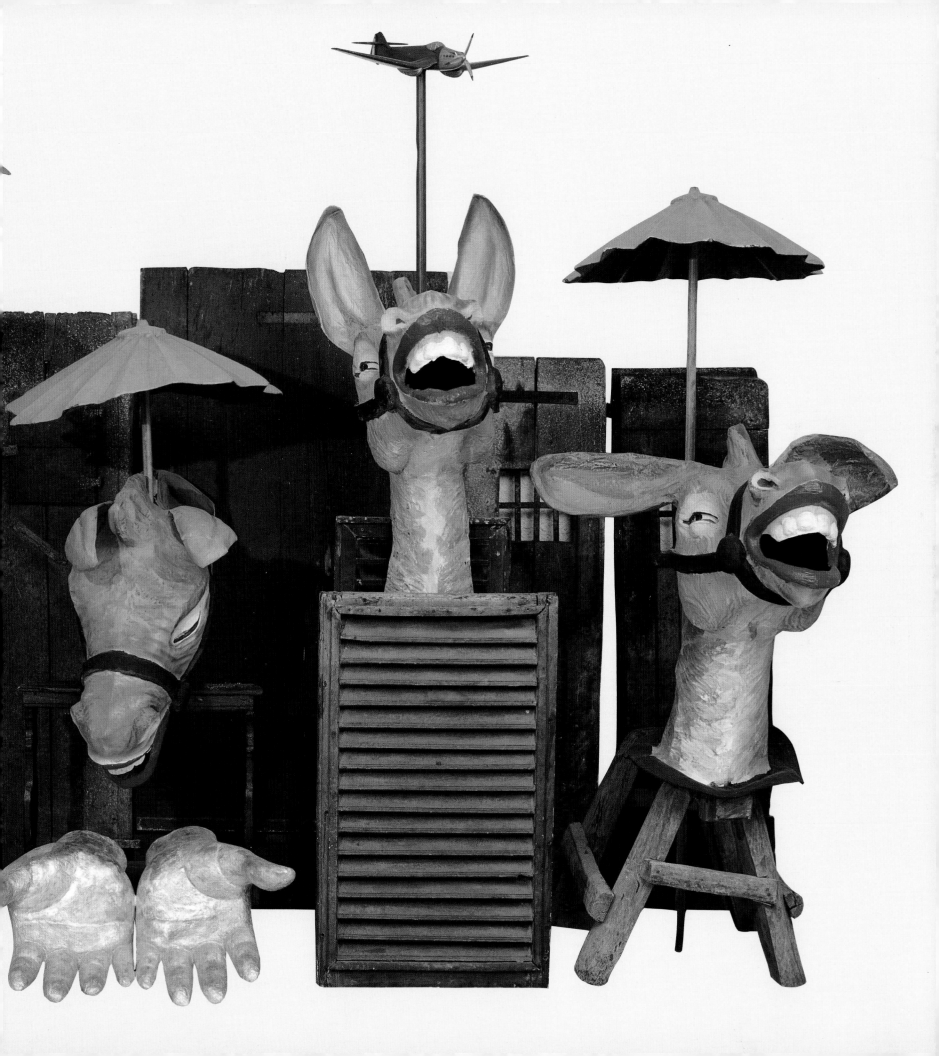

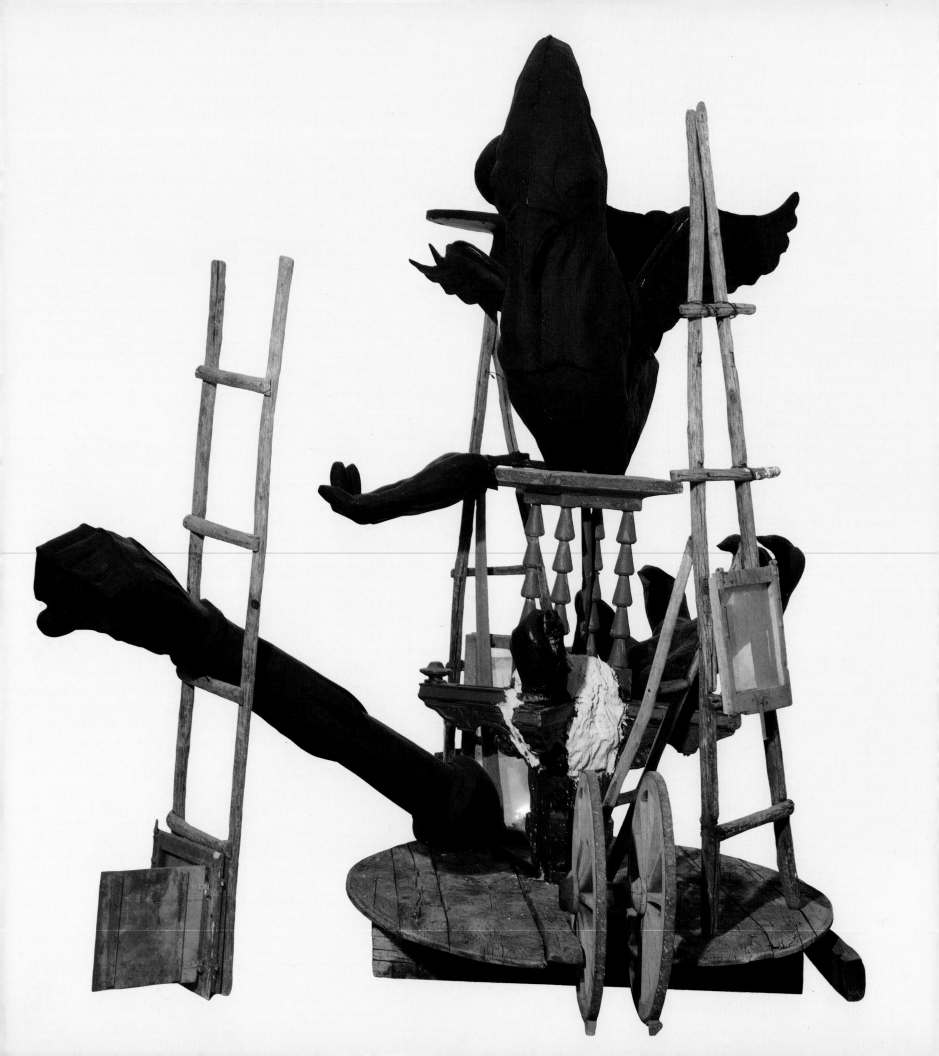

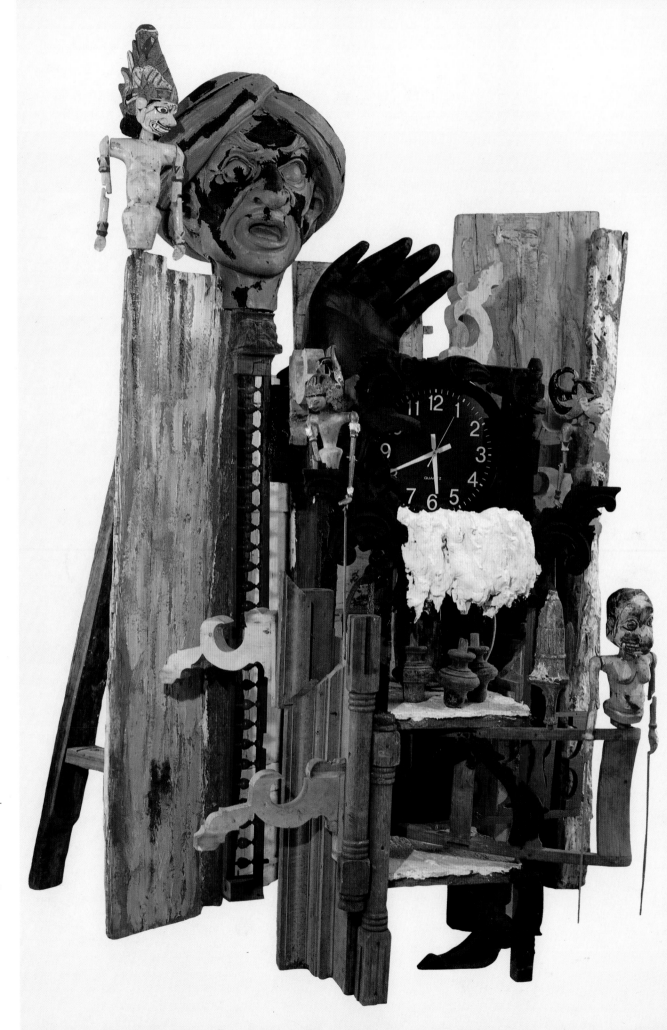

Preceding spread:
Singing Donkeys. 1992. Aluminum, papier-mâché, found objects, acrylic, and wood, 112⅝ × 142½ × 74″ (286 × 362 × 188 cm)

Opposite:
The Fountain. 1992. Plaster, papier-mâché, found objects, acrylic, and wood, 120⅛ × 97⅜ × 98⅜″ (305 × 248 × 250 cm)

Right:
The Clock. 1992. Plaster, papier-mâché, found objects, acrylic, and oil on wood, 98⅜ × 62⅜ × 57½″ (250 × 159 × 146 cm)

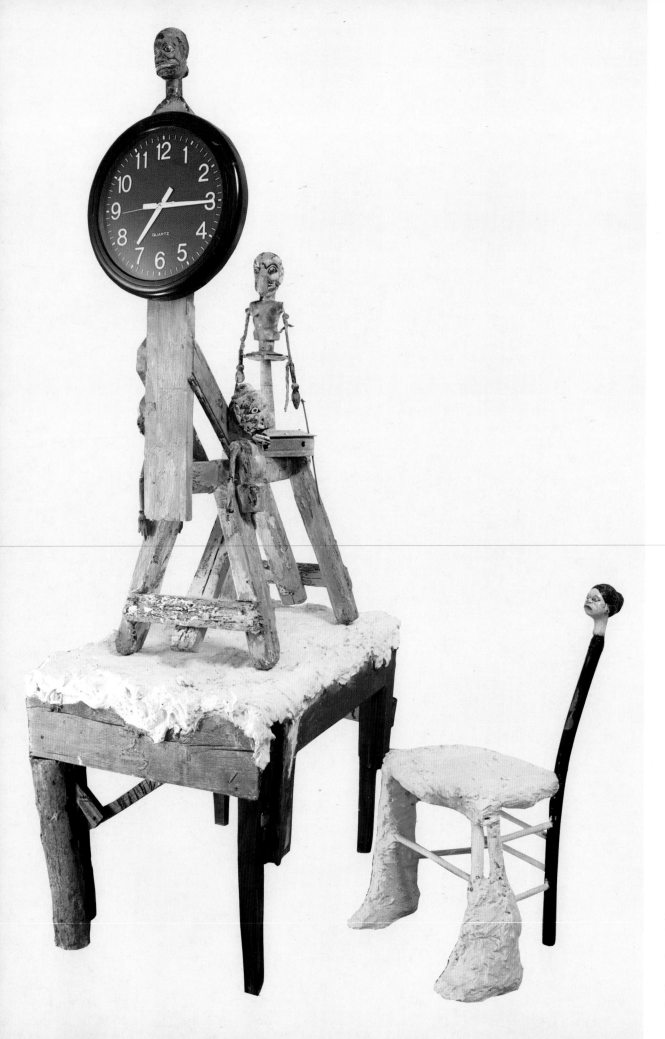

Left:
Clock with Table and Chair. 1992. Plaster,
found objects, and oil on wood,
95¼ × 49¼ × 41¾″ (242 × 125 × 106 cm)

Opposite:
The Accident. 1992. Plaster, papier-mâché,
found objects, acrylic, and wood,
84 × 48⅞ × 35⅜″ (213.5 × 124 × 90 cm)

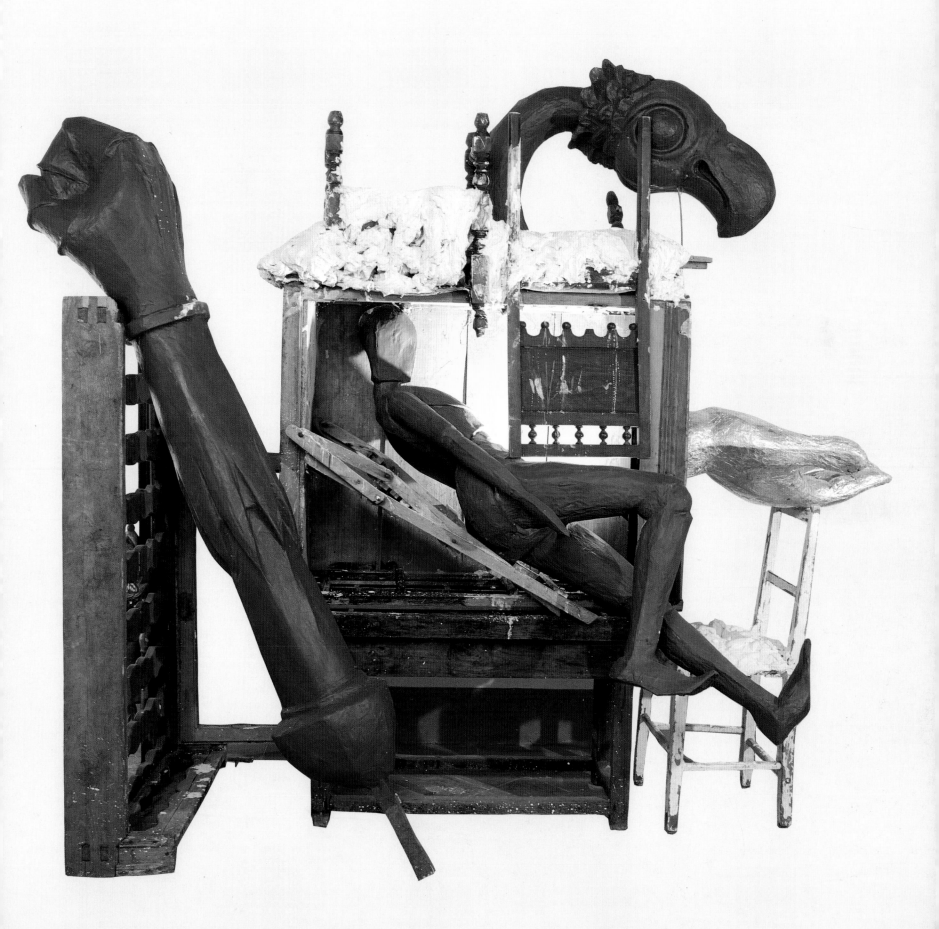

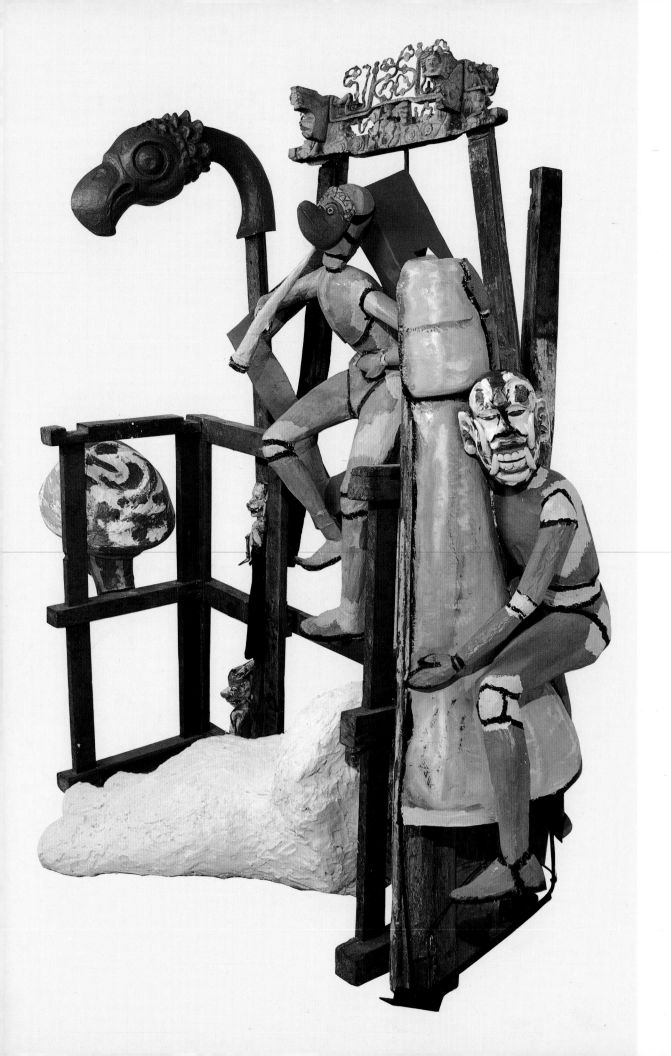

Left:
The Fluteplayer. 1992. Aluminum, papier-mâché, found objects, acrylic, and oil on wood, 118⅞ × 114⅜ × 51⅛″ (302 × 291 × 130 cm)

Opposite:
Wall Relief. 1992. Papier-mâché, found objects, acrylic, and oil on wood, 91¾ × 72⅞ × 15″ (233 × 185 × 38 cm)

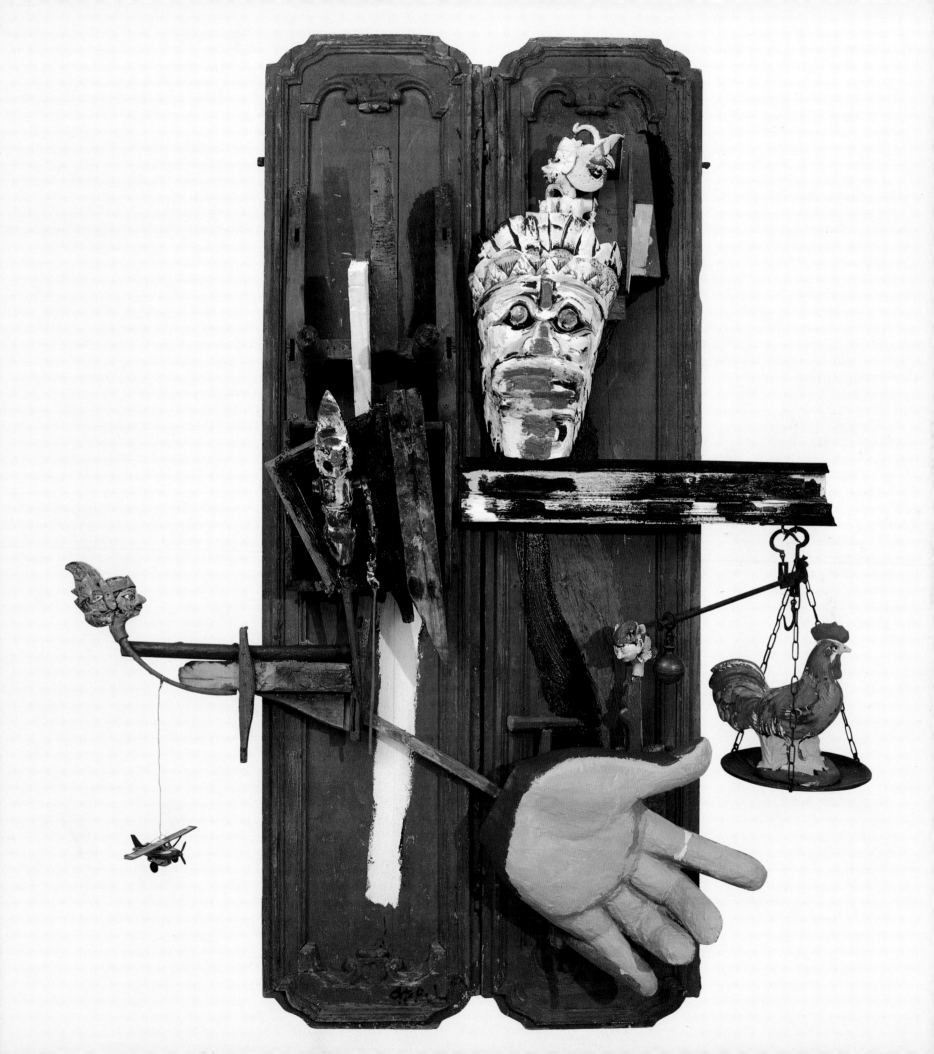

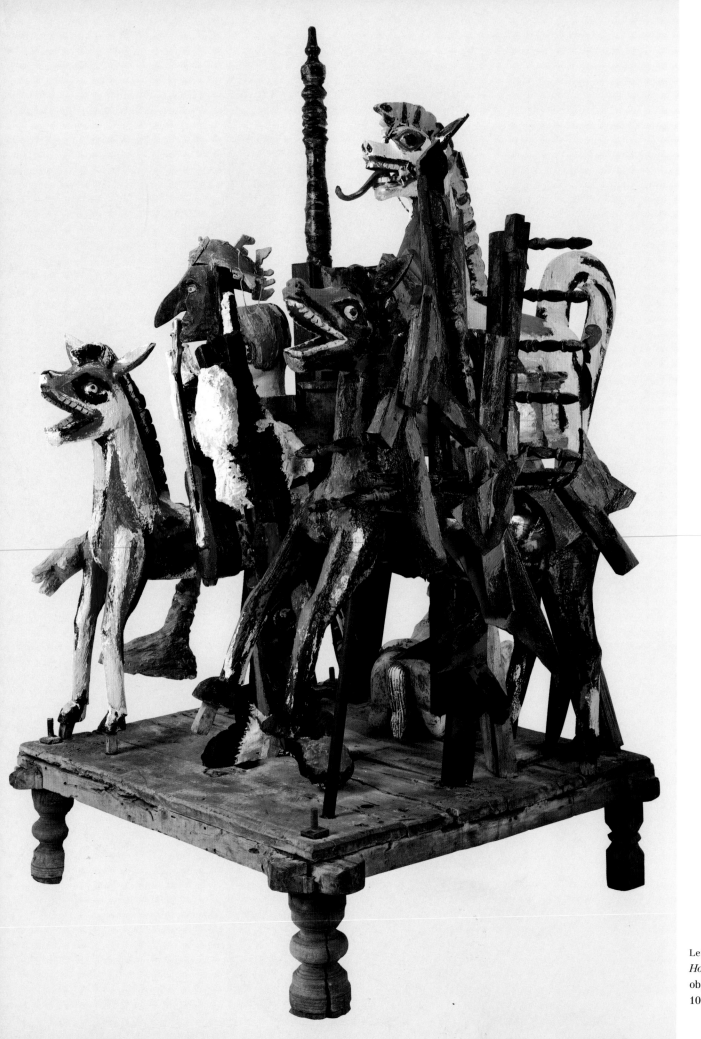

Left and opposite:
Horse and His Rider [2 views]. 1992. Found
objects, plaster, acrylic, and oil on wood,
105½ × 66 × 54¼″ (268 × 167.6 × 137.8 cm)

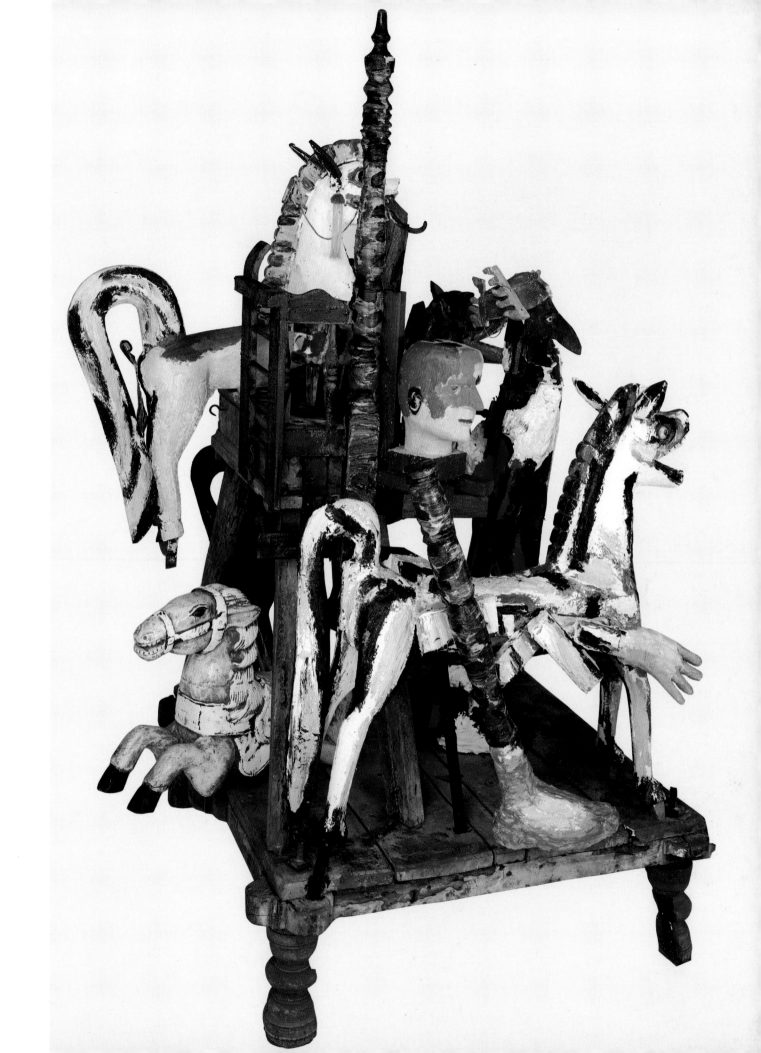

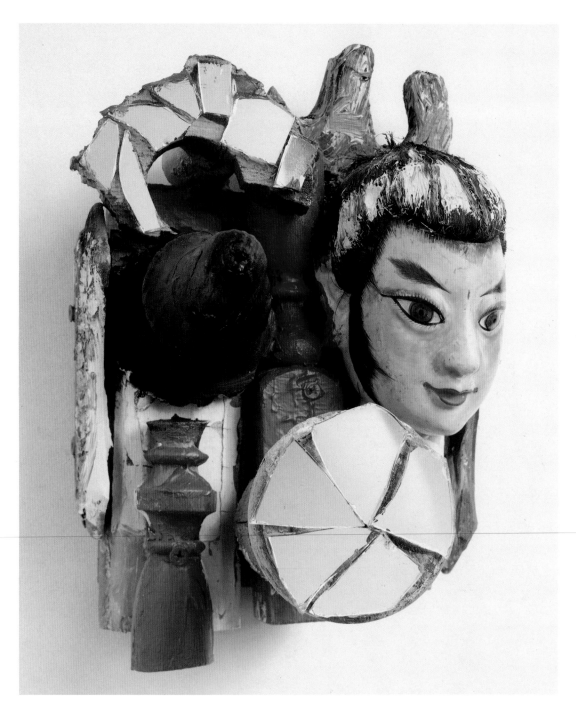

life; and they are highly stylized dramas—masques—not unlike ancient theater (if tragedy and comedy at once) or medieval mystery plays, in which the various forces of life are presented in allegorical form, often aided by masks. They are thus works of performance art, indeed, participatory theater, for the mirrors used in several of them implicate spectators in the work, drawing them onstage, as it were, as well as climactic examples of Appel's conception of life—and now death—as a crazy carnival. The male and female figures in *Forest in Black,* 1992—clearly symbolic of death, the "forest of the night"—are ghosts in the violent sexual drama which the carnival implicitly is, just as the *Elephant* of the same year is an actor in the circus of the carnival, as the fact that he is ridden by the face of a clown suggests. (Appel has

132

The Smile. 1992. Found objects, mirror, and acrylic on wood, 12 × 7 × 7¾″ (31 × 17.8 × 19.6 cm). Gilles Fuchs, Paris

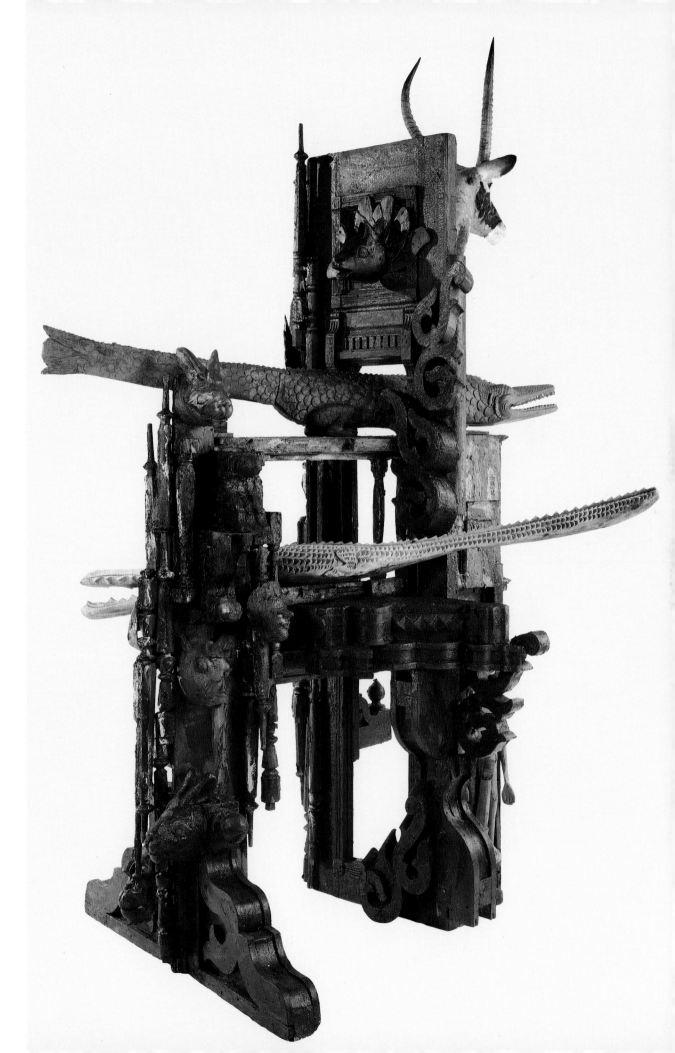

50 Years of Pyre Series: House of Crocodiles.
1992. Found objects, acrylic, and oil on
wood, 133½×87×108″
(339.1×221×274.3 cm)

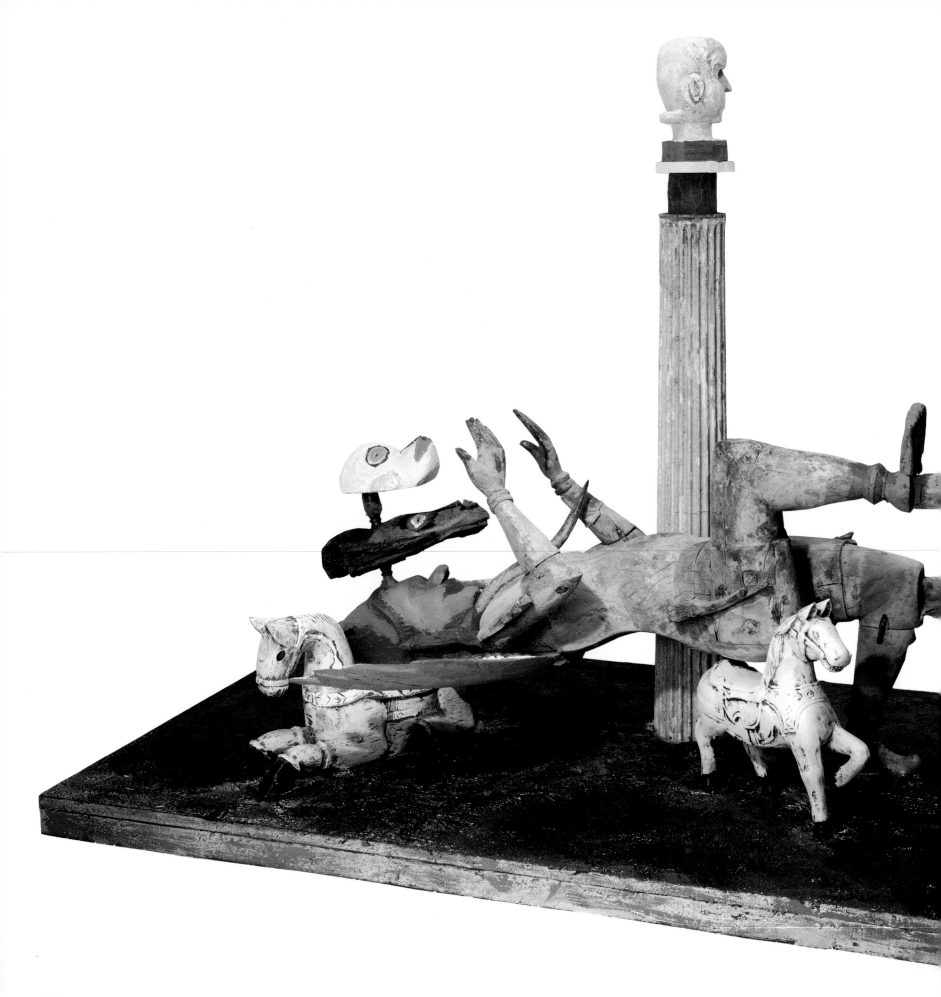

Opposite:
Fallen Angel. 1992. Found objects and oil on wood, 70½ × 49 × 96½″ (179 × 124.4 × 245.1 cm)

Right:
The Yawner. 1992. Found objects, iron, and oil on wood, 22½ × 19 × 8″ (57.1 × 48 × 20.3 cm)

Overleaf, left and right:
Frog with Umbrella. 1993. Found objects and oil on wood, 68½ × 31 × 46″ (174 × 79 × 117 cm)

50 Years of Pyre Series: Pyre with Fighting Lizards. 1993. Found objects, plaster, and oil on wood, 118⅛ × 89¾ × 90½″ (300 × 228 × 230 cm)

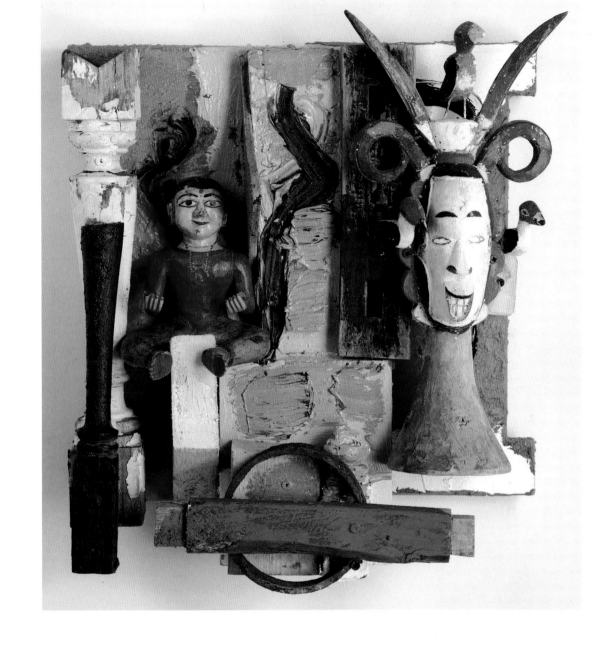

Page 138:
The Horseman. 1993. Found objects, rope, and oil on wood, 89½ × 48 × 48″ (227.3 × 122 × 122 cm)

Pages 138–39:
50 Years of Pyre Series: Pyre for a Lost Battle. 1993. Found objects and oil on wood, 68½ × 61½ × 101½″ (174 × 156.2 × 258 cm)

Page 140:
Animal Tower [2 views]. 1993. Found objects and oil on wood, 104 × 57 × 73″ (264 × 145 × 185.4 cm)

Page 141:
50 Years of Pyre Series: Pyre for a Hunter. 1993. Found objects, acrylic, and oil on wood, 100 × 74½ × 72½″ (304.8 × 189.2 × 184.2 cm)

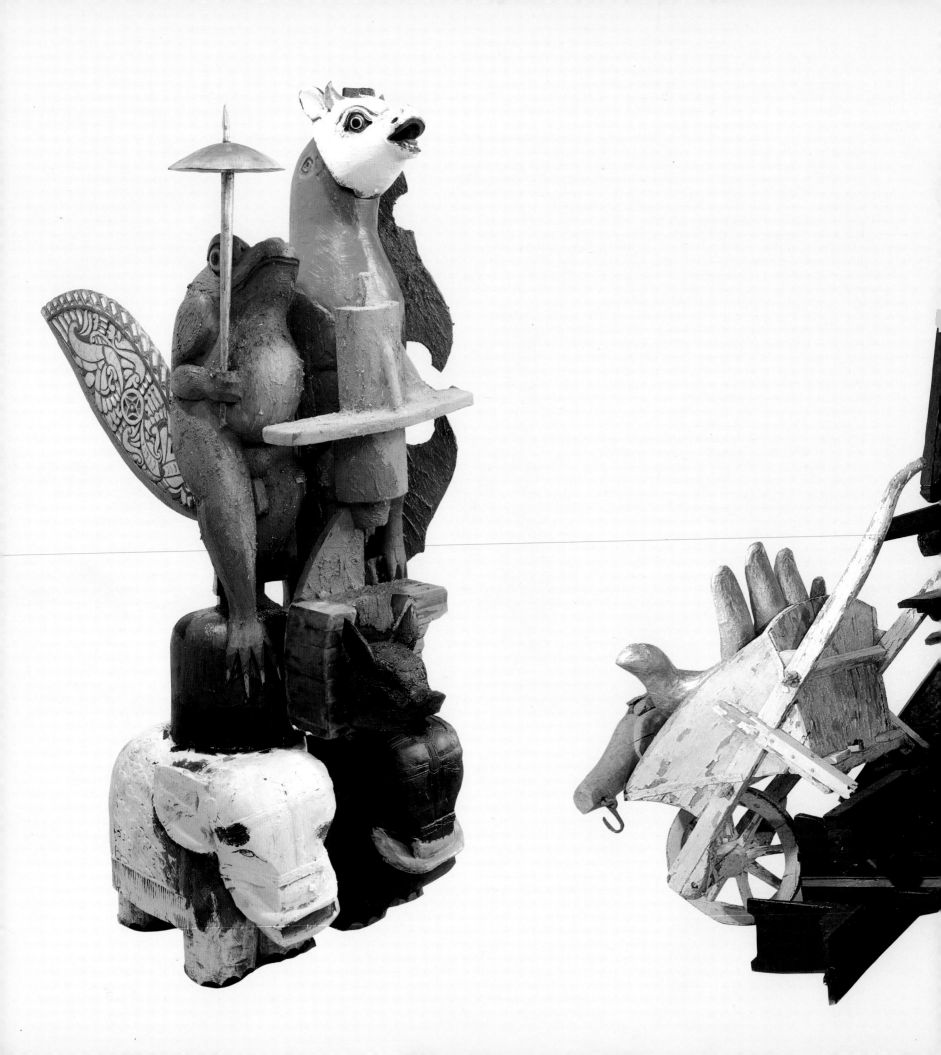

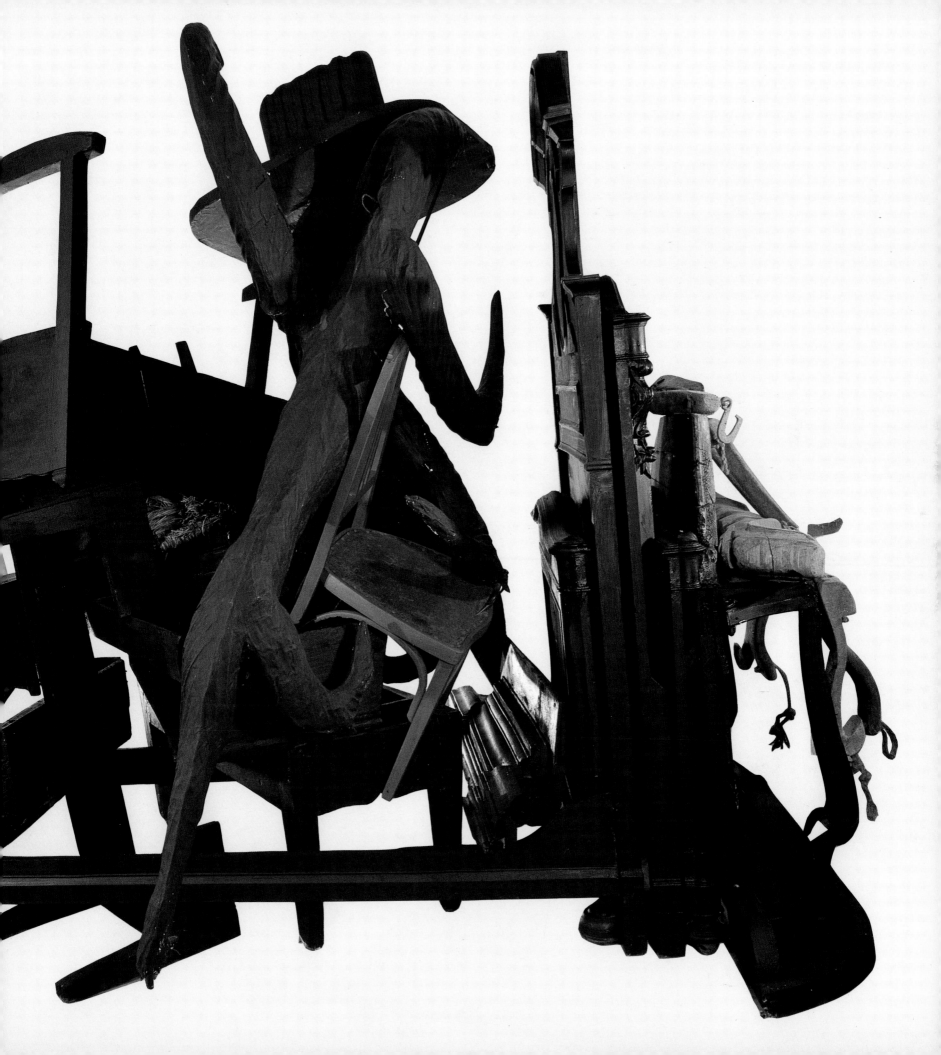

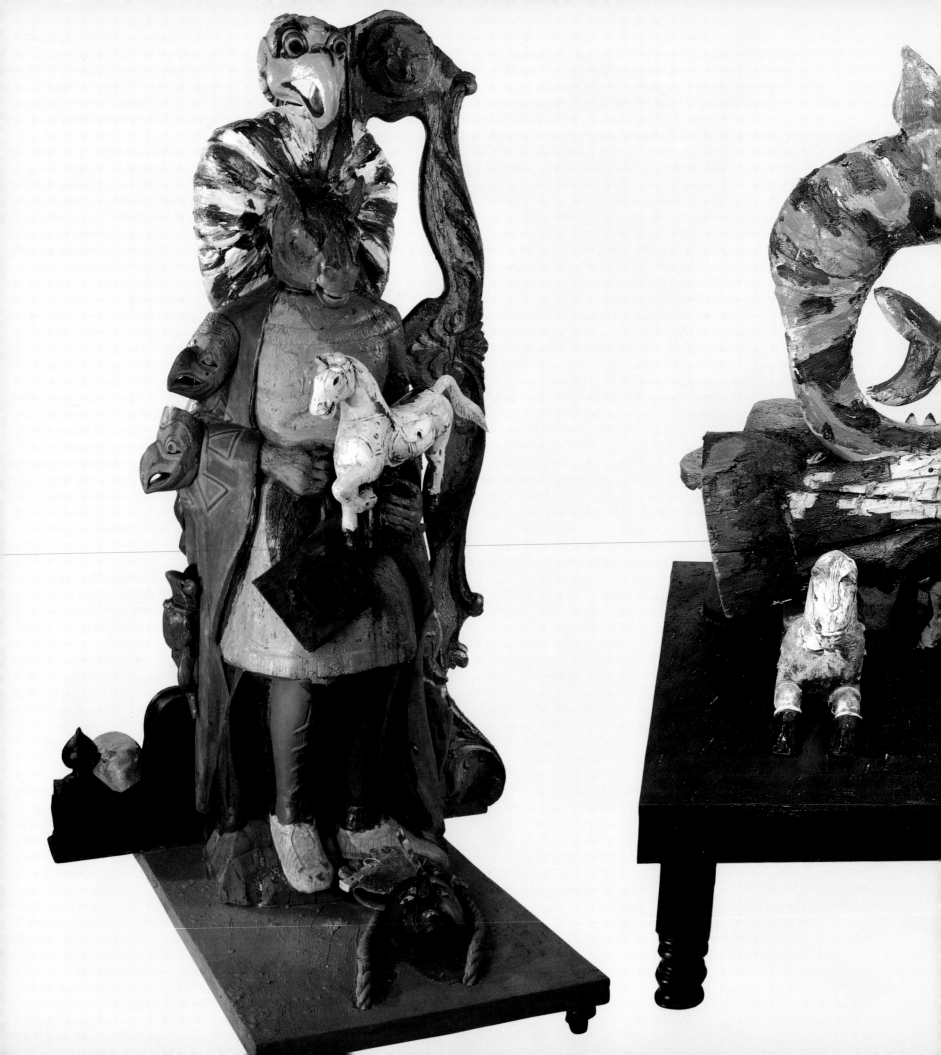

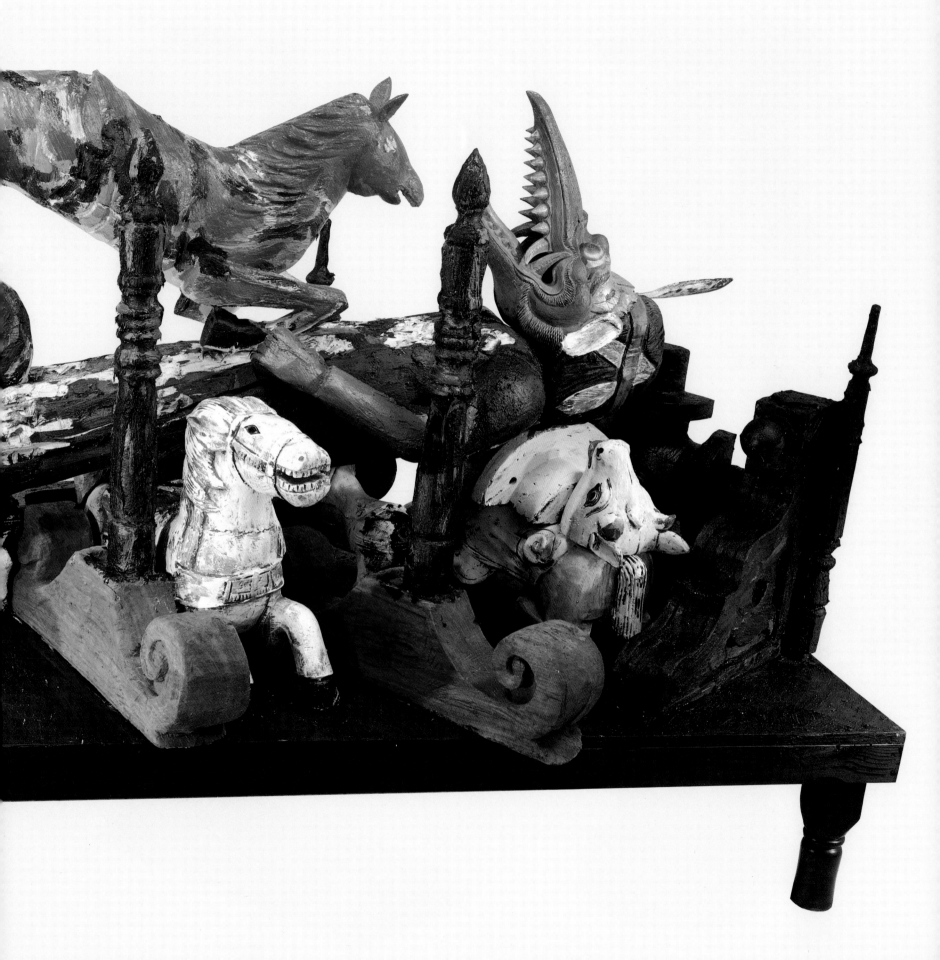

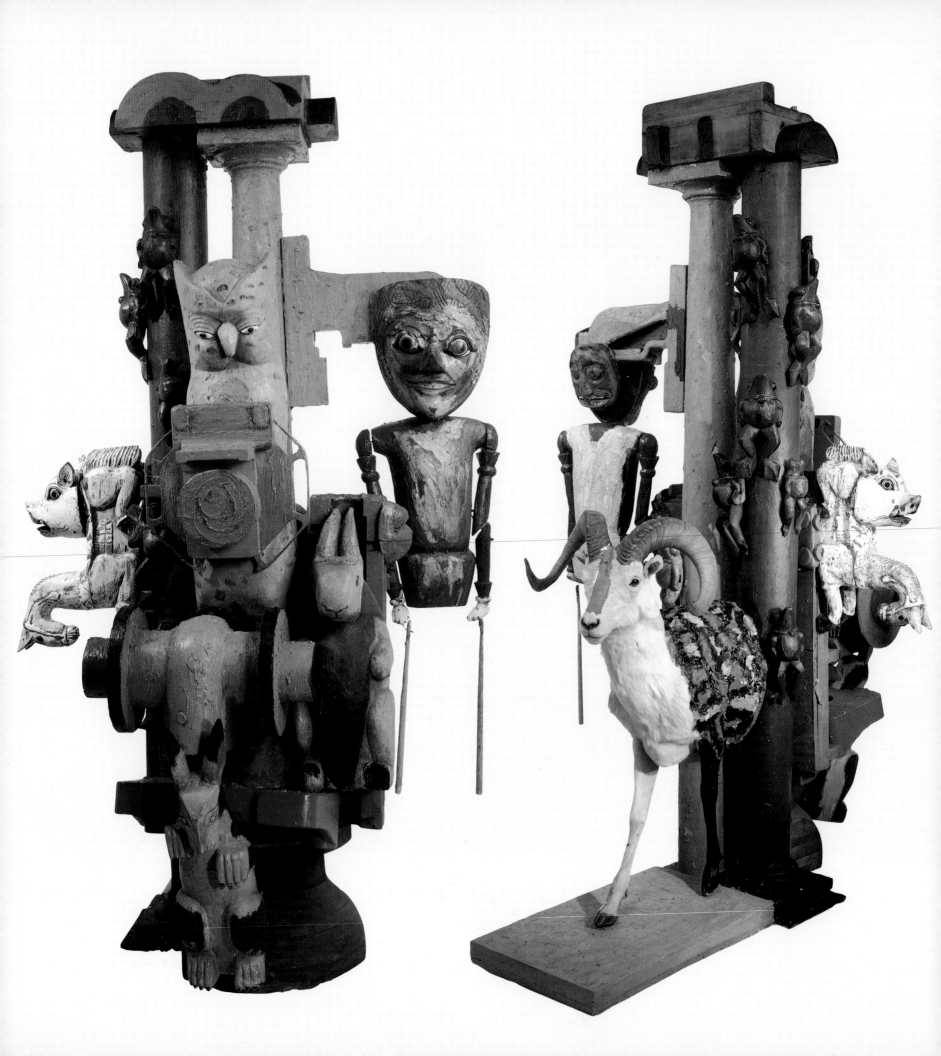

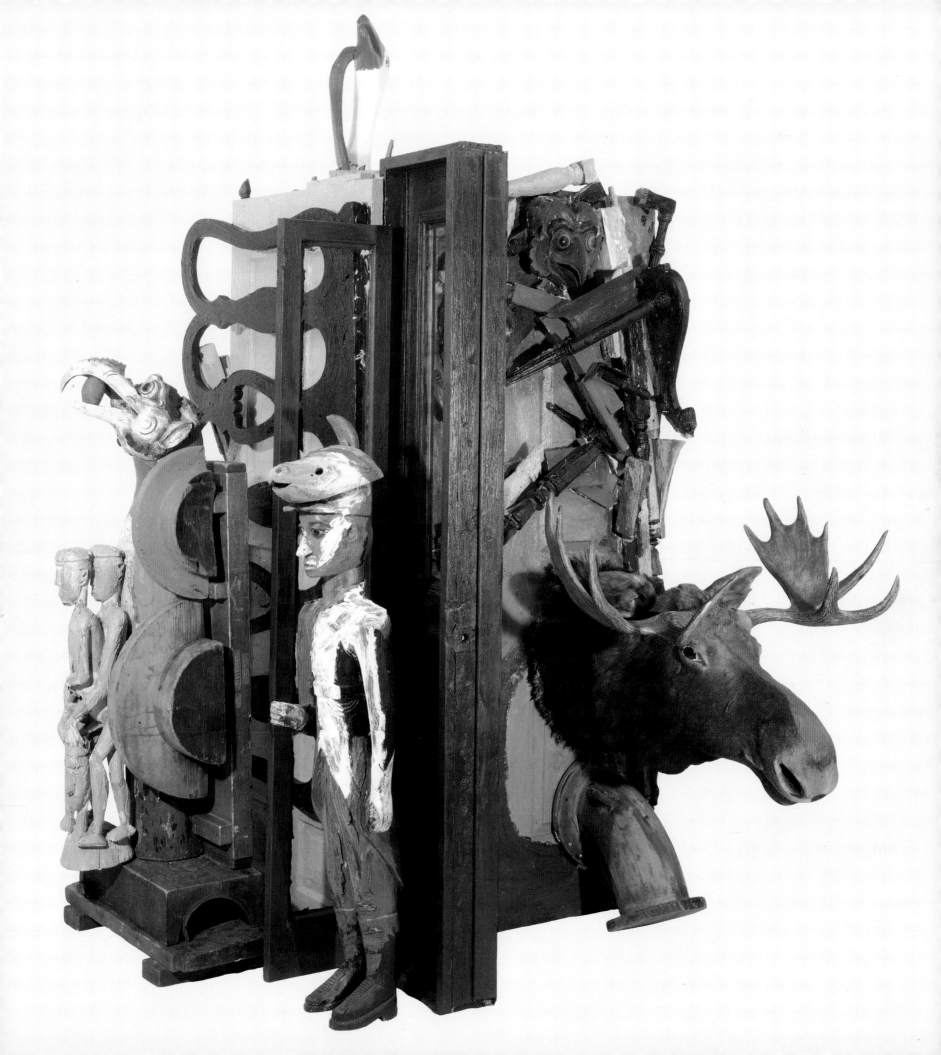

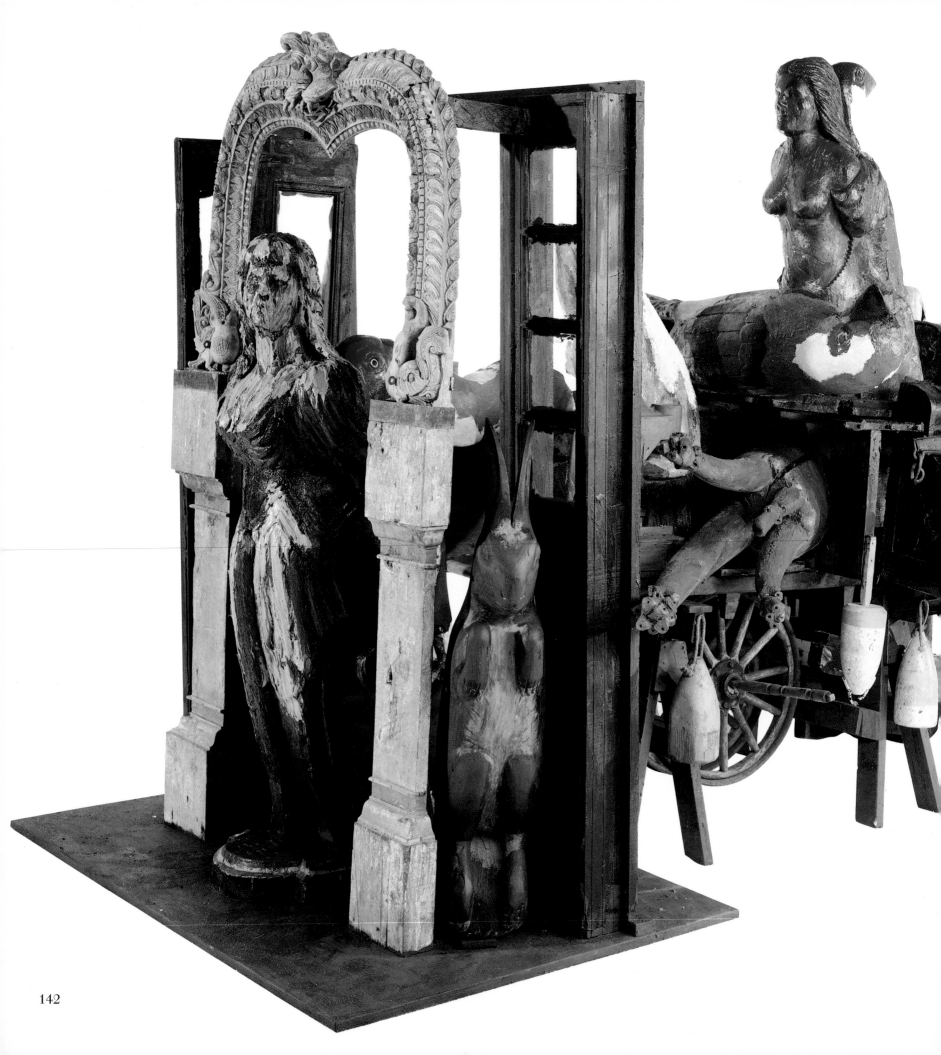

made almost half a dozen sculptures of elephants throughout his career.)

Nowhere is Appel's carnival attitude more explicit than in the heads of *Singing Donkeys,* 1992. They also seem to be laughing at the spectator, suggesting Appel's attitude toward him—and ironic conception of himself. That comic head changes into Pandora's head in *Pandora's Box,* also 1992—she has an explicitly funny, clown's mask for a face—and into a turbaned head in *The Clock* and *The Wheelbarrow,* both 1992, suggestive of an Oriental wizard or magician. All of these are actors in Appel's drama of himself—masks that he can put over his everyday face, depending on his mood; that is, depending on which part of himself he wants to dramatize. All are clearly possible heads for the headless pig in *Slaughtered Pig with Umbrella.* Brought out into the open, if in symbolic form, Appel can freely play with each part self as if with a part object, testing its possible reality. Appel is clearly an artist of many parts, and the use of the found mask is a brilliant way to articulate them.

That Appel's 1992 sculptures are works of art about making art, in particular about the necessity of being a child to make original art, is evident from the fact that the child's larger-than-life hand—the only hand that has ever made art for Appel— appears in almost all of them. It is the large red-and-yellow hand coming out of the cupboard in *Still Life*—it seems bare, but there is clearly still magic in it—and the gigantic black hand of death coming out of the cupboard that is *Pandora's Box.* It seems like the hand of a bully compared with the pair of smaller, meeker, white hands of hope that stick out of it—the same hopeful hands as those that the *Questioning Children* have—in fulfillment of the myth. Good and bad hands are clearly at odds, but it is not clear that the bad hand will win the emotional battle between them, however larger and more forceful bad is than good. A pair of giant white hands, which seem to be holding something invisible, come out of the cupboard in *Singing Donkeys.* A giant red hand, facing the spectator, and a giant black one, turned away from him and blocking the same head as appears in *Pandora's Box* (now painted brown rather than black) as though erasing woman from the picture, appear in the *Tricycle,* that child's toy. In *The Wheelbarrow,* there is a giant red hand; in *The Clock,* a giant black hand; and in *Looking Through the Open Window* No. 1, there is a pair of small white hands. We do so much with our hands! They mean so much to us. The loss of a hand is as unthinkable as the loss of one's head or penis. Appel shows us that he is still good with his hands, that he has not lost his touch—that he is still a masterful artificer. That is, like Daedulus, the inventor of sculpture and a great inventor in general, Appel is a great sculptural inventor and artistic inventor in general. He has come full circle, back to the outstretched hands of the *Questioning Children.* They have never stopped haunting him, so much so that

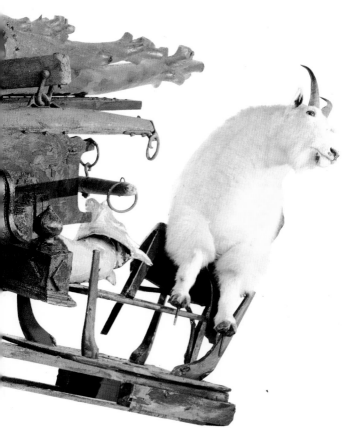

50 Years of Pyre Series: Pyre for a Caravan.
1993. Found objects and oil on wood,
96 × 180 × 76″ (243.8 × 457.2 × 193 cm)

143

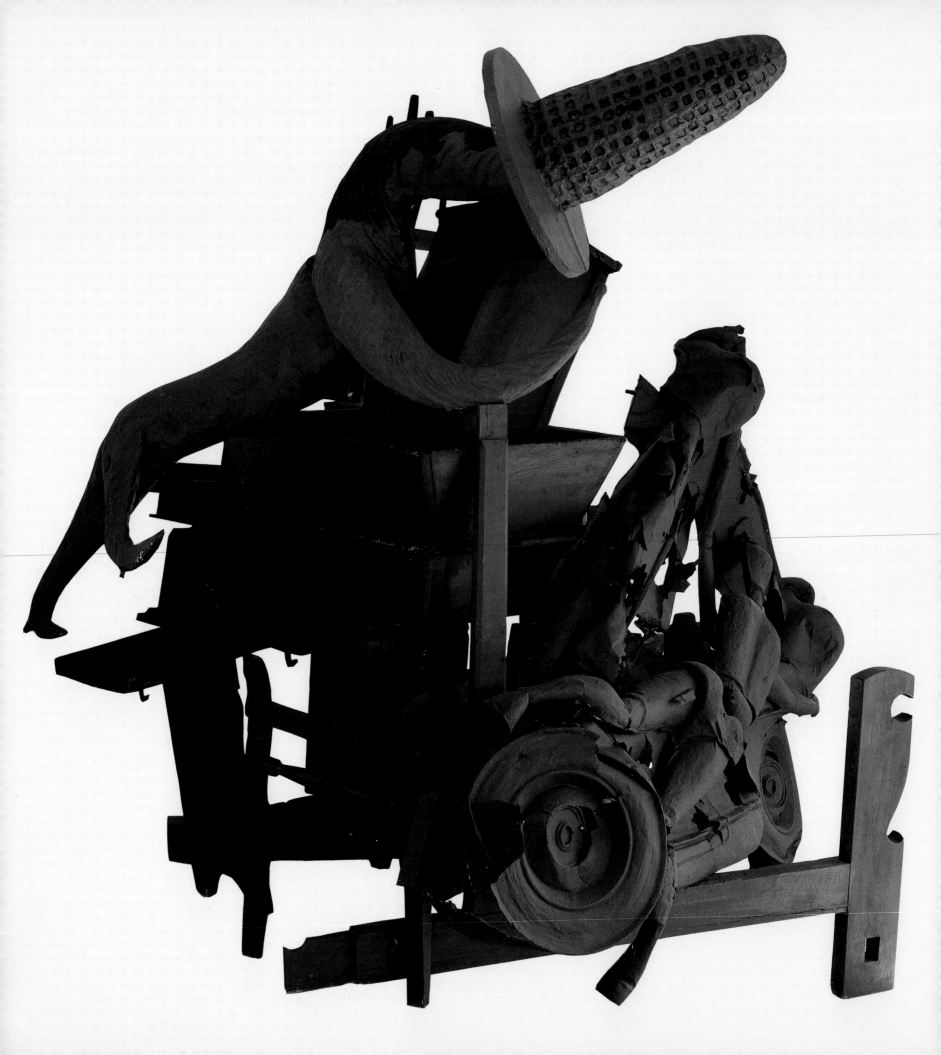

they seem his own. They have grown larger and more powerful with the passage of time, and as such, symbolize Appel's growth and power as an artist, but otherwise, the hands are not fundamentally changed.

In their complex intermingling of different methods of construction and expressive-symbolic allusions to life—their generally polyphonic, orchestrated character—Appel's sculptures of the nineties more than hold their own with David Smith's equally virtuoso *Voltri* series. It also is one of Appel's most original inventions, and a last will and testament. The comparison may seem strange, because of the obviously different character and materials of Appel's and Smith's works, but it is nonetheless apt in terms of their theatrical and visionary quality, and fusion of styles and wide-ranging means, to the extent that the word *sculpture* seems inadequate to them. They are simply art at its most authentic and visionary best. Interestingly, many of Appel's nineties sculptures, like the *Voltri* works by Smith, were made in Italy. Indeed, they were produced not far apart in Tuscany, suggesting the unconscious influence of Etruscan sculpture, well known for its vital articulation of life.

For Appel, vital primitive art is all the more necessary, as a kind of homeopathic medicine, in a "world which is becoming more and more primitive," as he has written in a letter, "and where the 'tribu desire' becomes reality and people are killing each other for that reason with sophisticated weapons. In that world," he continues, he is trying, especially in his sculptures, "to put all cultures together in order to explore a new form born out of hybridization and merging." Thus, his sculptures are necessarily "lyric, humorous, and tragic" at once, for they reflect a "desire to go beyond" himself and the world in a "delirious, desperate, immoderate" vitality in which there are no emotional holds barred. Appel seeks the "*Urleben (Ur an sich)* [in itself] beyond human pursuit. Searching beyond the limits is a reality of the mythological paradisiacal." The mythological paradise of primitive art—Etruscan, African, Indonesian, Indian, Native American (all of which have influenced Appel)—shows that in emotional fact it is possible to break through social limits to the origin of being, thus rejuvenating oneself despite all the death—including living death—in the world.

Appel's "insane" use of masks to symbolize parts of himself shows that he has the remarkable power to regress in the service of his creative ego. Such power of regression to the insane roots of being is in itself a form and sign of profound creativity. The regression to insanity projects an unexpected future for the self, in effect inviting it to change. Indeed, such regression is the beginning of serious change. Clearly, Appel does not think he is finished working and living and growing.

50 Years of Pyre Series: Pyre with Car Accident. 1993. Found objects and oil on wood, 96½ × 105⅛ × 102⅜" (245 × 267 × 260 cm)

Indeed, his sculptures of the nineties have a deliberately unfinished look, suggesting that they are works in perpetual process. They have the irritating rawness of a new beginning, as well as the terminal look of ramshackle structures. It is not clear that the nineties sculptures are the grand finale of his career rather than the prelude to even more innovative works. Their intensity suggests a manic defense against consciousness of death, and a final efflorescence of the life force in and for itself. But it also implies that Appel's creativity is still in flux—as madly in flux as the sculptures. The process of making is exasperatingly unending and maddening. Appel's highly fluid creativity promises that any new assemblages will be as unpredictable and vital as those of the early nineties.

Thus, the man walking through the door in *Slaughtered Pig with Umbrella* walks toward the future. He does not look back at the world that he leaves behind. The door is a way out of it, indeed, the only thing intact in the house of the past. The many open doors, windows, and cupboards in Appel's nineties sculptures—epitomized perhaps by *The Open Door* and the portals in the *Theater of the World,* both 1992— open onto the future. The clock in *Clock with Table and Chair,* also 1992, and *The Clock* is not yet stopped. Although it is black as death, its hands are as white as hope.

Similarly, the numerous primitive dolls that appear in these works, mocking one with their grimaces, seem to be visitors from the underworld, as their grotesque, mischievous, threatening appearance suggests. But however much they are punitive little devils, they function like the putti on ancient Roman sarcophagi. That is, they represent life impulses—instinct at its most uncontrollable and so, most lively. Every detail of Appel's sculptures is tricky, deceptive, and has a magical meaning, reflecting the inseparability of the life and death forces in them. However much Appel's nineties sculptures are his last will and testament, as I have suggested, they also show that he is full of ideas for the future. It is as though they are always in the planning stage— an effect of their vitality. Appel is constantly thinking of new characters to assemble onstage. The only limit to the way the parts of the sculptures can be arranged is Appel's limitless imagination, sense of self, and energy. Experiment and play are supposedly the prerogatives of youth. Their folk-carnival dimension, perversely turning the established order of things—including the established idea of art—upside down, supposedly reflects the polymorphous perversity and antisociality of the young child.[83] (This explains why genuine avant-garde art is so unsettling and threatening, indeed, virtually apocalyptic in its effect on the emotions.) However, Appel's playful, experimental carnival sculptures of the late eighties and early nineties show that it is possible to remain brilliantly creative and original to the end of life, if one is willing to keep the perverse, insane child in oneself alive.

Catalogue Section

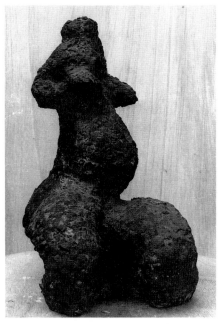
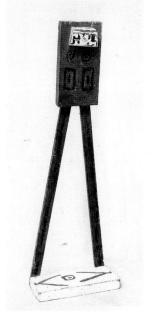
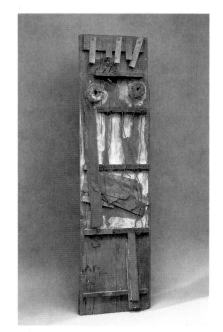

Naked Torso. 1936. Chamotte, height 12⅝″
(32 cm)

Figure. 1947. Oil on wood, 20½ × 6½ × 3½″
(52.1 × 16.5 × 8.9 cm)

Passion in the Attic, small version. 1947.
Found objects and gouache on wood,
43¼ × 11⅜″ (110 × 29 cm)

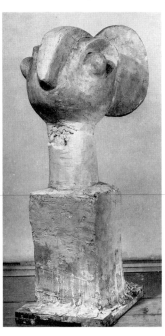
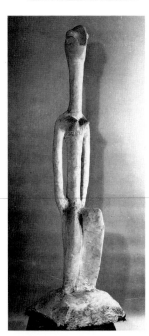
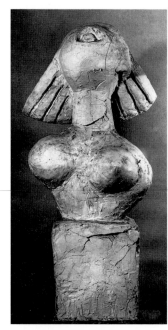

Bird's Head. 1947. Plaster, height 28⅜″
(72 cm)

Bird-Woman. 1947. Bronze,
64⅜ × 11¾ × 11⅜″ (163.5 × 30 × 29 cm)

Woman's Torso. 1947. Plaster,
38⅝ × 22⅞ × 15⅛″ (98 × 58 × 38.5 cm)

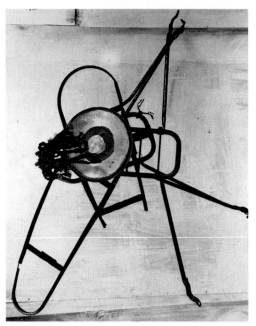
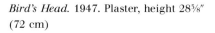

Untitled. 1947. Found objects on wood,
36 × 30″ (91.4 × 76.2 cm). Destroyed

Bicycle Collage. 1947. Bicycle parts, pan
cover, rope, and gouache, width 48″
(121.9 cm). Destroyed

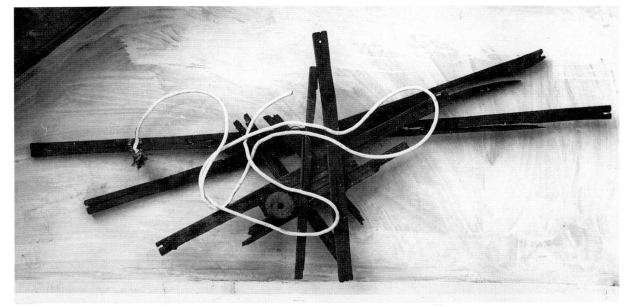

The Broken Ladder. 1947. Wood, electric wire, cork, and gouache, height 60″ (152.4 cm). Destroyed

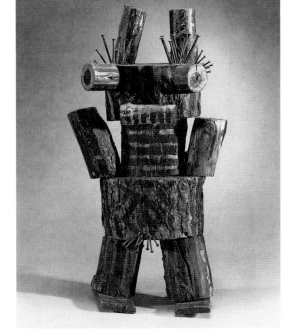

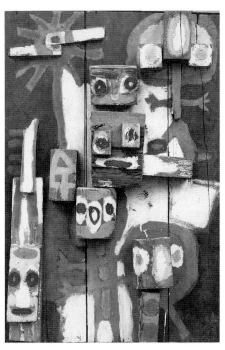

Standing Figure. 1947. Gouache on wood and metal nails, 24 × 12⅜ × 9″ (61 × 31.5 × 23 cm). Stephane Janssen, Carefree, Arizona

Questioning Children. 1948. Gouache on wood, 32⅝ × 23⅝″ (83 × 60 cm). Musée National d'Art Moderne, Centre Pompidou, Paris

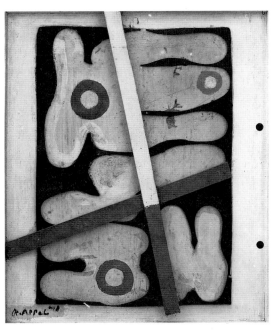

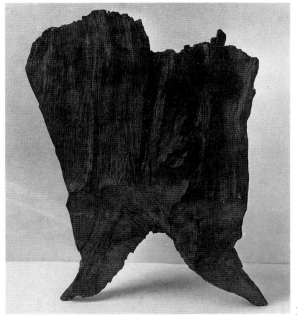

Composition. 1948. Found objects and gouache on wood, 24½ × 20½″ (62.2 × 52.1 cm)

Two Owls. 1948. Gouache on wood, 12¼ × 8½ × 3⅞″ (31 × 21.5 × 10 cm). Stedelijk Museum, Amsterdam

149

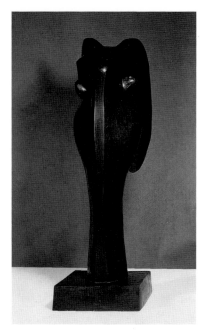
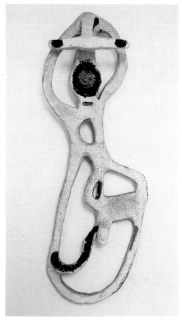
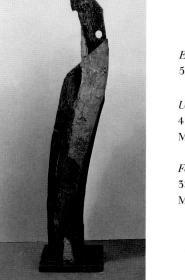

Elephant's Head. 1948. Plaster,
52⅜ × 14⅝ × 20⅞″ (133 × 37 × 53 cm)

Untitled. 1948. Gouache on plaster,
41⅜ × 13 × 6¼″ (105 × 33 × 16 cm). Stedelijk
Museum Schiedam, Netherlands

Fertility. 1948. Gouache on wood,
33½ × 5½ × 4¾″ (85 × 14 × 12 cm). Stedelijk
Museum, Amsterdam

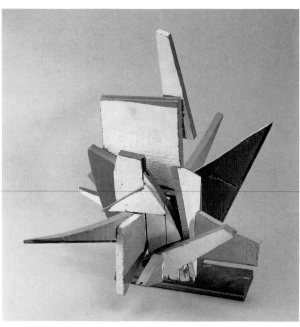
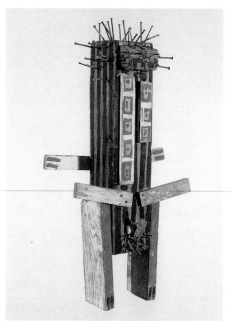

Construction I. 1949. Gouache on wood,
22 × 33″ (55.9 × 83.8 cm)

Standing Figure. 1949. Wood, gouache, and
nails, 22 × 11⅜ × 4¾″ (56 × 29 × 12 cm).
Bonnefanten Museum, Maastricht,
Netherlands

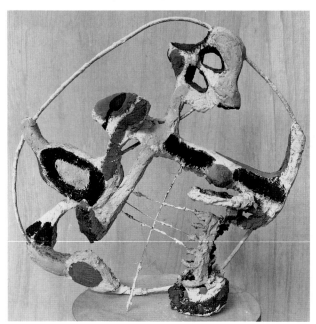
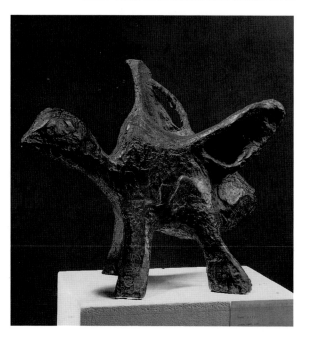

Sculpture with Bird. 1950. Gouache on
plaster and wire, height 22½″ (57 cm)

Cobra Bird. 1950. Gouache on plaster,
16½ × 13 × 20⅞″ (42 × 33 × 53 cm)

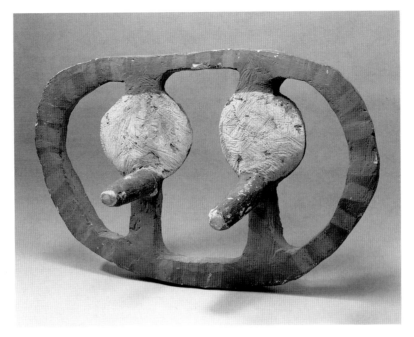

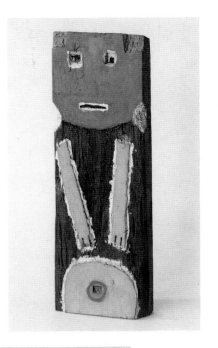

Untitled. 1950. Gouache on plaster,
8½ × 30⅛ × 19¾″ (21.6 × 76.5 × 50.2 cm)

Questioning Child. 1950. Gouache on wood,
18⅛ × 6⅛ × 2⅛″ (46 × 15.5 × 5.5 cm)

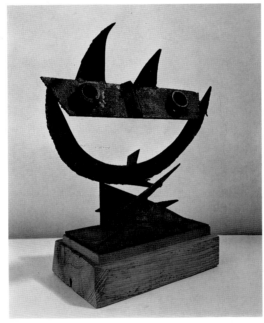

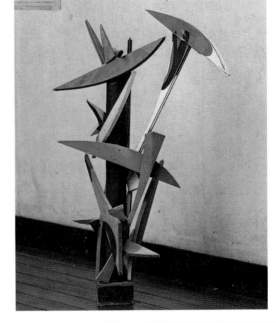

The Smile. 1950. Welded iron, 19 × 17 × 9″
(48.3 × 43.2 × 22.9 cm). Mr. and Mrs.
Nieuwenhuyzen-Segaar, The Hague

Tree of Life. 1950. Oil on wood, approximate
height 39′ (1500 cm). Destroyed

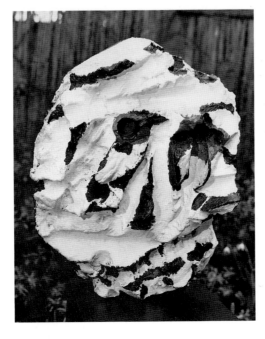

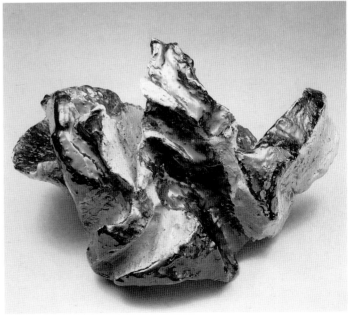

Head. 1953. Foam and oil on bronze,
19⅝ × 15¾″ (50 × 40 cm)

Untitled. 1954. Glazed terra cotta,
8⅞ × 16 × 14¼″ (22.5 × 40.6 × 36.2 cm)

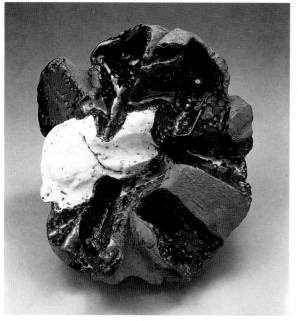

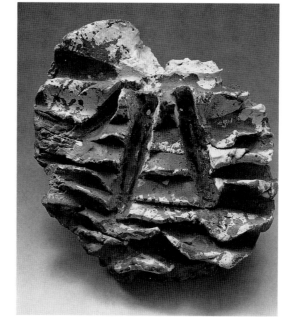

Untitled. 1954. Glazed terra cotta,
6¾ × 14½ × 14½″ (17.1 × 36.8 × 36.8 cm)

Untitled. 1954. Glazed terra cotta,
4¾ × 17⅜ × 5″ (12.1 × 44.1 × 12.7 cm)

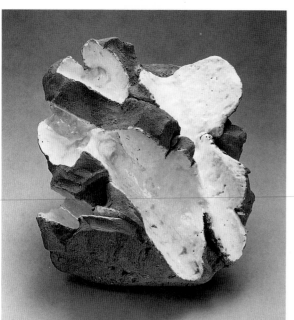

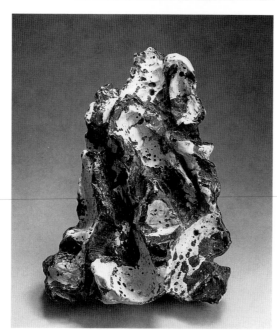

Untitled. 1954. Glazed terra cotta,
6⅞ × 16¼ × 15¾″ (17.5 × 41.3 × 40 cm)

Untitled. 1954. Glazed terra cotta,
4 × 16⅜ × 11⅜″ (10.2 × 41.6 × 28.9 cm)

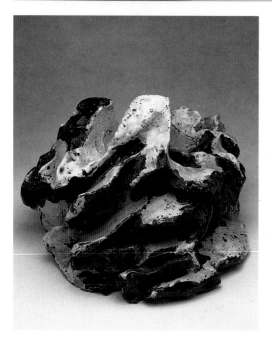

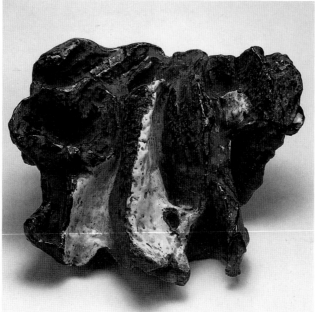

Head. 1954. Glazed terra cotta, 19⅝ × 17¾″
(50 × 45 cm)

Head. 1954. Glazed terra cotta,
19⅝ × 17¾ × 5⅞″ (50 × 45 × 15 cm)

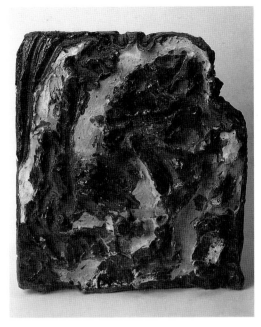

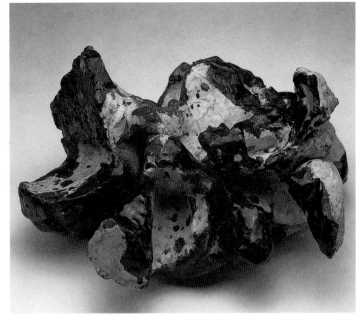

Head. 1954. Glazed terra cotta, 19⅝ × 17¾″ (50 × 45 cm)

Untitled. 1954. Glazed terra cotta, approximately 6 × 14½ × 14½″ (15.2 × 36.8 × 36.8 cm)

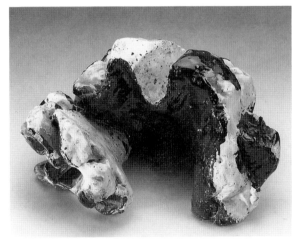

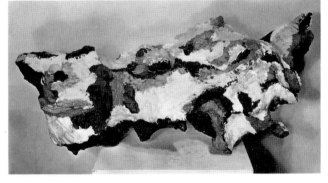

Untitled. 1954. Glazed terra cotta, approximately 6⅞ × 16¼ × 15¾″ (17.5 × 41.3 × 40 cm)

Cat. 1960. Acrylic on olive tree stump, 16⅞ × 39⅜ × 11¾″ (43 × 100 × 30 cm)

Dying Branch. 1960. Acrylic on olive tree stump, length 51″ (129.5 cm)

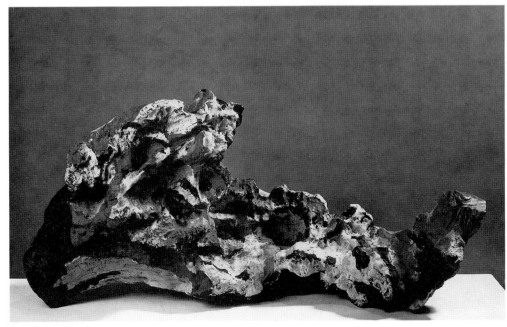

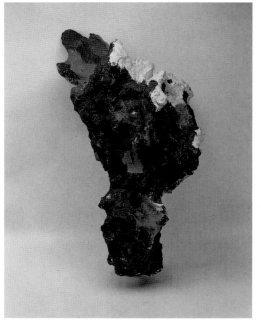
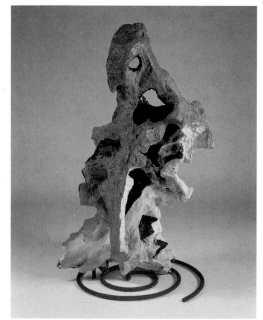

The Recluse II. 1960. Acrylic on olive tree stump, height 32″ (81.3 cm)

The Earthman. 1960. Acrylic on olive tree stump, 49¼ × 23⅝ × 27½″ (125 × 60 × 70 cm)

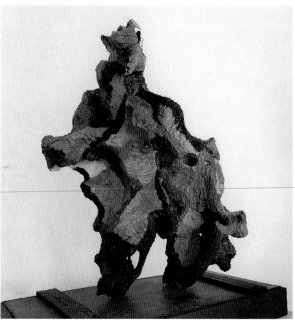
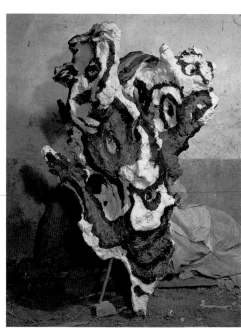

The Rooster I. 1960. Acrylic on olive tree stump, 36 × 36″ (91.4 × 91.4 cm)

Man the Witness. 1960. Acrylic on olive tree stump, 57⅞ × 39⅜″ (147 × 100 cm). Karel Van Stuyvenberg, Caracas

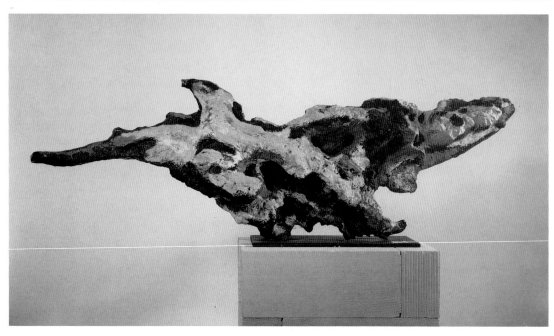

Wounded Animal. 1960. Acrylic on olive tree stump, 59 × 39½ × 19½″ (149.9 × 100.3 × 49.5 cm). Musée d'Art Contemporain, Dunkerque, France

Barbaric Bird I. 1960. Acrylic on olive tree stump, length 43¼″ (109.9 cm). Mrs. Symons, Amsterdam

Untitled. 1960. Acrylic on olive tree stump, height 13¾″ (35 cm). Mr. and Mrs. Ezio Gribaudo, Turin

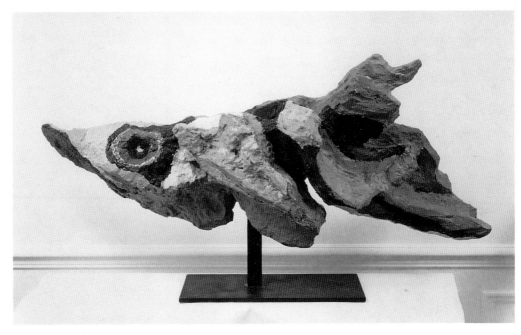

Barbaric Bird II. 1960. Acrylic on olive tree stump, 25⅝ × 51⅛ × 15¾″ (65 × 130 × 40 cm). Christian Cheneau, Paris

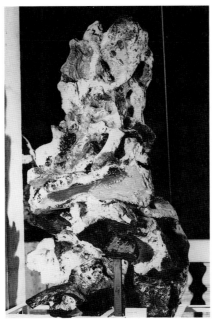

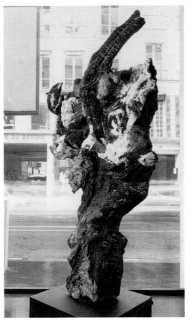

Blue Vision. 1960. Acrylic on olive tree stump, dimensions unknown. Private collection

Head with Horns. 1960. Acrylic on olive tree stump, dimensions unknown. Private collection

155

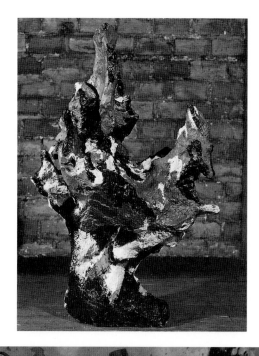

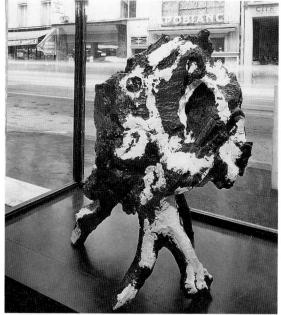

The Rooster II. 1960. Acrylic on olive tree stump, dimensions unknown

The Owlman II. 1960. Acrylic on olive tree stump, 35½ × 27½ × 24⅜″ (90.2 × 69.9 × 61.9 cm)

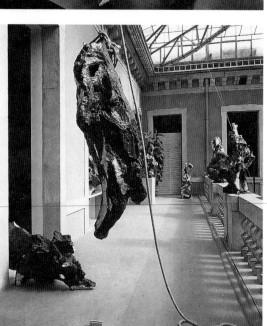

Love Struggle. 1960. Acrylic on olive tree stump, dimensions unknown

Slaughtered Animal. 1960. Acrylic on olive tree stump, dimensions unknown

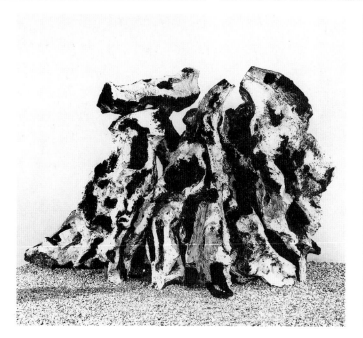

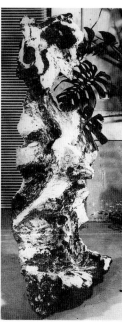

Phantom Forest. 1960. Acrylic on olive tree stump, dimensions unknown

Torso. 1960. Acrylic on olive tree stump, dimensions unknown

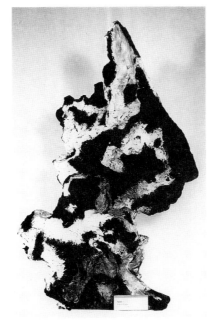

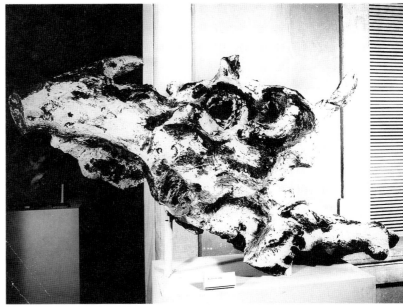

The Cry II. 1960. Acrylic on olive tree stump, dimensions unknown

Cow's Head. 1960. Acrylic on olive tree stump, dimensions unknown

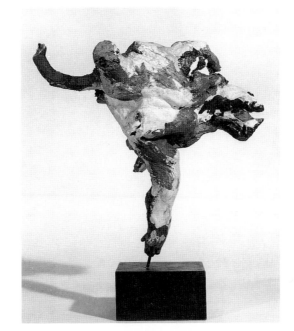

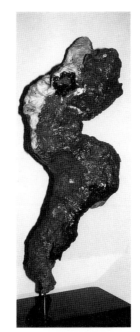

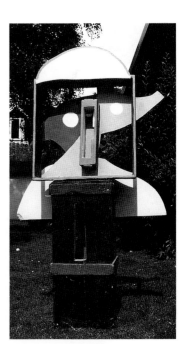

Animal Head. 1961. Acrylic on olive tree stump, 12×13×7″ (30.5×33×17.8 cm). Gimpel Fils Gallery, London

Untitled. 1961. Acrylic on olive tree stump, 29½×12⅝×10⅓″ (75×32×27 cm). Dr. Jacques-Marin Crestinu, Paris

African Mask. 1965. Oil on wooden panel, 84⅜×48⅞″ (215×124 cm). L. C. Heppener, The Hague

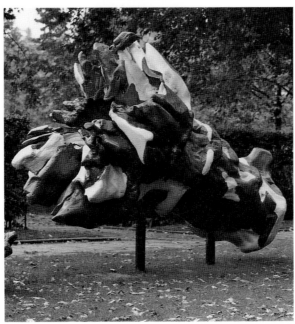

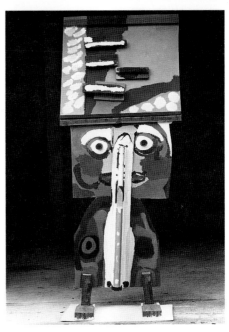

Untitled. 1965. Acrylic on tree stump, 98⅜×66⅞×78¾″ (250×170×200 cm). Destroyed

Man with a Hat Like the Sky. 1966. Oil on wood and panel, 106¼×43¼″ (270×110 cm). Private collection, Switzerland

157

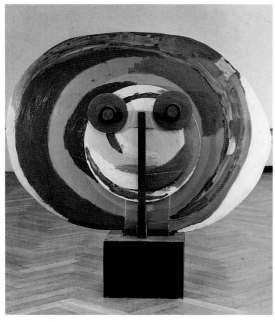

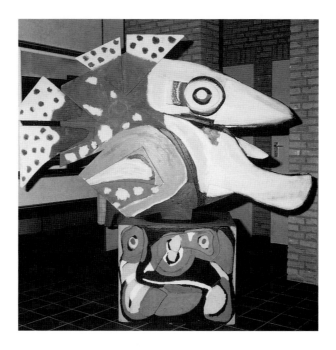

Luminous Head. 1966. Oil on wooden panel, 76¾ × 79⅞″ (195 × 203 cm). Jean and Eric Cass, Surrey, England

The Fish. 1966. Oil on wooden panel, 78¾ × 82⅝″ (200 × 210 cm). Private collection, Netherlands

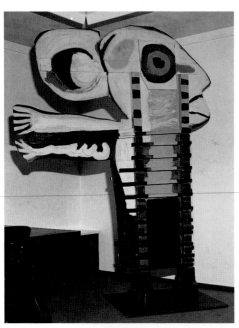

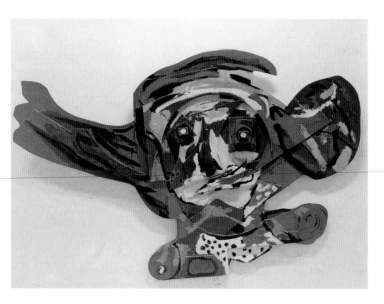

Man. 1966. Oil on wooden panel, 98⅜ × 70⅞″ (250 × 180 cm)

Big Head. 1966. Acrylic on wooden panel, 64½ × 85″ (163.8 × 215.9 cm). Musée d'Art Contemporain, Dunkerque, France

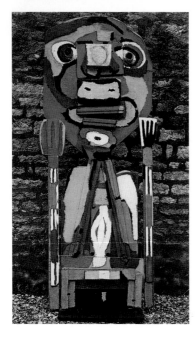

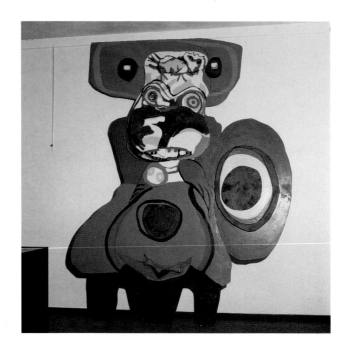

Personage. 1966. Oil on wooden panel, 89 × 36¼″ (226 × 92 cm). Galleri Stora Kovik, Sweden

Personage. 1967. Oil on wooden panel, 98⅜ × 76″ (250 × 193 cm). Private collection

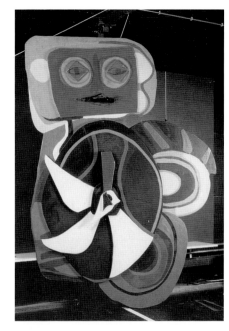

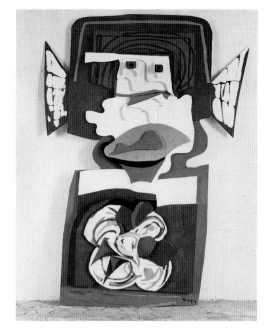

Personage. 1967. Oil on wooden panel,
100¾ × 70⅞" (256 × 180 cm).
Private collection, Netherlands

Big Red Head. 1967. Oil on wooden and
panel, 98⅜ × 70⅞" (250 × 180 cm).
Private collection, Netherlands

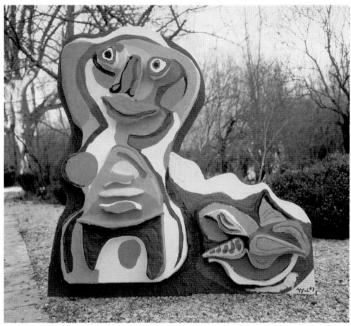

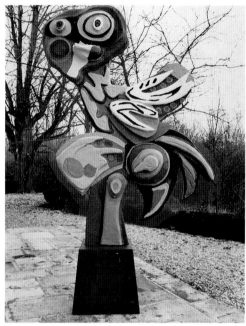

Woman and Flower. 1967. Acrylic on
polyester, 72⅞ × 70⅞" (185 × 180 cm).
Private collection, Netherlands

Bird and Flower. 1968. Acrylic on polyester,
137¾ × 72" (350 × 183 cm). Arthur Cinader,
New Jersey

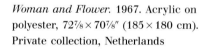

The Big Ear. 1968. Acrylic on polyester,
68½ × 65 × 27" (174 × 165.1 × 68.5 cm).
National Gallery of Canada, Ottawa

Personage and Bird. 1968. Acrylic on
polyester, 120½ × 85 × 24"
(306 × 216 × 61 cm). FNAC (Fond National
d'Art Contemporain), Paris

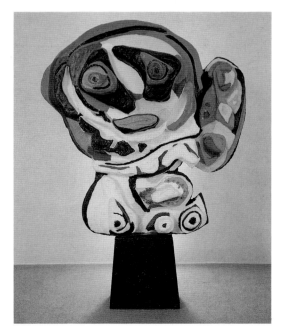

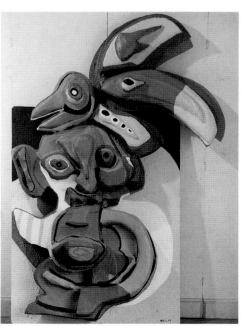

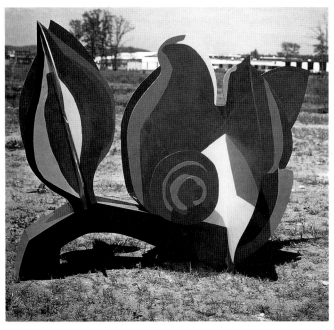

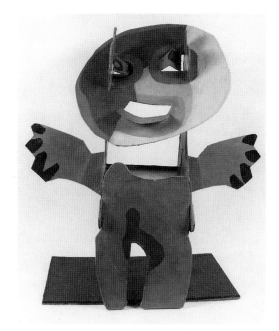

The Tulip. 1971. Polychromed enameled aluminum, 81 × 108 × 70″ (205.7 × 274.3 × 177.8 cm). Metro Dade Art in Public Places, Miami

Head on a Chair. 1971. Polychromed enameled aluminum, 108 × 84″ (274.3 × 213.4 cm). Mr. and Mrs. Korastinsky, Mougins, France

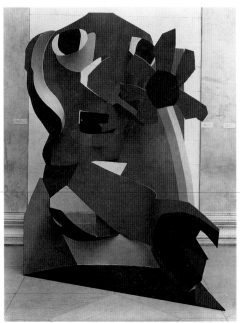

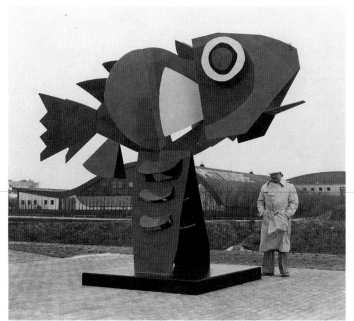

Man with Flower. 1971. Polychromed enameled aluminum, 98.5 × 72 × 48″ (250.2 × 182.9 × 121.9 cm). Albright-Knox Art Gallery, Buffalo

Flying Fish. 1971. Polychrome enameled aluminum, 137¾ × 88⅝ × 47¼″ (350 × 225 × 120 cm). Musée d'Art Contemporain, Dunkerque, France

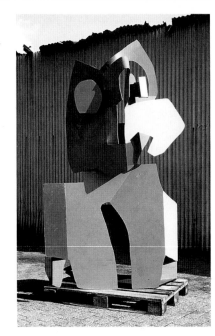

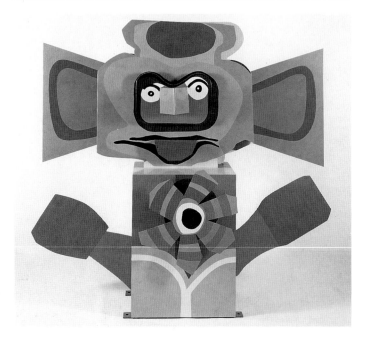

Iron Personage. 1971. Painted steel, 91 × 54 × 48″ (231.1 × 137.2 × 121.9 cm). Galerie Nova Spectra, The Hague

Man with Moving Ears. 1971. Enameled aluminum, 108 × 82 × 52″ (274.3 × 208.3 × 132.1 cm). Robert Abrams, New York

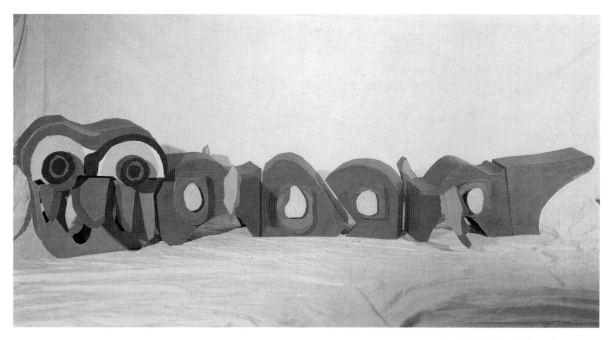

The Caterpillar. 1971. Polychrome enameled
aluminum, 33⅞×48×141″
(86×122×358 cm). Mr. and Mrs. David
Anderson, Buffalo

Anti-Robot. 1976. Stainless steel,
236¼×137¾×187⅜″ (600×350×476 cm).
University of Bourgogne, Dijon

Untitled. 1980. Acrylic and color crayon on
cardboard box, 20⅛×38⅝×7⅞″
(51×98×20 cm)

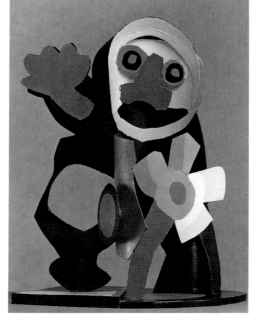

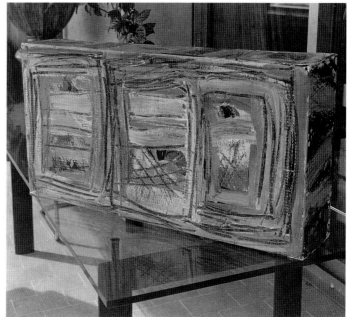

Untitled. 1980. Acrylic and color crayon on
cardboard box, 53⅛×20⅞×20⅞″
(135×53×53 cm)

Untitled. 1980. Acrylic on packing paper
and oilstick on cardboard box,
19⅝×4¾×11¾″ (50×12×30 cm)

Untitled. 1980. Acrylic on packing paper,
plastic cup, and wooden crate,
15¾×8⅝×6¼″ (40×22×16 cm)

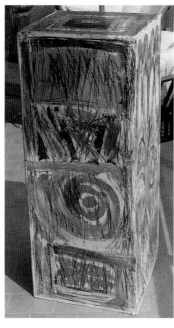

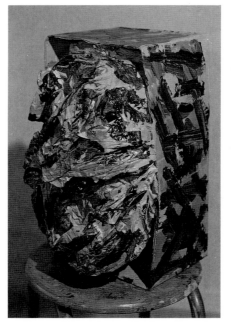

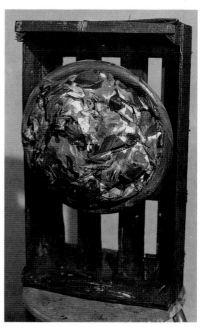

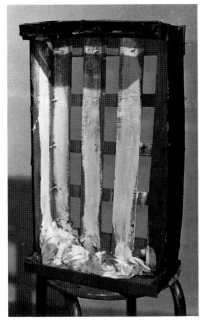
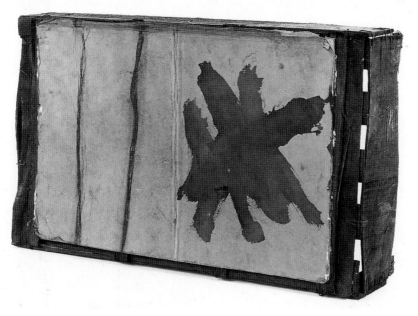

Untitled. 1980. Acrylic on cloth and wooden crate, 15¾ × 8⅝ × 6¼″ (40 × 22 × 16 cm)

Untitled. 1980. Acrylic on cardboard box and wooden crate, 15¾ × 8⅝ × 6¼″ (40 × 22 × 16 cm)

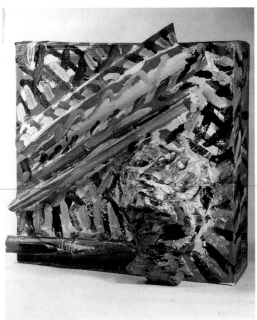
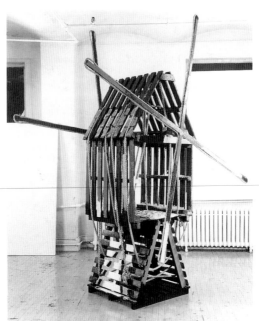

TV in Relief. 1981. Acrylic on packing paper and cardboard box, 42 × 39¼ × 21¼″ (106.7 × 99.7 × 54 cm)

Windmill. 1985. Oil, wood, rope, and plaster, 114 × 95 × 48″ (289.6 × 241.3 × 121.9 cm)

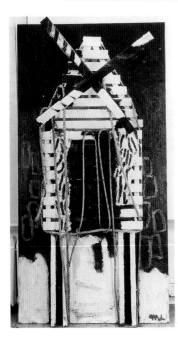
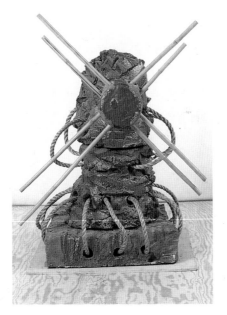
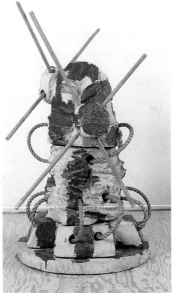

Windmill. 1985. Oil, plaster, wood, and rope, 96 × 48 × 26″ (243.8 × 121.9 × 66 cm)

Windmill II. 1985. White earthenware, rope, and bamboo, 50 × 35 × 23″ (127 × 88.9 × 58.4 cm)

Windmill IV. 1985. Terra cotta, rope, and bamboo, 40 × 37 × 26″ (101.6 × 94 × 66 cm)

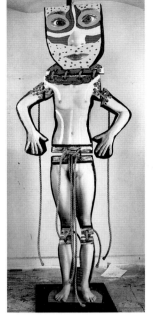

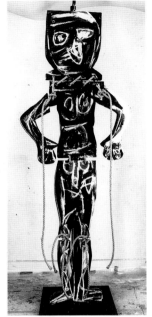

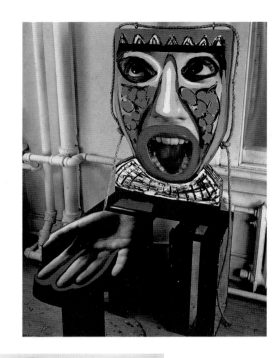

Standing Nude 3 [2 views, front and rear]. 1987. Polaroid, acrylic, wood, and rope, 114⅛ × 44⅞ × 3″ (290 × 114 × 7.5 cm)

The Beggar. 1987. Polaroid, acrylic, wood, and rope, 59⅞ × 43¾ × 29⅞″ (152 × 111 × 76 cm)

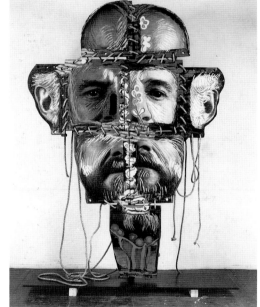

Between Banner and Flag. 1987. Iron, rope, and wood, 149⅝ × 59¼ × 108½″ (380 × 150.5 × 275.5 cm). The Stedelijk Van Abbe Museum, Eindhoven, Netherlands; on temporary loan

Study for a Portrait of Stephane Janssen. 1988. Acrylic, oilstick, Polaroid, mirror, rope, and wood, 122¾ × 87 × 24″ (311.8 × 221 × 61 cm). Stephane Janssen, Carefree, Arizona

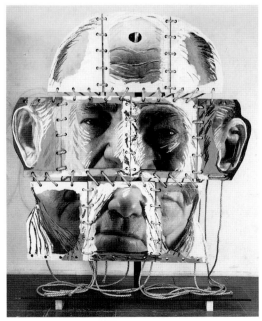

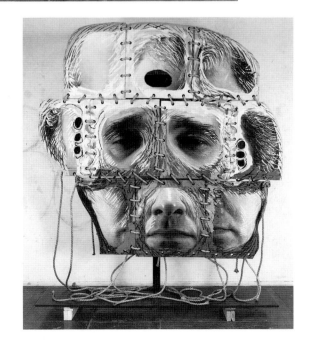

Study for a Portrait of Sam Hunter. 1988. Acrylic, oilstick, Polaroid, mirror, rope, and wood, 106¼ × 94¾ × 16″ (269.9 × 240.7 × 40.6 cm)

Study for a Portrait of Donald Kuspit. 1988. Acrylic, oilstick, Polaroid, mirror, rope, and wood, 122¾ × 94 × 24″ (311.8 × 238.8 × 61 cm)

163

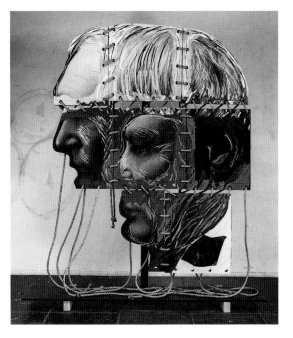

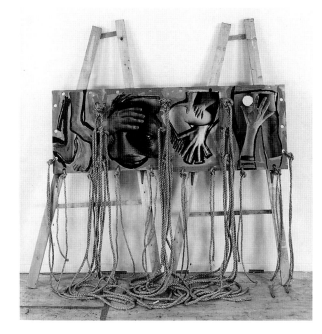

Study for a Portrait of Eelko Wolf. 1988.
Acrylic, oilstick, Polaroid, mirror, rope, and
wood, 120¼ × 73½ × 24″
(305.4 × 186.7 × 61 cm)

Titan Series No. 3. 1988. Acrylic, oilstick,
Polaroid, mirror, rope, and wood, 30 × 82½″
(76.2 × 209.5 cm)

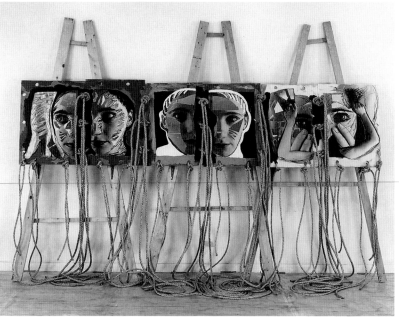

Titan Series No. 1. 1988. Acrylic, oilstick,
Polaroid, mirror, rope, and wood, 95 × 133″
(241.3 × 337.8 cm)

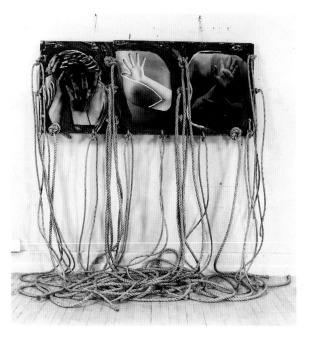

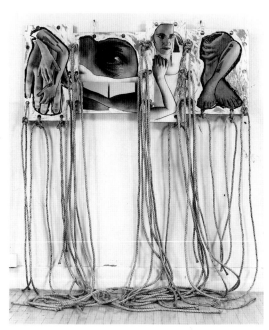

Titan Series No. 4. 1988. Acrylic, oilstick,
Polaroid, rope, and wood, 30 × 69″
(76.2 × 175.3 cm)

Titan Series No. 5. 1988. Acrylic, oilstick,
Polaroid, mirror, rope, and wood, 30 × 69¾″
(76.2 × 177.2 cm)

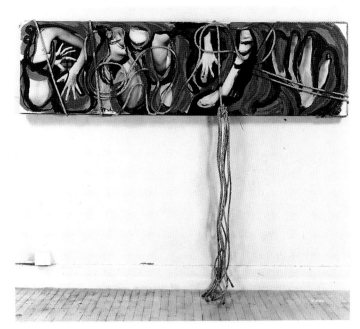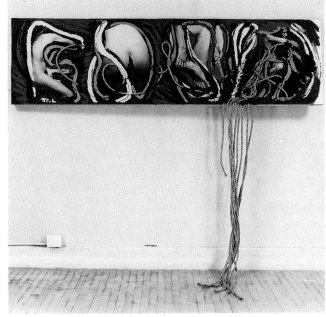

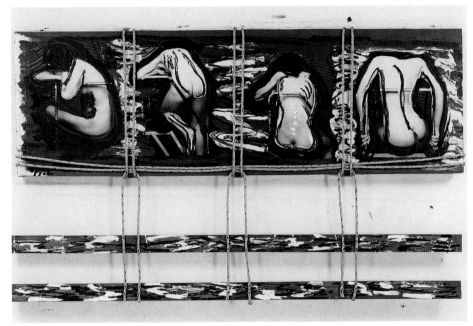

Titan Series No. 6. 1988. Acrylic, oilstick, Polaroid, rope, and wood, 27¾ × 100" (70.5 × 254 cm). Private collection, Amsterdam

Titan Series No. 7. 1988. Acrylic, oilstick, Polaroid, rope, and wood, 28¾ × 100" (70.5 × 254 cm)

Titan Series No. 8. 1988. Acrylic, oilstick, Polaroid, rope, and wood, 60 × 100" (152.4 × 254 cm). Polaroid Corporation, Cambridge, Massachusetts

Monument for Walt Whitman. 1989. Rope, mirror, plaster, and oil on wood, 104 × 21 × 91" (264.2 × 53.3 × 231.1 cm)

A Monument Called One White Flower for Pasolini. 1989. Plaster, terra cotta, plastic, aluminum cans, and acrylic on wood, 96 × 76 × 55" (243.8 × 193 × 139.7 cm)

Monument for García Lorca. 1989. Rope, mirror, plaster, and oil on wood, 108 × 21 × 54" (274.3 × 53.3 × 137.2 cm)

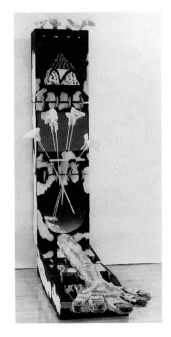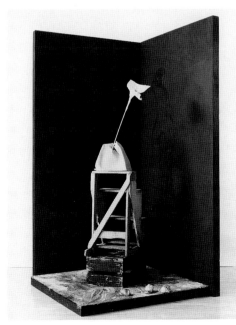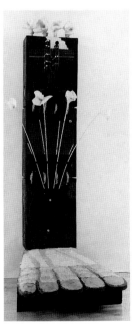

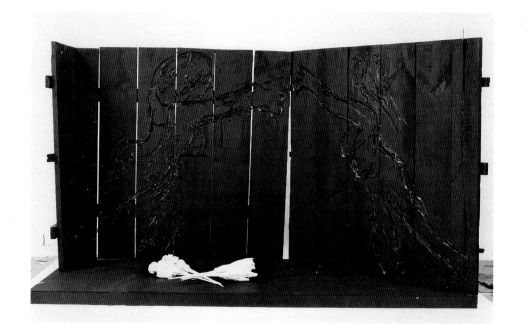

Farewell My Backyard with the White Smell of Daisies. 1989. Oil on wood and plaster flowers, 57×96×44″ (144.8×243.8×111.8 cm)

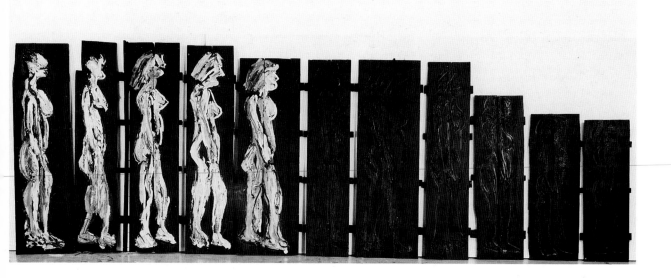

Walking Through the Shadow. 1989. Oil on wood, 80×232″ (203.2×589.3 cm)

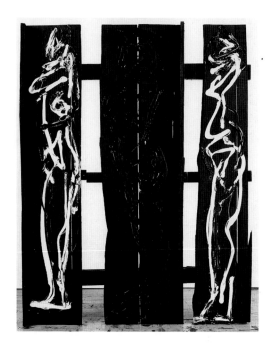
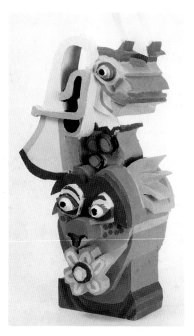
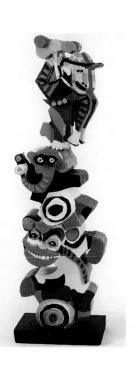

Three Nudes. 1989. Oil on wood, 62¾×48″ (159.4×121.9 cm)

Circus 1. 1978–90. Acrylic on foamcore (maquette), 36×16¾×14¾″ (91.4×42.5×37.5 cm)

Circus 2. 1978–90. Acrylic on foamcore (maquette), 49×13½×11″ (124.5×34.3×27.9 cm)

Circus 3. 1978–90. Acrylic on foamcore (maquette), 29½ × 14 × 7″ (74.9 × 35.6 × 17.8 cm)

Circus 4. 1990. Painted polystyrene foam, 157⅞ × 65 × 79⅞″ (401 × 165 × 203 cm). Fukutake Publishing Company, Japan

Black Flower. 1990. Plaster, mirror, rope, and acrylic on wood, 82 × 45 × 48″ (208.3 × 114.3 × 121.9 cm)

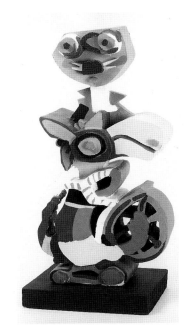
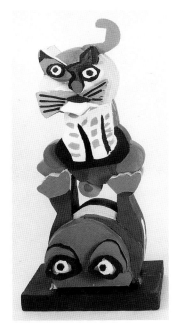
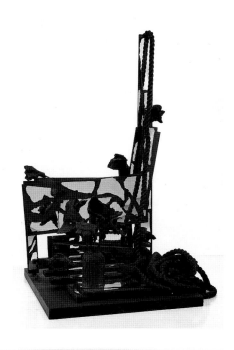

No Wind. 1990. Found objects, plaster, wood, acrylic, and oil on canvas, 92½ × 89⅞ × 19½″ (235 × 228.3 × 49.5 cm)

Still Life. 1990. Plaster, mirror, rope, and acrylic on wood, 46 × 29⅝ × 29¾″ (116.8 × 75.2 × 75.6 cm)

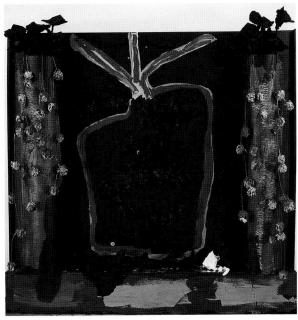

Flying Bird. 1991. Plaster, found objects, and wood, 59½ × 40½ × 17¾″ (151 × 103 × 45 cm)

Cat Standing on a Head. 1991. Plaster, brick, found objects, and wood, 58⅝ × 20¼ × 27½″ (149 × 51.5 × 70 cm)

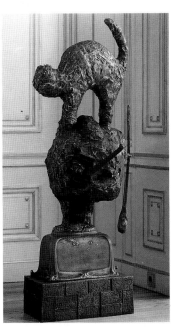
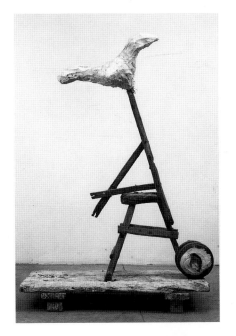

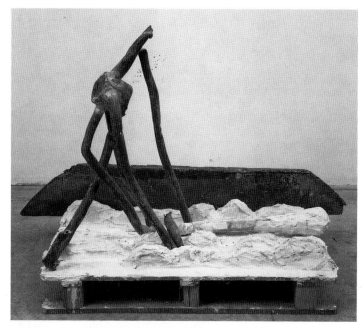

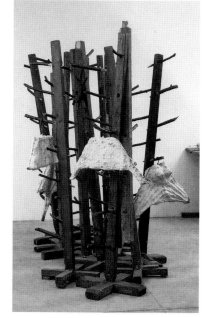

The Spider. 1991. Iron, plaster, brick, and wood, 36¼ × 51⅝ × 31¾″ (92 × 131 × 80.5 cm)

Forest. 1991. Plaster, found objects, and wood, 116⅛ × 80⅜ × 44⅞″ (295 × 204 × 114 cm)

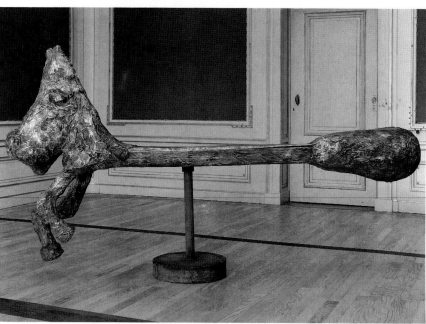

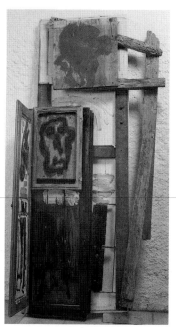

Horse. 1991. Plaster and wood with iron stand, approximately 63⅜ × 13¾ × 13¾″ (161 × 35 × 35 cm)

Window. 1991. Found objects and oil on wood, 89⅜ × 43¼ × 21⅞″ (227 × 110 × 55.5 cm)

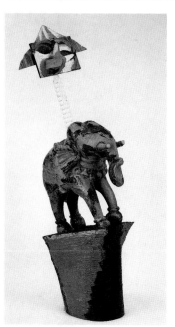

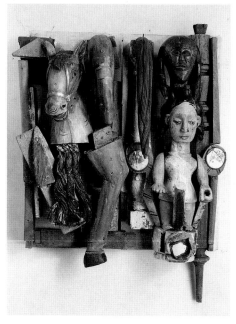

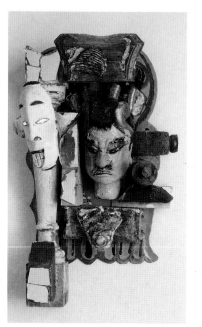

Elephant. 1992. Acrylic and oil on wood, height 50″ (127 cm). Kumar Family, India

Horsehead. 1992. Found objects, mirror, rope, and oil on wood, 32½ × 23 × 10″ (83 × 58.4 × 25.4 cm)

The Second Yawner. 1992. Found objects, mirror, and oil on wood, 19 × 10½ × 9½″ (48 × 26.6 × 24 cm)

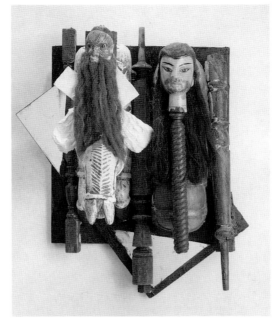

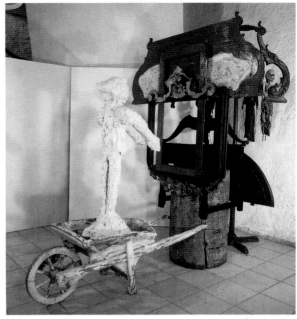

The Philosopher. 1992. Found objects,
mirror, plaster, and oil on wood,
33½ × 31 × 16″ (85 × 79 × 40.6 cm)

The Hanged. 1993. Found objects and oil on
wood, 82⅝ × 60⅝ × 96½″
(210 × 154 × 245 cm)

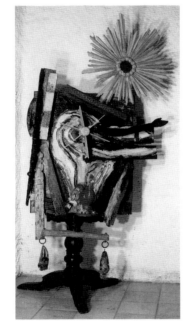

Sun with Rooster. 1993. Found objects and
oil on wood, 99⅝ × 61 × 35⁷⁄₁₆″
(253 × 155 × 90 cm)

50 Years of Pyre Series: Pyre I. 1993. Found
objects and oil on wood, 90½ × 82⅝ × 118⅛″
(230 × 210 × 300 cm)

50 Years of Pyre Series: Pyre II. 1993. Found
objects and oil on wood, 78¾ × 78¾ × 177⅛″
(200 × 200 × 450 cm)

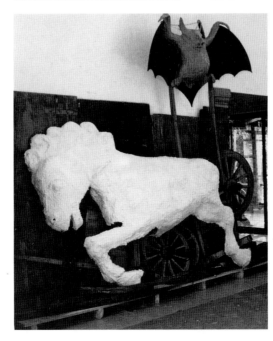

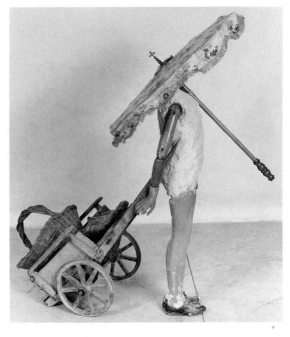

*50 Years of Pyre Series: Pyre for a Dead
White Horse.* 1993. Found objects, plaster,
and oil on wood, approximately
118⅛ × 196⅞ × 23⅝″ (300 × 500 × 60 cm)

Coming Down from the Mountains. 1993.
Found objects, plaster, and oil on wood,
approximately 59 × 59 × 19⅝″
(150 × 150 × 50 cm)

Notes

1. Charles Baudelaire, "A Philosophy of Toys," *The Painter of Modern Life and Other Essays,* ed. Jonathan Mayne (London: Phaidon, 1964), p. 199.

2. Lev Semenovich Vygotsky, *The Psychology of Art* (Cambridge, Mass.: MIT Press, 1971), p. 246.

3. Bruno Bettelheim, "The Importance of Play," *The Atlantic,* 259 (March 1987): 46. Accused of making art that is "not art" but "child's play," Appel replied: "Precisely. . . . We are trying to express the game-playing aspect of life." Quoted in *Karel Appel: Dupe of Being,* ed. Roland Hagenberg (New York: Edition Lafayette, 1989), p. 131. (Hereafter *Dupe of Being.*) Michel Ragon, *Karel Appel: The Early Years 1937–1957* (Paris: Editions Galilée, 1988), pp. 193, 202 points out that the "Dutch historian Johan Huizinga's *Homo Ludens,* published in 1939, had a salubrious effect on Appel's generation. Appel and his friends saw themselves as *homo ludens,* ludic men, gamesmen; in contrast to their *homo faber* compatriots, they believed in childhood, play, violence, tinkering, and fooling around."

4. Quoted in *Karel Appel: The Complete Sculptures 1936–1990,* eds. Roland Hagenberg and Harriet de Visser (New York: Edition Lafayette, 1990), p. 57. (Hereafter *Complete Sculptures.*)

5. Baudelaire, p. 199. Claude Estaban has used similar terms—"barbarian," "pagan"—to describe Appel's art. Quoted in Ragon, p. 522.

6. Quoted in Herschel B. Chipp, ed., *Theories of Modern Art* (Berkeley: University of California Press, 1968), p. 83.

7. Ibid., p. 84.

8. Quoted in Ragon, p. 377.

9. Speaking of the artists who have influenced him, Appel has said, in *Dupe of Being,* p. 245: "Although Van Gogh's canvases are strong with joyous color, you experience in them the tragedy of life. Picasso was a major inspiration for me, also Matisse for color, and from the Dadaist, Kurt Schwitters, I was influenced to utilize found objects." At the same time, after learning it all, he had to "forget it and start again like a child." He has also said (p. 154) that "the revolutionary canvases that Pollock had painted during the war . . . really were close to the spirit of CoBrA [COpenhagenBRusselsAmsterdam group], at least on the imaginative side." He felt the same about the work of de Kooning. "It's not the first time that men of the same period, though widely apart, have shared the same mentality and arrived at the same conclusions." Ragon, p. 439, quotes Appel as saying that "after the war CoBrA was the only new movement in Europe and in the world, aside from action painting."

10. Quoted in *Complete Sculptures,* p. 79.

11. It is worth asking why the bicycle inspired three major works of twentieth-century art. I think the reason is that the bicycle is the last toy or transitional object of childhood. That is, it is halfway between walking, in which the body is actively engaged, and riding in an automobile, the adult mode of passive transportation. The bicycle is a machine, but it is fueled by the body's energy, giving it immediate subjective consequence, in a way that the automobile, no matter how much one is emotionally invested in it, cannot equal. Moreover, the bicycle is not as functional and efficient a mode of transportation as the automobile, which also makes the bicycle like a toy. A toy is only nominally functional and efficient, however much it "works." Also, riding a bicycle is more playful—no doubt in part because one is freer to break traffic rules—as well as more physically strenuous than driving an automobile. Finally, the bicycle responds promptly to the rider's effort and direction, the way the artist's material seems to "respond" instantly to his very personal power and control. That is, the bicycle seems attuned to the individual the way an automobile never does. Thus, riding a bicycle unconsciously symbolized making art for Appel, Duchamp, and Picasso. They jumped at the chance to actually make art—literally chance art—out of it. Like the horse, the bicycle is a symbolic extension of phallic power, and thus of creativity. In using it, they were in effect toying with their creativity.

12. Quoted in *Complete Sculptures,* p. 79.

13. Baudelaire, p. 202.

14. Ibid., "The Painter of Modern Life," p. 7.

15. Ibid., p. 8.

16. Appel, *Dupe of Being,* p. 77, has said he "eagerly followed the experiments of youngsters in search for the reflex of war." I am playing upon the fact that Appel, along with Constant and Corneille, two other Dutchmen, was, in 1948, prior to the founding of CoBrA, a member of a group called "Reflex." In the second issue of the group's newspaper, also called *Reflex,* Corneille declared that "Life instills us with some emotions that remain with us forever." Art is in effect about these emotions, which is what gives it the vitality of life. In such art there is a "tireless struggle against all types of formalism." Quoted in Ragon, pp. 13, 15.

17. In other words, the toy is "transitional," in D. W. Winnicott's sense of the term, "between 'inner psychic reality' and 'the external world as perceived by two persons in common.'" "Transitional Objects and Transitional Phenomena," *Collected Papers: Through Paediatrics to Psychoanalysis* (London: Tavistock, 1958), p. 233. For Winnicott, it is in this in-between, hybrid space that culture develops and playing occurs, indeed, that culture develops out of playing. It is the space of creativity, which is always subjective and objective at once—that is, a matter of pleasurable making and painful reality testing, and of individual initiative and social playacting, brought to bear on the same given thing and task. Thus, art, insofar as it is cultural as well as "self-expressive," involves "the spontaneous gesture and personal idea" that comes from the True Self"—"closely linked with the idea of the Primary Process" and alone able to "be creative and . . . feel real," and thus, alive—and simultaneously the False Self, whose compliance to society serves to protect the True Self, which allows it to function freely, if also secretly. "Ego Distortion in Terms of True and False Self," *The Maturational Processes and the Facilitating Environment* (New York: International Universities Press, 1965), p. 148. Appel's sculptures, especially those of the late eighties and early nineties, are a superb example of art in that they use the found objects of the False Self—objects imprinted with a fixed form that implies they are in compliance with society—in the service of the True Self. That is, by handling them Expressionistically, Appel turns them into spontaneous gestures and personal ideas. They seem to be spontaneously generated by primary process rather than secondary logical matters. Where the child must move from subjectivity to objectivity, discovering and learning a reality that is not himself, the adult voluntarily uses art to recover a sense of the subjective reality of himself forgotten, even lost in complying, as he necessarily must do, to objective

reality. Unless the hidden child in him is allowed to come out and play creatively, as it can in effect do through the sublimated insanity of art, the adult will slowly but surely grow insane from compliance. Appel's art makes this reverse transition, as it were, with an astonishing directness and ease.

18. Baudelaire, "The Painter of Modern Life," p. 8.

19. I am alluding to Heinz Kohut's conception of "transmuting internalization." Kohut argues that psychological autonomy is achieved through a process of decathecting "those aspects of the object imago that are being internalized." *The Analysis of the Self* (New York: International Universities Press, 1971), pp. 49–50. I am arguing that a reversal of this process occurs in art in general and in Appel's art in particular, which forcefully repersonalizes introjects, to the extent of making them seem to have an objective life of their own.

20. Baudelaire, "The Painter of Modern Life," p. 8.

21. Andrew Samuels, *The Plural Psyche* (London: Routledge, 1989), p. 18.

22. Michele C. Stra,nerio, "Informal Song," *Diary of Ulysses at Roseland: The Sculpture of Karel Appel* (Turin: Edizioni d'arte Fratelli Pozzo, 1963), n.p.

23. Michael Eigen, *The Psychotic Core* (Northvale, NJ: Jason Aronson, 1986), p. 334, writes, in a remark with great relevance to Appel, that "Unintegration refers to the chaos of experiencing before it congeals into psychic formations that can be used defensively. It refers to a time or dimension of experiencing before the ability to split off and oppose aspects of the self to one another (particularly mind-body, thinking-feeling). It remains a state between organizations one can repair to, a kind of rest in which one forgets who one thinks one is, a moment's absentminded 'mystical' immersion in nothing in particular. [Such as a spontaneous, meandering gesture.] It is a letting go and clearing out. It is a relief to be rid of oneself and feel the deeper order unintegrated 'chaos' leads to. In it one senses a groping toward an 'original face.'" Eigen adds (p. 335): "This does not mean that one's original face is always 'pretty' or that there is no friction."

24. I am alluding to the famous sentence with which André Breton concludes his novel *Nadja* (New York: Grove Press, 1960), p. 160: "Beauty will

be CONVULSIVE or will not be at all."

25. Stranerio, "Informal Song," n. p.

26. Michel Tapié, "Appel's Total Adventure," *Dupe of Being*, p. 20. Tapié, p. 22, speaks of the new sense of "plenitude" that follows from such anarchy. Arthur Mitzman, "Anarchism, Expressionism and Psychoanalysis," *Passion and Rebellion: The Expressionist Heritage* (New York: Universe, 1983), pp. 55–80, is relevant in this context.

27. As Ragon, p. 167, says, for CoBrA, Mondrian and Magritte were the "foes."

28. Tapié, p. 21.

29. Appel, *Dupe of Being*, p. 105, says, describing his sense of chaos when he paints, that "it is my character to make the chaos positive.... We live always a tremendous chaos, and who can make the chaos positive anymore? Only the artist." This can be understood in terms of Eigen's remarks on inner chaos (note 23). Appel has also said (p. 592): "Today we no longer see any difference between chaos and freedom; that is, today a negative chaos holds sway over society, a social form is sinking into chaos. This is often mistaken for freedom. As for me, I work on the basis of a positive chaos; that is, I make use of chaos. I always start with chaos and, from there, I construct a form, something emerges halfway between chaos and order, and those forms, those expressions that occupy the median position represent the path of creativity ... the indeterminate gradually nurtures a certainty." Appel connects this regression to chaos and process of creation with antiart, but it is better understood through Winnicott's conception of transitional phenomena (note 17).

30. Ragon, p. 41, remarks that Appel's "joyous fecundity [is] reminiscent of Picasso."

31. Otto Rank, *Art and Artist* (New York: Norton, 1989), pp. 29–30, in the context of a discussion of tattooing and "artificial painting of the body," which are universal, quotes with approval E. von Sydow's assertion that "art rose, not in any isolated and self-contained work, but by the moulding of the human body, to a formative plasticity.... It is only when the art of the body has been perfected that it separates itself from the body and becomes self-dependent in a permanent work."

32. Robert Rousseau, quoted in Ragon, p. 439.

33. Claude Esteban, quoted in Ragon, p. 439.

34. See Ragon, p. 418, for a discussion of Appel's participation in "the two spectacular shows" Tapié "mounted in 1952 at the Paul Fachetti gallery [Paris]: *Signifiants de l'informel* (*Signifiers of the Informal*) and *Un art autre* (*An other art*)." Appel was also the only CoBrA artist featured by Tapié in *Un art autre,* a manifesto for an "other art" published "under the aegis of Dubuffet and Jean Fautrier, a violent, angrily temperamental, effusive, Tachist, informal, and matter-oriented art."

35. Quoted in Ragon, p. 448.

36. Ragon, p. 254, notes his 1949 characterization of *Reflex* as "the Dutch Experimental Group," as well as "the scandal of the Experimental Art show at the Stedelijk Museum" (p. 298), indicating Appel's early—not to speak of his continued—determination to experiment with the possibilities of art making.

37. Quoted in Ragon, p. 301.

38. His *Psychopathological Art* drawings, 1948, based on the art of the insane, are an explicit example of this interest.

39. Leonard Shengold, *Soul Murder* (New Haven: Yale University Press, 1989), p. 19, writes that "the capacity to destroy a soul hinges entirely on having another human being in one's power, and this confrontation of the powerful and the helplessly dependent is inherent in childhood ... psychic murder is founded on the relations between hostile, cruel, indifferent, psychotic, or psychopathic parents and the child prisoners in their charge." Soul murder ultimately involves, in Ibsen's words, quoted by Shengold, "killing the instinct for love."

40. I am alluding to the distinction Anton Ehrenzweig makes in *The Hidden Order of Art* (Berkeley: University of California Press, 1967) between a surface mode of perception composed of gestalten and a depth mode of perception that is gestalt-free. See John E. Gedo, *Portraits of the Artist, Psychoanalysis of Creativity and Its Vicissitudes* (New York: Guilford Press, 1983), pp. 30–34, for a discussion of this important distinction.

41. In "Ode to Red," *Dupe of Being,* pp. 358–63, Appel shows just how intensely and precisely he feels color.

42. See Ragon, pp. 302, 304, 307, for an account of the scandal the work caused. See also Christian Dotremont, "The Appel Affair," *Dupe of Being,* pp. 27–29.

43. Hannah Arendt, *Between Past and Future* (New York: Viking, 1961), p. 223, argues that culture and politics "belong together because it is not knowledge or truth which is at stake, but rather judgement and decision, the judicious exchange of opinion about the sphere of public life and the common world, and the decision as to what manner of action is to be taken in it, as well as how it is to look henceforth, what kind of things are to appear in it." Thus, she rhetorically asks (p. 215): "Could it be that taste belongs among the political faculties?"

44. In 1956, Appel said (*Dupe of Being,* p. 585): "I never try to make a painting; it is a howl, it is naked, it is like a child, it is a caged tiger." He has also said (p. 78) that "A painting is no longer a construction of colors and lines, but an animal, a night, a scream, a human being." For the Expressionist conception of the scream of chaos, see my "Chaos in Expressionism," *The New Subjectivism: Art in the 1980s* (Ann Arbor: UMI Research Press, 1988), pp. 81–92.

45. Kandinsky, of course, argued for the integration of color and sound in synesthesia, and wanted to make "musical" paintings. Appel's interest in jazz should be noted in this context. See his poem "Sentimental Saxophone," *Dupe of Being,* pp. 386–87, and his discussion of his relationship with jazz musicians in New York (pp. 585–86), where you can "howl a street poem in a nightclub" (p. 587).

46. Quoted in Chipp, p. 551. Theodor W. Adorno, *Aesthetic Theory* (London: Routledge & Kegan Paul, 1984), p. 326, notes "the tension between the general idea of a work of art . . . and the specific idea of the absolute scream" in Expressionism.

47. Gedo, p. 289.

48. Charles Baudelaire, "The Salon of 1846," *The Mirror of Art,* ed., Jonathan Mayne (Garden City, NY: Doubleday, 1956), p. 40, argued that art "is needed to restore the equilibrium of all parts of your being." He also asserted that "it is by feeling alone that art is to be understood."

49. Heinz Kohut, "'One Needs a Twinkle of Humor as a Protection Against Craziness,'" *Self Psychology and the Humanities* (New York: Norton, 1986), p. 244, argues that "Picasso's genuine work" shows "the restlessness of the search to put together the fragmented visual universe into some kind of cohesive form after it has fallen apart. . . . It is a

genuine description of an inner state. . . . You might say that it is discontinuity or fragmentation itself that characterizes 20th century art . . . but that is what gives it unity." Kohut also argues (p. 83) that "what moves society toward health is that of creative individuals in religion, philosophy, art, and in the sciences concerned with man." But unless "these 'leaders' are in empathic contact with the illness of the group self and, through their work and thought, mobilize the unfulfilled narcissistic needs and point the way toward vital internal change," there will be no healing. Kohut regarded the experimental artists of the Weimar Republic as lacking empathy for their German public, and thus indirectly responsible for the rise of Nazism, if far from its most important cause (p. 89).

50. Pierre Restany, "Street Art," *Dupe of Being,* p. 281.

51. Ludwig von Bertalanffy, *General System Theory* (New York: George Braziller, 1968), pp. 190–93, posits a basic conflict between robot and humanistic/organismic conceptions of man in twentieth-century thinking.

52. Appel, *Dupe of Being,* p. 589.

53. Ibid., p. 583.

54. R. M. Simon, *The Symbolism of Style* (London: Tavistock/Routledge, 1992), p. 8.

55. Ibid., p. 88.

56. Ibid.

57. See Clement Greenberg, "The New Sculpture," and "Modernist Sculpture, Its Pictorial Past," *Art and Culture* (Boston: Beacon, 1965), pp. 139–47, 158–63.

58. Appel, *Dupe of Being,* p. 140, remarks that "it was when I came across the self-destructive forms of Picasso that I got a real shock! They made me feel our whole civilization was in the process of blowing up." However, the influence of Picasso on Appel shows in his tamer anatomies, rather than in his catastrophic ones, which are more his own.

59. Restany, p. 283, describes "the Rabelaisian and casual frenzy" with which Appel makes his "modern carnival of Street Art." Marshall McLuhan, *Dupe of Art,* pp. 318–19, writes that Appel's works belong to the tradition of "the folk carnival, with its quality of belonging to the whole people," and asserts that "nobody . . . has done more than Karel Appel to deepen and enrich the spirit of folk carnival in our time."

60. Appel, *Dupe of Being,* p. 377.

61. D. W. Winnicott, "Psycho-Neurosis in Childhood," *Psychoanalytic Explorations* (Cambridge, Mass.: Harvard University Press), p. 71.

62. Appel, *Dupe of Being,* p. 594.

63. Ibid., p. 577. See also Ragon, pp. 44, 46.

64. Ibid., p. 595.

65. Ibid., p. 584.

66. Eigen, p. 27.

67. Tapié, *Dupe of Being,* p. 20.

68. Eigen, p. 28.

69. Ibid.

70. However, Eigen, pp. 28–29, notes that the psychotic's "dramatic fluctuations and constrictions of the sense of self and other . . . may seem to approximate the plasticity of infantile experience [but] is a cruel caricature of it." The psychotic is in fact too rigid to have "the infant's openness to grow through shifts in the quality of moment to moment interactions."

71. Joseph Sandler, "The Background of Safety," *From Safety to Superego* (New York: Guilford, 1987), p. 3, argues that there is "a 'perception work' corresponding to the 'dream work'" in that the ego modifies "incoming stimulation in exactly the same way as it modifies latent dream thoughts and transforms them into manifest content." Such perception work is "perhaps the most convenient way of heightening safety feeling" (p. 5), and can perhaps be regarded as basic to art. However, modern experimental art deliberately undoes it, which is part of its risk-taking and insanity.

72. Appel, *Dupe of Being,* p. 599.

73. Ibid., p. 92.

74. Adorno, p. 65, argues that "the tendency that proved most fruitful was for works to side with one of the extremes rather than to try and mediate between them." But that was true of early modernism. Today, such purity has become sterile, and only what Adorno calls "synthesis"—"the dialectic of [Expressionistic] mimesis and construction"—is creatively legitimate and can bear artistic fruit.

75. Ibid., p. 84.

76. Ibid., p. 85.

77. Ibid.

78. Ibid., p. 224.

79. Appel, *Complete Sculptures*, p. 87.

80. Appel, *Dupe of Being*, p. 246.

81. Martin Esslin, "Introduction: The Absurdity of the Absurd," *The Theater of the Absurd* (Garden City, NY: Doubleday, 1961), pp. xix–xx, notes that the "sense of metaphysical anguish at the absurdity of the human condition" motivates the theater of the absurd. However, while it shares this "sense of the senselessness of life" and "the irrationality of the human condition" with existentialism, it differs in that it tries "to achieve a unity between its basic assumptions and the form in which these are expressed," which must also be irrational and senseless.

82. Baudelaire, "The Salon of 1859," *The Mirror of Life*, p. 235.

83. Janine Chasseguet-Smirgel, *Creativity and Perversion* (London: Free Association Books, 1986), seems to regard perversion as the essence of creativity, as when she argues (p. 2) that it involves the "erosion of the double difference between the sexes and the generations" (one has only to think of Appel's titans), and thus the "hubris" of creating "the hybrid" of "the forbidden mixture" (p. 6). In general, she believes that "perversion represents a . . . reconstitution of Chaos, out of which there arises a new kind of reality, that of the anal universe" (p. 11). The problem is that she does not understand the necessity for the perverse creation of the carnival of chaos as a means of individual survival in a world which has too many false social, supposedly lawful, differences—too many artificial phallic powers drawing their lines in the dust and saying one cannot cross them—and a world that is already an anal folly.

Chronology

1921

Born in Amsterdam on April 25.

1936

Takes first painting lessons from his uncle.

As a young artist he is influenced by Walt Whitman's *Leaves of Grass,* and later, by Comte de Lautréamont's "The Songs of Maldoror" and the teachings of Krishnamurti.

1942–44

Studies at the Royal Academy of Fine Arts, Amsterdam.

Becomes friend of fellow student Corneille.

1946

Visits Denmark, where he meets the Danish painters who later will be members of the CoBrA group.

1947

First meeting with Willem Sandberg, director of the Stedelijk Museum, Amsterdam.

Creates a series of relief works by mounting found objects on wood.

In autumn, Appel and Corneille spend some time in Paris. Toward the end of 1947, they meet Constant in Amsterdam.

1948

On June 16, with Constant and Corneille, Appel helps to found the Dutch Experimental Group in Amsterdam.

The group publishes the periodical *Reflex.* Two issues appear.

The Dutch Experimental Group merges into the International CoBrA group, founded on November 8, at the Café de l'Hôtel Notre Dame in Paris, by Dotremont and Noiret (Belgium), Jorn (Denmark), and Appel, Constant, and Corneille (Netherlands).

In November–December, Appel, Constant, and Corneille participate in the "Höst-Group" exhibition in Copenhagen.

1949

March, publication of periodical *CoBrA* edited by Jorn and the Belgian poet Christian Dotremont.

Commissioned to paint the mural *Questioning Children* for the cafeteria of the Amsterdam City Hall. After a public outcry, the city council orders the mural covered over with whitewash. Architect Aldo van Eyck publishes *An Appeal to the Imagination* in defense of Appel's work.

"International Exhibition of Experimental Art," first CoBrA exhibition in Amsterdam, at the Stedelijk Museum, organized by Willem Sandberg and designed by Aldo van Eyck. Among the artists: Appel, Constant, Corneille, Jorn, and twenty-nine other artists from ten countries.

1950

Appel settles in Paris.

1951

Paints the *Appel-bar* at the Stedelijk Museum, Amsterdam.

1952

First meeting with the French avant-garde critic Michel Tapié, who later introduces the artist to the Martha Jackson Gallery in New York.

1953

First meeting with J. J. Sweeney, director of the Guggenheim Museum, New York.
Included in the São Paulo Biennale.
Spends the summer in Albisola, on the Italian Riviera, where he creates ceramic reliefs.

1954

Wins the UNESCO prize at the XXVII Venice Biennale for the painting *Wild Horse*.
Michel Tapié organizes a one-man exhibition at Studio Paul Facchetti, Paris.
Martha Jackson presents the artist's first American one-man exhibition at her New York gallery.

1955

Commission by architects Van Dan Broek and Bakema to paint a one-hundred-meter-long brick wall titled *Wall of Energy* for the exhibition "The Vitality of Rotterdam," the Netherlands.

1956

The Amsterdam Stedelijk Museum commissions a mural for its new restaurant.

1957

First meeting with Alfred Barr, director of the Museum of Modern Art, New York, and Sir Herbert Read, director of the Institute of Contemporary Arts, London.
Takes first trip to the United States and Mexico.
Awarded prize for best nonfigurative painter at the tenth "Premio Lissone" exhibition in Italy.
Using stained glass for the first time, he makes six windows depicting Genesis for the Paaskerk Church in Zaandam, the Netherlands.
Wins the International Prize for Graphics at the Ljubljana Biennale.

1958

Commission for a painting mounted as a mural in the restaurant of the UNESCO building in Paris.

1959

Wins the Grand Prize for Painting at the Fifth São Paulo Biennale.

1960

Becomes youngest artist ever to receive the Guggenheim Award for the Netherlands, and the Guggenheim International Award for the painting *Woman with Ostrich*, which was purchased by the Stedelijk Museum in Amsterdam.

174

Appel's sculpture studio at Abbey de Roseland, Nice, 1960

Appel at his studio, Molesme, France, 1968

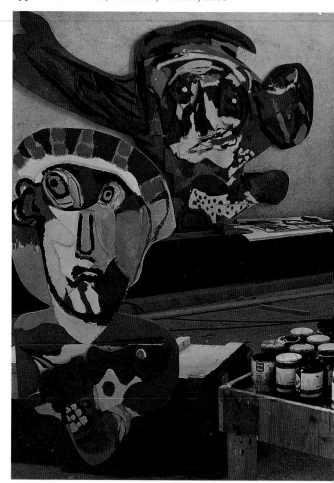

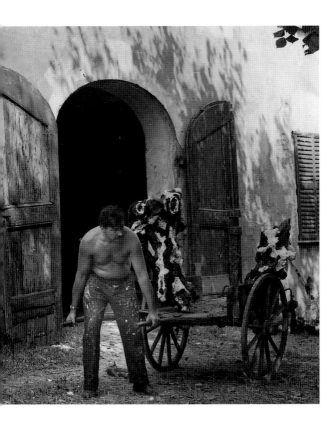

1961

First color film on the artist, *The Reality of Karel Appel,* made by Jan Vrijman with music by Dizzy Gillespie and Karel Appel.

Begins sculpting and painting trunks of olive trees at l'Abbaye de Roselande in the south of France.

1962

Makes set designs for theater piece *Een groot dood dier (A big dead beast)* by Bert Schierbeek in the Netherlands.

Publication of *Het dier heeft een mens getekend (A beast-drawn man),* a portfolio with text by Bert Schierbeek and lithographs by Appel.

1963

Incorporates plastic toys in his paintings.

Commission by Paulo Marinotti to create an entire room for the exhibition "Vision and Color" at the Palazzo Grassi, Venice, using silk drapery on ceiling, walls, and floor.

Commission by Harry N. Abrams, Inc., Publishers to make *Love Song,* "The Largest Art Book in the World," with poems by Hugo Claus and lithographs by Karel Appel.

1964

Acquires and substantially renovates the Château de Molesmes near Auxerre in France, creating several large studios.

1965

Begins large polychrome reliefs and free-standing figures in wood and polyester.

1967

Commission by architect Oud to create two ceramic walls *City People and Country People* for the Congress Building in The Hague.

1968

Title of Knight of the Orange-Nassau Order conferred by Queen Juliana of the Netherlands.

Commission by architect Maaskant to make a concrete and stained-glass relief for the Mamoet School, Rotterdam, the Netherlands.

1970

Records music compositions in collaboration with Merrill Sanders, Chet Baker, and other musicians and singers in San Francisco.

1971

In the United States, undertakes first series of large-scale sculptures in polychrome aluminum.

1976

With help of shantytown residents of Villa El Salvador, creates murals near Lima, Peru. A color film was then made of this event.

Makes and installs monumental polychrome-aluminum sculpture for the City University of Dijon, France, entitled *Anti-Robot*.

Creates *Appel Circus*, consisting of thirty hand-printed color etchings and fifteen hand-painted wooden sculptures.

Collaborates with Alechinsky in creating works on paper which will be published in the book *Two Brush Paintings*, with poems by Hugo Claus.

1977

Sells the Château de Molesmes and his studio in Paris.

Donates entire graphics collection to the city of Hamilton, Ontario, and is made an honorary citizen.

Begins a series of paintings using a flat brush in rectangular strokes, rhythmically arranged across the canvas, depicting landscapes, still lifes, and later, figures.

1980

Appel begins his series of window paintings. In these compositions, he produces the most abstract and contemplative paintings to date.

1981

New themes in his paintings emerge from his experience seeing the decay and poverty in the streets of New York.

1982

In May, collaborates with the writer José Arquelles and the poet Allen Ginsberg in creating a series of paintings and visual poems, which are later exhibited as part of "On the Road: The Jack Kerouac Exhibit" at the Boulder Center for the Visual Arts, Colorado.

1983

Begins a new series, Apocalyptic Cloud Paintings, and creates the windmill sculptures.

1984

Awarded *le Grand Prix du Salon* by the XXIX Salon de Montrouge, Paris.

1985

Begins the Nude Series on paper.

1986

Awarded *Commandeur de l'Ordre des Arts et des Lettres* by the Minister of Culture, France.

1987

Executes six sculptures (nine to thirteen feet high) using life-size Polaroid photographs, rope, and acrylic on wood. He will also use this technique in a series of paintings.

Commission by the Paris Opera, and given carte blanche to conceive and design a ballet in collaboration with the Japanese dancer and choreographer Min Tanaka and the Vietnamese composer Dao.

176

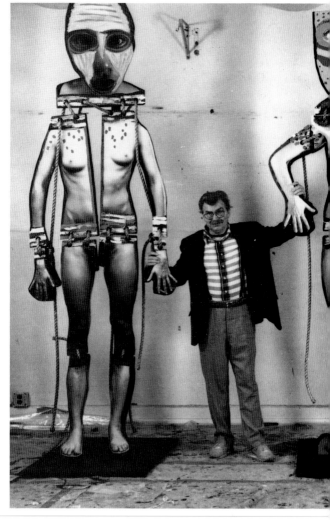

Appel with works from his Standing Nude series, 1987

Appel at work on wooden sculpture, 1993

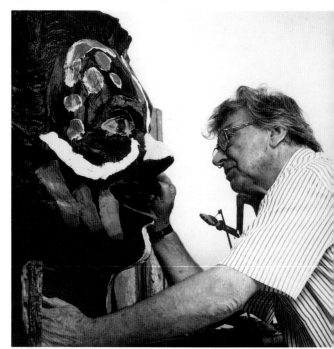

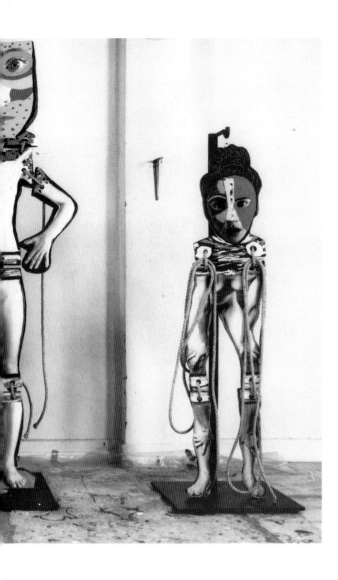

Commission to make a sculpture on the theme of the flag for the exhibition "Beelden en Banieren," conceived and organized by Rudi Fuchs at Fort Asperen, the Netherlands.

1988
Visits China, resulting in the Gobi Desert Series.

1989
Can We Dance a Landscape? is performed at the Brooklyn Academy of Music, Next Wave Festival, New York.
Begins a series of black paintings, followed later by all-white paintings.
Collaborates with the children of Hiroshima to make a mural for their city.
Creates three monument-sculptures dedicated to García Lorca, Pasolini, and Walt Whitman.

1990
Commission to make sculpture for the Naoshima Sculpture Park, Japan.
Collaborates with Min Tanaka at the Summer Art Festival in Hakushu, Japan.

1991
Creates Poetry-Painting Series with Allen Ginsberg and Gregory Corso.
Begins working on sculptures in wood and plaster with found objects.

1992
Collaborates with the architect Aldo van Eyck, in his commission for an art center in Middelburg, the Netherlands.

1994
Commission by De Nederlandse Opera to direct the opera *Noach* in collaboration with the dancer Min Tanaka, the composer Guus Jansen, and the librettist Friso Haverkamp.
Can We Dance a Landscape? is performed at Het Musiek Theater, Amsterdam.

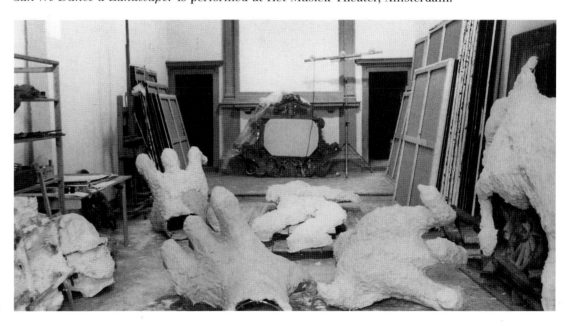

Appel's sculpture studio, summer 1993

Exhibition History

Selected Solo Exhibitions

1946
Beerenhuis, Groningen, the Netherlands

1947
Guildhall, Amsterdam

1951
Kunstzaal Van Lier, Amsterdam

1952
Kunstcentrum Het Venster, Rotterdam

1953
Palais des Beaux-Arts, Brussels

1954
First American Exhibition, Martha Jackson Gallery, New York
Appel, Studio Paul Facchetti, Paris

1955
Karel Appel, Stedelijk Museum, Amsterdam, and Galerie Rive Droite, Paris

1956
Stedelijk Museum, Amsterdam
Stedelijk Museum Schiedam, the Netherlands
Galerie Rive Droite, Paris

1957
Appel, Galerie Stadler, Paris
Galerie Espace, Haarlem, the Netherlands
Paintings: Karel Appel, Institute of Contemporary Art, London
Appel: New Paintings, Martha Jackson Gallery, New York
Paintings and Creative Portraits, Martha Jackson Gallery, New York

1958
Palais des Beaux-Arts, Brussels

1959
Gimpel Fils Gallery, London
Karel Appel, Galerie Charles Lienhard, Zurich
Musée d'Art et d'Histoire, Neuchâtel, Switzerland

1960
Karel Appel, Galerie Rive Droite, Paris
Gimpel Fils Gallery, London
Appel, Martha Jackson Gallery, New York
Galerie Rudolf Zwirner, Essen, Germany

1961
Galerie d'Art Moderne, Basel
Karel Appel Retrospective, organized by Dr. Thomas Levitt of the Pasadena Art Museum, California. Traveled to: San Francisco Art Museum; Pasadena Art Museum, California; Phoenix Art Museum, Arizona; Santa Barbara Art Museum, California;

Seattle Art Museum; La Jolla Art Museum, California; Stedelijk Van Abbe Museum, Eindhoven, the Netherlands; Haags Gemeente Museum, The Hague

1962
Karel Appel, Gimpel Fils Gallery, London
Karel Appel: Sculptures, Galerie Rive Droite, Paris
Karel Appel Collage 1949–1962, Galerie Charles Lienhard, Zurich
Karel Appel Paintings 1951–1956, Stephen Hahn Gallery, New York

1963
Appel Nus, Galerie Gimpel and Hanover, Zurich. Traveled to: Galerie Europe, Paris; Gimpel Fils Gallery, London; Martha Jackson Gallery, New York
Appel, Galerie Nova Spectra, The Hague

1964
Esbjerg Kunstpavillion, Denmark
Gimpel Fils Gallery, London
Toy Painting Series, Martha Jackson Gallery, New York
Appel, Galleria Blu, Milan
Appel Nudes, Stephen Hahn Gallery, New York
Appel, American Art Gallery, Copenhagen

1965
Kunstallen, Göteborg, Sweden
Leopold-Hoesch-Museum der Stadt Duren, Germany
Appel, Palais des Beaux-Arts, Brussels
Stadtisches Museum, Bochum, Germany
Statens Museum for Kunst, Copenhagen
Karel Appel, Stedelijk Museum, Amsterdam
Moderna Museet, Stockholm
Karel Appel: Paintings 1951–56, Donald Morris Gallery, Detroit
Karel Appel, Provinciaal Museum, 's-Hertogenbosch, the Netherlands

1966
Paintings 1947–65, Karel Appel, Moderna Museet, Stockholm
Karel Appel, Galerie Wolfgang Katterer, Munich

1967
Martha Jackson Gallery, New York

1968
Karel Appel 1966–68, Centre National d'Art Contemporain, Paris
Stedelijk Museum, Amsterdam

1969
Acrylics, Gimpel Fils Gallery, London
Acrylics, Gallery Gimpel and Hanover, Zurich
New Paintings and Sculptures, Martha Jackson

Gallery, New York
Stephane Janssen Gallery, Brussels

1970
Retrospective "Appels Oogappels," Centraal Museum Utrecht, the Netherlands
Lithographs, Kunstmuseum Winterthur, Switzerland
Richard Gray Gallery, Chicago

1971
Karel Appel: Aluminum Sculptures and Reliefs, Martha Jackson Gallery, New York
The Chelsea People Series, Martha Jackson Gallery, New York
New Editions, Martha Jackson Graphics, New York
Lithographs, Philadelphia Academy of the Fine Arts
Karel Appel, Galleria d'Arte Rinaldo Rotta, Milan
Karel Appel, Galerie Moderne, Silkeborg, Denmark

1972
Appel's Appels, Musée d'Art Contemporain, Montreal. Traveled to: Rothman's Art Gallery of Stratford, Ontario; Art Gallery of Greater Victoria, British Columbia; Edmonton Art Gallery, Alberta; Winnipeg Art Gallery, Manitoba; Art Gallery of Ontario, Toronto; Dalhousie University Art Gallery, Halifax, Nova Scotia; Art Gallery of Hamilton, Ontario; London Public Library and Art Museum, Ontario
Karel Appel's One-Man Exhibition, Galerie Allen, Vancouver

1973
Appel's Appels, New York Cultural Center in association with Fairleigh Dickinson University
The Early Fifties, Martha Jackson Gallery, New York
Karel Appel Recent Works, Aberbach Fine Art, New York

1974
Karel Appel Retrospective, Museum of Art, Fort Lauderdale, Florida
Karel Appel Retrospective, Oklahoma Arts Center, Oklahoma City
Karel Appel Retrospective, Phoenix Art Museum
Gimpel Fils Gallery, London
Appel, Quadrum Galeria de Arte, Lisbon
Appel, Galerie Ariel, Paris

1975
Appel: Paintings, Wildenstein Gallery, London
Fuji Television Gallery, Tokyo

1976
Karel Appel 1950–1975, Galerie Nova Spectra, The Hague
Appel, Gallery Moos, Toronto
Karel Appel, Gloria Luria Gallery, Miami

Karel Appel, Galerie Nova Spectra, The Hague
Karel Appel, Gallery Collection d'Art, Amsterdam

1977
Karel Appel: The Complete Graphic Works, Art Gallery of Hamilton, Ontario
Karel Appel Retrospective, Museo de Arte Moderno, Mexico City
Palm Springs Desert Museum, California
Prints, Fuji Television Gallery, Tokyo
Karel Appel Mange Ansigter, Galerie Moderne, Silkeborg, Denmark
Karel Appel: Forty Recent Paintings, Foundation Veranneman, Kruihouten, Belgium
Appel, Galerie Ariel, Paris
Karel Appel, Gallery Collection d'Art, Amsterdam

1978
Karel Appel Retrospective, Museo de Bellas Artes, Caracas; Museu de Arte Moderna de São Paulo; Museu de Arte Moderna do Rio de Janeiro; Museo de Arte Moderno, Bogotá, Colombia; Galerias del Palacio de Bellas Artes, Mexico City
Thirty Years of Karel Appel, Saarland Museum, Saarbrücken, Germany. Traveled to: Museum Van Bommel-Van Dam, Venlo, the Netherlands; Rheinisches Landesmuseum Bonn, Germany; Kunsthalle Wilhemshaven, Germany; Kunstpavillonen, Esbjerg Kunstforening, Denmark
Karel Appel Peintures et Sculptures, Château de Jau, Cases-de-Pène, France

1980
Karel Appel Recent Work, Hokin Gallery, Palm Beach, Florida
Karel Appel: New Style, Galerie Nova Spectra, The Hague

1981
Appel, Museu de Arte Moderna de São Paulo; Museu de Arte Moderna do Rio de Janeiro; Fondation Calouste Gulbenkian, Lisbon
Paintings from the 50's and 60's, Gimpel Fils Gallery, London
Apropos de l'Exposition des Gouaches Recentes de Karel Appel, Galerie Ariel, Paris
Exhibition for Appel's 60th Birthday, Galerie Nova Spectra, The Hague

1982
The New Work of Karel Appel, Paintings 1979–1981, Museum Boymans-van Beuningen, Rotterdam
Karel Appel, Objets Trouvés 1948–1953, Gouaches 1982, Galerie Michel Delorme, Paris
Biblioteca Nacional, Madrid
Works on Paper, Haags Gemeente Museum, The Hague. Traveled to: Staatliche Kunsthalle Baden-Baden, Germany; Städtische Galerie, Erlangen, Germany; Fries Museum, Leeuwarden, the Netherlands; Palazzo Medici-Riccardi, Florence; Liljevalchs Konsthall, Stockholm; Musée des Augustins, Toulouse; Henie-Onstad Kunstsenter, Oslo; Kunstforeningen, Copenhagen

1984
Karel Appel, Listasafn Islands, Reykjavik, Iceland
Karel Appel Recent Work, Palais des Beaux-Arts, Brussels

1985
Karel Appel 1984–1985, Galerie Rudolf Zwirner, Cologne
Karel Appel: CoBrA Paintings 1948–1951, James Goodman Gallery, New York
Appel, The Contemporary Art Gallery, Tokyo

1986
Recent Paintings, Marisa del Re Gallery, New York
Karel Appel Paintings 1980–1985, Arnolfini Gallery, Bristol, England. Traveled to: The Douglas Hyde Gallery, Dublin
Recent Paintings & Sculptures: Clouds, Windmills, Nudes and other Mythologies, Museum of Art, Fort Lauderdale, Florida

1987
Karel Appel, 40 Ans de Peinture, Sculpture et Dessin, Galerie d'Art Contemporain and Galerie des Ponchettes, Nice
Karel Appel, Dipinti, Sculpture e Collages, Castello di Rivoli, Turin, Italy
Karel Appel, Recent Paintings and Sculptures, Marisa del Re Gallery, New York
Karel Appel, Musée de l'Hospice Saint-Roch, Issoudun, France

1988
Karel Appel, Galerie Beyeler, Basel
Karel Appel, Portraits from the Titan Series, Marisa del Re Gallery, New York
Karel Appel, Gallery Guy Pieters, Knokke, Belgium
Karel Appel Portraits, Galerie de France, Paris
Karel Appel, Gallery Moos, Toronto
Karel Appel Retrospective Exhibition, Paris Art Center

1989
Karel Appel CoBrA, Marisa del Re Gallery, New York
Appel, National Museum of Art, Osaka, Japan. Traveled to: The Seibu Museum of Art, Tokyo; Tochigi Prefectural Museum of Fine Arts, Japan; Hiroshima City Museum of Contemporary Art; Hakone Open-Air Museum, Japan
Karel Appel in Tokyo, Fuji Television Gallery, Tokyo

1990
Karel Appel Sculptures and Paintings, U.M.B.C., Baltimore

Karel Appel, Ik wou dat Ik een Vogel was (Karel Appel, If I Were a Bird), Haags Gemeente Museum, The Hague. Traveled to: Josef-Haubrich-Kunsthalle, Cologne; Fundación Joan Miró, Barcelona; and Neue Galerie der Stadt Linz, Austria
Large-Scale Paintings, Beurs van Berlage, Amsterdam
Karel Appel Works on Paper, Gallery Urban, New York

1991
Karel Appel Black & White Paintings, Marisa del Re Gallery, New York
Karel Appel Recent Works, Gallery Delaive, Amsterdam

1992
Karel Appel, André Emmerich Gallery, New York

1993
Singing Donkeys, New Sculptures by Karel Appel, Paleis Lange Voorhout, The Hague

1994
Karel Appel Retrospective, The National Museum of Contemporary Art, Seoul, Korea. Traveled to: Kaohsiung Museum of Fine Art, Taiwan
The Many Sides of Karel Appel, Museum of Art, Fort Lauderdale, Florida
Karel Appel, Galleria Bergamini, Milan

Selected Group Exhibitions

1946
Young Painters, Stedelijk Museum, Amsterdam

1948
Constant, Appel, Corneille, Kunsthandel Sante Landweer, Amsterdam
International Experimental Art Exhibition, Hostudstillingen, Copenhagen
Journées d'Etudes du Centre International de Documentation sur l'Art d'Avant-Garde, Jean Bard Galerie, Paris

1949
International Exhibition of Experimental Art, Stedelijk Museum, Amsterdam. Traveled to: Hostudstillingen, Copenhagen

1950
CoBrA, Expression in Non-figuration, Problems and Tendencies of Art Today, Librairie 73, Paris

1951
Dutch Painting and Graphic Art of the 20th Century, Museum am Ostwall, Dortmund, Germany

Ten Modern Painters from Holland, Curaçao, Netherlands Antilles
Second International Exhibition of Experimental Art-CoBrA, Musée des Beaux-Arts, Liège, Belgium
Significance of the Informal, Galerie Paul Facchetti, Paris

1952
A Different Art, Galerie Paul Facchetti, Paris
Some Aspects of Modern Dutch Painting, Redfern Gallery, London
Salon 1952, Musée de l'Art Wallon, Liège, Belgium
Contour 1952, Stedelijk Museum Het Prinsenhof, Delft, the Netherlands
Carnegie Institute, Pittsburgh

1953
Salon de Mai, Palais du New York, Paris
17th Biennial Watercolor Exhibition, Brooklyn Museum, New York
2nd Biennale, Museu de Arte Moderna de São Paulo
Younger European Painters: A Collection, Solomon R. Guggenheim Museum, New York. Traveled to: Walker Art Center, Minneapolis; Portland Art Museum, Oregon; San Francisco Museum of Art; Dallas Museum of Fine Arts; University of Arkansas, Fayetteville; The Dayton Art Institute, Ohio; Addison Gallery of American Art, Phillips Academy, Andover, Massachusetts; Carpenter Art Galleries, Dartmouth College, Hanover, New Hampshire; Dwight Art Memorial, Mount Holyoke College, South Hadley, Massachusetts; Davidson Art Center, Wesleyan University, Middletown, Connecticut

1954
Collection Dotremont, Stedelijk Museum, Amsterdam. Traveled to: Stedelijk Van Abbe Museum, Eindhoven, the Netherlands
Pintura Contemporanea de los Paises Bajos, Montevideo, Uruguay
27th Biennale, Dutch Pavillion, Venice
Cazatteri della Pittura d'Oggi, Galleria di Spazio, Rome
Liège Collects Art, Stedelijk Van Abbe Museum, Eindhoven, the Netherlands
Individualités d'Aujourd'hui, Galerie Rive Droite, Paris
Galerie Marcel Evrard, Lille, France
Sezession 1954, Städtisches Museum, Schloss Morsbroich, Leverkusen, Germany
International Meeting of Albisola, 10th Triennial, Milan
Fru Elise Johansens Samling, Statens Museum for Kunst, Copenhagen

1955
Expressionism 1900–1955, Walker Art Center, Minneapolis. Traveled to: Institute of Contemporary Art, Boston; San Francisco Museum of Modern Art; Cincinnati Art Museum and Contemporary Arts Center; Baltimore Museum of Art; The Buffalo Fine Arts Academy
The New Decade, Museum of Modern Art, New York
International Exhibition, Milan
Eindhoven Collects, Stedelijk Van Abbe Museum, Eindhoven, the Netherlands

1956
Esthetique en devenir, Barcelona
Young Art from Holland, Kunsthalle Bern
New Trends in Painting, Arts Council of Britain, London
Contour 1956, Stedelijk Museum Het Prinsenhof, Delft, the Netherlands
Contemporary Dutch Art, Toledo Museum of Art, Ohio. Traveled to ten United States cities
Expressions et Couleurs, Galerie Stadler, Paris
New Aspects of Space, Martha Jackson Gallery, New York
Sixty-Sixth Annual Exhibition, University of Nebraska
Facetten 2, Haags Gemeente Museum, The Hague

1957
First Graphic Biennial, Museum of Modern Art, Tokyo
An Exhibition of Paintings from The Solomon R. Guggenheim Museum, New York, Solomon R. Guggenheim Museum, New York. Traveled to: Haags Gemeente Museum, The Hague; Ateneumin Taidemuseo, Helsinki; Galleria Nazionale d'Arte Moderna, Rome; Wallraf-Richartz-Museum, Cologne; Musée des Arts Decoratifs, Paris
Portrait Painters of the 19th and 20th Century, Munson-Williams-Proctor Institute, New York. Traveled to: Baltimore Museum of Art; Dallas Museum of Fine Art; Colorado Springs Fine Arts Center
International Art of a New Era, Festival of Osaka, Japan
Collection Urvater, Rijksmuseum Kröller-Müller, Otterlo, the Netherlands. Traveled to: Musée des Beaux-Arts, Liège, Belgium
10th Premio Lissone, Lissone, Italy
Art Autre, Tokyo. Traveled to: Sala Gaspar, Barcelona; Museo de Arte Contemporaneo, Madrid
Salon de Mai, Paris
Biennale de Paris, Paris

1958
Contemporary Art, The Buffalo Fine Arts Academy
Collection of Solomon R. Guggenheim, Musée des Arts Decoratifs, Paris

1959
Kring Spontanismen, Stockholm
Oils on Paper and Gouaches, Gimpel Fils Gallery, London
Fifteen Painters in Paris, Kölnischer Kunstverein, Cologne
Premio dell'Ariete, Galleria dell'Ariete, Milan
International Graphic Biennial, Ljubljana, Yugoslavia
Arte Nuova, Palazzo Graneri, Turin, Italy
Vitalita nell'Arte, Palazzo Grassi, Venice. Traveled to: Kunsthalle Recklinghausen, Germany; Stedelijk Museum, Amsterdam
Fifty Years of Recognition, Stedelijk Museum, Amsterdam
New Images of Man, Museum of Modern Art, New York
Recent Developments in Painting, Arthur Toothe Gallery, London
Fifth Biennial, São Paulo
Twenty Contemporary Painters from the Philippe Dotremont Collection-Brussels, Solomon R. Guggenheim Museum, New York. Traveled to: Stedelijk Van Abbe Museum, Eindhoven, the Netherlands
Inaugural Selection, Solomon R. Guggenheim Museum, New York
L'École de Paris dan les Collections Belges, Musée National d'Art Moderne, Paris
Dokumenta II, Kassel, Germany
Appel, Mathieu, Moreni, Riopelle, Kunsthalle Basel
School of Paris 1959, Walker Art Center, Minneapolis

1960
Turning Points in Dutch Painting 1920–1960, Stedelijk Van Abbe Museum, Eindhoven, the Netherlands. Traveled to: Groningen Museum, the Netherlands
Weihnachtsaustellung (Christmas Exhibition), Basel
International Exhibition, Solomon R. Guggenheim Museum, New York
Eindhoven Collects, from Jongkind to Jorn in Private Collections, Stedelijk Van Abbe Museum, Eindhoven, the Netherlands. Traveled to: Stedelijk Museum Schiedam, the Netherlands

1961
Famous Likenesses, Institute of Contemporary Art, Boston
Stedelijk Van Abbe Museum, Eindhoven, the Netherlands
Stedelijk Museum Schiedam, the Netherlands
Haags Gemeente Museum, The Hague

1962
The Dutch Contribution to International

Development Since 1945, Stedelijk Museum, Amsterdam. Traveled to: Montreal Museum of Fine Art; National Gallery of Canada, Ottawa
Collector's Choice, Gimpel Fils Gallery, London
International Sculpture, Martha Jackson Gallery, New York
Stockholm Museum
Galerie Rive Droite, Paris
Galerie Charles Lienhard, Zurich
Nederlanders verzamelen Hedendaagse Kunst (The Dutch Collect Contemporary Art), Museum Boymans-van Beuningen, Rotterdam

1963
Vision and Color, Palazzo Grassi, Venice
Galerie Gimpel and Hanover, Zurich
Gallery La Medusa, Rome
Galerie Nova Spectra, The Hague

1964
Van Gogh and Expressionism, Solomon R. Guggenheim Museum, New York
Appel, Lucebert, Jaap Mooy, Dutch Pavillion for the XXXII Biennale Internazionale d'Arte, Venice
Dokumenta III, Kassel, Germany
Esbjerg Kunst Pavillonen, Esbjerg, Denmark
Stedelijk Van Abbe Museum, Eindhoven, the Netherlands

1965
Museu de Arte Moderna do Rio de Janeiro
Holland: New Generation, Instituto Torcuato di Tella, Buenos Aires
Forty Key Artists of the Mid-20th Century, Detroit Institute of Arts
The Colorist, San Francisco Museum of Art
Statens Museum for Kunst, Copenhagen
Sculptures in Het Vondelpark, Het Vondelpark, Amsterdam
Collection Guepin, Stedelijk Van Abbe Museum, Eindhoven, the Netherlands

1966
Flint International, Flint Institute of Arts, Michigan
International Art 1965–1966, American Art Gallery, Copenhagen

1967
Lehigh University, Bethlehem, Pennsylvania
Junior Council Purchase Show, Fort Worth Art Museum, Texas
Redfern Gallery, London

1968
Akron Art Institute, Ohio
Six Painters from the Martha Jackson Gallery, Fort Worth Art Museum, Texas
Summer Exhibition, Redfern Gallery, London

1969
Portraits in Contemporary Art, Museum of Modern Art, New York
Works from the Peggy Guggenheim Foundation, Solomon R. Guggenheim Museum, New York
Wall Works Part I, Martha Jackson Gallery, New York
Art for Collectors, Toledo Museum of Art, Ohio
Collector's Choice, Gimpel Fils Gallery, London
Artists from the Martha Jackson Gallery, Esther Bear Gallery, Santa Barbara, California
Tajiri, Lucebert, Appel, Kunsthalle Basel

1970
Wall Works Part II, Martha Jackson Gallery, New York
Stephane Janssen Gallery, Brussels
CoBrA at Court, Court Gallery, Copenhagen
Painting and Sculpture Today, Indianapolis Museum of Art
Gemeentemuseum Arnhem, the Netherlands

1971
The 31st Annual Works on Paper, Art Institute of Chicago
The Martha Jackson Gallery Collection, Seibu Museum, Tokyo

1973
An Invitation to See, Museum of Modern Art, New York

1974
Primal Images: Appel, Calder, Dubuffet, Miró, DeCordova Museum, Lincoln, Massachusetts
CoBrA and Contrasts: The Winston-Malbin Collection, Detroit Institute of Arts

1975
CoBrA, Stedelijk Museum, Sint-Niklaas, Belgium. Traveled to: Maison de la Culture, Namur, Belgium

1978
CoBrA, Stadtliche Kornhausgalerie, Weingarten, Germany
CoBrA 1948/1978, Trondhjems Kunstforening & Galleri Riis, Trondheim, Norway

1979
Appel and Alechinsky, Dordrecht Museum, the Netherlands

1980
Boomerang: Une quarantaine d'oeuvres inattendues, Abbaye de Saint-Savin-Sur-Gartempe, France
Van Gogh Bis CoBrA, hollandische Malerei Von 1880 Bis 1950, Württembergisher Kunstverein, Stuttgart, Germany. Traveled to: Rheinisches Landesmuseum, Bonn, Germany

1981
Portraits D'Arbres, Centre Culturel de Boulogne-Billancourt, France
CoBrA, Galerie Nova Spectra, The Hague

1982
100 Works: The Peggy Guggenheim Collection, Venice. Traveled to: The Solomon R. Guggenheim Museum, New York
CoBrA 1948–51, Kunstverein, Hamburg
CoBrA, Musée d'Art Moderne de la Ville de Paris
Appel and Alechinsky, Fondation Maeght, Saint-Paul de Vence, France

1983
20th-Century Prints from the Godwin-Ternbach Museum, Godwin-Ternbach Museum, CUNY, Flushing, New York
Appel-Clave, Art 14'83 Basel, Galerie Jacometti, Basel
Modern Dutch Painting, Stedelijk Museum, Amsterdam
Creatures in Print, Corpus Christi State University, Texas
Expressive Malerei Nach Picasso, Galerie Beyeler, Basel

1984
CoBrA in Het Stedelijk Museum Schiedam, Schiedam, the Netherlands
Modern and Contemporary Masters, Richard Gray Gallery, Chicago
The Karel Van Stuyvenberg CoBrA Collection, Museo de Arte Contemporáneo de Caracas. Traveled to: National Museum of Art, Osaka, Japan; São Paulo Biennial; Hara Museum of Contemporary Art, Tokyo; Malmö Konsthall, Sweden; Taipei Museum of Fine Arts, Taiwan; Liljevalchs Konsthall, Stockholm; Konsthall Brands Klaederfabrik, Odense, Denmark; Nieuwe Kerk, Amsterdam
Creation: The Natural History of Modern Art, Scottish National Gallery of Modern Art, Edinburgh
La Grande Parade, Stedelijk Museum, Amsterdam

1985
Paris en Quatre Temps, 1911–1972, Galerie Zacheta, Warsaw
With a Little Help from Our Friends, Museum of Art, Fort Lauderdale, Florida
Group Show 1985, Annina Nosei Gallery, New York
CoBrA, the Dutch Contribution, Instituto Universitario Olandese di Storia dell'Arte, Florence

1986
The Meyer and Golda Marks Collection, Museum of Art, Fort Lauderdale, Florida
Inger and Andreas L. Riis Collection, Henie-Onstad Art Center, Oslo

Portrait of a Collector: Stephane Janssen, Louisiana Museum of Modern Art, Humlebaek, Denmark. Traveled to: University Art Museum, California State University at Long Beach
100 Years of Dutch Paintings, Niigata City Art Museum, Tokyo. Traveled to: Iwaki City Art Museum, Japan; Shimonoseki Art Museum, Japan; Tsukashin Hall, Amagasaki, Japan; The Seibu Museum of Art, Tokyo (in collaboration with the Fuji Television Gallery)
Un Musée Ephémère, Collections Privées Françaises, 1945–1985, Fondation Maeght, Saint-Paul de Vence, France
Sculpture for Public Places, Marisa del Re Gallery, New York
CoBrA Sobre Papel, Sala Mendoza, Caracas
Maîtres de l'Art Contemporain en France, Galerie Bab Rouah, Rabat, Morocco

1987
ICA: Forty Years and Beyond, ICA, London
Internationale Kunstnere, Galerie Moderne, Silkeborg, Denmark

1988
At First Sight: The Collection, Cleveringa, Noordbrabants Museum, 's-Hertogenbosch, the Netherlands
Max Loreau, l'Attrait du Commencement, Musée Botanique, Brussels
Aquarelle, Gouache, Zeichnungen, Galerie Beyeler, Basel
Bilder für den Himmel: Kunstdrachen (Art in the sky: Art kite), Goethe Institute, Osaka, Japan. Traveled to: Japan, Europe, Australia, and North America
Verzameling aan Zee (Collection next to the sea: works from the collection of the Haags Gemeente Museum), Haags Gemeente Museum, The Hague
Selections from the Ellen and Jerome Westheimer Collection, Oklahoma Arts Center, Oklahoma City
Päske Udstilling, Galerie Moderne, Silkeborg, Denmark
Olympiade des Arts, Olympic Center, Seoul, Korea

1989
L'Europe des Grandes Maîtres: Quand Ils Etaient Jeunes . . . 1870–1970, Musée Jacquemard-André, Paris
Estampes et Revolutions, 200 Ans Après, Centre National des Arts Plastiques, Paris
Am Anfang war das Bild (In the beginning, there was the image), Villa Stuck, Munich. Traveling exhibition
The Art Gallery of Hamilton: 75 Years, The Art Gallery of Hamilton, Ontario
Contemporary Art, André Simoens Gallery, Knokke, Belgium

CoBrA, Eine Europaische Bewegung, Städtische Galerie im Lenbachhaus, Munich
The Power of CoBrA, a Collection, Cultural Center, Hasselt, Belgium
II Biennale de Sculpture, Monte Carlo, Marisa del Re Gallery, Monte Carlo

1990
XX Anniversary, Fuji Television Gallery, Tokyo
Päske 1990, Galerie Moderne, Silkeborg, Denmark

1991
III Biennale de Sculpture Monte Carlo, Marisa del Re Gallery, Monte Carlo
Interactions, Collaborations in the Visual and Performing Arts, Institute of Contemporary Art, Philadelphia
Poets/Painters Collaborations, Brooke Alexander Gallery, New York
The Stedelijk at the Beurs, CoBrA from the Collection of the Stedelijk Museum, Beurs van Berlage, Amsterdam
Towards a New Museum: Highlights from the Collection, Stedelijk Museum, Amsterdam
CoBrA, Provinciaal Museum voor Moderne Kunst, Oostende, Belgium
Affinities in Paint, Crane Gallery, London
Die Wurde und der Mut, l'Art Moral (Dignity and courage, the moral art), Galerie Georg Nothelfer, Berlin
A Museum in the Making: The Stephane Janssen Collection, Scottsdale Center for the Arts, Arizona
La Femme Enfin, Musée des Jacobins, Toulouse; Musée du Luxembourg, Paris
Art Works, Stedelijk Museum, Amsterdam. Traveled to: École Nationale Supérieure des Beaux-Arts, Paris

1992
New Realities: Art in Western Europe 1945–1968, Tate Gallery, Liverpool
Table Sculptures by Modern and Contemporary Masters, André Emmerich Gallery, New York
Parallel Visions: Modern Artists and Outsider Art, Los Angeles County Museum of Art. Traveled to: Kunsthalle Basel; Museo Nacional Centro de Arte Reina Sofia, Madrid; Setagaya Museum of Art, Tokyo
Het Beeld van de Eeuw (Sculpture of the century), Stedelijk Museum, Amsterdam
Le Portrait dans l'Art Contemporain, Musée d'Art Moderne et d'Art Contemporain, Nice
The Interior, Paleis Lange Voorhout, The Hague
Images of Man, Figures of Contemporary Sculpture, Isetan Museum of Art, Tokyo. Traveled to: Daimaru Museum, Osaka, Japan; Hiroshima City Museum of Contemporary Art

1993
Henie-Onstad Art Center's 25th Anniversary, Henie-Onstad Art Center, Oslo
Table Sculpture, André Emmerich Gallery, New York
Continuous Departures: Eight Printmakers in the Modernist Tradition, David Anderson Gallery, Buffalo, New York

1994
New Displays 1994, Tate Gallery, London

Selected Bibliography

Books

Alvard, Julien, Wim Beeren, et al. *Karel Appel: 40 Ans de Peinture, Sculpture & Dessin.* Paris: Editions Galilée, 1987 (all texts have been printed previously).

Armengaud, Françoise. "Entretien avec Karel Appel." In *Titres.* Paris: Edit. Meridiens Klincksieck, 1988.

————. "Karel Appel, Alors Nait l'Animal." In *Bestiaire CoBrA.* Paris: Edition la Différence, 1992.

Bellew, Peter. *Karel Appel: Le Grande Monografie.* Milan: Fratelli Fabbri Editore, 1968.

Bowness, Alan, et al. *Dupe of Being.* New York: Edition Lafayette, 1989 (all texts have been printed previously).

Claus, Hugo. *Karel Appel: Painter.* Amsterdam: A. J. G. Strengholt Publishing Company, 1962. Copubl.: New York: Harry N. Abrams, Inc., 1962.

————. "25 Poèmes et 18 Contines." In *Appel & Alechinsky: Encres à deux Pinceaux.* Paris: Yves Rivière Arts et Métiers Graphiques, 1978 (Dutch ed., *Appel & Alechinsky: Zwart.* Amsterdam: Andreas Landshoff Productions B.V., 1978), (English trans., *Appel & Alechinsky: Two-Brush Painting.* Paris: Yves Rivière Arts et Métiers Graphiques, 1980).

de Towarnicki, Frédéric. "Conversation: Karel Appel—Frédéric de Towarnicki, Paris." In *Karel Appel.* New York: Harry N. Abrams, Inc., 1980.

de Vree, Freddy. *Karel Appel.* Kunstpocket No. 16. Schelderode, Belgium: Kunstforum, 1983.

Dotremont, Christian. "Appel." In *Bibliothèque de Cobra,* ser. 1, no. 3. Copenhagen: Editions Ejnar Munksgaard.

————. "Notice." In *Appel & Alechinsky: Encres à deux Pinceaux.* Paris: Yves Rivière Arts et Métiers Graphiques, 1978. (Dutch ed., *Appel & Alechinsky: Zwart.* Amsterdam: Andreas Landshoff Productions B.V., 1978), (English transl., *Appel & Alechinsky: Two-Brush Painting.* Paris: Yves Rivière Arts et Métiers Graphiques, 1980).

Flomenhaft, Eleonore. "Karel Appel." In *The Roots and Development of Cobra Art.* Hempstead, New York: Fine Arts Museum of Long Island, 1985.

Frankenstein, Alfred. *Karel Appel.* New York: Harry N. Abrams, Inc., 1980.

Ginsberg, Allen. "Playing with Appel." In *Karel Appel, Streetart, Ceramics, Sculpture, Wood Reliefs, Tapestries, Murals, Villa el Salvador.* New York: Abbeville Press, 1985.

Kuspit, Donald. "The Aging Model, the Eternally Young Body, and Other Signs of the Uncanny Presence of Death." In *The Complete Sculptures.* New York: Edition Lafayette, 1991.

————. "Sensual Madness as the Last Refuge." In *Dupe of Being.* New York: Edition Lafayette, 1989.

Lambert, Jean-Clarence. "Appel, la Voie de la Main Gauche" (Appel, the left-hand-way). In *Le Regne Imaginal, Les Artistes CoBrA, Vol. 1.* Paris: Editions Cercle d'Art, 1991.

————. "In Praise of Folly." In *Karel Appel: Works on Paper.* New York: Abbeville Press, 1980 (in French, "Eloge de la Folie." Paris: Yves Rivière Arts et Métiers Graphiques, 1977).

Lucebert. "Dagwerk van Dionysos, voor Karel Appel, 1948." (transl. in French, "La Journée de Dionysos, pour Karel Appel, 1948," in *40 Ans de Peinture, Sculpture & Dessin.* Paris: Editions Galilée, 1987).

Lyotard, Jean-François. *Karel Appel Peintre, Geste et Commentaire.* Paris: Editions Galilée, 1994.

McCormick, Carlo. "The I of the Beholder: Appel and the Sculpture of Experience." In *The Complete Sculptures.* New York: Edition Lafayette, 1991.

Ragon, Michel. *Karel Appel: The Early Years, 1937–1957.* Paris: Editions Galilée, 1988.

Read, Herbert. "Foreword." In *Karel Appel: Painter.* Amsterdam: A. J. G. Strengholt Publishing Company, 1962. Copubl.: New York: Harry N. Abrams, Inc., 1962.

Restany, Pierre. *Street Art, Le Second Souffle de Karel Appel.* Paris: Editions Galilée, 1982.

Sandberg, Willem. "Tout à Coup une Image peut Surgir du Néant." In *40 Ans de Peinture, Sculpture & Dessin.* Paris: Editions Galilée, 1987.

————. " . . . Wars Are Examinations." In *Karel Appel: Painter.* Amsterdam: A. J. G. Strengholt Publishing Company, 1962. Copubl.: New York: Harry N. Abrams, Inc., 1962.

Schierbeek, Bert. *The Experimentalists, Plastic Art in the Netherlands.* Amsterdam: J. M. Meulenhoff, 1964.

Stokvis, Willemijn. *CoBrA.* Amsterdam: De Bezige Bij, 1974.

Straniero, Michele L. "Diary of Ulysses at Roseland." In *The Sculpture of Karel Appel.* New York: Harry N. Abrams, Inc., 1963. Copubl.: Turin, Italy: Edizioni d'Arte Fratelli Pozzo, 1963.

Tapié, Michel. *Un Art Autre.* Paris: Gabriel-Giraud et Fils, 1952.

Verdet, André. *Fenêtres de Karel Appel (Windows of Karel Appel).* Paris: Editions Galilée, 1985.

————, and de Towarnicki, Frédéric. *Propos en Liberté de Karel Appel.* Paris: Editions Galilée, 1985.

Vinkenoog, Simon. *Appels Oogappels (The Appels of his eyes).* Utrecht: A. W. Bruna & Zoon, 1970.

————. *Het Verhaal van Karel Appel: Een Proeve van Waarneming (The story of Karel Appel: a proof of perception).* Utrecht: A. W. Bruna & Zoon, 1963.

————, et al. *Ecrits sur Karel Appel.* Paris: Editions Galilée, 1982.

Vrijman, Jan. *De Werkelijkheid van Karel Appel.* Amsterdam: De Bezige Bij, 1962.

Wingen, Ed. *Het Gezicht van Karel Appel/The Face of Karel Appel.* Venlo, the Netherlands: Van Spijk B.V., 1977.

Exhibition Catalogues

Alvard, Julien. "Les Monstres d'Appel." In *Karel Appel Reliefs 1966–1968.* Centre National d'Art Contemporain, Paris, 1968.

Beeren, W. A. L. *Karel Appel's Tragic Myth.* Museum of Art, Fort Lauderdale, Florida, October–November 1986.

————. *The New Work of Karel Appel: Paintings 1979–1981.* Museum Boymans-van Beuningen, Rotterdam, the Netherlands, January–March 1982. Transl. in Italian in *Karel Appel: Dipinti, Sculture e Collages.* Castello di Rivoli, Turin, Italy, October–November 1987.

Bowness, Alan. *Appel.* Arnolfini Gallery, Bristol, England, October 1986–January 1987.

Claus, Hugo. *De Wereld van Karel Appel (The World of Karel Appel).* Palais des Beaux-Arts, Brussels, 1953.

de Rodriguez, Antonio. *Karel Appel, Pintor del Grito que Sacude y Despierta.* Museo de Arte Moderno, Mexico City, October–December 1977; Museo de Bellas Artes, Caracas, March 1978.

De Wilde, Edy. *In Conversation with Karel Appel.* The Seibu Museum of Art, Tokyo, January–July 1989 (in English and Japanese).

Dotremont, Christian. *Le Stratificateur!* Palais des Beaux-Arts, Brussels, September–October 1965.

Fuchs, Rudi. "Het Bezoek" and "Karel Appel in Gesprek met Rudi Fuchs." In *Ik wou dat Ik een Vogel was (If I were a bird),* Haags Gemeente Museum, The Hague, December 1990–April 1991. Transl. in German, "Der Besuch" and "Karel Appel im Gesprach mit R. H. Fuchs." In *Ich Wollte Ich ware ein Vogel.* Josef-Haubrich-Kunsthalle, Cologne, June–August 1991. Transl. in English, "The Visit" and "Karel Appel in Conversation with R. H. Fuchs." In *Karel Appel.* Fundació Joan Miró, Barcelona, September–December 1991).

————. *Contractions.* Marisa del Re Gallery, New York, March–April 1991.

Hanlon, Alan. *Appel's Appels.* Musée d'Art Contemporain, Montreal, February 25, 1972 (in English and French); Galerie Ariel, Paris, June 1974; Wildenstein Gallery, London, July 1975.

Honnef, Klaus. "Innere Wirklichkeit und Aussere Wirklichkeit" (Interior Reality and Exterior Reality). In *Dreissig Jahre Karel Appel*. Rheinisches Landesmuseum Bonn, Germany, 1979. Transl. in Portuguese, Museo de Arte de São Paulo and Museu de Arte Moderna do Rio de Janeiro, May 1981.

Hunter, Sam. *Karel Appel, in the Spirit of Our Time*. Marisa del Re Gallery, New York, March–April 1986; Seibu Museum of Art, Tokyo, January–July 1989.

———*Past and Present*. Museum of Art, Fort Lauderdale, Florida, October–November 1986. Transl. in Italian, Castello di Rivoli, Turin, Italy, October–November 1987. Transl. in Dutch, Haags Gemeente Museum, The Hague, December 1990–April 1991.

Josephus-Jitta, Marriette. *Karel Appel, Ik Rotzooi maar wat aan. Enige Opmerkingen over een Uitspraak*. Haags Gemeente Museum, The Hague, January 1982.

Kaiser, Franz-W. *Karel Appel—Tussen Dorpen*. Haags Gemeente Museum, The Hague, December 1990–April 1991.

Kuspit, Donald. *Growing Younger*. Marisa del Re Gallery, New York, October–November 1987.

Looten, Emmanuel. *"A Feu et à Sang" [poem]*. Galerie Rive Droite, Paris, May 1960.

Lucebert. "Appels Verflichaam Leeft (1950)" (The body of Appel's work is alive). In *Karel Appel*. Stedelijk Van Abbe Museum, Eindhoven, the Netherlands, 1961.

———. "Drift op Zolder en Vragende Kinderen (Passion in the Attic and Questioning Children)." In *Karel Appel: Ik wou dat Ik een Vogel was (Karel Appel: if I were a bird)*, Haags Gemeente Museum, The Hague, December 1990–April 1991. Reprinted from *Museum Journal*, Ser. 5, No. 10, Amsterdam: May 1960.

Martin, Rupert. *Karel Appel. New Apparitions*. Arnolfini Gallery, Bristol, England, October 1986–January 1987.

Moreni, Mattia. "Appel ou du Grotesque Dramatique . . ." In *Appel*. Galerie Stadler, Paris, April–May 1957.

Pincus-Witten, Robert. *Big Appel and the CoBrA Paintings: 1948–1951*. James Goodman Gallery, New York, April 1985.

Ragon, Michel. *La Rage de Peindre*. Galerie Beyeler, Basel, March–June 1988.

Read, Herbert. *Appel Comes from* I.C.A. Gallery, London, April–May 1957.

Reinhartz-Tergau, Elisabeth. *Het Monumentale Werk van Karel Appel*. Galerie Nova Spectra, The Hague, May 1981.

Sandberg, Willem, and H. L. C. Jaffe. *Kunst van*

Heden in het Stedelijk Museum, Amsterdam" (Art of today in the Stedelijk Museum, Amsterdam). Stedelijk Museum, Amsterdam, 1961

———. *La Réponse de l'Art*. Galerie Rive Droite, Paris, 1962.

Sawyer, Kenneth B. *To many Americans . . .* Martha Jackson Gallery, New York, October–November 1960.

Schierbeek, Bert. *On Appel's Nudes*. Galerie Gimpel and Hanover, Zurich, October 1963; Galerie Europe, Paris, November–December 1963; Gimpel Fils Gallery, London, February 1964; Martha Jackson Gallery, New York, April 1964.

Tapié, Michel. "Une Alchimie de Tons." In *Karel Appel*. Galerie Rive Droite, Paris, October 1955; Stedelijk Museum, Amsterdam, November 1955.

———. *L'Aventure totale d'Appel*. Palais des Beaux-Arts, Brussels, October–November 1953.

———. *Une Véhémence Expressive*. Studio Paul Facchetti, Paris, May 1954.

Vinkenoog, Simon. *Karel Appel: een Vehikel voor Verf . . .* Palais des Beaux-Arts, Brussels, September–October 1965.

———. *Spontaneous Prose for Karel Appel*. Provinciaal Museum, 's-Hertogenbosch, the Netherlands, November 1964–January 1965.

Journals and Periodicals

Alvard, Julien. "Vous Etes Libres," *Cimaise*, Ser. 1, No. 8, Paris: July–August 1954.

———. "De l'Anarchie Considerée comme un des Beaux-Arts," *Art International*, Vol. 4, No. 6, Paris: 1960. Reprinted in *40 Ans de Peinture, Sculpture & Dessin*. Paris: Editions Galilée, 1987.*

*Hereinafter: *40 Ans*.

Alloway, Lawrence. "London Exhibitions," *Art International*, Vol. II, No. 8, Paris: November 1958.

Ashton, Dore. "Affirmation and Apocalypse in Karel Appel's Recent Paintings," *Arts Magazine*, No. 8, New York: 1983, pp. 68–69.

Bakker, Jan-Hendrik. "Karel Appel Ik ben 72 en begin helemaal opnieuw" (I am 72 and start all over again). *Haagsche Courant*, the Netherlands: February 16, 1993.

Barten, Walter. "Verftube als raket" (The paint tube as a rocket). *Financieel Dagblad*, the Netherlands: January 14, 1991.

Blom, Ansuya. "Simply Complicated," *Museum Journal*, Amsterdam: February 1991.

Boudaille, George. "Appel," *Cimaise*, No. 55, Ser. VIII, No. 3, Paris: September–October 1961. Reprinted in *40 Ans*.

Bordaz, Jean-Pierre. "Karel Appel—Interview with

Jean-Pierre Bordaz," *Flash Art*, No. 3, French edition, Paris: Spring 1984.

Borras, Maria Lluisa. "La Pintura como Grito, de Pasion," *La Vanguardia*, Barcelona: October 8, 1991, p. 7.

Bufill, Juan. "La Réalidad de Karel Appel," *ABC*, Madrid: October 24, 1991.

Burrey, Suzanne. "Karel Appel: Dutch Muralist," *Architectural Record*, Vol. 123, New York: January 1958.

Cabanne, Pierre. "Karel Appel: High Tension," *Elle*, No. 2238, Paris: November 28, 1988.

Capriele, Luciano. "Today's Masters," *Arte*, No. 175, Italy: July 1987.

Claus, Hugo. "Mélancolie et Fureur d'Appel," *XXème Siècle*, No. 27, Paris: June 1965.

Cotter, Holland. "Karel Appel," review, *New York Times*, New York: December 25, 1992, p. C29.

Coutinho, Wilson. "A Paintura de um Tigre Dentro da Jaula," *Journal do Brasil*, Rio de Janeiro: September 15, 1981.

Dagen, Philippe. "Karel Appel," review, *Le Gustidien de Paris*. No. 1268, Paris: December 22, 1983.

Dannatt, Adrian. "Karel Appel, André Emmerich Gallery," review, *ARTnews*, Vol. 92, No. 3, New York: March 1993.

Debailleux, H. F. "Tout le Monde Est Endormi" (Everybody is asleep), *La Liberation*, Paris: August 11, 1987, p. 24.

de Towarnicki, Frédéric. "Appel, l'Anti-Robot," interview, *Connaissance des Arts*, Paris: 1977.

———. "The Appel Circus," *Cimaise*, No. 142, Paris: 1979, pp. 73–84.

De Vree, Freddy. "Karel Appel in Kunstforum," *Kunstecho's*, No. 5, Antwerp, Belgium: September–October 1981.

Dobbels, Daniel. "Karel Appel du Vide," *La Liberation*, Paris: August 11, 1987, p. 24.

Ellenbroek, Willem. "Van het aapstadium groei ik naar de mens" (From ape to man). *de Volkskrant*, the Netherlands: December 7, 1990.

Fallon, Brian. "The Roaring Boy," *The Irish Times*, Dublin: January 14, 1987.

Frankenstein, Alfred. "Rambling Around Mexico City," *San Francisco Chronicle*, San Francisco: October 20, 1977.

Ginsberg, Allen. "On a Collage Painting of Kerouac by Karel Appel," May 1982 (in artist's archives).

Hahn, Otto. "Peinture à La Tronconneuse," *L'Express*, No. 1952, Paris: December 2–8, 1988.

Heyting, Lien. "Ik Wilde het landschap laten dansen" (I wanted to make the landscape dance). *NRC Handelsblad Cultureel Supplement*, Amsterdam: July 12, 1990.

Huser, France. "L'Appel de l'oeil," *Le Nouvel*

Observateur, No. 1254, Paris: November 17–23, 1988.

Illes, Vera. "Het zwart van Karel Appel" (The color black of Karel Appel), *Elsevier,* Vol. 46, No. 51, the Netherlands: December 22, 1990.

Jamie, Rasaad. "Appel Now," *Artscribe,* No. 45, London: February–April 1984. Reprint in French, "Appel Aujourd'hui," in *40 Ans.* Reprint in *Dupe of Being,* New York: Edition Lafayette, 1989.*

*Hereinafter: *Dupe of Being.*

Jones, Alan. "Let's Get Ignorant," *Arts Magazine,* New York: March 19, 1991. Reprint in *The Complete Sculptures,* New York: Edition Lafayette, 1991.

Kaiser, Franz W. "Over het Zinnelijke in de Kunst" (On sensuality in art), *Forum International,* No. 6, bilingual, Antwerp, Belgium: January–February 1991.

Kelly, Mary Lou. "Modern Masters, Primal Images," *Christian Science Monitor,* New York: 1974.

Klinkenberg, H. "Karel Appel," *Palaestra,* No. 3, Amsterdam: 1946.

Kontova, Helena, and Giancarlo Politi. "Karel Appel," *Flash Art,* International Edition, No. 134, New York: 1987, pp. 50–53.

Kramer, Hilton. "No One Denies that Painting Is a Material Medium," *New York Times,* New York: September 20, 1975.

Krebs, Patrick. "Les Yeux Grands Ouverts de Karel Appel," *Artstudio,* No. 9, Paris: 1988, pp. 112–21.

Kuspit, Donald. "Atomic Weather," *Art in America,* No. 4, New York: 1985, pp. 160–63.

———. "Karel Appel's Significance in the History of Expressionism," lecture for the exhibition "Ik wou dat Ik een Vogel was" (If I were a Bird), Haags Gemeente Museum, The Hague: December 1990 (in the artist's archives).

———. "Karel Appel," review, *Artforum,* New York: March 1991, p. 145.

———. "Karel Appel, André Emmerich Gallery," review, *Artforum International,* XXXI, No. 6, New York: February 1993.

Lahusen, Margarita. "Karel Appel, Portrait Emmanuel Looten 1956," *Kleine Werkmonographie 78.* Städelsches Kunstinstitut und Städtische Galerie, Frankfurt am Main, Germany: 1991.

Lambert, Jean-Clarence. "Karel Appel la Terre," *Opéra de Paris,* No. 47, France: April 1987, pp. 16–19.

Lamarque-Mouzon, Mary Lou. "Karel Appel, une Certaine Libérté de Propos," interview, *Art Themes,* Côte d'Azur, France: 1984, pp. 14–15.

———. "Karel Appel le Vertige du Noir," *Art Themes,* Côte d'Azur, France: October–November

1989, p. 15.

Lupasco, Stephane. "Appel, Peintre de la Vie," *XXème Siècle,* Supplement to Vol. 23, No. 17, Paris: December 1961. Reprint in English, "Appel, Painter of Life," in *Dupe of Being.*

Lyotard, Jean-Francois. "Sans Appel," *Journal for Philosophy and the Visual Arts,* Academy Editions, London/St. Martin's Press, New York: 1989. Reprint in French, "Image du Nord," *Art Studio,* No. 18, Paris: 1990.

Mason, Marilynne, and Allen Ginsberg. "Karel Appel's Inner Lights," *Northern Lights, Studies in Creativity,* University of Maine at Presque Isle, Maine: 1983–84.

Medina, Racquel. "Retrospectiva de Karel Appel en la Fundacio Joan Miro," *Diario de Tarragona,* Spain: October 31, 1991.

Meyer, Ischa. "Normad," *Vrij Nederland,* Amsterdam: April 28, 1984.

———. "De schilder en Het Licht" (The painter and the light), interview, *Revu Magazine,* the Netherlands: December 1990.

Paparoni, Demetrio. "Primavera senza Fine," *Tema Celeste,* No. 4, Siracuse, Italy: October 1984.

Ragon, Michel. "Expression et Non-Figuration— Problemes et Tendances de l'Art d'Aujourd'hui," Edition de la Revue Neuf, Paris: 1951.

———. "J'ai pris un modèle pour me liberer de l'abstraction," *Arts,* No. 918, Paris: May–June 1963.

Raynor, Vivien. "Karel Appel. Paintings on Show," *New York Times,* New York: March 28, 1986. Reprint in French, "La Passion à l'Origine," *40 Ans.* Reprint in *Dupe of Being.*

Restany, Pierre. "Karel Appel, le CoBrA Collecteur," *Beaux-Arts Magazine,* No. 47, France: June 1987.

Sandberg, Willem. "Appel and the Avant-Guarde, 1969." Reprint in French, "Appel et l'Avant-Garde," *40 Ans.* Reprint in *Dupe of Being.*

———. "Art's Reply, 1969," Reprint in *Dupe of Being.*

Serra, Catalina. "Karel Appel Pintor," *El Pais,* Barcelona: September 27, 1991.

Spiegel, Olga. "Karel Appel Entre lo Grotesco y lo Ludico," *La Vanguardia,* Barcelona: September 22, 1991.

———. "Entrevista a Karel Appel, Pintor," interview, *La Vanguardia,* Barcelona: September 27, 1991.

Van der Haak, Bregtje. "Karel Appel 50 jaar schildersdrift" (Fifty years of painter's passion), *Beelding,* Amsterdam: December 1990–January 1991.

Van Erkel, Ronald. "The Intuitive Logistics of Karel Appel," interview *Ned Lloyd World,* Rotterdam, the Netherlands: Autumn 1992, pp. 28–31.

Van Eyck, Aldo. "Een Appel aan de Verbeelding," a

manifesto, printed on pamphlet published by The Experimental Group, Amsterdam: 1950. Reprint in French, "L'Appel à l'Imagination," *40 Ans.*

Van Houts, Catherine. "Appel 'Ik twijfel tot de laatste lik'" (I am doubtful until the last stroke), *Het Parool,* Amsterdam: February 16, 1993, p. 8.

Van Tuyl, Gijs. "The New Reality of Karel Appel," *Dutch Art and Architecture Today,* Visual Arts Office for Abroad, the Netherlands: December 6, 1984.

Verdet, André. "Karel Appel à Nice," *Cimaise,* Vol. 34, No. 190, Paris: September–October 1987.

———. "On the Trail of a Metamorphosis, Karel Appel, the Thinking Eye," *Cimaise,* No. 187, Paris: March–May 1987.

Vila San-Juan, Sergio. "Karel Appel, El movimiento de la brocha o el pince lo contiene todo," *La Vanguardia,* Barcelona: February 23, 1988.

Villani, Laura. "Karel Appel: Un Omaggio a Firenze," *Scena Illustrata,* Vol. 127, No. 7, Florence, Italy: July 1992.

Wingen, Ed. "Karel Appel heeft het licht gezien" (Karel Appel has seen the light), *Kunstbeeld,* Vol. 15, No. 2, February 1991, pp. 23–26.

Texts by the Artist

1948
"Manifest": see 1987.
1969
"To Me, Color Is Form . . . ," *Art Now: New York,* vol. 1, no. 10 (University Galleries, New York).
1971
Karel Appel over Karel Appel. Amsterdam: Triton Pers (English transl. in *Dupe of Being,* by Alan Bowness, et al.; see "Books").
1982
Océan Blessé: Poèmes (Wounded ocean: poems). Paris: Editions Galilée.
"10 Poems by Karel Appel." In *Nine Dutch Poets.* San Francisco: City Lights Books, Pocket Poets Series no. 42.
1984
"La Dimensione del Sentimento" (Sentiment as a dimension), *Tema Celeste* No. 4, Siracusa, Italy; October, p. 7.
1986
"Artist's Statement." In *Karel Appel, Recent Paintings and Sculpture: Clouds, Windmills, Nudes and Other Mythologies.* Fort Lauderdale, Florida: Museum of Art (catalogue).
1987
"Poems, Aphorisms, and Reflections (1948–1986)." In *40 Ans de Peinture, Sculpture & Dessins.* Paris: Editions Galilée. (Includes French translation of

"Manifest," 1948, written for publication in *Reflex* periodical, but refused by the Dutch Experimental Group.)

"Lang Zal Hij Leven" (Long he shall live). French transl., "Longtemps Il Vivra." In *40 Ans de Peinture . . .* , pp. 66–68.

"For Min Tanaka," *Noise,* No. 7, Paris: Editions Maeght, May 3.

1988

"Chaos et Liberté." In *Karel Appel.* Basel: Galerie Beyeler (catalogue).

"These Six Portraits . . . " In *Karel Appel, Portraits from the Titan Series.* New York: Marisa del Re Gallery (catalogue).

1989

"Painting is a Tangible, Sensual Experiencing . . . " In *Karel Appel CoBrA 1948–1951.* New York: Marisa del Re Gallery (catalogue).

"Karel Appel: Can We Dance a Landscape?" *Art International,* No. 7, Paris: Summer.

1990

"Ik Ben Geen Verdediger . . . " (I am not a defender). Opening speech for the exhibition *Ik wou dat Ik een Vogel was (If I were a bird),* Haags Gemeente Museum, The Hague. Artist's archives.

1991

"And Now I Want to Talk about Willem de Kooning." Artist's archives, unpublished.

Works Illustrated by the Artist

1950

Claus, Hugo. "De Blijde en Onvoorziene Week" (The happy and unexpected week), *Reflex,* Utrecht.

1951

Vinkenoog, Simon, comp. *Atonaal (Atonal: anthology of Dutch experimental poetry).* The Hague: A.A.M. Stols. Drawings by Karel Appel and Corneille.

1952

Andreas, Hans. *De Ronde Kant van de Aarde* (The round edge of the earth). Paris: private printing.

1954

Schierbeek, Bert. *Het Bloed Stroomt Door* (The blood streams on). Amsterdam: De Bezige Bij.

Looten, Emmanuel. *Haine* (Hate). Paris: Publ. Michel Tapié.

1955

Looten, Emmanuel. *Cogne Ciel* (Sky police). Paris: Publ. Michel Tapié (pamphlet with one poem).

1957

Kunz, Ludwig, ed. *Junge Niederländische Lyrik mit elf zeichnungen von Karel Appel* (Young Dutch

lyrics with eleven drawings by Karel Appel). Germany: Verlag Eremiten-Presse.

1958

Looten, Emmanuel. *Rhapsodie de ma Nuit* (My night's rhapsody). Paris: Editions Falaize (pamphlet).

1962

Schierbeek, Bert. *Het Dier Heeft een Mens Getekend* (A beast-drawn man). Amsterdam: De Bezige Bij.

1980

Lambert, Jean-Clarence. *Le Noir de l'Azur* (The black in the blue). Paris: Editions Galilée.

1981

Appel, Karel. *Pepie en Jaco* (Pepie and Jaco). Amsterdam: Meulenhoff/Landshoff Publishers (text and illustrations from 1951).

1984

Morin, Edgar. *New York.* Paris: Editions Galilée.

1986

Appel, Karel. *De Kleurige Onbekende* (The colorful stranger). Amsterdam: De Bezige Bij (poems and drawings).

1987

Paz, Octavio. *Nocturne de San Ildefonso* (Nocturnal of San Ildefonso). Paris: Editions Galilée.

Selected Museum Collections

Ackland Art Museum, Chapel Hill, North Carolina
Albright-Knox Art Gallery, Buffalo, New York
Art Gallery of Hamilton, Ontario
Art Gallery of Ontario, Toronto
Baltimore Museum of Art
Bonnefanten Museum, Maastricht, the Netherlands
Brooklyn Museum, New York
Carnegie Museum of Art, Pittsburgh
Centraal Museum, Utrecht
Centre Georges Pompidou, Paris
Chrysler Museum, Norfolk
Dayton Art Institute
Frans Hals Museum, Haarlem, the Netherlands
Galleria d'Arte Moderna, Turin
Haags Gemeente Museum, The Hague
Hakone Open-Air Museum, Kanagawa, Japan
Hara Museum of Contemporary Art, Tokyo
Henie-Onstad Art Center, Oslo
Institute of Contemporary Art, Boston
Israel Museum, Jerusalem
Koninklijk Museum voor Schone Kunsten, Antwerp

Kunsthaus, Zurich
Kunstmuseum, Aarhus, Denmark
Kunstmuseum Winterthur, Switzerland
Los Angeles County Museum of Art
Moderna Museet, Stockholm
Montreal Museum of Fine Arts
Musée d'Art Contemporain, Dunkerque
Musée d'Art Moderne, Brussels
Musée d'Art Moderne et d'Art Contemporain, Nice
Musée des Beaux-Arts, Liège, Belgium
Museo de Arte Moderno, Mexico City
Museo de Bellas Artes, Caracas
Museo Nacional Centro de Arte Reina Sofia, Madrid
Museu de Arte Moderna de São Paulo
Museum Boymans-van Beuningen, Rotterdam
Museum des 20 Jahrhunderts, Vienna
Museum of Fine Arts, Boston
Museum of Modern Art, New York
Museum van Hedendaagse Kunst, Gent, Belgium
Museum voor Schone Kunsten, Gent, Belgium
National Gallery of Canada, Ottawa
National Museet, Copenhagen
National Museum of Art, Osaka
National Museum of Contemporary Art, Seoul
Neue Galerie-Sammlung Ludwig, Aachen, Germany
Palais des Beaux-Arts, Brussels
Peggy Guggenheim Collection, Venice
Peter Stuyvesant Foundation, Amsterdam
Phoenix Art Museum
Rijksmuseum Kröller-Müller, Otterlo, the Netherlands
Rose Art Museum, Waltham, Massachusetts
Silkeborg Kunstmuseum, Denmark
Solomon R. Guggenheim Museum, New York
Städelsches Kunstinstitut und Städtische Galerie, Frankfurt am Main, Germany
Stedelijk Museum, Amsterdam
Stedelijk Museum, Schiedam, the Netherlands
Stedelijk Van Abbe Museum, Eindhoven, the Netherlands
Tate Gallery, London
Tel Aviv Museum of Art
University of Arizona Art Gallery, Tucson
Vancouver Art Gallery
Vassar College Museum, Poughkeepsie, New York
Walker Art Center, Minneapolis

List of Foundries

Tallix, Beacon, New York
Lippincott, North Haven, Connecticut
Ledeur, Paris
Fratelli Bonvicini, Verona
Struktuur 68, The Hague

Index

188

Photograph Credits